The Unspeakable Confessions of Salvador Dali

The Unspeakable
Confessions of
SALVADOR DALI

As told to André Parinaud

Translated from the French by Harold J. Salemson

WILLIAM MORROW AND COMPANY, INC.
NEW YORK 1976

Printed in the United States of America.

1 2 3 4 5 80 79 78 77 76

Library of Congress Cataloging in Publication Data

Dalí, Salvador, 1904-
 The unspeakable confessions of Salvador Dali.

 Translation of Comment on devient Dali.
 1. Dalí, Salvador, 1904- 2. Painters—Spain—
Correspondence, reminiscences, etc. I. Parinaud,
André, 1924- II. Title.
ND813.D3P3713 759.6 [B] 75-25924
ISBN 0-688-02995-7

Book design: Helen Roberts

FOREWORD

This is a Dalinian novel, and if the hero, Dali, speaks in the first person, that is just a convention of style. Dali never says the French *je* (I) without also meaning *jeux* (games), as his *I* implies all the tricks of the *eye*. Dali is both yes and no, contradiction incarnate, challenge personified. When he does use I, it is not just Dali who is speaking, but one of the possible Dalis I know and hear from among the thousand others embodied in him.

Had Nietzsche known Dali, he would have felt he was finding his kind of superman (his Zarathustra) in Dali's will to power, his continual outdoing of himself, his hyperlucidity and permanent challenge to death, morals, the establishment, and men. History, as it comes down to us in literature or recollected legend, exhibits few examples of an existence asserted without shame, in its most extreme excesses, and an intelligence so sharp as to attain the paroxysm of lucid delirium. On more than one score, the Dali phenomenon is exemplary: as artist he is immense; as psychologist a prodigious mine; as intellectual encyclopedic. The man is fascinating, his success is glorious. After twenty years of devoted relationship I remain as curious about him as I was on the very first day.

5

Dali is at a great season of his life and looks back with an imperious eye, to pass judgment on it. A Dali Museum now exists at Figueras. He is one of the most highly prized of all living artists. Yet he remains the suitor of Gala, the passionate Catalan, the paranoia-critical Surrealist, a being more open than any other to the joy of living.

Salvador Dali in several books previously confided fragments of his recollections and ideas; endless interviews have strewn about his thoughts on current events like confetti. But now for the first time all the elements of his passionately interesting life are brought together within one view to be thought through once more, bring out its lines of force, attempt to determine the keys to it, and appreciate its powerful savor. To be sure, no one label can succeed in defining Dali, not even the label of Surrealism. It would be grossly presumptuous to enclose within one person, one style, one version, so exceptional a personage, and try to crystallize his inimitable manner of expression (yet, on several occasions within the text we have tried to use his expression word for word, as given in quotation marks at each chapter ending).

I have tried to follow the benchmarks and filiations of "wonderful" Dalinian thought through his writings, his memories, the testimony of his intimates and friends. Conversations, taped interviews, surveys, all the techniques of analysis have been used in order to situate the Dalinian statements in their proper contexts and frames of reference.

To Dali, dates and facts are but opportunities to transpose the present and create the future according to the principles of his paranoia-critical method, which allows for the simultaneous experience of several presents of a given situation or the evocation of as many different images as one's imaginative capabilities may suggest. We have checked out in the greatest detail the events of his amazing existence, although well aware that the essential lay less in authenticity of detail than in the deeper vision of a stance and the analysis that illumines this *sui generis* destiny.

The well-known public personage is but the too-visible part of the iceberg. I hope that, in reading this account of the adventure of a life, the reader may comprehend the interest of the prodigious human experience, the admirable succession of psychological recipes revealed by this unique case of genius.

ANDRÉ PARINAUD

CONTENTS

The Unspeakable Confessions of Salvador Dali

I

How to Live with Death

I, Dali, want my book to start with the evocation of my own death.

Not out of any sense of paradox, but so as to make understandable the genius of originality in my will to live.

I have been living with death ever since I became aware I was breathing; it has been killing me with a cold voluptuousness exceeded only by my lucid passion to outlive myself at every minute, every infinitesimal second of my consciousness of being alive. This continual, stubborn, savage, terrible tension is the whole story of my quest.

My supreme game is to imagine myself dead, gnawed by worms. I close my eyes and, with unbelievable details of utter and scatological precision, see myself slowly gobbled and digested by an infernal wriggling mass of big greenish earthworms, battening on my flesh. They set up in my eye sockets after having gnawed the eyes away and gluttonously start devouring my brain. I can feel on my tongue how they slaver with pleasure as they bite into me. Beneath my ribs, a breath swells my thorax as their mandibles destroy the

gossamer tissues of my lungs. My heart holds out just a bit, for the sake of appearances, for it has always served me well. It is like a big fat sponge gorged with pus, that suddenly bursts and runs out into a magma crawling with fat white maggots. And then there is my belly—putrid, stinking—that pops like a bubble full of carrion, a swarming compost of subterranean life. I fart one last time like an old volcano and tear apart in a dislocation of flesh and cracking of bones burst by the worms feasting on my marrow. I find it excellent training, and have been doing this as far back as I can remember.

The Earliest Dalinian Memory

I lived through my death before living my life. At the age of seven, my brother died of meningitis, three years before I was born. This shook my mother to the very depths of her being. This brother's precociousness, his genius, his grace, his handsomeness were to her so many delights; his disappearance was a terrible shock. She was never to get over it. My parents' despair was assuaged only by my own birth, but their misfortune still penetrated every cell of their bodies. And within my mother's womb, I could already feel their *angst*. My fetus swam in an infernal placenta. Their anxiety never left me. Many is the time I have relived the life and death of this elder brother, whose traces were everywhere when I achieved awareness—in clothes, pictures, games—and who remained always in my parents' memories through indelible affective recollections. I deeply experienced the persistence of his presence as both a trauma—a kind of alienation of affections—and a sense of being outdone. All my efforts thereafter were to strain toward winning back my rights to life, first and foremost by attracting the constant attention and interest of those close to me by a kind of perpetual aggressiveness.

Van Gogh lost his mind because his dead double was present at his side. Not I.[1]

For I have always known how to encompass and control within my memory even my most atrocious recollections; I can even remember my intrauterine existence.

I have only to close my eyes, pressing on them with my two fists, to see again the colors of that intrauterine purgatory, the tints of Luciferian fire, red, orange, blue-glinting yellow; a goo of sperm

[1] It is a well-known fact that Vincent Van Gogh's birth was also preceded by the death of a brother named Vincent. As a schoolboy, the future artist each morning was obliged to go by a cemetery in which he saw his own name on a tombstone.

and phosphorescent eggwhite in which I am suspended like an angel fallen from grace.

Dalinian Memories of Fetal Existence: Intellectual Creation or Obsession?

I was born like anyone else in horror, pain, and stupor. If I suddenly move my fists away and open my eyes wide in bright light, I again feel something of that shock which, filled with suffocation, choking, blindness, crying, blood, and fear, marked my entry into the world.

The dead brother, whose ghost was there at the start to welcome me, was, you might say, the first Dalinian devil. My brother had lived for seven years. I feel he was a kind of test-run of myself, a sort of extreme genius. His brain had burned out like an overheated electrical circuit through unbelievable precociousness. It was no accident that he was named Salvador, like my father, Salvador Dali i Cusi, and like me. He was the wisely loved: I was but loved too well. In being born, my feet followed right in the footsteps of the adored departed, still loved through me, perhaps even more than before. The excess of love lavished on me by my father from the day of my birth was a narcissan wound, one I had already felt in my mother's womb. Only through paranoia, that is, the prideful exaltation of self, did I succeed in saving myself from the annihilation of systematic self-doubt. I learned to live by filling the vacuum of the affection that was not really being felt for me with love-of-me-for-me; I first conquered death with pride and narcissism.

I have often seen death along my way under the most incongruous of circumstances. I am finishing a lecture at Figueras, my native city, before an audience including all of the local authorities. It is 1928. They have come to see and hear a local boy. I have put on an aggressive tone to shake up the sleepy locals, and at the end I almost shout at them, "Ladies and gentlemen, the lecture is over." The crowd, hard put to keep up with me, has not yet understood I have dismissed it. I keep quiet. There is a silent, motionless moment, and suddenly the Mayor, sitting right in front of me, almost at my feet, drops dead as a doornail. They get up all around, full of excitement and horror, carrying on. But I just stay where I am, without moving, contemplating the haggard face, the eyes forever closed, whose last expression had been animated by my thought.

Is Dali Afraid of Death?

Through that thought, the dead man was branded with the Dalinian seal. To me, the dead are a downy pillow on which I go to sleep, but I have often felt a horror of death.

I am five years old. It is 1909. One of my cousins, who is twenty, has shot a bat in the eye with his carbine, and put it in a pail. I throw a tantrum, and demand that he give me the small animal, and then run to put it in one of my secret places, a warehouse that I often hide in. I watch the trembling, suffering little mammal, shrinking inside its prison. I speak to it, hold it, kiss its downy head. I begin to adore it. And the next day, first thing, I run to see it. I raise the pail, and find the animal already dying, lying on its back, with ants swarming over it; I can see its little panting tongue and the old man's teeth around its nose. I regard it with infinite pity, then take it up and, instead of kissing it as I had first intended to do, suddenly in a kind of rage with one bite all but behead it. I am suddenly seized by the horror of what I have done, by the taste of blood I can feel in my mouth, and I frantically throw the little corpse into the washing vat at my feet alongside a large fig tree. I run away, tears streaming from my eyes. I turn back, however, but the bat has disappeared. Big black figs are floating on the surface of the water, like spots of mourning. Even today the memory of this can give me the shivers, and often just seeing some black spots is enough to bring that bat's death back to me.

As a child, I also had a porcupine that disappeared one day. A week later, I found it dead in the henhouse. But I remember that at first I thought it was alive, for its bristles were being so actively moved by the packet of maggots oozing around the corpse. The head was disappearing under a greenish gelatinous mess. At that moment I lived to its delirious limit the strange fascination of that death, that unspeakable corpse, the rotting stink that rose from the biological offal. I was able to tear my eyes away only because my legs were buckling under me and I had to flee the stench. It was just the time when the gathering of lime-blossoms started, and as I came out of the henhouse, a-tremble with horror, I was blessed with the soothing scent of their aromatic leaves. But the fascination was too great. I held my breath and went back into the chicken coop once more to inspect the decomposing carrion. Then, back out to breathe the fresh air, and back again into the henhouse. Stench, fragrance, shadow and light, corpse and beauty of flowers: they

kept alternating in a hysterical ballet until I was totally overcome by the desire, the need to touch that pile of vermin. I resisted at first and, the better to outwit my horrible desire, tried to jump over the porcupine. But by some sort of need to fail, I slipped and fell, with my nose almost right down in the mess of worms. I was horribly disgusted and, grabbing a grubbing-hoe, which to me was endowed with fetishistic powers, used the flat of the blade slowly to crush the porcupine: its skin finally gave way, revealing the teeming flesh beneath. I dropped the hoe and started to run away. I was breathless; the shock was overwhelming. I felt crushed. Yet I came back to retrieve my soiled fetish, which I then went and soaked endlessly in the waters of a stream, before throwing it down on the stacks of lime-blossoms drying in the sun. But I still had to let it soak in the dew of daybreak before it lost the stench of putrefaction. I had just brushed up against the horror of death.

How Dali Remembers His Father's Death

My father was dead when, having gotten there too late, I kissed his cold hard mouth with my ardently living lips. I have often said, paraphrasing Francisco de Quevedo, that the greatest of sensual enjoyments would be to sodomize my dying father. Can there indeed be for any man a more awful profanation or a greater proof of his own life, to give himself and to take, than this sacrilege, this defiance? Only my cowardice and circumstances kept me from committing it, but I can still dream of doing it.

García Lorca, whom I met in 1919 at the university, sometimes acted out his own death. I can still see his face, deadly and terrible, as he lay on his bed, trying to go through the stages of his slow decomposition. Putrefaction, in his version, lasted for five days. Then he described the casket, his coffining, the full scene of its closing, and the progress of the hearse through the bumpy streets of Granada. Then, when he was quite sure he had us all tense with terror, he would suddenly sit up, break into a wild gust of laughter that displayed all of his fine white teeth, and send us scurrying out the door as he went back to bed, to sleep quiet and free.

As a child, the slightest sign of death twisted my belly with fear, and the polymorphous perversity that I displayed so early was doubtless a deep reaction to the forces of life going into action within me against the forces of death. Born double, with an extra brother, I first had to kill him off in order to assume my own place, my own

right to my own death. I remember once having atrociously scratched the cheek of my nanny with a pin, because a candyshop was closed, but mainly because her smooth, red, docile cheek was like a slate I could write my name on in blood: in Catalan, Dali means Desire.

At five, I pushed a beautiful, curly-headed, little blond play-mate off into space as I was helping him along on his tricycle. Going over a bridge that had no railing, and having made sure no one could see us, I shoved him off from a height of several meters down on to the rocks below, then pretending to be heartbroken ran home to get help. He was bleeding profusely. The whole house was in an uproar. I can still see myself, on a little rocking chair, the whole time, rocking back and forth as I snacked on fruit and watched the feverish commotion of the parents, enjoying the peaceful dark-ness in my corner of the sitting room; without the slightest remorse, as if relieved by my act, more than ever the master of my life.

A year later, I kick my little three-year-old sister, who is crawling on all fours, right in the head. I am going to go gaily on my way. But unfortunately my father sees me do it. He locks me up. I hear the latch snapping shut. I can picture his hugeness beyond the door. But I stay motionless and furious. He is punishing me with the lockup, so I may not see the comet that the whole family is watching for with eyes riveted to the skies. I alone am deprived of the unique spectacle. At the thought, I start to sob until I choke. Every tear in my body pours out and I scream so loud I lose my voice, until my mother starts to worry about it, and soon has him worried, too. I immediately understand how I can turn such situa-tions to my advantage. I am six.

I got more revenge a few days later by pretending to choke on a fishbone, so that my father had to leave the table, because he could not stand my hysterical coughing, which probably re-awakened in him an echo of the painful death-throes of his first-born. I kept repeating these terrifying choking mimodramas, in order to savor my parents' horror.

By taking revenge on my father, I prolonged the enjoyment of my own desire.

In those days, all I had to do was go through my parents' bedroom, where there was a picture of Salvador, my forerunner, my double, to have my teeth start to chatter; I could not possibly have visited his grave in the cemetery. I later had to develop all the resources of my imagination to treat the theme of my mortuary putrefaction by projecting images of my flesh as a putrid worm and finally exorcising it so I could get to sleep.

How Dali Defines the Paranoia-Critical Method

I define the paranoia-critical method as a great art of playing upon all one's own inner contradictions with lucidity by causing others to experience the anxieties and ecstasies of one's life in such a way that it becomes gradually as essential to them as their own. But I very early realized, instinctively, my life formula: to get others to accept as natural the excesses of one's personality and thus to relieve oneself of his own anxieties by creating a sort of collective participation.

At the Marist Brothers' school at Figueras, one afternoon, walking down the stone stairway toward the play area, I felt like jumping off into space. Cowardice forbade it. But the next day, I made the jump and landed lower on the stairs, all bruised and battered. Both pupils and teachers were surprised, and no little frightened by what I'd done. The amazement I caused made me almost insensitive to pain. I was cared for, surrounded with attention. A few days later, I repeated my act, this time yelling loudly enough to have all eyes turn toward me. I did it again several more times, my own fear having completely disappeared in the great anxiety I caused my schoolmates. Each time I came down the stairs, the attention of the whole class turned toward me, as if I were holding a service, and I walked in deep silence—deathly silence, as the saying goes—so as to rivet their fascination until the very last step. My persona was being born.

The reward I got from all this was much greater than the inconvenience. It has often happened to me to yield to a sudden impulse and jump into space from the top of a wall, as though to risk the greatest danger and soothe my heart's anxiety. I even turned into a very skillful jumper. And I noted that each time these events brought me, after the fact, a deeper sense of the reality about me: greenery, trees, flowers, all seemed closer to me.

Afterward, I feel light; I can share normally in existence and "hear" my senses. By jumping before my associates, I create in them an angst equal to or even greater than my own, I take on a kind of dignity in their eyes, raising my act to the stature of a happening. Dali becomes the bearer of everyone's angst, and his weakness is transmuted into strength. I have gotten them all to recognize my delirium, to accept it, and forced them all to partake of the same emotion.

This is how the passion for death became a spiritual joy.

Which is typically Spanish. Not for me to "keep reason," as was said by Montaigne, whom I scorn for his petit bourgeois mind, his grotesque attempt to beautify death, deprive it of its sap, and overcome its horror. I would rather look death in the eye. I make my own the sublime outburst of St. John of the Cross: "Come, O Death, so well hidden that I feel you not, for the pleasure of dying might restore me to life." In the face of such a stand, how skimpy indeed the advice for falsification given by Michel de Montaigne. I hope for my death to come into my life like a thunderbolt, to take me entire like a spasm of love and flood my body with the totality of my soul.

In advance I can savor my desperation. My powerlessness to know on the other hand elates me, and my fright imbues me with the audacity of defiance. The prick of death bestows a new quality on my life and my passions. When Gala, the miracle of my life, underwent a serious operation in 1936, we spent our time in a state of apparent unconcern still creating Surrealist objects the day before the surgery. She amused herself at bringing together amazing disparate ingredients for the fabrication of what seemed to be a mechanicobiological apparatus. Breasts with a feather in the nipple and topped by metal antennas dipping into a bowl of flour (this assemblage being an allusive reference to her forthcoming operation). But it happened that, while in the taxi taking us to the hospital—we had planned to stop off at André Breton's and show him Gala's invention —an unfortunate bump knocked the contraption askew, dousing us with flour. You can imagine what we looked like when we arrived at the hospital.

What is to be underlined is that, later that evening, entirely engrossed in my own invention—a hypnagogical clock made up of a huge baguette of French bread into which twelve inkwells filled with ink had been implanted with a quill-pen of a different color stuck in each—I had eaten a hearty dinner, without for one second thinking of Gala's operation.

Until two in the morning, I continue to perfect my clock by adding to it sixty inkwells painted in watercolors on cardboards that I hang from the bread. I fall asleep, but at five in the morning, my tensed-up nerves awaken me, I am in a sweat and break into sobs of remorse. I get up unsteadily, weeping, my mind exalted by the images of my adored Gala in the various phases of our life, and I dash over to the hospital to shout my anxiety. For a week, I am overcome with sobbing, with death grabbing at my throat. Finally, the ill is overcome. I go into Gala's room, take her hand with all

the tenderness in the world, and say to myself, "Now, Galushka, I can kill you."

My soul battens on what crushes it and finds sublime orgasm in what denies it. Weakness itself becomes my strength, and I am enriched by my contradictions.

I live with eyes lucid and wide open, unashamed, without remorse, and emerge as spectator of my own existence.

Is Scatology Noble to Dali?

Do you think it is coincidence that the flights of the great mystics were so often associated with defecation and flatulence? The fact is that the anus, raised on high by Quevedo in his *In Praise of the Arsehole,* is mainly a symbol for the purification of our acts of cannibalism. All that is human when transcended by the spirituality of death becomes mystical. After the birth of the Dauphin, heir to the throne of France, his excrements were collected at Court, in the presence of all the Nobles of the Realm, and the greatest of artists were called in, that their palettes might take inspiration from the royal shit. The entire Court was dressed in the color of *caca-dauphin*. That is noble. It is the acceptance of man in his entirety, his shit as well as his death. Moreover, the excrementitious palette enjoys infinite variety, from gray to green and from ochers to browns, as can be seen in Chardin. And there is nothing gastronomically more eye-appealing than the shade of loose stools. The true scandal is that we no longer dare to say or think this. Long live Dauphin-shit!

Take Americans, who are unable to face death and have built up a whole industry on slogans like, "You do the dying—we handle all the rest!" so as to disguise the reality of the phenomenon, to minimize it, dress it up, pasteurize it, standardize it, and deprive it of its tragedy. But death conceived without grandeur can inspire nothing but a mean life with mediocre thoughts. There is no substance to the life of men if death is devoid of meaning. The U.S.A. would find Dauphin-shit unthinkable, so they replace it by sugar-candy-pink, i.e., blandness and mediocrity.

I dream of restoring its solemnity and fascination to death. Perhaps it will be necessary, as in the great days of the Escorial, to go back to the muckheaps on which one could be present at the slow decomposition of bodies, with sight and smell bringing to minds and memories the fermented values of a true spirituality. The worm-

ridden bodies accomplished their last noble function: the return to earth. In the acceptance of scatology, of defecation and death, there is a spiritual energy that I exploit with great consistency. I am convinced that, unconsciously, the deep impulses that moved me to disembowel my little dead and decomposed porcupine also doubtless demanded that I eat it.

Dali: Kill and Eat

I love to crack between my teeth the skulls of little birds, bones that I can suck the marrow out of, gamy woodcocks served in their own excrement, and I regret only that I never got to eat the famous turkey cooked live, which, it is said, is a magical dish.

I know I am fiercely ravenous, and my conscience is delighted with my cannibalistic appetite, for what I thus consume is the constant proof of my living reality. I salivate in a more lively way, knowing myself to be alive, when devouring something dead. The jaw, moreover, is a wonderful instrument for becoming aware of our own lust for life, and the quality of reality, which is in fact only a gigantic reservoir of rot, of which our dining-tables are the cemeteries. The truth is between our teeth. All philosophy is proved out in the art of eating. A man reveals himself when he is fork in hand. The aristocracy of Grande Cuisine has always appealed to me. Like my father, I am wild about seafood, those crustaceans whose virgin flesh is protected by the bones they are shrewd enough to grow on the outside, but I detest oysters out of their shells and the mushiness of spinach.

Joseph de Maistre said it all on this subject when he commented that on a battlefield man never disobeys and the whole earth continuously soaked in blood is an immense altar on which everything living is endlessly, measurelessly, relentlessly immolated, until the consuming of all things, the extinction of all evil, the very death of death.

Yes, obliteration is inevitable. We will all be digested by the earth. And I think of that all the time. Not one of my actions, one of my creations but is profiled against this background. At no moment in my life am I unaware of the presence of death. It makes me happy, witty. First of all, because everything in its shadow becomes unique and inevitable, and then because I intend to cheat a little by having myself hibernated, i.e., by extending the comedy two or three more acts into the coming century. Finally, because I believe

in the resurrection of bodies. It is too bad that I am not a believer. I have not lost hope. St. Augustine showed the way by praying to God to give him faith, but not without first giving him the time necessary to exhaust the pleasures available on earth. I desire eternal afterlife with the persistence of memory. I want to be able to remember every detail of my life. Beatitude means nothing to me without the certainty of remembering the whole of my life. I reject other forms of resurrection and in that case prefer not to die. At present there are at least ten methods for prolonging life virtually indefinitely, with periods of sleep that would add that much spice to the reawakenings. I will choose with the greatest efficiency, when the time comes. This attitude is a part of the game I play with death. I have my genius as an alibi for attempting to prolong the days as long as the fulfillment of my oeuvre demands. But in truth, all that I love deeply and viscerally is the inside of my body. My entire ethic consists of getting maximum pleasure through waiting, using resistance to extend desire by heightening it to the paroxysm, not only with all that might stand in its way, but especially by my own determination not to take what belongs to me, not to possess what is mine. And what is mine more than my death?

I confess, I believe myself invulnerable; I want to endure to the highest limit so as to provoke divine death in its very essence. By way of becoming as great as it is, of emulating it in dimension and quality. It is my glorious goddess, governing spirit of us all. It is sacred and absolute beauty. I know that this life is but the realm of the incomplete, but I shall make of the long and infinite succession of days that constitute my life a superb completion, carrying pride to the point of its fusion with God. I would like to write a poem to it, that would say: O Death, my beautiful divinity, Thou hast found Thy High Priest, Thy rival, and Thou servest me as I adore Thee. We work together to formulate an equation of the absolute such as has never had its equal. Each day I am increasingly the Great Archangel of the House of the Dead.

To get back to my intrauterine life, it ended on the eleventh day of May in 1904, at forty-five minutes past the hour of eight, as I was born from the legitimate belly of Doña Felipa Dome Domenech. My mother was thirty. And the birth certificate that my father, Don Salvador Dali i Cusi, made out two days later gives details of the genealogy of both my parents' families. On father's side, Don Galo Dali Viñas, native of Cadaqués, deceased, and Doña Teresa Cusi Marcos, native of Rosas. On mother's side, Don Ancelmo Domenech Serra and Doña Maria Ferres Sadurne, natives of Barcelona. Wit-

nesses: Don José Mercadér, native of La Bisbal, province of Gerona, tanner by trade, residing in this city, and Don Emilio Baig, native of Figueras, musician by profession, residing in this city, both being of age.

My father, who was born at Cadaqués, was then forty-one, and known as the "money doctor," being the *notario* * of Figueras, living at 20 Calle Monturiol.

I was given the Christian names of Salvador, Felipe, and Jacinto. And I am sure that all the glorious departed, all those whose souls enrich the mystical noösphere in which we swim, that cybernetic humus of spirituality, rejoiced on the occasion of my appearance on earth, since it constituted the greatest challenge the genius of man had ever issued to death.

In the long succession of centuries that saw so many illustrious men born, how many ever attained my quality of concerted cosmic delirium? What I can say is that I, Dali, feed my desires with the *élan vital* of all dead geniuses. I carry them all forward. I am the sun that shines on all the planets lost in the night of ages.

"DEATH IS THE THING THAT FRIGHTENS ME THE MOST, AND RESURRECTION OF THE FLESH, THAT GREAT SPANISH THEME, THE ONE MOST DIFFICULT FOR ME TO ACCEPT—FROM THE VIEWPOINT OF LIFE."

* While nominally meaning *notary,* this title, in Spain as in most Latin countries, designates a member of the legal profession empowered to act in fiduciary, escrow, and other matters of financial estate management and trust, but not licensed to plead before the courts; hence, the local guardian of fortunes and investments, or colloquially the "money doctor." (TR. NOTE)

II

How to Get Rid of One's Father

To the manchild I was, my father was a giant of strength, violence, authority, and imperious love. Moses plus Jupiter.

The love he had felt for Salvador, his firstborn, given the strength of his character and the quality of newness, was never to abandon him. At any rate, I was to experience its waves, its radiations searingly through me. When he looked at me, he was seeing my double as much as myself. I was in his eyes but half of my person, one being too much. My soul twisted in pain and rage beneath the laser that ceaselessly scrutinized it and then, through it, tried to reach the other, who was no more. And for a long time I had in my side a bleeding wound that my impassive, insensitive father, unaware of my suffering, kept continually reopening with his impossible love for a dead boy. For a long time this love was delivered to me like a sledgehammer blow, when through a word as fine-honed as a dagger it did not slash at my heart. In spite of him, in spite of this feeling of being superfluous, of being ill-loved for myself—choked within the corset of the image of the other that was being forced upon me— I tried to keep catching my breath, to fight back vigorously as one

does when drowning, to conquer my own place in the sun of life. This despair drove me to delirium, but yet, fascinated by the purely Spanish hardness of my father who was in fact the natural, biological, and psychological axis of my future personality, I could never stop admiring him. So, while afraid of the shadow of the oak he was, and trying at the same time to free myself of the oppressive hold it had on me, with my mind inspired by his example and his strength I skinned myself against its rugged bark and scratched my soul on its trunk. In order for me to become Dali, I had to immolate on the psychoanalytical altar my father Dali i Cusi; shrink him as do the Java headhunters to the size of one of those celluloid toys that as a child I hammered to bits, and swallow him like the Eucharistic host so as to digest him and be nurtured by his substance and essence. For, I must, at the same time, never cease to keep his admirable presence before me, so that my wild rage of power and resentment might not get the better of me, but remain channelized and mold itself little by little into the monumental projection that would be he and I, me and him, my genius flowering with the secret of his strength.

He spent the night sitting up with me when I was sick. The next day, a Sunday, he instructed that he not be disturbed.

A client, a Figueras peasant, came to the house asking to see him. Soon, he was demanding to see the notario, and his voice began to roar about those public servants who get paid for doing nothing and are never there when needed, spending their nights carousing and their days sleeping it off, while honest folk like him had to work even on Sundays. My father heard him, and suddenly was up. He was in undershirt and drawers. I heard the door violently flung open. He grabbed the man by the collar, with a yell, and they both lurched out on to the stairs; they went on fighting each other all the way down to the sidewalk, then in the public square, right under my windows. I ran to the balcony and watched through the bars as my father and that man rolled over and over on the ground, tearing at each other. My father's sex organ, breaking out through the fly of his drawers, now as the two wrestlers tugged back and forth, dipped into the dust and beat against the ground, like a sausage. When my father got mad, the whole *rambla* of Figueras held its breath; his voice broke out of his office like a torrential stream carrying away everything before it in its path.

A client who had come to deposit some money with him once asked for a receipt, pending getting the official document the next day. "After all, you might die tonight," he said. My father jumped

at him: "Do I look like the kind of man who might die?" And the notario of Figueras threw the impertinent client out.

In the sober aspect of his character, he was no less impressive. I could tell his worries by a tic he had. Taking a lock of hair between his thumb and forefinger, he would twist it into a coil that stood out like a horn on one side of his head, and his wrinkled brow, his majestic scowl, turned him into a Moses inspired, charged with divine authority.

I can see him rocking in his chair, with his ear toward the huge horn of the phonograph scratching out Gounod's "Ave Maria." Standing in front of him, against the background of the music I can see his leonine jaw coming and going above my head, full of its terrifying energy.

He had locked himself in, but I had seen him carry a platter piled high with the sea urchins he adores. I imagine him cracking them open in one movement and swallowing them with a sensuous enjoyment the more voluptuous for being savored privately.

I am seven years old, and he holds me by the arm with his huge hand. We are going across town. He has to drag me. I scream and refuse to go to school. Shopkeepers on their doorsteps watch the notario exercising his authority. He is just as furious as I am. This will be a dramatic confrontation. But the imposition of force will only increase my megalomania.

My father, being a free thinker, felt I should go to the public school rather than the one run by the Brothers, even though the latter was more in keeping with our social station. My arrival at the school was looked upon as an intrusion. In my little sailor suit, with neatly combed and scented hair, polished shoes, I was like a fashion plate suddenly dropped among these ragged street urchins. Everything about me, from my lace kerchief to the initialed thermos bottle with my four-o'clock hot chocolate, set me aside more implacably than a social disease. They came smelling around me, mocking me, calling me names. I lived in a kind of silently prideful quarantine, while around me there was a whole bustle of unaffected life, made up of shouts, fights, noisy games, in which the barefoot boys of Figueras gave vent to the vitality of their ages. I remained turned in on myself. And within a year I forgot everything my mother had taught me at home, all the letters of the alphabet and how to sign my name. I was so intimidated I could hardly even undress alone any more. To take my sailor blouse off was an exploit that came near choking me to death. I was unable to lace my shoes, and might stand gaping before a doorknob, paralyzed at the idea of having to turn it. The world

around me was loaded with deviltries, bristling with spikes, undermined by pitfalls. My nights were invaded by monsters and I would scream out in terror. My mother had to take me in her arms, and she would spend whole nights cradling me on her knees.

How Dali Remembers His First Class

Mr. Truiter, our teacher, looked like Tolstoy, with his white beard yellowed by the snuff he took mechanically but in massive doses. He had a strong smell and was dressed outlandishly, but he wore one of the rare high hats ever seen in Figueras. When he sat down, the two points of his beard surrounded his face like the flaps of a frock coat, and ran down to his knees. He was supposed to be very intelligent, and his eccentricity was equaled only by his gift for woolgathering. Truiter is a Catalan word meaning omelet. He must have eaten his runny and had trouble digesting them, for he spent the better part of his class time snoozing. Between dreams, he pinched snuff like a "fix," and then, after a good sneeze that shook his whole carcass, went back to his old-man's slumber. When one of the kids got too noisy and brutally brought him out of his dreams, his heavy mass of flesh as if needled by a nightmare jumped up into the middle of the room and he grabbed some youthful ear between thumb and forefinger, muttered a curse at the offender, then returned to the sweet arms of Morpheus. His pedagogy, as can be seen, shone best in the art of the siesta.

As the only socially acceptable pupil, although as dull a student as the rest—for obvious reasons—I was enshrined by Mr. Truiter in a special niche in the midst of his vegetative life. He had one passion—one escape—one way to fend off the present: collecting works from the past, which he did to the point of vandalism. They used to tell how once he was almost stoned to death when, in trying to swipe a Roman capital from the column of a belltower, he made a corner of the building collapse, narrowly missing bringing down the bells that might have crushed him, but not escaping the violent reaction of the villagers. This incident had contributed much to the legend of his being a man of culture and lover of art. He had a whole houseful of treasures he had pillaged and invited me to come and see them.

After a schoolday made up of alternate sleeping and violent awakening, Mr. Truiter would often take me to his caravansary. I remember one flat dried frog that he called his dancing-girl: it hung

from a thread in his bedroom. He said it acted as a barometer, but its grotesque movements horrified me. There was a statuette of Mephistopheles that he kept in a mahogany niche and he could make sparkling flares come out of its trident like a real display of pyrotechnics. He had also brought back from the Holy Land a giant rosary, cut from the olive trees of the Mount, which he dragged out on his shoulders for me and spread on the floor with a great noise of clanking of chains. But the real wonder was his optical theater: a kind of stereoscope that took on all the hues of the prism and ran moving pictures before your eyes. I can remember as clearly as if I were still looking at it the overwhelming (to me) appearance of a little girl in white furs, riding in a troika chased by wild wolves whose eyes shone in the darkness. She was looking out at me, calling to me for help, and my heart responded to her call and her presence. I was never to forget that face, that call, that image as magical as a first look of love. There were many other things in Mr. Truiter's optical show; but of all the visions none reached the intensity of that fantastic exchange between my solitary, megalomaniacal, hysterical, and absolute mind, and the dream image that came from nowhere to teach me that on earth and in the skies there was an angel watching over me, who also needed my help.

What Did Dali's Father Really Mean to Him?

We are on our way up to the château at Figueras. My father is holding my hand. Now it is becoming steep. At the top I see a red-and-yellow flag waving. I point to it and ask him to get it for me. My father reasons with me. Soon I am furiously demanding that I have it. My whim becomes a tantrum. I will not give in. My father loses patience. I scream and stomp my feet. My father is at a loss, but in order not to attract everyone's attention, he decides to turn back and quickly drags me away. I have spoiled his day.

Every day, I find some new way to drive my father to distraction, to rage, fright, or humiliation, and make him think of me, his son, Salvador, as an object of shame and displeasure. I amaze him, throw him, provoke him, challenge him ever anew: from my coughing fits, in which I pretend to be choking and carry on hysterically until he trembles with fear and has to leave the table, his own throat all knotted up, to my misconduct in school. I can still see my father, at the dinner table, reading my report cards and my teachers' comments about me, as his face grows more and more concerned. There was true

delight for me in seeing his discomfiture swell up like a wave and engulf him. I also often pretended to be sick, just to worry my parents, and then peed in bed with pristine pleasure. My father bought me a fine red tricycle that was set up atop a wardrobe, to be given me the day I stopped wetting the bedsheets. I was eight years old, and each morning I would ask myself: "The tricycle, or would I rather piss in bed?" And, having thought it over, knowing how humiliated my father would be, I opted for pissabed.

My shitting habits, I must say, were not without charm, either. I always tried to think of some perfectly unexpected place: say, the living-room rug, a drawer, a shoe box, a step on the stairs, or a closet. Then I went about it discreetly. After that, I ran through the house proclaiming my exploit. Everybody immediately rushed to discover the object of my elation. I became the leading character in the family play. They grumbled, they yelled, they lost their tempers as time dragged on. I tried preferably to select a time when my father was around so he could see it happen, if not be involved himself. One day, just to make things better, I dropped my doody in the toilet. They looked everywhere for the longest time, but no threat would get me to reveal the place I had chosen. So, for days on end, no one dared open a drawer or set foot on a step without worrying about what they might come upon.

For a long time I kept a king's costume that my Barcelona uncles had given me as a gift, with an ermine-lined cape and a topaz-covered crown, which in my eyes represented the highest of authorities. With a scepter in one hand and a whip in the other, I haunted the hallways of our home, where I watched in the shadows for the servants who had made fun of me, and cursed them with the most awful anathemas. I would have liked to beat them, and the crown and scepter were warrant to me that sooner or later I would get to do it. With age, my head got bigger, but I still kept that crown until I could no longer get it on without giving myself a headache, for in my eyes it represented everything I wanted to wrest from my father.

Since my father, on removing me from the tuition of Mr. Truiter, whose pedagogical inadequacy had finally gotten through to him, had enrolled me at the Brothers' school in Figueras, I had developed a strange new power: I could see through walls and isolate myself completely, something that went well with my unbelievable gift for dissembling. I succeeded in being almost permanently mentally absent from class. I had a gift for dreaming with my eyes wide open that no other equaled. My imagination had taken as its most common inspirational theme what I dubbed "the five sentries."

They were, on my left, two cypresses that I could see out of the classroom window, flanking it with their tips and marking the rhythm of our days with their shadows; on my right, the two silhouettes of Millet's *The Angelus,* facing each other, that could be seen lighted in a copy on the wall of the corridor leading to the classroom; and, in front of me, a big yellow-enamel Christ nailed to a black cross. Every afternoon, as we left the classroom, having pressed our lips against the hairy hand of the Father Superior, we crossed ourselves as we touched the feet of the Crucified One. The dirty fingers of several generations of pupils had finally turned the Redeemer's ivory color to a sallow gray.

My game consisted of imagining in minute detail the course of the sun and its subtle transformation through the branches, then associating that with the observations I had been able to make: the tone of the light in the Pyrenees, the glint of a windowpane reflecting a beam of light, the variations of colors in the plain of Ampurdan, in which my dream became wedded to geological formations. At the same time, there grew within me an unhealthy anxiety that arose from the two motionless characters of the Millet picture with that dead space between them. This distressing malaise was inexplicable, but I could feel it increase almost to the point of nausea. The dirty gray of Christ's feet and the wounds in the knees, perfectly imitated, letting the bones show through, fascinated me. In my head, all of these elements composed an obsessive décor, against which I set a dream ballet that nothing could interfere with, not punishments, not interruptions, nor making me change my place. From then on, my wide-eyed dreams are all I need. I can now project my little inward cinema, animate everydayness with the images of my own creation. Each day, I outdo myself in this, getting further and further from reality, finally to exit through a secret passageway from the circle in which the world is attempting to imprison my soul.

How Dali Got Free of an Obsession

I would soon put this power to work to free myself of my father. I could see his Jupiterian force diminish before my eyes as the repeated assaults of my caprices grew.

In the beginning, I brought him into my imaginings, gradually, transforming him, the Lord, the Strongman, the Invulnerable, into a subject dependent on my will, through fear, anger, shame, and disgust. I forced him to join in my games and break away from the rails of his

rationalism, his calm, his authority. He became one of the objects in my private cinema, one of the slaves of my paranoia. I gradually stripped him of the attributes of his power, reducing him to a mere symbol. I admire the prodigious cleverness that I then displayed; instinct and intelligence worked hand in glove to bring off this genius of an operation. For, lest I run the gravest peril, as of seeing my personality dissolve into permanent delirium like sugar dissolving in a cup of coffee, I could not cease to admire him in spite of everything so that I might identify with him in order to maintain his structure and mold myself in the image of his strength.

Even today, his structural ideas stop me cold: my father was an atheist, and I cannot find faith. He was afraid of venereal diseases. "I want," he would say, "to make a book with color illustrations that would make it impossible for men to go to bed with whores." That fear still paralyzes me. I have seen my father, weeping bitter tears with an atrocious toothache, yet crying out, "I am ready to sign a contract to put up with this pain forever, if only I need not die." Indeed I am his son.

But Moses little by little was losing the beard of authority and Jupiter his thunder. All that remained was William Tell: the man whose success depends on his son's heroism and stoicism. I trained myself to put up with suffering; not only by keeping my stools within me until it became unbearable, but by forcing myself to wear that royal crown on my head when it had gotten so much too small. The pain soon became atrocious, but I remained unbending with myself to the point of exasperation. A strange enjoyment grew out of these acts of masochism transcended by the most lucid intelligence.

One anecdote shows the quality of this development. I was then a student in Madrid. My father, to show how much he respected my intelligence, had treated me to a subscription to the *Gran Enciclopedia Espasa,* and each month he sent me a volume, but I had guessed that in his mind this gift was also a good investment. Each volume that he sent gave him another chance to complain about not hearing from me. One day, I tore the cover off the last installment he sent and wrote on it, "Wishing you a Happy Easter and a Merry Christmas," for good measure. Then I sent it to him. For a long time, I could gloat over the circumstances of that package's arrival. Delighted with my mail, which he doubtless imagined to be overflowing with the results of my work, he would order broccoli, his favorite dish, and put my packet aside to open as dessert. His stupefaction at my insult was doubtless immense. He left the table and went up to bed without a word. I held the magic key to victory.

Of course, he was to return me blow for blow, as when he tried, on the pretext of a future and my security, to turn me away from my vocation by wanting to force me to become an agriculturist. He did succeed in whetting my interest in the technology of the work, and the ways of peasant life, but he was unable to make me forget who I was. He also refused, when the time came, to allow Gala, my idol, my wife, to come and see him, and opposed my marriage on the phony pretext that Gala was a drug addict. But I got mine back later when, on returning from the U.S.A., I came to see him in a sumptuous Cadillac, the very evidence of my success and the uselessness of his revolt against my genius. I had succeeded in taking over and overtaking his own strength. What he did not know was that by digesting him I had also brought about his resurrection, and that he was living once again through me. Such ascesis in conquering and outdoing is the whole secret of my genius. My father, the vanquished Jupiter, has never ceased being reborn in the mental projections I constantly make. He reappeared in the person of Picasso as well as in the lineaments of Stalin, admirable in strength and hardness, but devoid of terror or fear, without the shadow of any fascination to paralyze me. A Freudian hero par excellence, I freed myself of his guardianship, by battening on every cell of his self, and he became one of the motive forces of my genius.

What Does Dali's Mother Mean to Him?

My mother, in the Dalinian Olympus, is an angel. Her breast, after her blood, brought life to me. Her sweet voice rocked my dreams. She was the honey of the family. I would have liked to drink her the way our upstairs Argentine neighbors, the Matases, drank their afternoon *maté,* which they took about six each day from a sucking-cup that they passed around the large living room from mouth to mouth. I joined in partaking of this huge teapot, and felt the sweet warmth of the liquid flow into me, as I gazed at the little wooden keg of *maté* with the picture of Napoleon on it looking back at me. The emperor had pink cheeks, a white stomach, and black boots and hat. For ten seconds, his strength flowed into me. I became Napoleon, master of the world. At that time, I was seven, and in love with beautiful Ursulita, one of the Matas daughters. A strange sensation filled me at the idea of putting my mouth where Ursulita and her mother had put theirs, yet at the same time a spark of jealousy stung my heart at the idea that they had drunk after someone else, not after me.

Thanks to that little keg, I long believed I was Bonaparte. At the time, if I were lagging as we came back from a long walk, all I needed was to be told, "Lead the way, Napoleon," and immediately all my fatigue was forgotten as I hopped on to my trusty warhorse.

I can still hear the regular noise of the crank on the projector my mother turned by hand as she showed us little films. I remember a documentary, *The Taking of Port Arthur,* reporting the Russo-Japanese War, in which generals saluted like automatons, and another picture, *The Schoolboy in Love.* My mother is behind me, in the dark. My sister and my friends and I strain our eyes toward the moving screen. She is the picture angel. When I think of her, I also see the carnations she planted on the balcony, or the tiny little cactuses she used for the Christmas crèche.

From my mother comes the fact that I have only two little teeth of the kind known as incisors, instead of four, in my upper jaw; I also have two babyteeth left in my lower jaw. I broke one of those once when I punched myself in a fit of rage.

My mother's death filled me with despair. For a long time, I would not believe she was gone. She alone could have changed my soul. I felt that her loss was a challenge, and resolved to get even with fate by becoming immortal.

"I HAD SEEN, ON A SORT OF LITTLE TIN BARREL FULL OF THE SWEET LUKEWARM DRINK CALLED MATÉ, *AN IMAGE OF NAPOLEON THAT STRUCK ME AS BEING OF THE MOST SUPERHUMAN BEAUTY FACIALLY AND ESPECIALLY SEXUALLY BECAUSE THE TENDEREST PARTS OF NAPOLEON BECAME IDENTIFIED WITH THOSE OF MY MOTHER."*

III

How to Raise Caprice to the Dimensions of a System

The irrational spurts constantly from our minds and the shock of reality, but we do not perceive it, for we are so deeply conditioned to recognize only good sense, reason, and acquired experience. Yet, miracle is ever present, and we possess all the necessary keys to live within the secret of the soul of the world. But we have forgotten the ways of truth. We have eyes yet see not, ears yet hear not.

I, Dali, have discovered the pathways of revelation and joy, the dazzle of happiness shown only to lucid eyes. My whole being participates in the great cosmic pulse. My reason becomes a mere instrument to decipher the nature of things and detect my delirium the better to appreciate it.

Only a long search led me, in spite of everything, to allow the true language of life to speak within me.

I remember, in earliest childhood, playing at Little Father Patufet—the Tom-Thumblike Catalan hero who, to protect himself from the storm, let himself one day be swallowed by a bull because in his belly there would be neither snow nor rain. I used to get down

on all fours and swing my head left and right until it was gorged with blood and I became dizzy. With eyes wide open, I could see a world that was solid black, suddenly spotted by bright circles that gradually turned into eggs fried "sunnyside down." I was able to see a pair of eggs in this condition, which my attention followed, as if in hallucination. Then the eggs became innumerable and turned into a kind of soft white easy-to-handle substance, that I shaped somewhat as a baker would knead his dough. I felt that I was at the source of power, in the cave of great secrets. I was back in a kind of warm protective paradise, the essence of raw sensual enjoyment. The feeling I had merged with the dizzying memory I still retained of my mother's womb, before I was born: two huge phosphorescent eggs like the cold expressionless eyes of a gigantic animal with a slightly bluish white of the eyeball. I long took pleasure in deliberately re-creating the apparition of these phosphenes, pressing against my closed eyelids to go back in this way to the precious images of my embryo, and even now I can, at will, though without the magic of the moment, propel myself back into that world of angels so similar to a divine aura.

With my sister and friends, we also played at grottoes: this meant squeezing as hard as we could into a closet or other opening so as to fit as many of us as possible into the least conceivable space. For instance, into the dining-room window alcove, deep as the thickness of the wall, between the outer and inner shutters, we might get half-a-dozen of us, crushed right into each other. I let myself be grasped by this feeling of crushing, pressure, constraint, that was almost exquisite, while my eyes kept following the paths of the sun's rays through the slats of the shutters.

All I need do in sleep is to assume the fetal position, knees up under my chin, arms between my thighs, and hands on my face, fingers and thumb squeezed together and intertwined, the sheet enveloping me like a sac; then, if two added conditions obtain—my upper lip sucking the pillow and my little toe being slightly out of line—I can let the divine weight of sleep invade my head, my body acting as nothing more than a crutch. I am back in my original shell, the paradise from which I was expelled.

Mr. Truiter's optical lantern, with the dazzling suddenness of its images, had been an overwhelming magic to me, imparting almost human shapes to my hypnagogic feelings. It acted as developer to the photographic plate of my memory, and gave meaning to my quest. The appearance of the little girl became realer than she herself, and at the same time allowed me to eradicate, to erase the true-

life setting, giving absolute all-powerfulness to her image. I fell in love with a dream, but it seemed normal to me that her physical consistency, her incarnation should be as possible, as evident and probable in her flesh as were color and light, the presence of her image. Perhaps I needed only to look for her. I did not yet know that I had to think and believe for my hallucination to become reality.

Dali Dreams While Awake

I am walking with my mother and sister in the snow, which I am experiencing for the first time. I float on a magic carpet that crackles lightly beneath my step, but at the same time ceases to be immaculate. Soon we are out of Figueras and going on into a forest; and suddenly I stop: in the middle of a clearing, a magic object is there on the snow, as if waiting for me. It is a plane-tree pod, slightly split so as to reveal the fuzz inside. A single ray of sun, sneaking through the clouds, hits the yellowish fuzz like a tiny projector and brings it to life. I rush up, kneel down and, with all the care one would take to pick up a wounded bird, cup my hands to cradle the little pod. I bring my lips near the fuzzy slit and kiss it. I take out my handkerchief and wrap it up completely. I tell my sister I have just found a dwarf monkey, which I refuse to show her. I can feel the monkey moving in my hand inside the kerchief. My only desire now is to show my find to the little girl in the optical theater. I know she is waiting for me at the fountain. I insist that my mother take us there immediately. She agrees. Soon, we bump into some friends, and she stops with them. I rush toward the fountain, and there—oh, ecstasy!—the little Russian girl with the troika is sitting on a bench waiting for me. She looks at me. My monkey is moving under my hand, in my pocket. It seems as though my heart is about to stop. I run off, back toward my mother. Then I start up again, but this time make a detour and watch the little girl from the rear. I kneel in the snow, motionless, my mind paralyzed. I can see and hear a man coming to the fountain to fill a jug, and the noise of the gurgling water awakens me from my dream. I take the pod out of my pocket and with my penknife begin to peel it: it will be a gift for my love whom I will kiss on the nape of the neck as I hand it to her. But she suddenly gets up and goes to fill a small jug herself. My knees blue with cold, I arise and go toward the bench to put the fuzzy ball down there. All my limbs are trembling. At that moment, my mother appears. Very concerned about my condition, she wraps me in her

shawl and says we must go right home. My teeth are chattering; I can't utter a word. I would like to stay there, forever, holding on to my vanishing dream.

I discovered the way to relive the wonderful moments of my meeting with Galushka—which is what henceforth I shall call her. All I have to do is stare at the wet spot on the ceiling of Mr. Truiter's classroom. I can transform real shapes at will, making them first into clouds, then faces, then objects. One might say that in my mind there is a projection-machine that radiates out through my eyes and follows my scenario on the ceiling screen. Whenever I wish, I can run it backward, correct some part of it, make a detail clearer, multiply bodies and situations to the point of orgy. First I make up Galushka's sled with its furs, then a battle of wolves galloping along, their ferocious maws foaming with rage. Soon the ceiling is no longer big enough. I take as my target the sleeping head of Mr. Truiter, and use his beard to weave an enchanted carpet, transforming that forest into a city sumptuously ornate with cupolas, towers, and crenellations; Galushka is its princess. My games can go on indefinitely; I am amazed at my own docile power, which like a gift from heaven reveals a whole world to me.

I had a friend, as blond as I was dark-haired, as pink as I was swarthy. Everyone called him Butxaques, because, along with tight pants that clung to his buttocks, he wore a jacket with many pockets, and *butxaques* is Catalan for pocket. I let him in on the secret of my monkey and Galushka, during our delightful walks to the fountain, arm in arm like lovers. Our mouths met each time we left each other, and I was transported by this communion. Each day I gave Butxaques another present, as evidence of my feelings. Soon, there were no more small objects left at home, much to my parents' amazement. My mother was surprised when Butxaques' mother came to see her and brought back a soup tureen I had given him. This was the beginning of our cooling off, and finally our break. My presents had to stop, and Butxaques wanted no more of me. He even committed a sacrilege: he grabbed my monkey, made fun of me, and threw it out into the street. To me, he became the infamous traitor. I hated him even in my dreams.

It often happened that I could not tell the real from the imaginary, and I might have let myself be carried away by the rush of delirium with no feeling at all for reality. This fact was perhaps the only sign that I was in a special state. But the delirium I experienced was such that nothing in me rebelled against the temptation:

on the contrary, I constantly increased the opportunities for it so as to run my waking dreams as I wished.

My intention was, while remaining awake, incessantly to increase my desires by all my imaginative possibilities. But I was not yet aware that with my genius I would invent the paranoia-critical method, and at the time I mainly had the happy surprise of discovering the fantastic secret strengths of my body and mind that began to awaken. It was during my childhood that all the archetypes of my personality, my work, and my ideas were born. The inventory of these psychological materials is therefore essential. And since at the same time I was coming to realize my uniqueness and my genius, the understanding of this period is a veritable formula for becoming Dali.

A Few Examples of "Delirium" in Life

It is a little before Christmas, the year I am eight, and I am in the dining room with my uncle. At the end of the table are laid champagne bottles, rare and precious wine for the family ceremony to come. I am at the other end, gazing at them. My uncle, in an armchair, is reading his newspaper. Suddenly the maid, going through the room, exits with a loud slamming of the door. One of the bottles is shaken up and begins to roll. I watch calmly as it rolls past me; at the end of the table, it falls to the floor with great noise and a wondrous ejaculation. My uncle, at this point, looks up from his paper and at me. Meanwhile, another bottle, under the same impetus, also starts to roll. He can see I will do nothing to stop it and rushes to catch it. My father comes in, and my uncle says to him, in bewilderment: "Your son is not like other people." Then he explains how I reacted to the situation. But to me this recital constituted a divine liturgy: the bottle starting to go, rolling along, crashing into a geyser, what a series of wonderful steps! How explain that to these people?

Of course, chance was not always good enough to furnish me such diversions. I had to fill in with my own caprices. I have told how I scratched my infant-nurse right down to the bone with a pin, because she refused to get me a sugar-onion, when the candyshop was closed; how I pissed in bed or shit in bureau drawers. My days were thus made up of demonstrations of my irrational will, which was instinctively to become my system of life and thought. Sometimes adults paid no attention, but most often my caprices goaded them to amazement, stupefaction, and anger.

My father one day told me to go and buy him some bread for a sandwich, specifying that he did not want me to bring bread stuffed with a French-style omelet, the baker's specialty. When I got back, he saw the bread stained with eggyolk, and demanded, "What did you do with the omelet?" "I threw it away," I told him, "because you told me you didn't want it." Naturally, he flew into a rage and I seemed even stranger in his eyes, but he made no greater effort to understand me.

At the same period, on vacation at the Pichots', friends of the family's, I decided to take a corn bath. I took off my trousers and poured a sack of kernels out on me, to form a big pile on my belly and thighs. I was wallowing in the enjoyment of the corn heated by the burning sun, and the prickling of the kernels against me, when Mr. Pichot came into the loft, where I was. I have never forgotten his amazed look. Nevertheless, he said nothing to me, but just turned and left. I was very much ashamed of having been caught in my quest for sensual pleasure, and I had such guilt feelings that I found it hard to get the corn back into its sack. The handfuls of grain seemed to me as heavy as so much lead. I had to learn how to handle shame and guilt and make them work to my advantage.

The clouds, meantime, helped me pursue my waking dreams. Lying on the balcony, I watched the foaming waves in the sky as they went by through the brilliant light. Breasts, buttocks, heads, horses, elephants paraded before my eyes. I was witness to monstrous couplings, titanic struggles, tumults, and gatherings of crowds. All the phantasmagorias of my childhood came back to life at my command. Sometimes, thunder joined in, and I made Jupiter's lightning part of my game. With training I became so adept that nothing could resist my will. All I neded to do was look at an object for it to be transformed and re-created to suit my whim.

What Limit Was There to This Power of Re-creation?

My powers ceased before the ideal and the real: I mean the wonderful little village of Cadaqués that I adored, whose every cove and rock I knew by heart, and which embodied for me the most incomparable beauty on earth. No need to embellish it with the fantasy of the mind. I never tired of contemplating its charms; at such moments, there always intervened the grasshopper, a diabolical insect, whose leaps paralyzed me. But I overcame them both.

I liked to watch the progress and conflict of shadows and lights across the rocks, every day. I invented a game that consisted of attaching an olive to a piece of cork, and setting it at the exact place where the last ray of the sun set. As I drank water at the fountain, I watched my olive; then, when the thing had happened, when it had exploded before my eyes with the final ray of the sun, I grabbed it, shoved it up my nostril, and ran until I was winded and expelled the olive from my nose with the violence of my breathing. Then, according to a very precise ritual, I washed it off and ate it with deepest pleasure. It was a way of ingurgitating nature and its strength.

As a very small boy I loved grasshoppers, which I always looked for, so as to collect their richly colored wings; then one day I noticed that a little fish I had caught, a "drooler," had a face just like a grasshopper's. I don't know why, but this horrified me so that I had a fit. All of my playmates, of course, took advantage of my terror. I almost fainted when one of my girl cousins squashed a grasshopper against my neck; I broke the classroom window by throwing a book through it when I found a grasshopper crushed between its pages. It became an obsession. Until the day when I invented an antidote for my trouble: a folded-paper bird that I transferred all my obsessions, all my fears to, by telling one and all I was a thousand times scareder of it than of a grasshopper. From that moment on, my persecutors gave up grasshoppers in favor of paper birds, and I put on a terrified act that delighted them. Naturally, I had to pretend to be terrified—which was nothing compared to my real fear—and that eventually brought about my expulsion from school. The Father Superior was in the classroom when I discovered a paper bird in my cap. I had to scream loudly, because the whole class was watching me. And I refused to handle the object that I was being told to bring up to the teacher. I managed to spill a bottle of ink over the bird. "Dyed blue, it doesn't scare me any more," I said, as I delicately picked it up and hurled it at the blackboard. Unfortunately, my explanation was interpreted as impudence.

Along with the paper bird, one other object became part of the Dalinian panoply of my childhood: a crutch, which I found in our friends the Pichots' loft. Seeing this instrument for the first time, I immediately elected it my fetish. Its functional strangeness appealed to me and the materials it was made of pleased me. I loved the worn and dirty fabric that covered the armpit support. This crutch to me meant authority, mystery, and magic, conferring on me a veritable will to power. It seemed to me that through it I was going to experi-

ence the voluptuousness of new caprices. Even today the crutch still holds a very special place in my oeuvre and my mythos. Every Dalinian ought to have his own personal crutch as a magic wand.

Evenings, I enjoyed going into the garden and biting just once into each of the vegetables and fruits, onion, beet, melon, plum. I let a little of the juice run into my mouth through the wound made by my teeth, but did not even retain the bit of pulp, like a vampire drawing his strength from the sources of life.

In this way, I allowed desire to develop in me, ever more desire, and an unquenchable need for satiation. Irrational forces took possession of me, new senses came into place, while my strangeness grew and grew.

It was at Cadaqués that I was to perfect my illumination and the awareness of my situation. It happened because one day I noted that the leaves of a certain tree had a life of their own. I mean, they seemed to move of themselves. I was soon to find out that a tiny invisible coleoptera hid under the branches, and its movement caused the leaves to flutter. The mimesis was such that it took sustained attention to tell the insect from the leaf. Unbelievable as it may seem, no one else thereabouts had yet observed this phenomenon. So I was able to mystify everyone by pretending I had the power to bring to life the leaves I set down on the table; they moved when I hit the table with a pebble.

My discovery impressed me profoundly; it confirmed for me my powers of observation and deception, and revealed to me one of the secrets of nature I have never ceased using in my paintings. The leaf-insect became one of the favorite subjects of my paranoia-critical delirium, and a source of extreme pleasure. I named it *morros de cony,* which, in Catalan, means a woman's cunt, and is symbolic of deception and evil-doing. The image was very fitting. I could have taken it for my own as well.

"I BELIEVE I AM A RATHER MEDIOCRE PAINTER IN WHAT I PRODUCE. THE GENIUS LIES IN MY VISION, NOT IN WHAT I AM IN THE PROCESS OF CREATING."

LANCINATA
PHOLIMORFA

IV

How to Discover One's Genius

Genius: You either have it or you don't. Then let it settle. Watch for its first shoots. Don't try to rush it; it might go to seed. Don't cut its excrescences too soon. Allow it to blossom in all directions until a clear path asserts itself. Pluck the first fruit. Season to taste and serve hot. A simple recipe that parents of a genius ought to know by heart. But how to know they are father and mother of a genius? It takes one to know one.

My maternal grandmother, Anna, who was ninety, after the death of one of her daughters fell into a kind of mild madness and took refuge in the past, remembering in great detail the events of her happy existence. She spoke in verse, reciting Gongora. We had become strangers to her, and her only contact with reality appeared at mealtimes when she showed her fondness for meringues. An hour before her death, she half-rose on her bed and exclaimed, "My grandson will be the greatest of Catalan painters." Then she fell asleep forever. Impending death can bring clairvoyance.

I made my first drawing on a little table, sitting on a low bench. I also adored decalcomanias, and my sister Maria and I spent

whole days splashing in a saucerful of water to try to get the bright-colored pictures off. I had a good eye for forms and colors. One day, in a bunch of bank notes, I immediately spotted the counterfeit my father had playfully slipped into it. I was never without my Art-Gowens, a collection of masterpieces of painting that my father had given me as a present. And a pad of sketch paper was always at hand: I drew the belltower, the lake, portraits, and soon took to singing as I worked, almost buzzing through my closed lips. "He sings like a golden hornet," García Lorca would later say.

I was nine. My parents sent me on vacation to the Pichots', at their estate two hours away from Figueras: The Mill Tower. They were a family of gifted artists, comprising six brothers and sisters. Ramón Pichot was a painter, his brother Ricardo a violoncellist, Luis a violinist, Maria an opera singer, Pepito, though having no specialty, was gifted in many ways, and Mercedes was to marry the poet Eduardo Marquina.

Pepito Pichot, his wife, their adopted daughter Julia, and I left by horse and buggy. We got there by evening, when there was just enough light for us to make out the tower that gave the place its name; it seemed magical to me, what with the regular gnawing sound of the mill mechanism like the inexorable noise of the passage of time, and the massive vertical stoniness that seemed crushing to me. I had to wait two days for a key to be brought so I could get into the edifice, which had charmed me in advance.

I rushed out finally on to the terrace above the abyss. I spit as far as I could out over the bushes and gazed at my realm: the ribbonlike stream that fed the dam, the vegetable garden, and the forest stretching out to the mountains. I was intoxicated with dizziness and power.

But breakfast time was when I felt most intensely moved, as I noted the paintings on the walls. I was eating buttered honeyed toast steeped in café au lait, all by myself, when I suddenly saw the pictures. They were the work of Ramón Pichot, who at the time was painting in Paris and much involved with Impressionism. I gazed in fascination at the spots of paint, apparently put on without any order, in thick layers, that suddenly shaped up magnificently, if one got the right distance away, into a dazzling vision of colors that communicated a deep, sun-soaked image of a stream, a landscape, or a face. I think my eyes were popping out of my head. Never had I experienced such a sensation of enchantment and magic. That, then, was art! Both precision—I was beside myself at the red hairs in the armpits of a dancing-girl—and the radiance of reality in all its

splendor. The pointillist technique especially aroused my admiration. The re-creation of real life by way of the decomposition of particles into minuscule spots of color seemed pure genius to me. I grabbed the cut-glass stopper of a carafe to use as a monocle so as to decompose reality into its elements and then reassemble them into the Impressionist images of the pictures. The game turned into a method; I spent entire days rethinking the world through my own eyes. This frenzied interest possessed me completely—or almost, for I did not at the same time cease to indulge other desires, the source of more sensual pleasures.

How Dalinian Sensitivity Manifested Itself

First thing in the morning, I put together an exhibitionistic show. Each time, I had to dream up a pose in which my nakedness might arouse Julia, whose job it was to wake me. I would pretend to be asleep while the young lady opened the shutters. Completely motionless, I would wait with bated breath for her to come and pull the sheet up over my genitals, which I had made sure to have in evidence, either between my spread legs or in rear view. I then tried to exploit the situation by making her look more closely at me on the most varied excuses: an itch, a pimple, or a scratch. . . . At breakfast, which I gulped down greedily, I did my best to let some of the café au lait spill down my chin, along my neck and on to my chest, where it dried in sticky patches. I sometimes even got it to go all the way down my belly. One day, Mr. Pichot's sharp eye caught my maneuver, and he remembered it years later as an early sign of my paranoia. However, my greatest source of satisfaction was my "studio," a whitewashed room bathed in sun all day long. With delight, I painted rolls of paper there that I later strung along the walls. This was the locale of my earliest masterpiece.

All the paper being used up, I decided to use a dismantled door, which I laid on the backs of two chairs. I had planned to paint a handful of cherries from the basketful that I had emptied on the table. For each cherry, I planned to use only two colors: vermilion for the sunlit red and carmine for the shadow, with white creating the reflections. In rhythm with the old mill, I applied my colors with a relentless rigor that made my joy all the more intense. Mr. Pichot's complimentary remarks added even more to my pleasure and pride. Friends and neighbors were soon streaming in to see it, and brimmed over with encouraging words. But, since they pointed out that I had

failed to paint stems on the cherries, I began to eat the fruit, sticking each stem left in my hand on to one of the painted cherries. These collages gave the whole thing a most striking feeling of reality. I even made use of the worms that were eating through the door, digging them out with a pin, to give a further quality to the representation of the painted cherries. Pepito Pichot watched this operation raptly, and commented, "That's pure genius." I was sure of it.

It took him a little time to convince my father that I ought to have drawing lessons, but I didn't care about that. I just kept saying, "I'm an Impressionist painter." At twelve, I was enrolled in the drawing class of Professor Don Juan Nuñez, at the municipal school. A former Prix de Rome winner in engraving, he was a remarkable pedagogue, to whom I owe a great deal. I well remember the precious hours he put in commenting to me about an original Rembrandt engraving that he owned, showing me the subtleties of the chiaroscuro. He was able to impart to me his mystical faith in art, convince me of the high value of the painting profession, and reconfirm the conviction I had of my own genius. He tried also to get this across to my father. But since my marks in school were far below my artistic talents, and the possible painting career before me frightened my father, he was deaf to Nuñez's urgings about my direction. "Later, later," he would say. "First, let's see how you do on your *baccalauréat.*" But he did buy me the art books I asked for.

Each day, I watched Mr. Nuñez, dressed in black, going to the cemetery where his beloved daughter was buried. This three-hour pilgrimage impressed me greatly through its constancy and fervor, but not for anything in the world would I have gone with him to that place where my elder brother Salvador slept, buried with half my soul, while I continued to be marked by him as indelibly as by a wound. Yet, in my eyes, Mr. Nuñez returned all the greater for this frequentation of the dead.

But my self-assurance was such that I never hesitated to contradict my teacher on the artistic level, on which he was the master. I did it, in fact, systematically.

Here, I would like to retrace an "experiment" which perfectly illustrates the efficacy of that sense of logical contradiction that ceaselessly drives me on to new heights, all the greater as each challenge I set for myself is more impossible.

The class was supposed to draw a beggar with a curly white beard. After looking at my first sketches, Nuñez warned me that I had too many lines and that they were too heavy to allow me to render the downy quality of the beard. He suggested I start again,

leaving more white space, and just barely pressing down on the paper. But I resolved to persevere and, without heeding his advice, literally chopped up my drawing with strong black lines. I was working in a kind of rage, and quickly attracted the attention of the whole class. Soon, my drawing was nothing but one dark shapeless mass. Nuñez came over and expressed his desolation at my stubbornness. Then I smeared the whole thing with India ink. And, as soon as that was dry, with a penknife I scratched at it in spots, tearing away a layer of paper so as to obtain perfect whiteness. Where I spread saliva on it, the white became gray. I succeeded in creating a feeling of both lightness and depth, which I accentuated by composing a perspective of oblique light. On my own, I had rediscovered the engraving methods of that magician of painting named Mariano Fortuny, one of the most famous of Spanish colorists. My teacher was stunned. I will always remember how he said, "Look how great that Dali is!"

These compliments were not enough for me. I wanted more, ever increasingly, warranted by the ceaselessly more brilliant affirmation of my genius. I worked with unbelievable ardor. From the moment I awoke, until night fell, I was devoted to comprehending the laws and relationships of light and colors. My research led me to making canvases covered with a thick layer of matter that caught the light, creating relief and presence. That was when I decided to stick stones into my picture, then painting over them. Among others, I did a dazzling sunset in which the clouds were made up of stones of every size. My father was happy to hang that one in the dining room. Unfortunately, the paste was not strong enough to hold the weight of my materials, and our evenings were often disturbed by the sound of falling objects, which my father satirically described as "nothing but stones falling from our child's sky." Yet, he was being slowly won over to the idea that, like Nuñez, I might become a drawing teacher—in a word, have a respectable job.

How Dali Became Informed of the International Art Movement

I continued to go my way stubbornly, discovering Cubism and delighting in Juan Gris through articles in the magazine *L'Esprit nouveau* (The New Spirit), to which I subscribed. I read voraciously. After the Christian Brothers', I went to school at the Marists' to get ready for my higher studies. But, outside the curriculum, I was devouring Nietzsche, Voltaire's *Philosophical Dictionary,* and especially

Kant, whose categorical imperative seemed beyond my comprehension, and who threw me into depths of reflection. I ruminated for a long time over the ideas of Spinoza and Descartes, thus accumulating much speculative material and sowing seeds of deep thought that one day would bring forth the basis of my philosophical methodology. I was still short on ideas, though long now of hair and sidewhiskers. To contrast with my thin swarthy face, I wore a huge ascot tie. My jacket was complemented by plus fours and gaiters that came up to my knees. A Meerschaum pipe the bowl of which was the head of an Arab grinning broadly and a tiepin made of a Greek coin were my usual vestimentary accessories. My getup created a sensation, and attracted attention to my talent. Some thirty artists from Gerona and Barcelona, who were having a show that year, 1918, at Figueras, invited me to take part in it. (Half a century later, this was the very place where Spain built me a museum.) I was highly noted by two of the most important critics, Carlos Compte and Puig Pujades, who predicted I would have a great future.

I had a huge desire to shed my adolescence as quickly as possible and complete my metamorphosis. I worked without letup, reading all the available magazines, *L'Amour de l'art, L'Art vivant, L'Art d'aujourd'hui, La Gaceta de las artes, L'Amic de les arts, Variétés,* and *Der Querschnitt,* as well as all the art books that came out. I also wrote for an art magazine, *Studium,* printed on wrapping paper, in which I was in charge of the department devoted to the great masters of painting. I wrote about Velázquez, Goya, El Greco, Michelangelo, Dürer, and Da Vinci, with special emphasis on their plastic techniques, but keeping to myself what I learned of their methods. I also started to write an essay, *The Tower of Babel,* and covered several hundred pages on the theme of death. I came out against the compromise by which men pretend to have become reconciled to and forgotten death. On the contrary, I celebrated that event, which to me was the basis of all artistic creation and the very quality of imagination.

Most human beings seemed like wretched wood lice to me, crawling about in terror, unable to live their lives with courage enough to assert themselves. I deliberately decided to emphasize all aspects of my personality, and exaggerate all the contradictions that set me that much more apart from common mortals. Especially, to have no dealings with the dwarfs, the runts that were all around me, to change no whit of my personality, but on the contrary to impose my view of things, my behavior, the whole of my individuality on everyone else. I have never deviated from this line of conduct. So I became more

and more of an oppositionist by design. I spit on everything with voluptuous delight. Tears of rage came to my eyes at the mere idea that I might not at every single moment be radically different from all others. My aim was to have absolutely nothing in common with anyone.

Oh, had I only been able to be one of a kind! Alone! Just me! I carried my taste for mystification to the extreme, in dress, in attitudes, and in the slightest events of my life. I claimed the woman's profile on the Greek coin of my tiepin was Helen of Troy. I was always waving a cane—I had a weird and amazing collection of them. I let my hair grow to phenomenal length. I darkened my eyebrows. Each of my dandified gestures was histrionic. I even tried to pretend I was a madman. One of my tricks was to buy a one-peseta coin for two pesetas from one of my classmates, and then openly gloat over how I had made a killing, according to a secret mathematical system that I claimed to have in a notebook. They thought I was crazy, and I delighted in my loneliness and the lack of understanding by which I was surrounded.

What Dali's Philosophical Position Was at the Time

I was an anarchist, and privately composed hymns to my own will to power. One morning, coming to school, I saw a group of students yelling as they burned a Spanish flag in the name of Catalan separatism. I was just getting into their group, when they suddenly began to disperse. I proudly thought my arrival was what had turned them away, but a troop of soldiers rushing up on the double surrounded me as I was picking up the charred remains of the flag. I was arrested, despite my protests, and indicted. But the court acquitted me, because of my age. My legend, however, grew as a result, and in my contemporaries' eyes I was a hero. Yet, if I increasingly impressed them, I did nothing to win their affection. I took delight in picking on boys smaller and weaker than I. Pretending to have my nose in a book, I would choose my victim. I remember one boy, especially ugly, who was busy eating a chocolate bar, alternating each mouthful with a bite of bread. His placidity and the bovine regularity of his mastication drove me crazy. When I got near him, I slapped him as hard as I could, sending his snack rolling in the dust, and then ran away, leaving him speechless.

Sometimes, things went less well for me. One day I went over to a sickly-looking kid with a violin. I patiently waited for him

to put the instrument down to tie his shoelace, then suddenly kicked his behind as hard as I could, and trampled on his fiddle. Unfortunately, the boy had long legs, and his wild fury endowed him with a strength I never would have suspected. He caught up with me. A picture of cowardice, I threw myself at his knees and begged him to spare me, offering him twenty-five pesetas not to hit me. In his fury, he did not even hear me and beat me up good and proper, knocking me to the ground and tearing out a handful of my hair. I began to scream, out of pain—and design. My hysteria had the desired results. My adversary was taken aback, and stopped, as a teacher who heard it all came over to us. He asked what had started the fight.

With complete assurance, I stated that in smashing the violin I had wanted to establish the supremacy of painting over music. They all broke out laughing.

"How did you think you'd do that?" the teacher asked.

"With my shoes."

More laughter from all concerned.

"That's perfectly senseless," the teacher now replied.

"To you and the fellows, it may be," I countered, "but my shoes don't see it that way."

And I was right, as I have since proved in my paintings by showing the realistic virtues of the shoe—which I even immortalized by putting it on women's heads when Elsa Schiaparelli executed my hat—while I reproduced musical instruments limp, soft, or broken, thus making a monument out of every detail of my existence, even the worst of them.

The teacher, floored by my answers, did not punish me, and I was the subject of even greater admiration. The efficacy of my eccentricities began to be intriguing and my alleged madness appeared as proof of my extraordinary temperament. I realized that my delirium could convince people and subjugate them. It was easy to fool everyone about the origin and meaning of my actions, and thus create a beneficient confusion all about me.

I worked a great deal, except at those subjects needed for the *baccalauréat*. My artistic work went on apace. I began doing tempera paintings, my favorite subject being Gypsies, who happily filled my studio on Calle Monturiol, and willingly served as my models. Two or three works a day went up on the walls, but I was perpetually unsatisfied with the results, which to me always failed to come up to the idea I had inside myself.

What Hold Did Dali Have over His Schoolmates?

My legend preceded me. The armistice ending World War I was the occasion for great rejoicing in Catalonia. A public celebration was decreed for Figueras, with parades and flags. And to the great delight of my father, who loved to do the sardana, there was to be dancing on the *ramblas*. The students, however, decided to debate whether or not to take part in these festivities. I was asked to make the opening remarks. My first public speech. I studiously figured out before the mirror what attitudes would make me appear to best advantage, and polished my words with fine Dalinian emphasis, which was to floor the audience by its originality. I learned it by heart, but at the mere idea of speaking to an audience I got a mental block, and could not control myself. I was trembling with rage.

When the day came, I was more out of control than ever. I made a copy of my speech, and rolled it up carefully, then went to the Republican Hall an hour ahead of time to get used to the setting and the intimidating platform all decorated with flags. At the appointed time, I took my seat between the president and the secretary, who got up to explain the aim of the meeting. He was heckled

by a few spoilsports who did not think we were serious about demonstrating. Before turning the floor over to me, he mentioned what he called my "heroism," in the incident of the incinerated flag. I got up. Silence in the hall. I had not known how pleasing it would be to have this sensation of acceptance and total anticipation—intimidating though it was—presented to me by the group of men and women waiting just to hear me. What pleasure there was in that desire of which I could sense the fervor! But not the first word of my speech came back to me. I just eyed the crowd with the utmost authority. Blank. And then my genius pointed the way out. I yelled at the top of my lungs: "Long live Germany! Long live Russia!" and at the same time overturned the table on the platform and knocked it down into the audience. But, strangely, my gesture brought no adverse reaction toward me. The audience immediately broke into two groups, who started to insult and hit each other. The tumult was deafening. I bolted out.

Martin Villanova, one of the leaders of the movement, gave a very convincing explanation of what I had done: Dali wanted to say there were neither winners nor losers, that the Russian revolution, now spreading to Germany, was the real result of this war. And he shoved the table down into the hall, because he felt we were too slow in catching on. That very evening, we had a parade through Figueras, behind German and Soviet flags. I was carrying the German banner. I had turned the situation to my advantage.

That year, I began growing a beard and my sidewhiskers took on respectable size. I lost my mother, and a world of sorrow broke around my head. She adored me and I venerated her. Only the immortal glory I had now decided to earn was able to console me for this loss.

The great day for the departure to Madrid arrived, and I left, with my father and sister. I was to compete for admission to the Fine Arts School. The competition involved making a drawing in six days of a casting of Iacopo Sansovino's *Bacchus*. On the third day, making small talk with the concierge, my father found out that my drawing was not the prescribed size. He was terribly worried. As soon as I came out, he rushed over, and questioned me, worrying me, too. The next day, I erased the whole thing in half an hour, but now my handicap was too great, and I was unable to get anything on paper for the new drawing. That day I took evil delight in torturing my father, who was fit to be tied and beginning to be sorry he had said anything to me at all. He did not sleep a wink that night. The next day, I did my very best, only to discover finally that my

drawing was too big and would not fit entirely on the sheet. I erased it. My father wept when he heard this. He could already see us returning shamefaced to Figueras. I took further unfair advantage of the situation by adding to his despair with defeatist talk, trying to put the whole responsibility for my failure on his shoulders.

My father was of course crushed by this situation, and the weaker he became the more my own strength battened on his anguish. The last day, I set to work with extraordinary skill and determination. I finished my entry with amazing speed, and still had an hour left over to admire my handiwork. I took careful note, and now saw with surprise that its size was even smaller than that of my initial effort. I informed my father of this when I came out, and was elated at his utter breakdown. I was accepted to the school, with the mention, "Although the drawing was not done in the prescribed dimensions, it is so perfect that the jury has accepted it."

My father entrusted me to the charge of his friend, the poet Eduardo Marquina, who gave me a recommendation to the head of the University Residence, Gimenez Fraud. This was the start of a monklike period for me, devoted entirely to solitary work: visits to the Prado, where, pencil in hand, I analyzed all of the great masterpieces, studio work, models, research. I painted under the inspiration of Cubist theories, particularly reproductions of the work of Juan Gris. I also altered my palette, eliminating violent colors in favor of sienna, olive green, black, and white. I assiduously went to class, drunk with learning the secrets of technique—the painter's métier—and I was greatly disappointed to find that the teachers, turning their backs on all the lessons of academicism, in order to suit the taste of the day essentially encouraged freedom and self-expression. I had no need of them to give me that kind of genius.

What I wanted to learn was the formulas for mixing oils and colors, the way to spread the colors, the quality of marriages of tones, the best way to put in grounds, and all the technological information there might be about the great masters. The fact is, the teachers knew nothing of the essential, and their approach was empirical and vulgar. They taught the absence of rules, while my highest ambition was to learn the laws of the art of painting. I was furious with them. The only one who escaped in my eyes was José Moreno Carbonero, one of the oldest ones, who had solid métier and faultless professional conscientiousness. But the pupils laughed at him, at his coat, the black pearl stickpin he wore in his tie, and his white gloves. His skill was unmatched, but no sooner did he turn his back than the little upstarts erased his corrections, which in fact reflected the gifts of a true master.

I preferred to keep apart from that bunch of loafers and idiots, and go on with my Cubist experiments. One of my paintings led to my making contact with my new friends.

Within the Residence, there was a sort of segregation based on intellectual snobbery. Around Federico García Lorca, Luis Buñuel, and Eugenio Montès, a small avant-garde literary and artistic group had taken shape. One of its members, Pepin Bello, passing down the corridor one day, peeked through the open door of my cell-like room and saw the Cubist canvas on the easel I was working at. He imparted this news to the others who had thought I was backward-looking and were happily surprised at my avant-gardism. They would have been even more surprised, had they known that it was out of a concern for better understanding of representation and realism, of the exact science of drawing, and for research in perspective, that I was indulging in this manner, and not out of any drive toward abstraction or provocation. They made me one of them.

How Does Dali Remember That Period?

My attire, since my arrival, had acquired a waterproof cape that came down to my heels, and a broad-brimmed hat. Wearing gaiters and hair down to my shoulders, and my huge ascot tie, I never went unnoticed. My friends were all Beau Brummels, in the finest manner of English dandyism. They came from some of the best families of Spain, but their admiration was undivided and their friendship total. My words and ideas intrigued them, and quickly became the group's gospel. They adopted my revolt against the faculty, with its demagogic pedagogy that was thirty years behind the times, teaching Impressionism when Cubism was fashionable, while disregarding all true tradition. With them, and through them, I first heard the expression that was to be so successful—and make me so, at the same time—"It's Dalinian."

But I quickly wearied of their flattery and their open-mouthed speeches. The fact is, very few of them were worth my attention and I would very soon have left a great distance between me and all of them, except for Lorca, whose personality and gifts truly impressed me, but they did reveal a world to me that I was unaware of: that of the pleasure born of alcohol, orgy, music, and painting the town a bit of an off-color red.

It was at the Crystal Palace, one of Madrid's most elegant tearooms, that I got my baptism of fire. Our entry, with me at their

head in my painter-anarchist's uniform, made quite a little sensation. To the point that in later similar circumstances, my friends, led by Buñuel, were generally turned into bodyguards, and forced to fight it out. This time, there was no disturbance, but for the first time I saw what might be termed an elegant lady, plucked eyebrows, armpits bluish and devoid of hair, and gown and jewels of greatest luxury; and I had only one idea left: to please her. So, I decided forthwith to return my outfit to the wardrobe department. I thanked my friends for their fortitude, and to their great consternation, for they enjoyed the game and found it a magnificent opportunity for provocation, decided that I too would be a Beau Brummel, whom women might be interested in. Once more, they mistook my intentions and thought I was acting this way out of friendship.

As I was having my hair cut, I thought I would faint at being shorn of the signs of my singularity, but I stuck to it. I bought a sky-blue silk shirt, a pair of sapphire cufflinks, ordered a fashionable suit, and to top it off plastered my hair with a coat of picture varnish that turned it into a plaque as flexible as galalith, giving me a veritable black helmet. In my hand I nonchalantly twirled a bamboo cane, and took my place on the terrace of the Café Regina. It was the start of a new era. . . .

This era was marked by two revelations: alcohol and the all-powerfulness of money. The effect of cocktails on my stomach was explosive. Vermouths, champagnes, martinis opened a new world to me as in olden days the Pichots' cut-glass carafe stopper had shown me an "Impressionist" universe. We spent our days and nights in discussions, eating and drinking in the midst of laughter and shouting. With the wee morning hours we wondrously discovered jazz at Rector's Club. We swore all kinds of pacts, sealed in champagne. (One of my friends from those days still has a hunk of cardboard with our six signatures, swearing we would all meet again in the same place fifteen years hence. I had clean forgotten that childishness.) Of course, we needed money for drinks, gardenias, meals, and the sumptuous tips that turned waiters into slaves. I signed notes to the Bursar of the University Residence, to be honored by my father, being only too happy to make things as disagreeable as possible for him.

In October, the Dalmau Gallery in Barcelona showed some of the students' works. I exhibited a jug that scored quite a hit, but I never got time to enjoy it.

After one particularly hard-drinking night, when I had thrown up everything in me, I had to take to my bed, unable to keep food

down. When I got back to school the following day, I found things in a tizzy. A contest was being held to name a new professor of painting, on the basis of one free work and one obligatory subject. The works of all the candidates had just been exhibited, and all the students agreed that Daniel Vázquez Díaz had submitted the most remarkable pictures. But there were backstage maneuvers we were perfectly well aware of, which eliminated him and substituted an old fogy we wanted no part of. The students wanted me to be their spokesman in the revolt.

Everything happened as foreseen. The president of the jury announced the result, meaning we had lost. I rose and stalked out without a word. I did not come back until the next day, but then found out that after I left the students had insulted and manhandled the jury, and then barricaded themselves, making it necessary to call in the police. Since my departure, though wordless, had been the apparent signal for the fight, I was the obvious suspect as leader. I was given a year's suspension. And, as if that were not enough, as soon as I got back to Figueras, the police came to arrest me and move me to Gerona, where I spent a month in jail. That gave me time to ponder the success, the glory, and the popularity that lay before me.

How Dali Acted in Adversity

My freedom meant the start of a wondrous vacation. Catalonia had been shaken by the tremors of an abortive uprising that General Primo de Rivera (whose son José Antonio was to be founder of the Falange) put down with an iron hand. Obviously, it was these circumstances that accounted for my arrest and detention. I went back to Figueras, where everyone treated me as a local celebrity. Without waiting, I got back to work as if I were in a hurry to make up for all the time lost in my nights of wild carousing.

I saw Nuñez again and developed a passion for engraving. My father even had a press set up in one of the rooms at home. I was soon up on all the techniques and in addition developed a few of my own.

García Lorca came to stay with me for a long visit at Cadaqués. He read us extracts of *Mariana Pineda,* the play he had just finished writing, for which I was to design the sets. (It was staged in Barcelona, at the Goya Theatre, by Marguerite Xirgu.) I can still hear his vibrant voice hammering out,

I remain alone, the while
Beneath the flowering acacia
In the garden, death waits for me.
My life is here.
My blood is moved and trembles
Like a tree of coral
Cradled by the deep.

We even danced the sardana on the *rambla* in his honor before he left. I at the time was painting Cadaqués landscapes, my father, my sister, everything that could be a subject for my frenzied brush. I was paying close attention to Chirico's paintings, through the magazines. I was contributing to Barcelona's *Gaceta de las artes* and *L'Amic de les arts;* and one book was always at my bedside, Ingres' *Thoughts.* I decided I would take some essential notes out of it as preface to my first one-man show, at the Dalmau Gallery, Barcelona, in November 1925. I put into the catalogue: "Drawing is the touchstone of Art" and "He who calls upon no mind except his own will soon find himself reduced to the most wretched of all imitations, namely, that of his own works."

This tribute to the beauties of craft and tradition corresponded exactly to my own ideas. This is the basis on which one can afford to be a genius. I exhibited five drawings and seven paintings. The critics, who are always laggards and unaware of truth, were nevertheless enthusiastic.[1]

There was another show at Dalmau's, from December 31, 1925, to January 14, 1926, this time including twenty paintings and seven drawings, and equally successful. I was not unhappy to display the admirable classical tradition that inspired me—and paradoxically had inspired the anarchist suspended from the Fine Arts School.

I exhibited among others a girl of the Ampurdan, with an admirable pair of buttocks, and a basket of bread that a representative of the Carnegie Institute, visiting from the U.S., was to borrow for an exhibition at Pittsburgh, where it was bought and remained in the States.

I returned to Madrid, the year of my suspension having come to an end. And I saw my old friends and fell into the same kind of

[1] "He has covered so much ground that the present exhibition classes him as one of the most dependable values of the recent generation of Catalan artists." *La Publicidad*

"His brush is like a sharp surgeon's scalpel initiating us to the mystery of reality and reveals him, like the philosopher, wrapped in the melancholy of transcendency with which humble things are covered." *Gaceta de las artes.*

"Young Salvador Dali has a strong soul, the gift of materializing his pictorial vision and reflecting things of this world in their corporeal aspect without depriving them of an intensity that never eliminates grace." *D'ací i d'allà*

nightlife. My father, cautiously—so he thought—had granted me only a tiny allowance, but I signed chits everywhere to be forwarded to him, and he had no choice but to pay them. My friends, who were always ready to go along with any idea of mine and had greeted my return with delirious delight, proved that I had lost none of my prestige, far from it. I came out magnified by this adventure, during which I had even found time further to polish my craft, while having the wildest of times. They pooled their resources to be able to pay for my whims. The Municipal Pawnshop (sometimes known as the Mount of Piety) became a familiar haunt of young Madrileños, and we had developed the fine art of "mooching" on our friends to the level of an institution of cynical technical perfection. Any expedient, any pocketbook, flush or meager, any lie was acceptable—if it did the trick.

Did the Low Life Not Bother Dali?

We were really greedy, cunning, and diabolical little lowlifes. I was in the grasp of a self-destructive mania against all values, as if to test their resistance and establish a new hierarchy, selected by my own genius.

Even my friendship with Lorca now was subject to question. I had veritable fits of jealousy that made me shun him several days running. I systematically tried to become more debauched and more detached from all past ties. In painting class, being assigned one day to paint a Gothic Virgin atop a ball, I drew a balance-scale and assured the bemused professor that "That is what I see in the model." I might also have pointed out to him that in the Zodiac the respective Virgo and Libra are right next to each other, and connected, but that would not have helped any.

The final flourish was sounded by the publication in the official gazette on October 20, 1926, of my order of final expulsion from the Fine Arts School, signed by King Alfonso XIII. I had seen how the King, when visiting the school during my first year there, had adeptly flicked his cigarette butt into the spittoon over two meters away, just like any Madrileño street urchin. Now he disposed of me in the same manner. Need I confess I had been hoping that luck would vouchsafe that kind of experience to me, so I might make a full break with a life that was becoming as unbearable in the monotony of its fake enchantment as the uninterrupted daily routine in the life of a petit bourgeois? By now I knew what a guttersnipe adolescence was like. Well and good. I could leave again for Figueras, hands in my

pockets, leaving my luggage behind at the Residence and using my last bit of legal tender to buy a bouquet of gardenias as a gift to an old beggar woman.

When I got home, my father was in the middle of writing the preface to a logbook he was planning to keep as a record of my worldly successes! He was trying to console himself for the mishap that spelled finis to his hopes of seeing me get into an official career as a teacher. It was a real heartwarmer to see how broken up he was over it. I made a faithful drawing of him, with my sister, in lead pencil, and it is true that he had a leaden complexion, his eyes heavy with angst and uncertainty; I devoted a great deal of talent to immortalizing his discomfiture. With a somewhat asinine application, he was trying to paste the pieces of his dream together again. I had no need of such childish pasteups to convince me of my genius.

I now had solid teachings and a technical mastery that allowed me, like a piano virtuoso, to play everything available on my keyboard, in the noblest classical tradition, while permitting the most secret elements of my subconscious to express themselves. I had developed an unquenchable thirst for knowing and imagining. I had been able to test the hold I could have over the most varied kinds of audiences. I had made everyone accept my singularity. I had exaggerated my persona to every kind of theatrical excess, each time quite capable of perfectly entering into it. I had spurred on all of my inner contradictions, my wildest tendencies, my maddest imaginings, savoring each time to intoxication the feeling of being alive right out to the tips of my emerging mustache. Now all I lacked was love, glory, and money. And I knew my destiny held triumph in store for me.

How Dali Lived Through His Military Service

I did nine months' military service. It was de luxe service—generally referred to as "per diem"—with permission to eat out, wear a tailor-made uniform, and sleep at home. There was a small group of us, theoretically not subject to any duty roster, although a few irritated and jealous noncoms missed no opportunity to ride us, which led some of my buddies to react. For my part, I gladly acceded to all of their demands. Nothing suited me better than latrine duty, and the stinking regimental toilet bowls were made to shine like brand-new living-room vases. I saluted everything in uniform, even firemen: I was a model soldier, and took simplistic sensual pleasure in this easy

submission to slavery and constraint. To submit to things of one's own free will: what could be more delightful!

But, since I hated to stand guard at the prison at night, out of laziness and especially fear (for there were sometimes desperate escapes), I pretended to be subject to nervous fits, while affecting to do all I could to control them, but making sure that each one was seen by some officer. The ruse worked. I was exempted, even when I volunteered. My skill at deception was proving itself once again. That left me a lot of time to think about the future.

> *"I HAVE HAD THE GIFT FOR PAINTING SINCE THE CRADLE. I HAD A CRIB WITH TWO WOODEN SIDEBARS—SO I WOULD NOT FALL OUT—AND THEY WERE BLACKENED WITH MY DRAWINGS. DRAWINGS THAT WERE ALWAYS REPRESENTATIVE OF HIGHLY IMAGINATIVE FIGURES. IF IT WAS A DOG, IT WAS A DOG WITH A WOMAN'S BREASTS OR A HUMAN FACE, NEVER JUST A NORMAL DOG. I PAINTED WITH COLORED CRAYONS BECAUSE I ALWAYS WANTED TO REPRODUCE THE INTRAUTERINE IMAGES THAT WERE SO HIGHLY COLORFUL AND, TO ME, ALWAYS HAD A PARADISIAC FEELING. I ENCOUNTERED THIS PARADISIAC FEELING AGAIN WHEN I READ* THE TRAUMA OF BIRTH, *WHICH GAVE ME THE KEY TO SUCH CLEAR MEMORIES THAT I WAS IMMEDIATELY ABLE TO PLACE AS COMING FROM MY INTRAUTERINE PERIOD."*

V

How to Become Erotic
While Remaining Chaste

At twenty I was a being of desires, savoring pleasures, all pleasures of the senses and the mind, with refined, exquisite voluptuousness, with an Olympian fulfillment that obeyed a long-nurtured code of hyperlucid discipline. My eye, my intelligence, and my prick were my most delectable media of enjoyment, and the almost infinite variety of combinations among them pleasured me with delights ranging from scatology to exhibitionism, from daydreaming to masturbation (one not excluding the other); the confirmation by action being always the least interesting part, except where voyeurism was concerned, and even then it would happen that the failure, refusal, or accident, interfering with consummation, might give me greater satisfaction than success itself. The point indeed was to remain chaste while becoming erotic. The formula demands a very high degree of self-control. In a word, the mastery of the paranoia-critical attitude. But the facts speak for themselves.

My love at the age of seven for beautiful Ursulita Matas, who, according to Eugenio d'Ors' legend, inspired his *La Bien Plantada,* was not due only to the quality of her beauty, but the orgasmic oral

delights I got from Napoleon. The plump flanks of the emperor with the *maté* inside and the big silver sucking-cup that was passed around allowed me to suck in at the same time a honeyed liquid sweeter than my mother's blood, a bit of Ursulita's spittle, and the imperial strength of Napoleon that came to me from his guts through the little keg. For a few moments I was the lover connected by umbilical cord to the bellies of his mother and his beloved, and in my ecstasy this libation made me the all-powerful master of the world. My mouth was the source of a warm but troubling well-being. I turned simultaneously into the embryo-little boy and the jealous lover, who always arranged to be next to beautiful Ursulita so as to capture the most of his beloved's mouth and the reflections in her fascinating hair.

My desire to return to the nourishment, the warmth, the protection of the preparturient placenta was also combined with an intense taste for the strong odors of the human body: blood, sweat, urine. I liked to hide behind the kitchen doors so as to breathe in the suggestive smells of the maids in heat, whose broad beams went about their business at my eye level. The preparation of meals also provided me with a source of deep satisfaction, what with the fragrances of kidneys, pots and pans, spices, acids, and deep fries floating out like so many promises, with flies dancing over all. I drooled over eyefuls of creamy froths, beaten eggwhites, oozing, soft, and viscous organic matters. The fact that I was forbidden to go into the kitchen only added to the quality of my savoring. Somewhat as if I had raised the huge skirts of one of the servant girls that fascinated me, and violated the secrets kept from me under them.

I continued wetting my bed for a long time, not just out of contrariness, but to have the pleasure of feeling my warm urine running down my legs and wallowing in its odor. Adults too quickly forget the intense satisfaction there is in rolling around in one's own filth and becoming intoxicated with one's self. Imperative taboos turn us away and condition us against the primal verities of skin and senses. I have been able to keep intact my gifts of organic participation.

One of my memories from this period goes back to about my fifth year. I am out walking with three very beautiful, elegant, and refined young women. Three images of grace. They are speaking in low voices and try to keep a distance from me, but I have my eye on them. One of them stops, as the other two watch. With her two hands, she slightly raises her long skirt. And suddenly a stream of urine comes spurting between her two white shoes, breaks the dust of the path like a little crater, and soon runs off around the two

feet, spattered and tainted with a long wet spot that turns gray on the Spanish white. Then two other little rivulets are started in silence. Wild-eyed, I look at the three streams that soil the soil, splattering shoes and petticoats, and each splash hits me like a prickling of shame. I am fascinated by the simmering foamy yellowness that makes such cracklets in the ground. One of the young women sees me—the petrified witness—and all three laugh at once, relieved, and provocative. I stand motionless, haggard-eyed. . . . The blood rushes from my head, and my eyes rise slowly toward the veil of one of the women, whose mocking eyelids crinkle.

I let the three ladies walk ahead of me, and follow them, sensually aroused with a voluptuous feeling of having violated their secret. I have picked up a firefly and my closed fist is full of sweat. A drop falls to the ground and cuts like acid through the thin crust of the path. I feel gooseflesh popping up on my arms.

At that time, first out of awkwardness, but later out of pleasure, I liked to splotch my undershirts with café au lait that made spots all the way down to my belly. One of my games was biting into the fruits in the Pichots' garden and letting the juice run down my chin, while I gargled it in my mouth. I bit a different type of fruit each time, in order to vary the sensations, spoil as many fruits as possible, and especially not fill myself up.

One of the girl lime-blossom pickers at the Pichots': blooming, heavy, solid breasts. She is up on a ladder. I have my fetish-crutch in hand, and feel a violent, immanent urge to lift her breasts with the fork of the crutch. So I perform an admirable example of paranoia-critical transfer, with natural deceptiveness, although this is long before I conceived the method.

Completely absorbed by my will to satisfy my fantasy, I note that in the vestibule of the house there is a transom, and if she were to set her ladder up before that little window, at a given time her breasts would be framed right in the transom, as if artificially cut off for my special delectation, and from the inside I would be able to contemplate them without fear of being seen. While looking at the two turgescent mammaries, I would use my crutch to raise the melon hanging from the ceiling, and slowly crush it, thus gaining the full enjoyment of my act through substitution. To get the woman to come over to the transom, I leaned out of the second-story window, and got my Diabolo tangled in a rosebush that climbed the wall there, so that, in order to free it, one would have to climb up to the transom level; then I begged the girl to come to my assistance. I contemplated her up on the ladder, sexually excited at the view of

her tits, and further aroused by seeing her hairy armpits, from which a drop of sweat rolled and fell on my forehead like manna that was a harbinger of the pleasure that lay before me.

She finally moved the ladder, which gave me time to take refuge in the vestibule, get undressed—for I planned to do all this naked—and don the ermine cape that was my royal uniform. As I had anticipated, her fine breasts fitted through the transom. I shed the royal ermine, and as she made efforts to release the Diabolo I raised the crutch and slowly squashed one of the hanging melons as my eyes feasted on those gorgeous tits. My pressure crushed the melon completely, and its fragrant sticky juice ran down in a long stream that I tried to catch in my mouth. My whole face was flooded with sweet effusion. My eyes, moist with sublime tears, went constantly from the breasts to the melon, until they no longer could tell them apart in the dim light. When the woman came down from her ladder, light suddenly flooded into the vestibule. The squashed melon came tumbling down on my head, and I collapsed haggard on my ermine cape, broken, enchanted, spent. For a moment, I was sorry that as she came down the ladder the woman had not been able to see me naked and sticky. But I was so weary that soon I had but one desire: to stretch out on my bed. I had just experienced a mental orgasm that I was never to forget.

From those hours, I have retained a sharp taste for armpits and the strong smell of their sweat (but I have since divested the precious place of its hairy attributes. Today, I prefer depilatoried or shaved armpits, with a slightly bluish tint), and the ample, plethoric, turgescent breasts of my childhood remain very powerful erotic archetypes. Certainly, the creative process of my genius developed during these intensely pleasurable moments, and among them the games that I would call intrauterine are the most precious of all.

My tub-game was one of the most important contributions to the crystallization of my paranoia-critical delirium. At the Mill Tower, I would place a chair in the middle of a tub that I filled with warmish water that had been long in the sun, and I worked that way, soaked almost to the armpits, painting on hatbox lids that I placed on a washboard set on the rim of the tub.

I was reconstructing the warm ambience and protective isolation of a belly.

I painted Helen of Troy or sketched Venus de Milo with delicious little erotic thrills. By playing the embryo-genius in that way, I gave birth to the genius; setting up the conditions for its birth, I created its cause. My paranoia reversed the order of physical values,

for to me effects can just as well be causes. I shortcircuit the logic of reactions by introducing irrational elements into the chain so as to cause mutations. Salvador Dali was invented inside a belly created by Salvador Dali. I am at once my father, my mother, and myself— and perhaps bit of a deity, too.

Mr. Truiter's optical theater and the appearance of Galushka coincide with a period when I might have enjoyed being a girl. The Narcissus in me was surprised to find beneath his hand a scrawny, moist, and limp appendage, a kind of useless excrescence that I tried sometimes to hide by squeezing it between my thighs, when I donned the ermine and crown of my royal panoply. I was the less proud of being a boy for the fact that my elder brother, Salvador, vied with me for first place in my parents' memory. But the situation called for my having male organs. And in my daydreams, Galushka was virtually sexless, with a flat chest and a crotch that could hardly be divined beneath her dress, even when she fell down and her legs spread. At one time, I might even have fallen in love with Butxaques and his little rear end so clearly marked out by his tight-fitting pants, had he been willing not to behave like a violent, brutal boy who was already sex-conscious.

The girls of my own age that I saw on the street, alive, laughing and chattering girls, scared me, paralyzed me, and I even felt ashamed when my eyes met theirs. Not one of them would ever be able to understand me. What good would it do to talk to them? I did not belong to any sex, I was neither boy nor girl, but perhaps angel or demon. Seated in my vaginal tub, I was remaking a sex for myself.

Dali Faces Solitude

I accentuated my solitude by reducing to the minimum contacts with others. Meals were knocked off in short order. I took refuge in the toilet on the slightest of pretexts. I have almost always had, at home or at my parents' friends', one room that was mainly my isolation booth and studio. I avoided boys of my age, even at school recess. Along with my aggressiveness—of which I have given many examples—self-destructive tendencies were also developing. I was fascinated by empty spaces. While I adored high places that let me dominate situations, I experienced dizziness that both scared and excited me. I would repeatedly jump into space from the top of a stairway or wall, whether alone or for the excitement of doing it before everyone. I was aware of the danger and of my strength, of

the headiness of death and the narcissistic voluptuousness of my body.

Galushka was in a way my enchanted double, a perfect image of myself that I could love, re-create, adore, till my eyes streamed sublime tears. She was my spiritualized accomplice, the part of my soul that I was lacking because Salvador the First had taken it with him into the grave.

With Dullita, my narcissism bloomed. I often found I had my hand on my genitals, surprised by the sweet, burning sensation born from that contact. I was really not precocious when it came to sexual understanding; the conversations I had overheard among my schoolmates had taught me little, and I was yet to discover the joys of solitary or group onanism. My sexual exasperation first took the form of incoherent speeches; the profusion of the words that poured out of my mouth was like an orgasm and in no way expressed the sublimeness of my thoughts. My sharp-as-a-blade intelligence seemed to penetrate the mysteries of the laws of the world through the intoxication of my genius, on which I sold myself with fanatical pride. But, toward myself, I was filled with deep tenderness, while also subjecting myself to real suffering, experiencing a masochistic voluptuousness in forcing down on my head the royal crown that was too small and tortured my temples, or keeping my two ears pinned under my schoolboy cap, in order later to free myself and let the wind blow around my suddenly bare head, closing my eyes to savor the ecstasy of the delicious caress. When I had a nosebleed, a big metal key was applied to my back, and I forced it into my flesh like a hairshirt. At the same time, I considered myself inordinately handsome, and loved to look at my nude body whenever I got the chance.

I had invented Dullita in order to test my new power, taking as archetype a little girl whom I had seen in back view on the street, urged along by two girl friends who held her by the waist. I only heard her name and did not see her face. The mere memory of her wispy waistline brought tears to my eyes. But I also dreamed of making my beloved suffer, making her my slave, forcing her to lean out over empty space in order to terrify her. And with perverse joy I longed to torture her mentally. I finally one day did meet a little girl, who had come along with her mother to gather lime-blossom leaves at the Pichots', and right off, touching her with my fetish-crutch, I dubbed her Dullita.

My passion turned fanatical, despite the upsurging anguish at having to share my narcissistic exaltation. I would have wanted to make her an angel so as to read my reflection in her eyes, and drink

my own saliva from her mouth. I would have wanted her to die of love, as my very own luxury, and become the plaything of my caprice. I dragged her along into my wide-awake dreams, and with her lived through a dangerous and magnificent existential experience.

I courted her first by skillfully manipulating my Diabolo before her, creating the finest poses to show myself to advantage, sending the Diabolo into such extreme configurations that finally it got away from me. Dullita rushed to pick it up. She immediately asked if she could play with me. I reacted to her request as if it were a provocation. How dared she? When she could just stand there and admire me. I resented her lack of submission. And when, out of coquetry, she tried to hold on to the Diabolo for a moment, I got angry and grabbed her so roughly I made her cry.

Later, alone in my tower, I watched the approaching storm, and saw the clouds attacking the sky in a terrifying tumult threaded through with lightning. Swallows in the van, mere lines in the sky, announced the tempest ahead. The entire countryside, consenting, submitting to the forces that electrified it, thrilled with the thirst of desire. The rain unfurled with erotic violence. The entire humus surrendered its odors like a woman fully possessed. Dullita, pressed against me, in the tower loft, was frightened by the thunderclaps and furious rain squalls. The darkness grew deeper. And to feel this little bird nestled against me in the isolation that made her wholly dependent on my strength, allowed me to savor the instant with ravishing delight.

But Dullita lay on her back and closed her eyes. As I bent over her to observe her tense face, she suggested we play at sucking each other's tongues, and forthwith stuck out toward me a little pointed tongue. I pushed her violently away, feeling wounded with shame at this salivary exchange which would perhaps have enchanted me had I conceived it myself as an evidence of Dullita's subjugation. But this sharing horrified me as if it were a profanation of my own person. I showed my anger so threateningly that she became frightened. I would have liked to take her by her narrow waist and break her in two. The rain stopping, I suggested we go to the top of the tower, and ran headlong for the stairs. She did not follow immediately. Fearing my prey might escape me and being impatient, I doubled back, furious, and grabbed her by the hair, painfully forcing her to come on up the steps. When I was sure she was obeying my wishes, I let her go on alone continuing up the calvary of her enslavement. Obviously, she could not know that each movement of

hers corresponded to the scenario I had mentally conceived days before, as I dreamt of taking Dullita to the top of my tower, like the master of the world revealing his domain to his queen, drunk with power and perfectly capable, as the absolute tyrant, of hurling her from the top of the dungeon—his whim being the only law.

I had set my fetish-crutch and my Diabolo out like flagpoles to welcome her. The clattering, shattering tempest above our heads supplied a décor out of the Apocalypse. To get her to the exact place I wanted her to be, I pretended the opposite of what I wished, knowing that her desire to provoke me would make her react in reverse: I told her that if she did not go near the edge, I would give her my Diabolo. Naturally, she mockingly rushed over there and sat down on the parapet, her legs dangling over the side, to defy what she took for my concern and protectiveness toward her.

I moved stealthily away and grabbed my crutch. I was fascinated by Dullita's frail back as, innocent as the lamb, she swung her legs while her eyes followed the last skirmishes of the winds driving away the clouds.

Softly, lovingly, with the sublime courage of Abraham raising his knife against Isaac in the name of Jehovah, I set the fork of my crutch against her narrow waist, and pressed slightly so it would fit in well. I was experiencing unprecedented pleasure. I was the celebrant holding the Eucharist above the bowed heads of the faithful. By a sort of sublime misunderstanding, my Dullita, totally unaware of my intentions, saw me and, falling in with what she thought to be a game, coquettishly herself tightened her hips against the fork of the crutch and settled in with the satisfaction of a woman offering her charms. She smiled, and her face had an expression of intense contentment. This charming grace was a sign from heaven. I inserted the end of the crutch into the opening of a flagstone, then, suddenly taking the Diabolo from her hands, flung it from the top of the tower, down into the darkness that was beginning to envelop the ground.

I had just killed the dream-image of Dullita by exorcising all that haunted me through this symbolic act that transformed the impulses of death into spirituality. This transfer made her memory into a sublime image which would one day incite me to resurrect her through artistic re-creation.

This sacrifice had definitely tempered my narcissistic soul by revealing to me all the resources I might anticipate from the wonderful lode that in my eyes the limitless blossoming of my personality now was.

At What Point Did Dali Become an Adolescent?

Drying in the sun, after bathing, one morning at the Gulf of Rosas, I noticed a light black down, prolonged by a few longer hairs outlining my pubis. I delicately grasped one of those hairs and pulled on it, causing the flesh to rise as the hair doubled in length. With a sharp tug I pulled it out and looked at it in the sun, surprised at this new part of me which I had not seen coming into existence. I wet it with saliva, and the light became iridescent on it. Rolling it around my finger, I made it into a band the ends of which stuck together perfectly. Then, with my saliva, I made a kind of bubble that turned into a little rainbow through which I could see the beach and the sea. I hardened one of my thickest hairs by wetting it and letting it dry in the sun, then used it as a pin to prick the bubble.

I had less innocent games, too, having discovered the joys of masturbation in the toilets at the Drawing Institute, but it had not given me any true pleasure yet, supplying mainly astonishment at seeing my penis grow big, then suddenly blossom and spew out its sperm. My hand quickly gained expertise in this caress, and I found more delight in the gestures of adoration addressed to this living part of my body than in the rapid ecstasy that revulsed me at the termination of the exercise. I was seized with the view of this physical transformation of my sexual organ, as it went from a soft appendage to being a long hard one, the tip of which turned into a red and then purple glans until its little lips spread and projected their semen. The whole of this operation fascinated me as an extraordinary process of possession. I was vaingloriously proud of being able to know and live this phenomenon and also full of consternation at what I was doing, realizing how reprehensible it might be considered. In truth, I was very backward by comparison to my schoolmates who had long since become addicted to onanism, and whose bits of overheard conversation on the subject I had been intrigued by. I had been totally unaware of how one went about procuring such pleasure. I only knew it could be done alone or in twos, but my singularity kept me from asking any of my fellows to explain it to me. My ignorance, the secrecy in which this was carried on, and the belated revelation of its ecstasy all endowed me with a painful feeling of guilt. I remember that, after the first time I experienced this solo pleasure, feeling let down and guilty, I determined I would never do it again—a resolution that lasted only three days. After that, the practice became almost automatic.

This period of the discovery of my sexual proclivity was also characterized by dreams in which I lost all my teeth, while I became subject to violent nosebleeds. My guilt feelings increased the more. Then, to overcome my remorse, I devoted myself to drawing with unequaled attention and energy, and my progress was constant. And each work session was generally followed by a masturbation session. I had by now perfected the caress so as to increase and refine the enjoyment. I quickly came to associate the pleasures of masturbating and drawing. And further to enhance the voluptuousness of it, I invented a method: rather than feel guilty or fight the temptation, I decided to set one day aside for "doing it," Sunday.

The week now went by in anticipation, exaltation, and a restraint that almost made me dizzy. The anticipation became more voluptuous than the consummation. It was these hours of my adolescence that taught me one of the key principles of my method: exacerbation of desire until it is immobilized, with anticipation becoming an ascesis, and refusal to take what one can possess, a source of delectation. What we call pleasure, moreover, the quick ejaculation, soon appeared to me as a mere wink of voluptuousness, quickly gone, compared to the deeper satisfactions I could get from the complex display of my will power; postponing my desire, molding it, stretching it, working it to suit my imaginative fantasy. I could live "in" pleasure that way for a whole week and constantly impart to my whole body the feeling of my desire, whereas the spasm wore out my muscles, dispelled my enchantment, and left me swollen with regrets.

This was when I started looking girls in the eye. Until then, they had intimidated me, made me blush, and I had been able to watch them calmly only from my balcony. I had never been involved in the evening games that sent boys and girls together out into the streets of Figueras, in chases punctuated by laughter and cries; and I reveled in my moroseness, my originality, intoxicating myself with my chimeras, cultivating my latent masochism as if it were some rare plant.

How Dali Remembers His First Love

One afternoon, at the Institute, after an elective philosophy lecture that was held out-of-doors, I exchanged a long look with one of the girl students. When our eyes met they recognized immediate agreement in each other. Without hesitation, we left together. Running, the better to hide our emotion, we were soon outside the town.

The countryside was not far away. I pointed to a wheatfield. A few more steps, and we were lying down in a little nest made by the bent wheatstalks. Her fine firm tits attracted me. I put my hands on them and felt them moving under her dress. I took her mouth at length, wildly, almost choking off her breath. And since she had a cold, she sniffled hurriedly, unable to hold back the mucus that smeared over her cheeks. As soon as I released her, she would dab at her nose with her little hankie, then with the hem of her skirt. She did not stop sniffling during our whole date, and seemed terribly embarrassed. I took her in my arms, rubbing my lips against her blond hair to wipe off the streaks of dried snot that tickled my lips and try to inhale the little-lamb fragrance that came up from her armpits.

It was on this *novia* that for five years I was to essay the keyboard of my egotistic, narcissistic, paranoiac, and sexual feelings, and bring out the various aspects of my sexual perversity.

First, to fascinate her. Through my vocabulary, my kisses, my attitudes, my ambitions. She was easy prey. My natural lying and hypocrisy quickly created a spell that conquered her. Then, to break any resistance she might have. From the very first afternoon, I had hit her with a terrible truth that dumbfounded her: "I'm not in love with you."

Very quickly, I let her know that I would go with her for only five years, without ever falling in love. Our love affair was chaste: caressing of breasts and much tongue-kissing. This continence, my contemptuous tones, my rude attitude wove the artful net of moral slavery I wanted to impose upon her.

Servitude, far from decreasing her love, made her even more devoted, and confirmed to me that the natural masochism of people was a lode to be exploited as one of the true sources of my delight. My coldness made her have an even greater feeling of guilt, inferiority, raising even higher the level of her unrequited desires, that I aimed to bring to "white heat."

At each of our meetings, I set the dialogue in such a way that every sentence I spoke became a dart aimed at her heart and her love. I wanted to get her to experience the sensation of a complex pleasure, based on the single fact that she suffered from knowing her love for me was hopeless and that I battened on her suffering.

Her beauty was an ideal instrument for me to test my desire on. I had decided there would be no love between us. This sentiment had to remain in the domain of daydream, the imaginary and absolute. I used her as a totem whose tits I could squeeze, whose spit I could drink, whose mouth I could bite; as a guinea pig I would in-

oculate with love before placing it in the center of a maze of traps set to test it, to measure its susceptibility to suffering, and study the evolution of its illness. I would have been delighted had the experiment not had to halt this side of death.

She was incessantly reborn out of my worst wickednesses and responded with immeasurable docility to my whims: show me your tits, lower down, lie down, play dead, stop breathing, kiss me. The comedy went on at each meeting without her obedience ever flagging. Sometimes she had weeping fits that I coldly cut off. Each of her moments of weakness made me the more demanding. I even ordered her to stop seeing any of her friends, so she might be entirely devoted to me alone. She acquiesced. I destroyed in her mind any esteem she had for her kin by demolishing them with bitter criticisms. I created a desert around her, and her sadness grew deeper by the minute. I tortured her by counting out the months that remained until we were to separate, as I had irrevocably decreed. I finally made it so she was unable to sleep, and she lost that healthy look that disgusted me so. She became waxen, sorrowful, and love-hungry. Our daily half hour together was a torture ever renewed, but that she could not live without. I started skipping days. She wrote me letters of exquisite banality, but overflowing with passion, which I left in my pockets. I soon had her weeping every time so I could drink her tears in with the kisses. I alternated tenderness and violence the better to keep her off balance. When she was reduced to the state of a mental and sentimental wreck, I said farewell. The deadline had come, anyway: I was leaving for Madrid.

Our affair had lasted for five years. I had gotten her into a kind of state of mystical exaltation. I had imposed my cynicism, my violence, and my lies on my Niña, and especially I had perfected the principle of my system: maximization of sensual pleasure through the deliberate unfulfillment and subjugation of one's partner. Naturally, I was not really in love with her, but I got all the satisfaction I could from her subjection, her veritable bestialization. I regretted only that the end of the affair did not also signify the death of my mistress. We were both virgins when we separated.

Love seemed to me a kind of sickness, somewhat like seasickness, with the same annunciatory symptoms: shivers, anxiety, and loss of balance. I said at that time that the feeling of falling in love might be mistaken for the need to vomit. But this made me no less susceptible to the beauty of women, and the image of the broad-buttocked cooks with their turgescent tits, stiff hairs, and strong smells that had awakened my childhood senses, was being slowly

transformed. At eighteen, I was taken with elegance, paid no more attention to breasts, but insisted on an elongation of the iliac bones which beneath the dress had to appear like the aggressive handle of a basket. I liked shaved, bluish armpits, and wanted even the stupidest of women to have an intelligent look in the eye, for appearances were all my eroticism cared about. Wholesomeness seemed to me to be in bad taste, except where hair was concerned.

My eroticism found its fodder in three elements: angelicism, i.e., an expression that was seemingly asexual; cold, crude, refined, cruelty that killed sentiment; and a scatology which, as in the paintings of Gustave Moreau, is reflected by the accumulation of jewels, chains, buckles, raiment. Gold and shit, as is well known, represent the same thing to psychoanalysts. A woman in the grip of the shimmering tyranny of jewels is as if covered with excrement, and makes my mouth water.

Two things haunted me, and paralyzed me, at the time. One, a panic fear of venereal diseases. (My father had bred in me a horror of microbes. It is something I have never gotten over, and at times it has led me to fits of madness.)

But, more especially, I long suffered from the terrible ache of believing myself impotent. Naked and trying to compare myself to my schoolmates, I found my cock small, pitiful, and soft. I have

never forgotten a pornographic novel I once read in which a Don Juan effected new holes in female bellies with ferocious delight, stating that what he loved was to hear women crack open like so many watermelons. I was sure I would never be able to make any woman crack open like a watermelon. And that weakness gnawed at me. I tried to hide this aberration from myself, but I was often overcome by fits of uncontrollable laughter, reaching the point of hysteria, which were like the external sign of the great shifts that were taking place deep inside me. It was time for me to meet Gala.

"REPUGNANCE IS THE SENTRY STANDING RIGHT NEAR THE DOOR TO THOSE THINGS WE DESIRE THE MOST."

VI

How to Conquer Paris

I was dreaming not of love but of glory, and I knew that the road to success led through Paris. But in 1927 Paris was far from Figueras, far away, mysterious, and big. I landed there one morning with my sister and aunt, to judge its distance and size, as a boxer does during a round of studying his opponent.

First I discovered Versailles (and continued to like the Escorial better) and the musty Musée Grévin waxworks. My self-confidence increased daily, but nothing essential had been accomplished. What I needed was the accolade of the only Parisian who mattered in my eyes: Pablo Picasso.

I had carefully prepared my way to him. I knew that Picasso had seen one of my paintings in Barcelona, *Muchacha de espaldes* (Rear View of a Girl; known in English as *Girl's Shoulder* or *Girl's Back*), and had liked it: he had mentioned it to his dealer, Paul Rosenberg, who had written me out of the blue to ask for some photographs of my work. I had asked a friend of Lorca's, the Cuban painter Manuel Angel Ortiz, to take me to Picasso's studio. As soon as I got to 23 Rue La Boétie, I knew those two jet-black button eyes

of his had recognized me. I was "the other one"—the only one able to stand up to him. (In truth, now I know the world was a little too small for the two of us. Fortunately, I was still young!)

I respectfully tendered a gift to him, another Figueras *muchacha* such as the one he had appreciated, and it took me quite a while to extricate it from its mummy's wrappings; but it was a real live painting that came out of the diapers and it seemed to me that as he looked at it, it took on a sudden new life. Picasso spent a long while, scrutinizing it minutely, and it had never looked finer to me. From that minute on, he was at great pains to dazzle me.

My opening agitation was now replaced by assurance, as he took me into his studio on the floor above and for two hours kept displaying his paintings for me, the largest as well as the smallest, which he put on his easel. He went to and fro, choosing, weighing, setting up, silent and quick, stepping back, carefully inspecting his own genius but dancing his courtship dance for me alone and looking at me with long looks of complicity.

We each knew who we were. Our mutual silence was charged with an electricity of the highest potential. On coming in, I had told him I wanted to see him before wanting to visit the Louvre. And with Olympian assurance he had accepted this compliment that might have choked a Spanish grandee. It was my way of admitting the head start he had over me. It was 1927, and I still had to prove myself before I could overtake him. He must have sensed something, for our last glances at each other were a mutual sign of understanding and challenge. On your guard, Picasso! On your guard, Dali! I had accomplished the main thing. Paris did not scare me any more. The probe had come up with satisfactory markings. Soon, I would be able to say without any doubt, "Paris is mine!"

Back in Figueras, I painted a great deal: an empty-eyed harlequin, a soft guitar, and a flexible fish in *Nature morte au clair de lune* (Still Life by Moonlight), and *Le Miel plus doux que le sang* (Honey Sweeter than Blood), which, like the sucking-cup of my childhood *maté*, when I think of it fills me with a liquid that supplies the honey of my uterine life. And also a sun dripping with light and bathing women fit to eat. This ardent work alternated with intense meditation. I put together, for my own account, the jigsaw puzzle of my genius, and conceived the early beginnings of my paranoia-critical method, which those works attest. I ceased forever having any doubts about the imperious requirement of my own witness. Henceforth, an indefeasible lucidity sorted and channeled all the assaults of the world about me and even my own unconscious im-

pulses to make the whole of the world, even in its most violent contradictions, serve toward the satisfying of my desires. I was henceforth in the saddle, but ever more solitary, as evidenced by my laughing jags, so unusually intense. I was suffocating beneath the pressure of my own genius.

I knew a mysterious machinery was at work forming the circumstances of my destiny. I had but to be myself in order to exist and when the time came everything would be ready for my triumph. I had not the slightest doubt about my royal future and laughed in advance at the interference, the delays that a few grains of sand would try to cause in my inexorable march forward.

Pierre Loeb, a Parisian dealer who was proud of the many artists he claimed to have discovered, happened to come through Figueras with Miró, who knew and liked my work. So he gave him a chance to show what a talent scout he was. But to no avail. A week later I got a letter from the dealer, urging me to work to reach "the development of [my] undeniable qualities so he might be able to handle [me]." He had just passed his chance by and returned to the grisaille of his grocery shop. But the very same day Miró was writing my father to assure him of his conviction of my "brilliant future." Everything happened as anticipated. And another of my friends, Luis Buñuel, became the messenger of my fame.

Buñuel had conceived the remarkable idea of getting his mother to finance a film, and the mediocre idea of a childish scenario: the animation of the various sections of a newspaper, news in brief, theatre, comic strips, and so on. I wrote him that it just happened I had written a scenario that would revolutionize contemporary cinema and that he had to come on at once. He came.

The result of this meeting was *Un chien andalou* (An Andalusian Dog). Script under his arm, Buñuel went back to Paris. I was to join him there two months later.

I had thought up a film that I expected to revolt, provoke, upset the ways of thinking and seeing, the sense of bourgeois entertainment of the intellectuals and snobs of the French capital. A film that would carry each member of the audience back to the secret depths of adolescence, to the sources of dreams, destiny, and the secret of life and death, a work that would scratch away at all received ideas and in a massive blow prove my genius and Buñuel's talent. In thirty minutes my name had to become engraved in the memories of the audience in nightmarish, fantastic, surrealistic letters.

Un chien andalou is an animated Dali painting. All the sym-

bols of my plastic dream dance a mad round in it to the rhythm of my orgasm. The film was intended as a pyrotechnic display to write Dali's signature in letters of fire and allow me to cross the stages of celebrity by giant steps. All histories of film give it careful analysis, and even the least well-disposed are forced to recognize that it was a date in film history, a scandalous act, the expression of a will to shock, and conceived in such a way as to create the greatest possible visual malaise at the spectator level. Revolt, angst, dream, imagination, scatology, all made this concept of mine an antifilm contrary to all cinematic rules. I had hoped to see audiences faint during the first sequence when a straight razor runs through and slits a girl's eye; see them vomit at discovering the scene of the rotting donkeys with their empty eye sockets and chopped-away lips; see them weep impotently at the naked woman carrying a sea urchin on each arm; sweat with fear as the couple behind the window does on discovering the accident in the street below. . . . An admirable sadistic realization appealing to everyone's latent masochism, *Un chien andalou,* that *succès de scandale,* marked my first Parisian recognition.

When I got to Paris, Buñuel had already chosen our leading man, Pierre Batcheff, a being who might have come out of the eye slit at the start of the film, in unstable equilibrium on the borderline between the conscious and the unconscious, who kept himself drugged with ether in order to remain present in the world, and swung between life and death until at last committing suicide on the final day of the shooting schedule, like a holocaust offered to Moloch for my greater glory.

The poet Eugenio Montès, who ten years later was to be one of the key men of the Spanish Falange, wrote after seeing the film that *Un chien andalou* refuted everything that was

. . . known as good taste, pretty, agreeable, epidermic, French . . . Spain is a planet on which the roses are rotted asses . . . Spain is the Escorial . . . In Spain, the Christs on their crosses really bleed. . . . This is a date marked in blood, as Nietzsche would have wanted it, as Spain has always done it!

These lines, which tied me in with the great tradition of Catalan creators, were a happy echo to my own ambition. A snobbery was born about my name. I had just given myself a certificate of Parisianism and made an entrance as shattering as would be my exit from the Surrealist group several years later. My Parisian début was a masterstroke.

As if to add to my aura, Federico García Lorca publishes in

La Revista de Occidente the *Ode to Salvador Dali* that stands as Spain's salute at the dawn of my new career:

> Forever vivid finger marks of blood on gold
> Crossing the heart of eternal Catalonia.
> May stars like falconless fists light your way
> As your painting and life come to flower.
>
> Eschew the waterclock with its membranèd wings
> And the inflexible scythe of allegories.
> But color your brush and paint ever out in the open
> Facing a sea alive with sailors and boats.

The U.S. with its International Painting Exhibition at Pittsburgh's Carnegie Institute at the same time discovers my *Corbeille de pain* (Basket of Bread), *La Jeune Fille assise* (Seated Young Girl), and *Ana Maria,* three canvases that make a deep impression through their modern classicism.

All this, of course, is now getting about, both in Barcelona— where my friends on the magazine, *L'Amic de les arts,* whom I had turned into fanatical boosters, are lauding my name to the skies— and in Paris where the fluid Surrealist group is making use of my personality to revive the movement, although the first article to appear about me in Paris, signed by Charles-Henry Ford, had prophetically brought into view my anti-Surrealist ideas. But no one here knows as yet who I am nor what I want.

What Dali Dreamt of Apart from Glory

First, women, for my erotic reveries. I had still never had intercourse, but my thirst for Eros was all the greater for that. Landing at the Gare d'Austerlitz, the first thing I did was to jump into a taxi and instruct the driver to take me to Paris' best whorehouses. I made the grand tour of Parisian bawdry, starting, of course, with Le Chabanais, the One Two Two, Le Panier fleuri, with their ceilings, baroque furnishings, Chinese room, mirrored walls, and lubricious apparatuses, such as the King of England's adjustable armchair, designed to allow him to satisfy his lusts despite his regally huge potbelly. I was passionately gripped by the atmosphere and gorged on that erotic climate like a sponge storing up a stock of images for my private dreams. I did not touch the women, who were very vulgar, too fat, and devoid of any of the charms I anticipate from an erotic surprise.

It was in the streets, in buses, on sidewalks that I looked for women, but so timidly that it seemed I would never make the grade. My imagination went wild with the vision of all those bodies offered like so much prey yet inaccessible to my hands, my cock, or my mouth, that only glory would bring tumbling into my bed. I panted with desire. I sat down on a café terrace, paying for my drinks in advance so that I might get up and leave at the slightest encouragement. I tried autosuggestion by telling myself every woman who went by was all primed to be willing, and that all I had to do was state my desires for her to accede to my whims.

I looked first at their legs, the calves, the feet, then mentally sketched the thighs that I tried to picture, which led me to visualize the vulva with its labia and the forest of pubic hairs implanted about it. When they walked slowly, I had time to recompose their fragrance, but more often they hurried by and I had to imagine the shape of their buttocks and backs. But if the face and the elegance of movements did not please my eye, I went on to the next and again began my lascivious undressing.

How many cunts, thighs, bellies, arses had I digested in that manner? Sometimes I went so far as to wink boldly and was rewarded with a dark angry look. I would have wanted to slice one of those beautiful girls with a sadistic, barbaric razorstroke to expunge the affront from my memory. I kept wondering what I might do with that harem that kept passing me like so much bait. I dreamed of shoving my upright cock into those pretty mouths and exploding inside them with volcanic voluptuousness, or else I visualized myself forcing the café waiter to sodomize them before my eyes while they greedily swallowed my genius-laden sperm. They were naked on all fours, panting with desire, offering their arses, awaiting my caresses, eyes riveted on my cock, and I passed among them like an animal-tamer among his wild beasts, awarding my favors only parsimoniously and almost cruelly. With a sharp fingernail, I made a red mark across a firm white buttock. I scratched a breast with my claws. Here I tore out a handful of pubic hair, bringing blood. I sat down on a back and nonchalantly crossed my legs, as I tapped the taut arse with my switch. It was a great erotic moment and my cock swelled wondrously.

The whorehouse décors were also very useful to me. I rolled around on beds as huge as Arab tents and covered with animal skins, surrounded by naked women, their nipples at the alert, their pussies shaven, their bellies flat, slaves to my desires and bending to my slightest wink, doing the tiniest of my biddings. We made fantastic

human tableaux, making love in groups of four, five, or six, and acrobatic, delirious positions that I dreamed up, reflected on all sides in wall mirrors like a veritable fireworks of lust.

I would have liked to be able to get up, stand on the café table, and ejaculate publicly amid the bravos and huzzahs. But when I rose from my seat suddenly to follow a pair of buttocks that wiggled ahead of me, it was only to discover that the woman had not even noticed me. I followed her stealthily along the sidewalk, not daring to talk to her, and soon getting to hate her for the advances I dared not make. I wanted to whip her, slash her with a razor, beat her, throw her down and vent my useless passion upon her. Sometimes I caught up with her on a bus and got to sit down next to her. Then, timidly, I would rub knees with her. I never got one to respond. I had been told that, during rush hour, some men succeeded in getting their cocks out, showing them to the object of their desire, and getting them to fondle them! With me, at the first rub, she almost always got up, leaving me with my soft useless tool, and a short time later there I was again back on the sidewalk, swallowed up by the crowd, pushed around by hostile arses, tough thighs, rough hands, and pitiless faces. I even tried to work it on the ugliest of women! I was young, well dressed, attractive, and a genius. None of them could see it. I hated them for their indifference, stupidity, vanity, and the shame they caused me.

I would have liked artfully to torture them with molten lead that I would have strewn on their bodies drop by seething drop, cutting away the tips of their tits, ravaging their cunts and their beautiful provocative arses. But I rushed back to my hotel room on Rue Vivienne and, watching myself in the wardrobe mirror, grabbed my cock in both my hands, making it tumescent, and slowly caressed it up to its orgasmic revulsion. My sperm flooded all over the mirror while tears flowed from my eyes, making a screen composed of orgiastic visions of all those females who had rejected me. I fell to my knees, praying God to burn them all in hell.

How Dali Dominated His Despair

This despair was one of the stations of the cross in my passion. I would have to pay for my victory, and I knew it. But even the hardships reinforced my conviction. I bathed in hatred, resentment, and my caprices became ever more ferocious. My belief in my sovereign intelligence never wavered. I knew I had only to find the chink

in other people's armor. I knew I had but to wait and will in order to win and that my contagious delirium would be recognized by all as proof of my genius. My paranoia-critical method had proved itself. The true conquest of glory would have been to have women at my feet, tendering their arses. Meantime, I still had Paris to discover.

Miró, with whom I had renewed relations, invited me to dinner several times, but I had no dinner jacket and I believe I disappointed him greatly by not being properly outfitted for conquest. I had to get such clothing, made to order. That was how I came to meet the Duchess of Dato, Countess Cuevas de Vera, and the Vicomte and Vicomtesse de Noailles who acted as my sponsors in high society. I very quickly appreciated the cultural refinement of these aristocrats whose race and mummification brought them so close to my own concepts. Like me, they turned their backs on the reality that the bourgeoisie and its intellectual running-dogs were trying to impose in opposition to tradition.

I avidly appreciated the secrecy of their manners, which enchanted me. The art of conversation, which consists of talking without saying anything and captivating one's audience, with your mouth full, while the others digest your witticisms. The dignity of the wine-steward lisping the detail of a vintage into your ear as if it were a state secret. The attractiveness of their walls on which you got hung among the greatest of the great as if you were a member of the family. Had I not been shy, I would have liked to restore to these aristocrats the conviction they seemed to lack of their own historical value, their great future in a decomposing world; they were the last remaining true strength. But I was as yet unknown as philosopher and prophet. I was a painter and they were beginning to buy my works. Each thing in its own good time. The Noailleses had notably acquired my *Le Jeu lugubre* (The Lugubrious Game), which I consider one of my finest paintings, and hung it between a Watteau and a Cranach.

I ate, I drank, I watched lights and shadows outline the most beautiful bosoms in Paris. I took an evil pleasure in staring ardently at one of the pretty ladies present while mentally undressing her and leaving only her pearl necklace and other jewels—which, as we know, are excrements in psychoanalytical parlance—and then listened, making the most of the moment, as her pretty rouged lips pronounced social small talk while I meaningfully stroked her lower abdomen with an imaginary ardent hand.

At these soirées there were always one or two social climbers who tried to remake the world in their own image and spat venom

as a skunk does his stink. I picked them out early and forthwith discouraged them from spewing their acid on me by urgently requesting that they talk about me and my genius. I made them so certain of my success as well as my madness that they no longer knew what to think, lest they make themselves ridiculous. They became my courtiers rather than feel crushed, preferring to laud what they could not bring down to their own level. I have always created a humus for my success with the corpses of those who least favored my genius. I attract crackpots and backbiters, whom I turn into steppingstones or footmats for my success. In those periods I met many rattlers whom I reduced to common gardensnakes so I might tan their hides for my wallet.

I turned each obstacle obstinately into an opportunity to go forward. The 1928 Salon d'Automne turned down my *Grand pouce-oiseau pourri et lune* (Big Thumb, Plate, Moon, and Decaying Bird —now in the A. Reynolds Morse Collection), the jury, it seemed, being shocked by some of its erotic allusions. So I published the *Groc Manifesto,* as insulting as a slap to them, and painted *Les Premiers Jours du printemps* (First Days of Spring), a canvas that truly is a veritable erotic delirium. Ever forward, ever stronger. Ever more Dalinian.

Did they think me surrounded, shocked, refuted? Well, my genius being above all handicaps, I reappeared like a mole in the middle of the garden, right at the center of the clump they were trying to protect.

Pavel Tchelitchev took me into the Métro for the first time. I was terrified by the noise and the mob, suffocated by the horrible claustrophobic feeling, the sense of being lost. And the more panicky I became, the more delighted Tchelitchev, magnifying my shame and malaise. He despicably abandoned me at the next station. I rushed for the exit like a drowning man who, in his determination to reach the air he needs, shoves everything out of his path. Reaching the surface, I stood haggard for a long time, coming back to myself. I felt I had been spewed out of some monstrous anus after having been tumultuously tossed about within an intestine. I had no idea where I was; as if spat out on alien soil, a small useless excrement. I slowly regained possession of my senses. And, O miracle! my lucidity, my pride, my strength returned instantly to me with increased power. I understood I had just been through a great initiation. The shock was a beneficent revelation. At every opportunity, one had to use the underground routes of action and mind, cover one's traces, appear un-

expectedly, conquer oneself incessantly, and never hesitate to bugger one's own soul so it might be reborn purer, stronger than ever.

So did I go from discovery to discovery, of my self and of the others, in this protean city.

The others were the Surrealist poet Robert Desnos, whom I met when I had just finished *First Days of Spring*. He was sitting at the bar of La Coupole. This was the holy place of Montparnasse Bohemia. Through a revolving door, you came in from the boulevard to a narrow long rectangle of a room cut in two by the bar at which bartender Bob officiated. On the other side of the swinging doors there was a huge restaurant room used mainly by the "*café-crème*rs," permanently idle intellectuals who gazed into the bottoms of their cups as if their fortunes were written there. In the cellar, three hundred people danced the tango from afternoon-tea time to four in the morning in an overheated *dancing*. Desnos was one of the crowd of habitués I used eagerly to peer at, though trying to assume a blasé nonchalance: Derain, Kisling, Brancusi, Ehrenburg, Zadkine; writers, models, all kinds of pretty girls on the hoof, ranging from streetwalkers to petites bourgeoises out for a lark, and girls from the provinces gone astray. Nothing for me. Not at Le Sélect, the rendezvous of homos (although Prévert had a regular table there), nor Le Dôme, the quarter's gathering-spot for addicts.

Desnos absolutely insisted on seeing my painting, and made me take him to my place. He waxed lyrically enthusiastic.

"This is absolute *jamais-vu*," he passionately proclaimed. If he had had money, he would have bought it from me, but his compliments were small change as beneficial as the morning dew.

The others were Paul Eluard, whom I came across at the Bal Tabarin. I was with Camille Goëmans, who had offered me a contract and, while awaiting my reply, was treating me to the sights of Paris-by-Night. My dealer-to-be whispered a few details to me about the tall, blond, slim, and handsome man.

"He's a friend of Picasso's. Knows all the talented painters. He's a well-informed collector and dealer. Also well off. He carries weight with the Surrealists. In 1917 he married a woman with a gorgeous body, and carries a picture of her in his wallet. He shows it to those of his friends who know how to softsoap him. She's in Switzerland right now. Name of Gala."

Goëmans invited us all to have champagne together. Eluard impressed me greatly by his air of distinction. I learned that he was one of the great poets of Surrealism. His voice and hands trembled a

little, giving him a touch of pathos. His sensuous eyes lit up every time they followed a feminine figure, even though he had with him an exquisite creature in a sequined black gown. He said yes when I invited him to come and visit the next summer at Cadaqués.

Slowly, the pawns of fate were falling onto the proper squares of my chessboard.

The others were also André Breton who already seemed a pontiff, even when his conclave met in a café on the Place Blanche, with the apéritif as Eucharist. A newcomer was required to show assiduity, this serving as his initiation.

No way of getting away from listening to Breton orating to his court of followers like a big turkeycock. The main reason for these gatherings was to let him keep control over his troops; to maintain his authority by killing in the egg the slightest tendency to dissent and making sarcastic remarks about those who were not present, and therefore automatically at fault—among the Surrealists even more than elsewhere! The bittersweet apéritifs were supposed to keep up the morale of the Surrealists while Breton read the newspaper aloud to them or pilloried some poor nameless nonentities who had had the misfortune of displeasing him, by some kind of articles, tomelets, or even just in gossip. All extracurricular liaisons were sharply condemned: it was sort of like a Tribunal of the Inquisition set up in the village's main café.

I was bored to death, although occasionally amused by the flareups between Breton and Aragon in which one could already sense a tension that went beyond mere irony. I had quickly come full circle around these verbose revolutionaries, and for a time wondered whether I ought not to take the leadership of them, for on the rare occasions when I spoke up my ascendancy was accepted without question. I could see Breton's blue eye looking fixedly at me and forming a question mark above my head. He mistrusted me. He need not have! I had found the stakes to be second-rate and left him the presidency of the stockless company.

I *was* Surrealism.

I decided to go back to Cadaqués to work and wait for the maturation of the seeds I had sown in a Paris that no longer held any fright for me. So I went back to painting, and let the rest of the world go by. A few days later, a wire from Camille Goëmans made him definitely my dealer, through the remittance of three thousand francs that gave him ownership of three of my paintings and a right of first refusal. My father rubbed his hands with a satisfaction not devoid of

worry, for someone had told him it was sometimes my habit to dissolve a bank note in a glass of high-quality whiskey.

"THE PAINTER IS NOT THE ONE WITH INSPIRATION, BUT THE ONE CAPABLE OF INSPIRING OTHERS."

EPiNGLE DE
CRAVATE ROAYALE

1973

VII

How to Make Love to Gala

I felt the spasm come on like an unextinguishable force start-ing in the deepest part of my being. A cry sprang from me that might have broken the terrible tension that was racking me, but it died in my throat and came out as a revulsion of my whole face. My mouth opened to scream, my tongue retracted, and a frightening fit of laugh-ter shook me, like a bout of the D.T.'s. Tears spurted from my eyes like peas. I tried to hold my chest in with both hands, so it would not burst from the blows of the diaphragm that were smashing against my rib cage. I was choking. My whole body was being shaken up. I seemed literally to be exploding with laughter. Each limb, every muscle had its own separate existence under the effect of this demo-niacal frenzy. I was being atomized in laughter.

Bent in two, I fell to my knees and rolled on the ground exhausted, trying to catch my breath, haggard, convulsively shaking, trembling. Face smeared with dust, legs broken, chest aching, I tried to get up again, but only to collapse in another fit of mortal joy that floored me.

These excesses might last as long as fifteen or twenty minutes,

until all of my strength was gone. And I came to, like a drowned man on a beach, washed up by the waves, emptied of all substance, as after an uninterrupted torturesome masturbation. My whole life was swallowed by that maw of laughter, at the bottom of which I could see yawning the abyss of madness.

Awakening, dressing, speaking to relatives or friends, in bed or on the street, nowhere was I safe from the terrifying explosion. And each day the fits became more numerous and lasted longer and longer. It took very little to set me off: a face, a word, a situation could trigger my verve. Sometimes in the middle of a sentence I was saying, my laugh would break out in place of the expected word, and the person I was conversing with would be amazed to see my face and body before his eyes turn into a wild St. Vitus's dance. Not knowing which way to turn, he would stare at the young man with the fine, delicate face, the mustachioed dandy rolling, hiccuping, in the dust. Unable to be of help, he would circle around me, speechless, useless and mortified, and that incoherent attitude only added further to my wild glee.

But most often I would bring on my laughing fits myself by building up some scatological image in my imagination. My method was the invention of the shit-bedecked owl. I pictured the person before me balancing on his/her head a sculptured owl about the size of a hand. And on the owl's head, an excrement—one of my most sumptuous turds, beautifully shaped into a roll, and making a strange crown above the bird's cruel head. The combination of owl, well-placed Dalinian shit, and a serene, smug bourgeois head brought on a violent rupture of rational balance and caused me to laugh the more because none could understand why.

The amazement of my vis-à-vis only increased my glee. But some heads would not lend themselves to the game. The shit-bedecked owl didn't fit, but I could mentally transport it quickly to some other pate. My scatological headpiece always ended up finding a face it could clownishly transform, and I burst into laughter. My game was a kind of acid that could eat away the distinctive image of adults, reducing their self-satisfaction to skeletonization, turning their personality into putrefaction. At the same time that I played this game of death, I developed inward faculties of self-destruction. Everyone could tell I was allowing the marks of dark delirium to live within me.

I was also living some weird hallucinations. This was the time when, returning one morning to my bedroom after having gone down to the second floor to the toilet, I found a woman in a nightgown who

seemed to be waiting for me, sitting in profile before the window. I knew immediately that it was a hallucinated vision, but I accepted it naturally and without concern. Slowly I went back to bed without taking my eyes off the apparition. She was perfectly clear, if evanescent. I felt happy and as if floating in beatitude. I don't know how long the feeling lasted, but for a moment I turned my eyes away and it was all gone. I tried in vain to bring the precious image back, but I have always retained a nostalgia for that unique privileged moment and the hope that I might once again know such grace. I often told myself those awful fits of laughter and the derangement of my faculties were none too great a price to pay for the power to project such visions, and even today before I open a door it often happens that I feel my Unknown Woman will be waiting for me there, sitting in profile before the window, just as she did that Sunday morning in the summer of 1929 in my bedroom at Figueras.

I was in fact living in a kind of perpetual hysteria, what with my fits, my hallucinations, my masturbating—in which I found the greatest delight in the artful caresses that would bring spurting from my cock the pleasure that revulsed me right into ecstasy—and my work. As soon as I got back from Paris I painted without a break a canvas that was to become *Le Jeu lugubre* (The Lugubrious Game), in which I did my best to depict a pair of underpants sullied with excrement. Little by little my entire universe was being colored by the glints of madness and I was wasting my genius in laughter, sperm, and visions. It was time for Gala to give me back a soul.

How Dali Met Gala

Camille Goëmans, my dealer, and his wife, the Magrittes,[1] and Buñuel had been in Cadaqués for several days, when one morning Paul Eluard arrived. Gala got out of the car looking dour, just as I was going into one of my fits of uncontrollable laughing. Our first contact took place in a wild burst of laughter.

Some time later, I was to meet them for an apéritif on the terrace of the Hotel Miramar. Another outburst. Eluard, taken aback, listened most carefully as my friends expatiated to him about my condition. Little by little, I was losing control of myself. My fits depended on chance, coincidences, and the associations in my overworked imagination. Like a drowning man, I was desperately awaiting a life

[1] The Belgian painter Magritte and Dali have been lifelong friends.

buoy. It all went very fast. But forever fresh in my memory are a few privileged images of those moments.

I spent a great part of my time painting, alone and naked in my bedroom, and it often happened that I would put my brush down so as to take my cock in the same hand and go from one pleasure to the other living through the same ecstasy. I made lengthy preparations for when I went out, so as always to achieve some theatricality. Since my university days in Madrid I had been pomading my hair to turn it into a veritable black helmet, flexible and tough as plastic. But I altered this Argentine tango-dancer look by dressing in women's clothes: silk blouse of my own design, with broad puffed sleeves that I completed with a bracelet, and a low neckline to set off my necklace of fake pearls. I became a bachelor-girl, androgynous in appearance. I was a man through my white pants. At first blush, Gala did not make me out. The mask was misleading.

I might have spoiled the whole thing if, the next day, I had followed my first intention. We were going bathing with the Eluards and were to meet on the beach. My idea had been to floor them by my eccentricity. To the little provincial that I was, this couple were the very salt of Paris; their self-assurance, their blasé attitude, their luxuriousness were a shocking provocation that fascinated me. Gala, with her up-to-the-minute unfolding valises that turned into wardrobes, and spewed out gowns and fine lingerie, scared me. I decided to show them a side of myself exactly the opposite of what I had been the day before, and to transform the decadent youth into a ragged bullherder. I scissored the life out of my best shirt, reducing it a third in size to make it into a sort of bumfreezer, and cut off the collar. Two slashes in the chest showed me hirsute and nippled. Mixing some fish-paste with goat's dung I made a sordid musk that I doused myself with, and completed the makeup by shaving my armpits, deliberately cutting myself so as to let the blood run down and coagulate. I added to it some laundry bluing that my sweat promptly spread over my torso. I stuck a jasmine behind my ear, and stunk of goat to high heaven. Then, I opened my window wide, and stood there, hideous and superb.

That was when I saw her back. Gala was there, sitting on the beach. And her sublime back, athletic and fragile, taut and tender, feminine and energetic, fascinated me as years before my baby-nurse's had. I could see nothing beyond that screen of desire that ended with the narrowing of the waist and the roundness of the buttocks. Cut the comedy. Like Jupiter's lightning, the strength and dazzle of life overwhelmed me. My getup turned my stomach. I would have liked

to go to her stark naked, with hands outstretched. It took a lot of doing to get rid of that goat stink, and when I did get to the beach, I was so shaken that I became convulsed with laughter and was unable to say a word to her. I sat at her feet, choking, but attentive as a dog to her slightest whims. Ignoring all those about us, I had eyes only for her. My most daring action was to graze her hand so I might feel the electric shock of our mutual desires. I had no other intention than to remain eternally at her feet, my life dangling from her gaze. Her pupils wore a deep question and an appeal that I could not make out despite my intuitive genius.

If a love be great because of the ordeals it overcomes and tempered by the obstacles it masters, then ours is unshakable. In the whole history of the sentiment of love in the literature of all ages, you will not find wildness and equilibrium, strength and mildness, magnetism and volcanic passion so intense in the lives of any couple. Gala and Dali incarnate the most phenomenal myth of love transcending beings, wiping out the vertigo of absurdity, and proclaiming the pride and quality of human genius. Without love, without Gala, I would no longer be Dali. That is a truth I will never stop shouting or living. She is my blood, my oxygen.

Gala had been told I was a shiteating coprophagist when she saw my *Lugubrious Game* with its underpants covered in excrement. She interpreted that image as an attempt to exalt my freakiness.

Why did I tell her the truth, I who had always preferred to lie to women the better to reduce them to subjection? I looked intensely at her, appreciating not only the beauty of her thin olive-dark face, her eyes distended by a paroxysm of feelings, her almost undernourished skinniness, her wasp waist, but also the frank, honest, noble expression of her attention, that forbade me suddenly from dissembling with her, and most of all, I was truly snobbily taken by Gala's cosmopolitan charm. Here I had, within reach of my hand, of my mouth, a Parisienne, the wife of a famous Surrealist poet, an elegant, divine woman, coming to me from the far corners of Europe—Eluard and Gala were back from Switzerland, where they had visited René Crevel, who was there for his health—with her wardrobe valise lush with laces and labels of great couturiers. A woman I had heard so much about, who was the stuff on which I much had dreamed. And this woman was talking to me about me, asking me about my secret self, and I was able to spread myself before her, evoke her deeper curiosity and passionate interest. Gala was of my own size. I had just found the sister soul.

I told her that grasshoppers, blood, and shit were terrifiers to

me, and explained to her my method for creating a controlled delirium that gave me the upper hand over my terrors and allowed me to fascinate "the others." Gala took my hand with a grace and strength I can still feel today. In the fullest sense of the term, she was taking me in hand. She had understood all about me and my soul and I do believe about her own at the same time.

The contact of her skin brought on a new convulsion in me, but to her ears my laughter must now have had a different ring. The genius of her intuition had just perceived me completely. I felt her strength entering me as the pressure of her hand increased. She knew I was not the flighty Argentine dancer I seemed to be, nor one of those blasé characters around her, but an abysm of terror, of fright, a child of genius lost in the world, the horrible world teeming with stupidity as well as monsters with mandibles, claws, and talons, imbued with hatred for all that was beyond them. And my frightening laugh was a cry of despair and rage, an appeal from my whole being, the final message from an intelligence getting lost in the labyrinth of nothingness. Gala heard me. She adopted me. I became her newborn baby, her child, her son, her lover—the man to make love to—she opened heaven to me and we both sat down on its clouds, far from the world. She took unto herself the power to be my protectress, my divine mother, my queen. I conferred on her the strength to create the mirage of her own myth before her eyes and before the world. Our two lives were henceforth going to justify each other. *"Mon petit,* we are *not going* ever again to leave each other." These words of Gala's sealed the pact of the Dalinian miracle.

Gala drove the forces of death out of me. And first and foremost the obsessive sign of Salvador, my dead elder brother; the Castor whose Pollux I had been, and whose shadow I was becoming. She brought me back to the light through the love she gave me, of which I could feel the emanations. Gala had already achieved a degree of maturity and despair that made her sensitive to the full reality of my tragedy, allowed her to communicate immediately with my most secret self and offer me the gift of her radiant energy, almost mediumistically. Through her I was in communion with the cry of life.

The steps were difficult and often dramatic. I dragged Gala with me on my mad dashes along the strand and we climbed playfully to the highest rocks that were several meters above the sea. We grazed the abysses. Gala went along with me without demur, her sphinxlike smile and great eyes following me. One day I understood she had not been taken in. We had gotten to the top of a huge mass of pink granite and I suddenly started pushing into the sea blocks of

stone that I threw with rage. My state of excitement was becoming frenzied. I felt Gala was observing me, and instantly stopped. I sped down the sharp incline, my criminal intentions laid bare. Like Dullita, from the top of the Pichots' mill tower, I was dreaming of throwing Gala down to the sharp-ridged rocks below. I identified in the same archetypal image the little girl and the woman who had both offered to save me from my solitude. I did not yet understand that this was the price of my salvation, and became intoxicated with my own despair.

Why was I not able to kill Gala? How could she put up with the harassment of my reproaches and the wounds of my injustice? As if I had not been the asker, the inciter, the calculator of this nascent love, I accused her of distracting me from my painting, leading me far from my inner self, and dissipating my genius. Actually, I was scared to death of *l'amour*. I went from the state of the most cowardly and unreasonable aggressiveness to the most servile subjection; kissing Gala's feet and shoes and begging her to show the slightest interest in me—she who was giving me her soul!—and, crushed, atomized with fear and shame, silent, unfriendly, humiliated of myself, I left her at the door of her hotel.

But she was sublime. Coming back from an outing, I painted a picture that I called *L'Accommodation du désir* (Accommodations of Desire), and today I know it was trying to exorcise me and foretold my fate.

Was Dali a Virgin Despite His Sexual Experiences?

I masturbated frequently, but with great control over my penis, mentally leading myself on to orgasm but disciplining my actions so as the better to savor my ecstasy. Masturbation at the time was the core of my eroticism and the axis of my paranoia-critical method. The prick I was hooked on, so to speak. There was me and my orgasm—and then the rest of the world. I went from my painting *Le Grand Masturbateur* (The Great Masturbator), which is the expression of my heterosexual anxiety—with its mouthless character incarnated by a grasshopper while the ants eat its belly—to *Accommodations of Desire,* in which lions' maws translate my terror before the revelation of the possession of a woman's cunt that would lead to the revelation of my impotence. I was getting prepared for the recoil of my shame. At this period, my laughing fits turned hysterical.

Eluard elegantly decided to return to Paris alone and went off

with his friends. In September of that year, 1929, I remained alone with Gala. My passion grew daily, the more so since Gala changed her clothes three times a day and at each meeting I rediscovered her anew.

"You will soon understand what I want from you," she said to me.

All I could answer was, "Just don't hurt me. Promise me that. We will never hurt each other."

I was delirious with fear and anxiety, possessed of the strange happiness that perhaps binds the victim to the executioner. It was grape-gathering time. Gala sat in the sun on a retaining wall and ate the muscadines I had just given her. I watched, fascinated, as her hand carried the fruits from the bunch to her mouth. She was all grace and beauty, the image of the fullness of enjoyment and charm. I swelled with desire and recorded this instant so strongly that later in my *Etude pour la ville paranoïaque* (Study for a Paranoiac City) I had only to close my eyes to recapture intact the picture of Gala gleaning the grapes.

I can see her still, dressed in white, her fragile little body outlined by the wind, walking on the path along the rocks. So thin, so seemingly weak that I would have liked to take her in my arms and I asked her to sit down sheltered from the breath of the sea behind a rock. We both felt that the great moment was at hand. I had been pursued for days now by erotic obsessions growing out of my feelings of impotence. I took revenge in my dreams on what haunted and frightened me. I possessed my beloved like a brute, I tore her dress, laid bare her breasts, tattered her underclothes, and impaled her on the ferocious stake of my upstretched cock. I twisted her around into every position of desire and frenetically bent her to my wishes. I ejaculated over my fantasies and over her tender and grateful submission. But as soon as I was actually with her, her eyes, her voice, her smile swept away my fancies. Once more I was headlong into love and fear.

I took her in my arms. The silence became terrifying with nothing but the whistling of the wind against the shards of slate. Suddenly I knew Gala was weeping. Big liquid pearls were running down her cheeks.

I brought my lips close to hers. Her mouth began to open. I had kissed before, but cynically, almost pervertedly, falsely and to fool myself, to ape desire and love, to do myself some good by doing evil. Now I discovered what a kiss is, a being giving herself by turning into a wisp that you drink in with her saliva as you breathe her

breath. I ran my tongue as far as could be into her mouth and drilled it into hers which I was gobbling into me. Several times, like live animals ours tongues mixed it up, wound around each other as if to fight the better to love each other.

Never had I experienced such a feeling of power, possession, and grace. Our salivas were love potion. Our tongues were exacerbated sex organs. Our teeth bumped sharply against each other's like shields, but these barriers only made our desires that much more ardent. I would have wanted to be able to dive into her, to lap her, eat her, tear her flesh. And I bit her lips violently until the taste of her blood filled my mouth and I was able to suckle on the fluid sweeter than honey. I was turning vampire, becoming ferocious, falling into a chasm of unheard-of enjoyment. I was a lover.

I remember taking Gala by her hair and throwing her head back, as I cried, "Tell me what I should do now. Tell it to me obscenely so I can become a man and an animal."

Then something unheard-of happened. Gala's face became fatal and as if fixed by time standing still, assuming the implacable expression of a goddess and at the same time the pathos of a pythoness, as she told me, "I want you to make me croak."

In a flash, I understood that Gala had seen through me, seen right through my soul. She was throwing my own mystery right back in my face. Gala had laid bare my criminal intentions. As she walked airily in front of me, along the paths, over the chasms, or watched me pushing the rocks down into the sea, she knew I was thinking of killing her. She appeared to me suddenly as the Immaculate Intuition. Her clairvoyance overwhelmed me. At the same time, she showed me the esteem she had for me. Gala judged me worthy of the most daring of actions and the most divine courage and capable also of having them brought out. Gala was the love to whom I could pledge myself.

But the truth was even greater than that. Tearing herself away from my furiously grateful kisses she spoke to me of my crime with the detailed precision of a director setting up a key scene. She explained to me that I had nothing to fear, for she would leave a letter disguising my horrible felony as a suicide. She was thanking me in advance for shortening her days, but just wanted the murder to be done as quickly as possible, so as to avoid any suffering, even mental. This fear of death and the instants that precede it was always present in her as an obsession. In choosing me as her executioner she gave away her secret and proved her love for me. We talked at great length about the different methods that my imagination provided. Of course, I was not capable of choking her; poison was somewhat doubtful and

might also lead to painful death throes; throwing her from a high parapet or the tower of a cathedral did not have the warranty of non-suffering that Gala demanded. The main thing was to avoid waiting and suffering. Total surprise and immediate success were the key conditions. A revolver? I was all thumbs. Gala discussed her death with assurance, with calm, almost voluptuously. Like the mistress of a house giving her orders for laying the table. With a seriousness that showed me this was no affectation, but a fundamental metaphysical intention. Gala wanted to die and I was the one she had chosen as the lord high executioner. I was the magic element in her life, the miracle of fate. Her suffering, her loneliness were the equals of mine. Her quiet courage amazed me. That she would submit like the Paschal Lamb overwhelmed me. In a flash, a capital mutation took place in me. My soul was being tempered in the spectacle of this admirable attitude. All the disparate parts of my genius were coming together. I had exhausted the subject by going over in imagination all the details of my crime, as if I had explored my own madness. My cruelty, my ferocity, my desire to humiliate and to soil were being transformed like a laser beam in the diamond prism of Gala's heart and intelligence. From that moment on, I was cured of my haunting obsessions, my laughter, my hysterics. Unbelievable, wonderful—in the full sense of the word! A kiss sealed my new future. Gala became the salt of my life, the steel of my personality, my beacon, my double—ME. Henceforth there were Dali and Gala united for eternity.

I no longer know whether we made love at that minute, for I was too delirious. My limbs no longer belonged to me, an unbelievable strength had possession of me. I felt myself a man, freed from my terrors and my impotence. By her, I was henceforth gifted with telluric vertical forces such as allow a man to penetrate a woman.

How Love Transformed Dali's Vision of the World

Gala revealed Dalinian love to Dali. I was at the point of almost absolute narcissism, particularly during masturbation. I garnered sexual pleasure from my self exalted and totemized into my penis standing erect and caressed on to ecstasy. But the ultimate moment of pleasure is the instant in which there appears, just before the spurt of sperm, a strong image that dazzles me and of which my act is somehow the negation: my father on his deathbed, for example, or else I gaze with the greatest intensity at an image as if I were trying to engrave it in myself and arrest time. I masturbated scores of times

looking out the small attic window at the steeple of the Figueras church—because it was what was before my eyes, of course, but it was also a premonitory attempt, since the steeple was razed during the Spanish Civil War. And in truth, that delight in the image which I expel from my memory or which I record intensely at the moment of orgasm constituted my true erotic joy. I am imagefully orgasmic, and my painting is a pursuit of ecstasy.

I have always taken delight in making up erotic games that in my imagination are films in which the image of each frame is unbelievably precise. I reconstitute with hallucinated exactness the details of a position, every pubic hair, every grain of the skin, every line, and my pleasure springs from the quality of fineness and precision of my visions.

With Gala pleasure became joy by complexifying itself in an unbelievable way. I can give no better idea of it than to refer to Proust who with the taste of a madeleine re-creates a whole world. Gala is like a magic mirror toward which the most marvelous moments of the successive presents of my life converge. Just before I explode inside her, after having penetrated and caressed her with my cock, on a rhythm that is natural and full of tenderness, I can feel mounting in me a power of imagery that dazzles me vertiginously. Not a radiant image but an unbelievable wealth of visions that are so many privileged moments with the retinue of their odor, their affectivity that is part of it, a quality of memories that submerges my consciousness. As if ruled by the gridwork of a decoding system, these images soon become orderly and convey to me a unique truth from which my erotic enjoyment is born.

Over the Figueras steeple associated with the memory of my adolescent masturbations, are superimposed the lines of the St. Narcissus church at Gerona and a view of the Delft church painted by Vermeer. The superimposition of these three privileged churches gives my orgasm a new and exalting dimension. The pleasure of the flesh can be achieved only if a special dimension is created, a sort of stereoscopic phenomenon, an imaginary hologram as true as true. My mental life has to take part intimately in the blossoming of my body. At the minute when I melt into Gala I always succeed in a grandiose superimposition of my visions, and my orgasm at one and the same time occurs in three dimensions: Gala's body, my own, and a kingdom that is the present of all my presents.

I have suddenly to have present all of these images of my past that make up the whole cloth of my life. They are the bed of my enjoyment. Each time, Gala is making love with all of the Dalis

that ever existed. In painting I have tried to convey this sensation by reconstructing the vision of a fly's eye that gives the feeling of being in all dimensions, up and down, right and left, front and back, or even the moiré fabric that superimposes luminous images of reality in which one can select one's vision according to distance. Every microscopic element of the moiré can give birth to a separate vision. To make love comes down to inventing an anamorphosis of reality into the Dalinian conception of eroticism.

Gala has become a fundamental catalytic element in my life. My visual and affective memory has been transcended by her. Thanks to her—to her love felt and accepted by myself—I can bring forth this sheaf of projections of images and am capable of selecting among them the strongest, most qualitative, so I can decant my prodigious wealth to produce the diamond of Dalinian reality. She is indispensable to me because thanks to her I can produce my elixir, my semen, and the substance of the strength that allows me to conquer and dominate the world.

I might have remained nothing but a voyeur impassioned of the spectacle of couples whipped to frenzies of desire. Gala allowed me to accede to the spiritual delights of Eros, she knocked out the barriers of my childhood fancies, my death anxieties, by appearing nude before me, stripped down to her own obsessions. She cured me of my self-destructive rage by offering herself as holocaust on the altar of my rage to live. I did not go mad, because she took over my madness.

As important as her gifts of love, are her gifts of persuasion. Her discourse is essential to my soul. She calms me. She reveals me. She makes me. She convinces me of my talent to live. The paranoia-critical method owes its all to her. She forced me to transform my lucidity into a faculty of self-analysis that screens my most awful and awesome thoughts to turn them into light and action. I should have died crushed under the weight of my imagination and fears. I became wealthy with all the mud that I turned into gold. I channeled the torrent of my impressions with which I domesticated my reality.

Once I wrote a manifesto against the blind and afterwards experienced fear, even anguish, over the loss of my sight. I spent entire days maintaining the madness of a poor fisherboy of Cadaqués who finally committed suicide. Feeling guilty, I went into a state of arrest, becoming unable to eat or drink, by way of self-punishment. These are two cases out of a hundred. Gala was always there to explain my attitude to me, bring me back to normal, return me to my paintbrushes, and turn my haunting obsessions into genius.

Out of the most terrible mental malady, my fantastic wan-
derings, my paranoiac visions, my deliriousness, she made a *classical
order*. She de-li-mit-ed—I might say Dali-mit-ed—my delirium and
set up the mental mechanisms that determine the share of truth.
Thanks to her, I can differentiate between dream and reality, between
ethereal intentions and practical inventions. By exercising constantly
with her intelligence, I developed my sense of objectivity while at the
same time maintaining the freedom of the irreducible share of my
paranoia from which my genius derives. This dualism is the most
unbelievable originality of my being. I achieved the sublime mutation
of evil into good, madness into order, and even succeeded in getting
my contemporaries to accept and share my madness. Dali projected
himself on the world and thus became truly Dali.

Had Dali Already Made Love to Another Woman?

Dali cannot come with any other woman. It is impossible.
You cannot be unfaithful to your shadow, and to lose it is to lose
your soul. That is quite enough for me, and I do not think either of
having children. Those embryos disgust me. Their fetal aspect bothers
me wildly. Nor could I ever, like any genius, give birth to anything
but an idiot.

I also do not want to face up to the reality of Gala's death.
My mind would need to call on all of its resources to survive that.
But with the training she has put me through I am certain I could
maintain my intelligence at the level of my love of life. Though hence-
forth I could overcome the most abysmal of misfortunes, she would
remain irreplaceable. I have moreover so often thought of her death,
from the very first day of our love, that I am as if prepared for that
tragedy. Gala today, as on that first day, goes on saying that her
death would be the finest day of her life. Perhaps I would say, despite
my immense sorrow, as I did the day after our first coming-together,
in Figueras when I saw her to the train as she was departing for
Paris, despite my love and my sorrow at seeing her leave, "Alone at
last." For nothing is greater than to discover one's true dimensions
and put up with one's solitude. Gala taught that to me, so it would
be one more way of paying deep tribute to her by going on living as
she had wanted.

At that time, I was hardly inured despite my pride and like
one obsessed I had to look for my strength and courage among the
things she had imprinted with her mark, her odors, her memory: an
old pair of rope sandals, a swimsuit, a pebble. I kneaded them in my

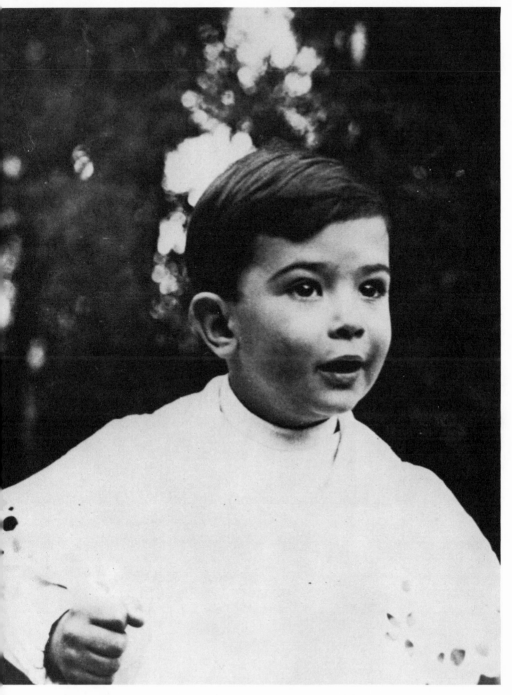

The eye of Dali as a child, with the look that twenty years later would be termed paranoia-critical.

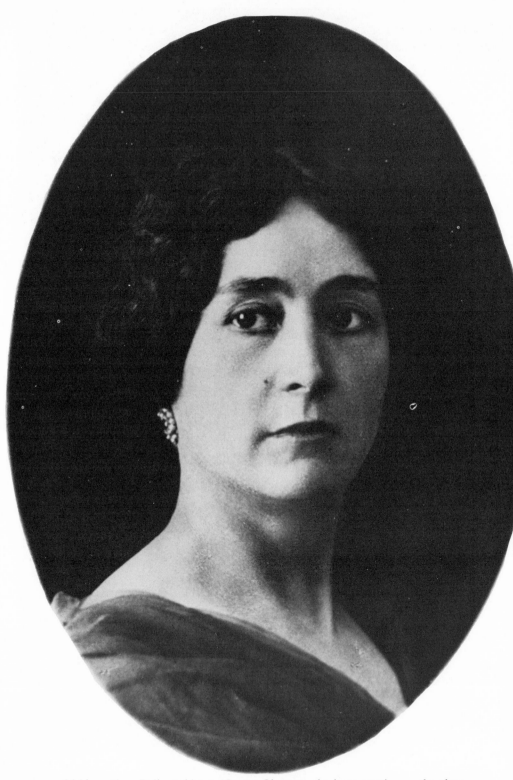

Of his mother, Dali would say, "In my Olympus, she is an angel . . . she alone
might have transformed my soul."

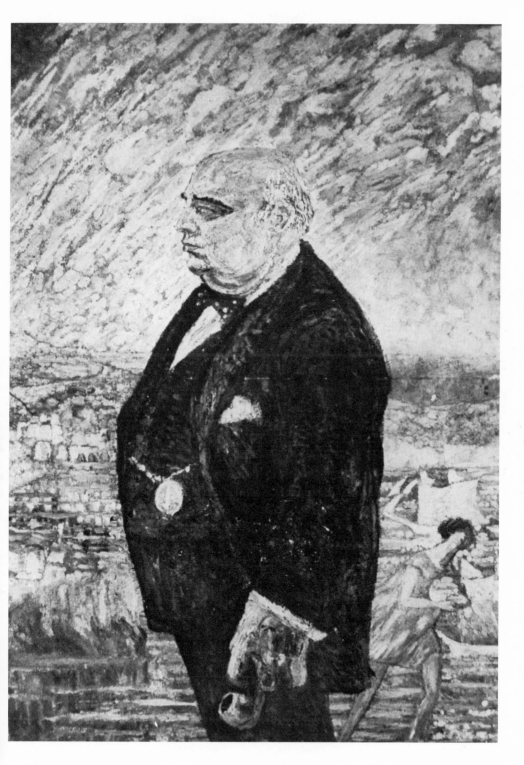

"My father was a giant of strength, violence, authority, and imperious love. At once Moses and Jupiter."

Lidia was the widow of Nando, the Cadaqués fisherman. She dreamt only on the novelist Eugenio d'Ors, who had spoken to her only once. "The mystical, passionate, inquisitorial Catalan soul lived in her in all its magnificence!" She provided the most wonderful of paranoiac climates.

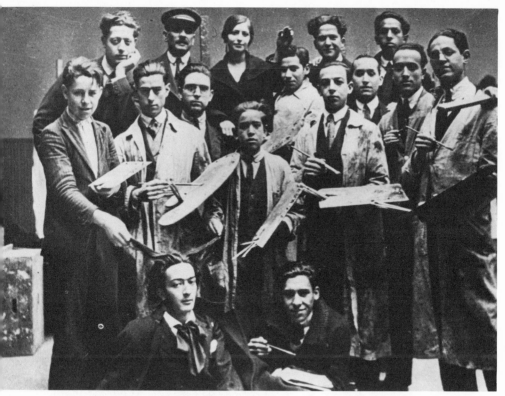

Dali, front left, with one of his fellow students pulling his hair, at the Madrid School of Fine Arts, where he made friends with Federico García Lorca, Luis Buñuel, and Eugenio Montes. He was suspended from the school first in 1923, then permanently expelled in October 1926, for outlandish behavior.

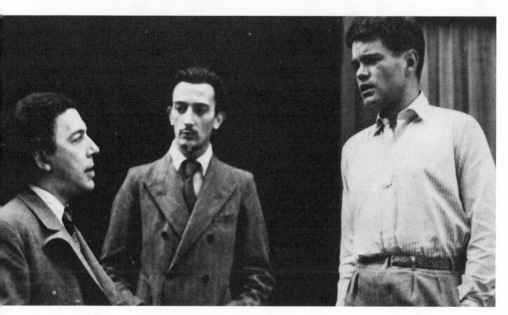

André Breton, Dali, René Crevel, and Paul Eluard, at the period of Surrealist friendship. Dali was condemned by the movement in 1934, but further took part in its 1938 International Exposition of Surrealism, for which he was a "special consultant."

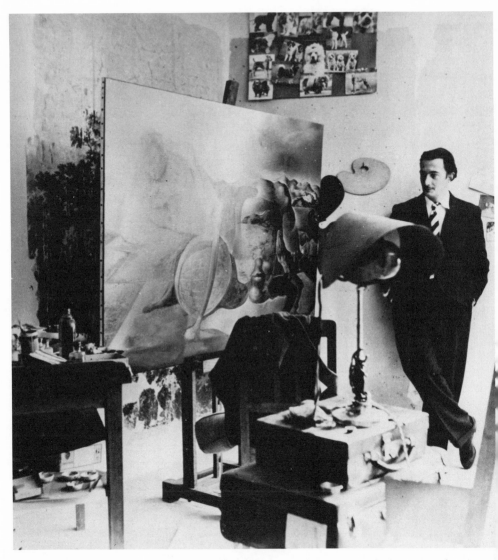

In his studio at Roquebrune, in 1938, at the home of Coco Chanel, the queen of haute couture.

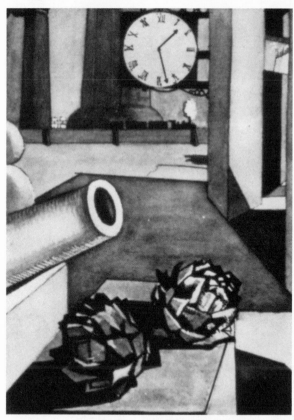

Araignée du soir, espoir (below, Salvador Dali Museum, Cleveland), done in 1940, expresses the Dalinian case with its penis-cannon and its limp runny beings and objects. "I paint," Dali says, "to be and unite all the forces of my self." This can be compared to the Giorgio de Chirico painting (at left), which on the same theme demonstrates the difference in their personalities: in Chirico, everything is "hard." Dr. Roumeguère has done a study of this comparative aesthetics of the hard and the limp. (From Cassenne Labs., after Dali and Chirico.)

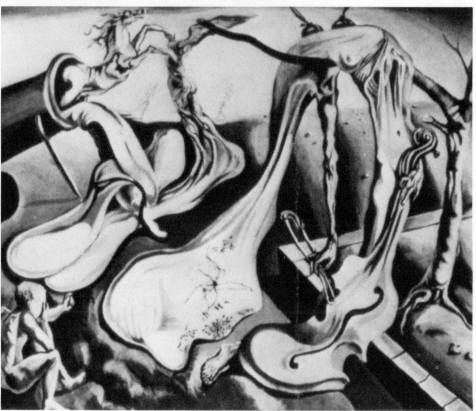

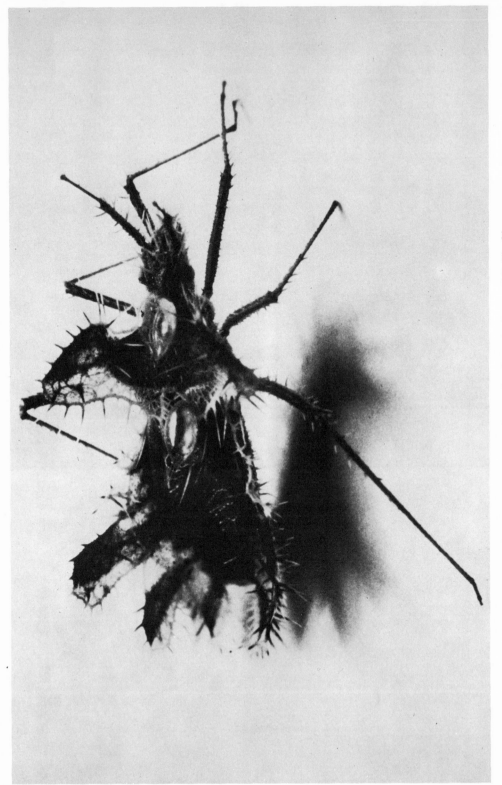

The *morros de cony*, the chameleon-insect that is at the heart of Dali's Olympus.

hands, smelled them with delight, trying to recapture a bit of her presence and her life, and warming my heart with the magnetism they still radiated.

I had my work. I locked myself in my Figueras studio for a month. I finished *The Great Masturbator* and *Portrait of Paul Eluard*. I felt it incumbent on me to fix forever the face of the poet from whose Olympus I had stolen one of the muses.

I left for Paris at the end of the summer, to arrange for my first show, which was to open in November at the Galerie Goëmans. That period remains for me a series of strong images that embody the voluptuousness of deliberate defeat.

I am in a florist's shop and do not have enough money to pay for the hundred roses I have just ordered for Gala.

I wait until the very last moment before going to see Gala whom I am dying to see again.

On our honeymoon at Sitges and Barcelona, I let Gala go back to Paris alone, so as to go and see my father, who tells me it is unthinkable that I should marry a Russian woman. Despite my denials, he believes Gala is a drug addict and has turned me into a narcotics dealer, which alone in his eyes would explain the unlikely sums of money I have been making.

He was to write me that he disowned me. Out of pain, I decided to shave my head completely and, before leaving Cadaqués, went and buried my hair on the beach with a batch of sea-urchin shells fragrant of cunt.

I am on the highest hill overlooking Cadaqués and stare at my village for a last farewell. With my bald scalp, I leave for Paris, a picture of the anguish, pain, and sorrow that indicate the passage to maturity and the landmarks of the Galactite ordeals.

In Paris, all the paintings in the show have been sold and my success is enormous. Gala has just finished transcribing my notes that I plan to publish as *La Femme visible* (The Visible Woman). Buñuel wants us to start work without delay on the scenario for *L'Age d'or,* a new film that has just been commissioned from him by the Vicomte de Noailles, who put up a million francs, a fantastic budget for those days. A leaf of my life is being turned, I am emerging from the shadow to the light.

To live with Gala became an obsession to me. To digest her, possess her, assimilate her, melt into her. With my shaven skull and fiery eye I looked exactly like a Grand Inquisitor, but one consumed with love. Gala understood that we had to flee the world so as to temper ourselves as a couple in the crucible of life alone together.

A small hotel on the Riviera, at Carry-le-Rouet, took us in. We rented two rooms. In one, my easel, my canvas of *L'Homme invisible* (The Invisible Man), inspired by the research of Archimboldo, on whom I had meditated for so long, my books, and my brushes; in the other, the bed. They brought our meals up to us. We opened the door a crack only to let the valet or chambermaid in.

I was methodically exploring Gala with the detailed care of a physicist or archaeologist exalted to high pitch by delirious love. I fixed in my memory the value of every grain of her skin so as to apprehend the shadings of their consistency and color; so as to find the right attentive caress for each. I could have drawn up a map of her body with a perfect geography of the zones of beauty and fineness of her fleshly coil and the pleasures to be derived and evoked. I spent hours looking at her breasts, their curve, the design of the nipples, the shadings of pink to their tips, the detail of the bluish veinlets running beneath their gossamer transparency; her back ravished me with the delicacy of the joints, the strength of the rump muscles, beauty and the beast conjoined. Her neck had pure grace in its slimness; her hair, her intimate hairs, her odors intoxicated me; her mouth, teeth, gums, tongue overpowered me with a pleasure I had never even suspected. I became a sex freak. I wallowed in it to the very paroxysm of cockcunt, voraciously gobbling, frenzied in the unleashing of my finally sated instincts.

Even today, from those passionate hours of our isolation in sex, my memory retains the images of our orgiastic comings-together —animal but perfect and beautiful in their wildness. We were like two monks of sex, at every hour of the day celebrating the adoration of their god.

Only lack of money—a few pieces of silver—made us surface again. And then everything was silvery, the pale winter sun, the landscape, our cadaverous complexions. Unsteady on our legs, led along by our dazzled eyes dilated by pleasure, we went as far as a café terrace, attracted by the tropism of the rays of the sun. Gala ordered a gala lunch to celebrate our return to life with others and, during the meal, we laid out the tactics for getting our finances afloat once more. A letter had come that morning from the Vicomte de Noailles—we had been expecting it for several days, for Gala had read the cards and foretold the imminent arrival of a letter, a token of great friendship and much money—and now it informed us that my dealer Goëmans was about to go broke but that, on the other hand, the Vicomte wanted to buy my next painting. There was no

time to waste. Gala decided to go to Paris at once to collect the amounts still due me by Goëmans, while I would go to see the Noailleses who were spending the winter at their château at St. Bernard, near Hyères, and discuss the subject of my next picture with them. We decided that twenty-nine thousand francs was the proper advance to request from aristocrats of their standing, their thoughtfulness, and their wealth.

Gala left. And then I had a call from the floor valet who, livid with terror, told me that while sweeping the hotel salon he had inadvertently knocked down a master's painting and run it through with his broomstick. He would obviously lose his job, unless I, the artist, could find a way to repair the damage. I was still all full of love and open to pity. I agreed, and with very great care I did away with all traces of the hole. I thought this was the end of my good deed, but when mealtime came the valet arrived with three dozen oysters that he implored me to accept by way of thanks. I had just heard that an epidemic was rife in the oysterbeds and the very idea of guzzling one of those mollusks turned my stomach and filled me with horror. I was already thinking on how to dispose of the tray of them, but the man was so overflowing with gratitude that he wanted to watch me eat them, and opened and handed them to me one by one. I thought I should die and for two days was in a sweat of terror awaiting my death. That night I decided I would never be nice again and I have stuck to it. Gala alone receives my generosity and the attention of my heart.

With my beloved Beatrice away, I got another initiation, in connection with the Vicomte de Noailles' check. Coming back from his château, I had put the pink paper on the desk and considered it most carefully. Its shape, its delicate shade, the way the letters were printed on it, the figures written by hand, and the signature; it seemed to me that all of this contributed to creating an enthralling *mise-en-scène* celebrating the cult of money. But this little piece of paper was worth millions. The dynamite of an awesome power was hidden in those symbols. The check assumed the shape of a case full of ingots, or turned into meals, fabrics, clothes. It seemed to me that the mere fact of carrying it in my wallet afforded me the protection of armor and the power of a prince. An army of imaginary valets whirled respectfully about me, full of deference and attentive to my slightest whims. I had but to raise a finger and everything became easy. Where there was a will, there was a way. Money was a magic wand. By the time Gala got back, I was giddy with gold.

How Dali's Love for Gala Expressed Itself

During these two months devoted to *l'amour* and the adoration of Gala I had gone down to the very sources of the pleasure of living in the abyssal depths of being. It was a kind of journey to the center of being I had made, going back to my intrauterine memories, to the very nourishment of the birthing placenta, and in my wild mind seeing Gala's cunt and my mother's belly as one. A philter sweeter than honey flowed within me. Gala's senses, Gala's belly, Gala's back exalted my dreams, their shapes mixed together, merged, compounded as the lines and rhythms of the waves of joy that rocked me and carried me over an ocean of felicity. My paranoia knew no bounds. My delirium rose to perfection and Gala's superintelligent complicity allowed me to attain the omega point of my inventions. All I had to do was touch the beautymark on Gala's left earlobe to be carried away on the flying carpet of my wild love.

This wonderful spot seemed to me to be the proton of my beloved's divine energy, the sun of her heart, the geometrical locus of our passion for each other, the very point at which any contradiction between our two beings ceased to be. All I had to do was rub it with my finger to be flooded with strength and faith in my own destiny. This divine beautymark to me was the proof of the definitive death of my brother Salvador, his mystical tomb; stroking it, I was rubbing against his gravestone. I thus took blanket possession of my existence in one stroke and had the intoxicating feeling of erasing the memory of this dead brother at the same time that I possessed the whole of the woman I loved, capturing all the beauty of the world and even living and making love to my own life. Even my father was not immune to being symbolically gobbled when I took Gala's earlobe between my lips and let it slowly give me suck. Later, Picasso capped my great happiness by showing me he had the same beautymark as Gala in exactly the same place. That day, he even made her a present of a Cubist painting—showing that that awesome personage's possessive genius could not resist Gala's radiation. It is true that Gala selected the smallest among the paintings he let her choose from. A fulcrum is all you need to raise the globe and with Gala's beautymark I can reconstruct the geometry of Dalinian intelligence. Her sacred ear sucked away all the dizzinesses of my soul to allow me to be reborn lucid, complete within unity, the master of the genius of my twin's personality, capable of overcoming my father's curse, the virile son of my mother. My entire unconscious found stability

around that axis, like a planet around its sun, a believer taking his Host. Magical beautymark, alpha and omega of Dali!

Further to reinforce my paranoia, during our isolation I had gotten letters from Lidia, the widow of Nando, the Cadaqués fisherman, who with her two sons seemed in my eyes the perfect illustration of paranoiac delirium. The Oracle of Delphi would have turned pale with envy alongside Lidia. She spoke sublimely. Because the writer Eugenio d'Ors once, while on vacation at Cadaqués, having gone fishing at sea several times with Nando, said to her, as she was bringing him a glass of water, "Lidia, how well set you are!" her head and heart had been carried away. It was love-at-first-sight, and after Nando died she dreamed only of Eugenio d'Ors. Especially when she read his book *La Bien Plantada* (The Well-Set Woman), in which she unwarrantedly recognized herself. She read every article by her hero, who did a regular feature in *La Veu de Catalunya* (The Wind of Catalonia), and in each piece decoded the words to interpret them as a love letter to her. She finally convinced herself that d'Ors did this to mislead her rivals. And of course she wrote him. The amazing part was that she could always find in the next day's article a word, an allusion that referred back to her previous day's letter. With an unheard-of genius for interpretation she found links between the most conflicting ideas, working out the strictest syllogisms to demonstrate the logic in her most unbelievable of algebras.

Lidia was sure of Eugenio d'Ors' most absolute love and the thinnest of allusions whipped up her passion. Beyond that, she remained a thrifty housekeeper and the most faithful of friends. The mystical, passionate, intransigent, inquisitorial Catalonian soul lived in her in all its magnificence. When I persuaded Gala to invest the Vicomte de Noailles' twenty-nine thousand francs in a home at Cadaqués, I was dreaming of a return to my native country, defying my father, and also sharing with Lidia the most wonderful of paranoiac climates, fascinated by the implacable coherency of the mind of this woman who could make parallels out of perpendiculars. I never found an intelligence more subtle in dealing with the absurd and implanting impeccable geometry over chaos. Like an experienced philologist, she interpreted the meanings of words, sniffed out love like a diamond in its matrix, establishing concordances and relationships, raising raving to the level of fine art. With her, I was breathing my own kind of air.

I landed at Cadaqués like a pariah disowned by his father. Against me there was the weight of this curse which was subscribed to by all right-thinking people, especially since I was living in sin

with a foreign woman who was supposed to be damaged goods. The Hotel Miramar, claiming it was undergoing repairs, refused to rent to us. A lousy little boardinghouse took us in. Lidia, whom I had advised of my return, welcomed us like a mother, and indulged my desire to turn our backs on all the petit bourgeois magnetized by my *notario* of a father, so we could face the sea I so admired. She found us a little fisherman's hut at Port Lligat, the other side of the Cadaqués cemetery, in a heavenly place. But our castle was a cabin four meters to a side and our first move was to get a carpenter to transform a storeroom three steps up into a shower, a toilet, and a kitchen.

A series of events followed each other very rapidly, nightmare fashion. We had gone to Barcelona to cash the Vicomte's check when Gala took to bed, burning up with fever. It was pleurisy. I was sick along with her, suffocating, choking, raving just as she did. The osmosis between us was such that I thought I was able to impart some of my strength to her and share her torment. Psychically and mentally, I was sicker than if I had been ill myself. Finally, she began to convalesce. We were in dire straits because we had mutually agreed that we would deposit the full amount of the Vicomte's check in the hotel safe so it could all go toward setting up our Port Lligat nest. The fixing-up of "our" house, the creation of our shell, seemed to us the most important thing in the world, a vital necessity. We did not want this little nest to be tentative, but rather the shell that gives birth to the invincible coral reef. Meantime, for all our pile of gold, we were broke until a friend who lived in Málaga asked us to be his guests, letting us pay him with paintings. I interpreted this proposal as a happy omen.

It was but a brief stop in the series of adversities that were to beset us, but I had gotten back into my springlike happy frame of mind.

I rented a house at Torremolinos surrounded by flowers and looking out to sea, having Gala pose as queen of the carnations in the middle of a brilliant parterre. My frenetic sexuality turned into a wild debauch of tenderness. During her illness, in order to keep up my hopes, I had spent entire days dreaming of the presents I might concoct for her the day she was well. I had no other ways to prove my love to her than my hands, my brushes, and my cock. Gala was so weak that the slightest effort exhausted her. We would walk out slowly in the sun, or else I would stay alongside her on a chaise longue as she motionlessly lay there and tanned almost visibly. She quickly became black and golden as a brioche and her energy daily

came back in waves. Her weeping spells, which expressed her depression, soon stopped. She laughed even at the sadistic tortures I inflicted on her.

How Dali Explains His Strange Sadistic Tenderness

Love is strength, power, ingestion, digestion. It is sex organ, tongue, tooth, claw, caress. It is domination and submission, obedience and refusal. The animality sleeping in all of us that awakens with possession and orgasm is the essential of the ecstasy of love. Fantasying and symbolism are but a way of exploring the vacuum that one's male strength is going to fill and, for the woman, the make-ready of her being to prepare to satisfy her man. Illness had made Gala as fragile as her diaphanous skin, and her tender beauty challenged my sexual violence. I raged to have to put up with such impotence. Having to be satisfied with holding her in my arms, I squeezed her as if to crush her, covering her with kisses, licking her like a dog in love with his master's hand. She suffocated beneath my embraces, choked, and soon was weeping in my arms. Her beautiful face turned ugly beneath the tears and I sometimes took pleasure in turning it into a clown's mask. I would bite the end of her nose to make it turn red, knead her cheeks to bring out their sanguine color, twist her ears into conches, and pull her lips out with the suction of my mouth. I found a kind of pleasure in these tortures of love. But that was only an accident, a way of getting even for what I had suffered while she was ill. Health brought a masterful Gala back to me and I was once again her fulfilled lover. We rolled over and over on the bed, living through the joy of finding each other again in the intoxication of our bodies. Gala, moulded by our lovemaking, then went walking through the blooming fields and even into the village, her bosom bare and victorious. I watched her with pride and enjoyment, my cock at attention with the joy of life.

I was working on finishing *The Invisible Man*. In the evening, we would walk along the beaches, very careful not to squash the gorgeous turds that the fishermen deposited in such provocative little piles. Shitting sessions, in the evening, after dinner, were the highlight of the village. The forum hour. They would gather by family affinity or commonality of interest to be able to discuss what was on their minds while they dropped trousers. Our presence did not in any way

embarrass them. With a bit of encouragement they might easily have asked us to join them, for we had become very popular. I watched them most interestedly as these excrements extruded from the hard white arses and formed into such perfect spirals. Their healthfulness was patent in these stools as in their way of shitting together without bashfulness.

We would have extended these Homeric sessions if the ends of the evenings did not generally degenerate into fights. For, while the fathers were sharing their shit and piss, the children were exchanging stones as hard as their slingshots could carry them. The fights quickly turned nasty and bloody. Then the adults would raise their trousers without wiping themselves and no sooner were they buttoned up than they joined the fight, each on the side of his own offspring. When the knives started coming out, the women mixed in and separated the combatants. The beach rang out with curses, insults, shouts, and cries. We slowly went back up toward our house and the noise of the arguments followed us far on up the hill. I have never forgotten those men and those times; not only because these memories are linked to precious images of a brutal, true, and marvelously Spanish lifestyle, but because these pictures of a certain kind of happiness in living were the prelude to heavy, dark, and trying moments in my existence.

We were often visited by friends coming through or artists and intellectuals in thrall to the then-fashionable Surrealist "keys." Each of them, as a welcome greeting, brought us some bits of news from the outside world which we had systematically cut ourselves off from since coming to Torremolinos. This was how in the matter of a few hours we found out that Buñuel—probably under the influence of his Marxist friends—had started shooting *L'Age d'or* without waiting for me to be there, suggesting betrayal with the worst kind of banalities, and that the Galerie Goëmans had gone broke. I was morally and materially ruined. To cap the calamity, we did not have a penny left and our Málaga friend had left this very day for a long trip through Spain, without even warning us or leaving an address. That evening, the postman brought us the Cadaqués carpenter's bill, which had grown to double the original figure. I suddenly felt myself surrounded by the hyenas of misfortune. The next day we had nothing left to eat, all that was on hand being a remainder of olive oil, which I ordinarily used to relish with some anchovies, then rubbing into my hair whatever was left over of the salad dressing.

My Samson hair in this way regained its original strength and shape.

What Effect Did Lack of Money Have on Dali's Character?

I found a hallucinating image deep in my memory. I am on my knees in a dark grotto. I see the hole of light at the entranceway like a gigantic cunt. My pants are open and down. I am holding my cock in both hands. I am trying to get the pleasure to spurt from my flesh and am madly masturbating. My eyes are riveted to the luminous opening but I close the lids so as to project on their screens the erotic and slightly dirty picture of the huge cheeks of the arse of a Gypsy woman I just saw stoking a campfire. I hear the sound of men's voices a few meters away. A baby is crying because the breast has been taken from it. Before my eyes, there is a hallucinating go-round: the ugly faces of militiamen who that very morning had come near our house to arrest a half-crazed neighbor who during the night had killed his mother with a pruning-hook. With the murderer wrapped up like a package, the cops are having their sport shooting at schools of migrating swallows passing over like clouds. They laugh very loud and every shot lashes me like a whip. I run through the fields in a paroxysm of rage, my switch playing havoc with the flowers, and just as a rain of carnation heads comes down on me like the burst of a fireworks my sperm ejaculates. I plant a man in the ground and allow myself to sink slowly down, spent. I am hungry. I am thirsty. I wish I could go with Gala and live like an outcast among the Gypsies. Only the idea of having to move Gala's huge wardrobe-trunk dissuades me, but my fury catches fire like a bundle of vinestems. I grow terribly angry with myself and as hard as I can I punch myself on the lips. Crack! My mouth fills with blood. I am left speechless by my action and slowly tongue my teeth. My tongue pushes up a tiny sliver of ivory that I spit out. I have just broken a babytooth. I have a mouth as singular as my genius. I had three babyteeth left till I was twenty-six, and I am still short two molars.

My violence immediately ceases. Having ejected my sperm and broken my tooth has brought about a mutation in me. When I get up I am another man. The little tooth in the palm of my hand is a talisman—my solidified sperm that has just come back to me.[1] There and then I decide I will hang this spermatic babytooth by a thread right in the center of our house at Port Lligat. Eros has brought my genius the solution to my misfortune.

On returning home, I told Gala of my decision. We went and

[1] In psychoanalysis, *tooth* signifies *sperm*.

asked one of our friends to telegraph the hotel in Barcelona and have them send us some money out of their safe, and then we would go on to Paris determined to increase our fortune tenfold. In the depths of despair, resolve had come to me. My good-luck spermatic tooth was going to bring gold raining down on the house at Port Lligat—gold that I would cause to spurt out of my genius.

We got there at the height of a scandal. First, as we had anticipated, Buñuel had betrayed me by selecting to express himself images that reduced the Himalaya of my ideas to little folded paper-dolls. *L'Age d'or* had become an anticlerical, irreligious picture. Buñuel had taken over the most primitive meanings of my way-out ideas, transforming them into associations of stuttering images without any of the violent poesy that is the salt of my genius. All that came to the surface here and there out of my butchered scenario were a few sequences he had been unable not to bring off, since my staging directions had been so detailed. And they were enough to gain him a personal triumph. With admirable opportunism, Buñuel left Paris for Hollywood on the eve of the Paris première. Three days later, Studio 28, in which *L'Age d'or* was shown, was a wrecking site. The royalist Camelots du roi had shot up the ceiling with their re-volvers and driven the audience out with stinkbombs, before smashing bottles of ink against the screen; they had broken all the show-cases exhibiting Surrealist books and lacerated my paintings on dis-play in the lobby. It was a memorable, if pitiful, evening. The Pre-fecture of Police, with the endorsement of part of the press, banned the movie. I expected I might even be deported.

On this occasion, I discovered a certain number of essential realities. In Paris there were still friends of freedom of expression who considered a Dali a creative genius. He had to remain sole master of his work and of his means of expression, henceforth refusing to be a partner with anyone. It was obvious that I alone would be tarred with the *Age d'or* scandal, as a cat is belled with an old tin can tied to his tail, and I had to try to turn this handicap into an advantage. Gala was the only being in the world who could make me forget this set-back—my fear—through the magic of her presence. Our love emerged stronger from this bump in the road and the dark tunnel it led into.

Did Dali Feel Persecuted?

I was alone with Gala. My so-called Surrealist friends already detested me and now they were especially promoting ideas absolutely

opposed to my deepest convictions. Linking hands with Picasso, they were glorifying African art against the classicism of which I was the liege. Art magazines and galleries of the period, dominated by a phony avant-garde, wanted none of me. We had no money, and yet not a week went by but what my intentions were shamelessly looted. Two things gave me courage: people were beginning to associate my name with whatever was astounding, delirious, sensational in this century. Dali was becoming synonymous with genius. And in addition each day Gala was becoming my woman, my wife, my double, my faith, and my conviction. Each morning and each afternoon she left me alone in my studio before my canvas, trudging off with a case under her arm to try to sell some of the fruits of my most sparkling inventions which since then have knocked contemporaries for a loop and made the fortune of a few clever dealers always unabashedly ready to grab the main chance by the short hairs. I had the happy surprise of seeing false fingernails made of mirror appear on the market, as well as transparent-aquarium mannequins with goldfish swimming around in them, streamlined automobiles, baroque bathtubs, and so on. I was sowing by handfuls to every wind that blew all the facets of an immense talent. Despite the conspiracy of silence, stupidity, and misunderstood interest, the 1930 period was not able to squelch me. But if I was not embittered by the blows I endured, nor by the humiliation heaped on me, I owe it all to Gala. To her courage. She never complained of the grueling visits she had to make, the waits, the rebuffs, the mockery, the loutishness she was exposed to. I was demoralized, and often wept. Her valiant little soul kept glowing in the dark like a beacon of hope. She never gave up. She prepared our skimpy meals by performing miracles of economy and ingenuity. The house was always spotless. She turned seamstress to make her own frocks, and simply refused to be seen socially in Paris.

All about us there was snobbery, perversion, drugs, whoring, pederasty and its closet fraternity. I was becoming tough as a Port Lligat rock, unyielding, proud but sure of myself. One morning, with my easel, my palette, a batch of spirit lamps, some books, metal furniture, and ten valises, we set off to our own house. The departure from the Gare d'Austerlitz was truly Dalinian. I can still hear the north wind whistling across the mountains that greeted us. Having blown out the lamp, I took Gala in my arms in the warmth of our bed, telling myself that, in the midst of the ocean of destructive forces unleashed by nature and mankind, love was a sufficient talisman. I fell asleep reassured as with the last glance before dozing

off I saw my babytooth dancing at the end of its thread in the center of my dream castle.

"I FELT A KIND OF CALM, A KIND OF STABILITY, AND IMMEDIATELY KNEW MY LIFE WAS ASSUMING A SYSTEMATIC GOODNESS . . . IT SEEMED THAT MY WIFE'S EYES HAD ALREADY STRUCTURED MY PARANOIA-CRITICAL ACTIVITY . . . ALL THE DISPARATE, EXCESSIVE, AND DOMINANT ELEMENTS OF MY LIFE WERE TURNING INTO AN ARCHITECTURE."

VIII

How to Become a Surrealist

On February 5, 1934, André Breton had brought the whole upper echelon of Surrealism together in his studio at 42 Rue Fontaine, to pass on my behavior. I was running a fever and getting a sore throat. With my habitual cowardice, the very idea of illness made me even more uncomfortable and facing this ordeal upset me extremely. But in my weakness I was able to find the paranoiac logic that was to turn the situation completely in my favor. I dressed very warmly, put on my camel's-hair coat, placed a thermometer under my tongue so as to keep vigilantly thinking about my case, and as I was about to leave discovered I was forgetting to wear shoes. I slipped them on without lacing them.

When Gala and I got there, everyone was waiting for me, seated on sofas, chairs, or the floor. It was foggy with smoke. Breton, dressed in bottle green from head to foot, looked like the Grand Inquisitor and lost no time in beginning to intone the litany of my deviations and errors. He paced back and forth continually in front of my painting, *La Gradiva,* hung near the fancy window of the studio. I listened to him for a moment with attention, but my rising

fever seemed more urgent to me and, while lending one ear to the recital of the Attorney General, I took out the oral thermometer and read it. It was 101.3, which was high. Medical practice in such a case calls for all possible measures to bring it down. I took off my shoes, overcoat, jacket, and sweater. Then I put my jacket and coat back on, because in such cases it is also important not to cool off too quickly. Then I put my shoes back on. Breton looked daggers at me during all this. He was nervously puffing on his pipe.

"Dali, what do you have to say for yourself?"

I retorted that the accusations leveled against me were based on political or moral criteria which did not signify in relation to my paranoia-critical concepts.

Breton was looking furious. The fact was that, having forgotten to take the thermometer out of my mouth, what I said was incomprehensible and I was spitting all over him. I fell to my knees, begging him to understand me.

He yelled louder than I did.

Then I got up, took off my coat and jacket, and a second sweater that I threw at his feet, quickly putting the jacket and coat back on so as not to catch cold. The whole bunch broke out laughing.

I turned to them, urging them to understand me, but my spittle-laden statements only made them laugh twice as loud.

Breton almost lost his composure. I should have taken the thermometer out of my mouth, but I was so obsessed with the state of my health that that would have paralyzed me. I had to choose between muteness and mumbling. Breton, meanwhile, was continuing his accusatory monologue, indicting everything I had done since I first joined the Surrealist group. What I got from it mainly was the immense distance that from the start had separated him and me.

We had met in 1928, introduced by Miró, the second time I came to Paris. He had immediately assumed the guise of a second father to me. I felt at the time as if I had been vouchsafed a second birth. The Surrealists to me were a kind of nourishing placenta and I believed in Surrealism as in the Tablets of the Law. With unbelievable and insatiable appetite, I assimilated the letter and spirit of the movement which indeed corresponded so exactly to my deeper nature that I embodied it most naturally. The farcical nature of this whole trial was the more paradoxical since I was probably the most Surrealist of the whole group—perhaps the *only* Surrealist—and what I was being accused of in essence was being too much so. Priests imprisoned in their own scholasticism were trying to refute a saint. . . . The story was as old as religion itself!

What Breton had really never forgiven me for was having been able to amaze him from the word go: the way I gave large bills to taxi drivers and did not take my change—because I never know how much of a tip I ought to give—how I made people laugh through my incongruous assertions, brought about downright hallucinations through my opinions and deportment, and undermined his authority; my entire attitude went against his own reflexes as a meticulously well-ordered man, a bookkeeper even in his moods, because, for all that he proclaimed the glories of delirium and freedom, Breton was basically rational and bourgeois.

Our first run-in came over my painting, *The Lugubrious Game*. In it, there was a rear view of a man whose underpants had well-formed excrements coming through them. Gala had already asked me whether I was coprophagous, merely putting into words what the whole group felt. The truth, as we know, was that I had to follow my unconscious impulses in order to free myself of my fears, but to Breton this was not explanation enough. Claiming to be truly shocked by the picture, he demanded that I state that the scatological detail was meant to be only a sham. I tried to laugh it off by saying shit brought good luck * and that its appearance within the Surrealist corpus was a sign of the whole movement getting another chance. Besides, historical literature was full of excrementitial allusions, from the story of the hen that laid the golden eggs to Zeus' divine defecation of gold on Danaë; but I understood from that day forward that these were merely toilet-paper revolutionaries, loaded with petit bourgeois prejudices, in whom the archetypes of classical morals had left indelible imprints. Shit scared them. Shit and arseholes. Yet, what was more human, and more needful of transcending! From that moment, I knew I would keep on obsessing them with what they most dreaded. And when I invented Surrealist objects, I had the deep inner fulfillment of knowing, while the group went into ecstasies over their operation, that these objects very exactly reproduced the contractions of a rectal sphincter at work, so that what they were thus admiring was their own fear.

I had hoped, at the beginning of my relationship with the group, to use it as a springboard, but I quickly sensed its dogmatic limitations. I had at one time thought of acceding to power in it, but the idea of fighting to be second in a small village when I could be first in Rome turned my stomach. I was satisfied to drop a few bomb-

* In French show business, *"Merde!"* (Shit!) is the phrase which is superstitiously supposed to bring good luck, as its counterpart "Break a leg!" is in English. (TR. NOTE)

shells in that small-town café where the Surrealist Revolution held its assizes.

This indeed is what Breton was indicting me for with the vehemence of Savonarola. I chose this moment to take my shoes off again, while getting out of my topcoat, jacket, and a third sweater. I was feverish and did not put jacket or topcoat back on, but only the shoes. I mumbled something through the thermometer in my mouth, just enough to give them another laugh.

When I say all the Surrealists had those petit-bourgeois taboos, I can prove it: they talked sex in a symbolic manner and the Church Fathers would not always have been moved to censor their words. Aragon's most daring action was writing *Le Con d'Irène* (Irene's Cunt), a labored erotic novel—but within the group, buggery or anal fantasies were not recognized as being part of the arsenal of love, any more than pederasty, or mysticism. I was completely amazed to find that Breton set up a whole scale of values to be observed in one's dreams. For instance, it was strictly forbidden to make mention of any dream involving Mary, Mother of Jesus—whom I often dreamt about—nor could I confess that I was obsessed by the hairs of her arse. That was held to be ill-bred and in bad taste. And woe betide any who did not respect the code of sexual fidelity—by swiping a friend's wife or even being unfaithful to one's mistress! Desire and lust were no laughing matters here. There was freedom only to have great theoretical, Platonic love affairs.

I considered it a normal thing to pay close attention to my stools and talk about them. My shit is an integral part of myself, and its consistency, odor, and shape are connected to my moods, my work, my way of living. I had had explosive, foul-smelling bowel movements when I was a student painting the town; today I have admirable stools, well modulated and shaped since I have become an ascetic. Likewise, although I have virtually given up farting for my own use, I still give it my closest attention, as did St. Augustine, the most famous *pétomane,* or fart-artist, of Church history. One of my most precious possessions is the thoroughly charming recording of a score of pétomanes.

The fart as well as excrement are capital subjects; both medicine and philosophy should consider them most thoughtfully. So should metaphysics, and I deplored the fact that the Surrealists held their noses at the mere idea. It seemed to me that the really Surrealist thing to do at this mock trial would have been to read a few quotations on the art of farting from the *Manuel de l'artilleur sournois* (Manual of the Crafty Artillerist) by Comte de La Trompette, which

might have put the discussion on its proper level: poetry, freedom, man and his nature. I knew parts of it by heart, and could have reeled off some definitions that could have made for merriment, such as the proverb: "For a life that's long and hale and hearty, 'tis best to have one's arse be farty." I could have pointed out the difference between the arsehole fart and the belch, or Spanish repeat, but the wind, whether it breaks from above or below, is all one.

Antoine Furetière, in his *Essai d'un dictionnaire universel* (Attempt at a Universal Dictionary), stresses that the Earl of Suffolk, a vassal, on each day of Christmas, was called upon to deliver before the King a jump, a belch, and a fart. I might have gone so far as to outline the different kinds of farts: the vocal or loud farts, naturally known as firecrackers, topped by the Giant Firecracker fart (or Pétard, as in "hoist on his own . . ."). This phoenix of farts does indeed compare well with the burst of cannons or giant bladders, and it is always accompanied by a distasteful odor that defines its essence and offends the sense of smell; therein lies its sin, for it is followed by the most shameful of satellites and leaves no question about the bad company it is in. But the true, or light, fart has no smell at all.

The Latin word *crepitus,* from which the French *pet* (fart) derives, means only a noise without odor,* but it is often confused with two other forms of malodorant flatulence, one silent but stinking, sometimes called lady's gas, and the other, more likely to be substantive, known as the thick or brewer's fart.

Any air that gets trapped in the body and after having been compressed in it breaks out, is known as flatulence or windbreaking, and the longer or shorter the time these winds remain inside and the greater or lesser ease with which they are expelled constitute the differences between them. There are composite farts, comparable to continual gusts of wind, that follow one upon another something like fifteen or twenty gunshots fired successively or as in a round; these may be termed diphthongs, and it is said that a person of stout constitution can emit up to twenty of them at one blow. The ear hears a greater or smaller cannonade, and seems to recognize the enunciation of diphthonged syllables such as *pa pa pax, pa pa pa pax, pa pa pa pa pax.* There is nothing prettier than the combination of diphthonged farts, and we are beholden to the anus for them. The diphthong-fart in sum is pocket-thunder. Its virtue and salubrity are active—and retroactive. It is of infinite value and was thus recognized from the days of earliest antiquity, whence the Roman proverb that

* *Cf.* English *crepitation*. Partridge indeed gives the derivation of *fart* as a deformation of the French *pétard* (firecracker or, more simply, farter). (TR. NOTE)

a big fart is worth a talent. The Emperor Claudius, that thrice-great ruler who thought of naught but the health of his subjects, having been informed that some of the latter out of respect for him had gone so far as to perish rather than fart in his presence, and learning from one of Suetonius' reports that before dying they had been subject to the most baleful of colics, promulgated an edict under which he allowed all his subjects freely to fart, even at his table, provided it was done lightly. The Egyptians made the fart into a god, of which figures are still extant. Some of the ancients considered the degree of loudness of their farting to be indicative of rain or fair weather.

The Comte de la Trompette, in his wisdom, concluded with some excellent practical advice:

> If a person be so slave to his prejudices that he cannot break away from them, rather than try to convince him not to fart when nature orders him to, let us give him the means at least of covering his outburst. Let him make certain, then, at the very moment that the fart is let, to accompany it with a vigorously vocal clearing of the throat. If his lungs will not accomplish this, let him make as if to sneeze most explosively; then he will be welcomed, commented happily upon by all present, and the recipient of a variety of blessings.
>
> If he be so awkward as not to be able to do either of these, he may spit very loudly, or move his chair with great rumbling, or in any other way create such noise as will drown out the fart. And, failing all of that, by squeezing his buttocks together as hard as possible, he will through compression and tightening of the great rectal muscle turn feminine what might have come out broadly male: but this unfortunate refinement may well cause an offense to the nose far worse than what it spares the ear.

As for me, had it not been for my fever, I think that on that solemn occasion I might have given forth with a gigantic diphthong-fart that would have acted as the trumpet blast to signal the hue and cry Breton was whipping up against me. I settled for taking off my fourth sweater. Everyone was beginning to feel the heat: the smoke was becoming opaque.

High-priest Breton had long since been suspicious of my formal anti-Surrealism. Indeed, I had never sworn allegiance to him, and he was in no position to demand that I account for my actions. For it was he himself who had installed Buñuel and me in the group after seeing *Un chien andalou,* the mere appearance of which had forced the Surrealists *in spite of themselves* to proclaim it as the *first Surrealist film.* With my scenario and only two hundred and thirty-

five thousand francs of the period, in six days' shooting Buñuel, a onetime assistant to Jean Epstein, had swept away ten years of phony movie avant-garde.

Un chien andalou had popped full-blown out of Jupiter's thighs—mine, that is—and Breton had had no alternative but to recognize its existence; as was the case with my painting which has proved fascinating from the first, though without benefit of theory or dogma. The first thing I wrote, *La Femme visible* (The Visible Woman), inspired by my absolute love for Gala, was an admirable illustration of total Surrealism that had no need for legitimization by the movement. My passion for Gala, my authentic lack of interest in anything that was not my own burning desire—two days before the opening of my show at Goëmans', in November 1929, I was to leave Paris because *nothing* mattered to me any more except the woman of my dreams and I was fanatically devouring my love—were so many undeniable Surrealist *facts*.

What Deeper Differences Separated Breton, the Movement, and Dali?

Politics—commitment, as the Surrealists called it—came between us. Marxism to me was no more important than a fart, except that a fart relieves me and inspires me. Politics seemed to me a cancer on the body poetic. I had seen too many of my friends dissolve into political action and lose their souls in it while trying to save them. Social science, economics seemed ridiculous to me, useless and especially phony—the inexact science par excellence; a lure set out with inextricable contradictions in which to trap artists and intellectuals, that is, those least fitted to resist emotional appeals so they could be mobilized in defense of causes that, come what might, would eventually be solved in natural course by the forces of history, in which intelligence played only a very minor part. Poetry and art were the great sacrifices to the historical event. Having no part of it seemed to me the only effective method of action and self-defense. The only honest way to deal with the poesy one carried within oneself like a rare and delicate flame.

The defense of my own intimate interests seemed to me as urgent, proper, and fundamental as that of the proletariat. Besides, what would the victory of the proletariat mean if artists did not provide the elements of a style of life based on freedom and quality? A

world of nameless grains of sand! Ant-heap technocracy! Dali was fortunately irreducible to smoky ideologies. Breton talking politics seemed to me like a grade-school teacher trying to give driving lessons to a herd of elephants going through a china shop. Discipline! That was now his favorite word! To an artist, it was leprosy!

I wanted to hear no more of it. The miserable runts littered by Communist cells who were trying to impose their morality, their tactics, their infinitesimal ideas, their illusions on Dali, made me laugh through their pretentions. I shrugged. Breton, on the other hand, bowed humbly in the name of Marxism-Leninism! Before getting down on all fours, he fortunately had a salutary reflex and the Aragon Affair that followed allowed him to take more wholesome positions, but at the same time he tore out his left ventricle of friendship, and I am not sure he ever got over the expulsion of his founding brother who disowned him after the appearance of *Misère de la poésie* (Wretchedness of Poetry). I was responsible for that break.

Issue No. 4 of *La Révolution surréaliste,* in 1931, under the title of *Rêverie,* had published a piece of mine which, without *any censorship whatsoever,* developed an erotic description around Dullita, one of the heroines of my childhood lovelife. The Communist Party judged it to be pornographic and a committee of inquiry was named. It summoned the representatives of the Surrealist group, Aragon at their head, and the latter was commanded to publish a statement of condemnation. Breton was revolted by this, and in his *Misère de la poésie* wrote that one day it would be "to the honor of the Surrealists that they had violated a ban so remarkably petit bourgeois in spirit."

That was the break. The moralistic Party faithful suddenly appeared totally at one with the narrow morality of the monogamous family dominated by private property, and Aragon, their vassal, was mainly looking for any opportunity to break with the Surrealists who stood in the way of his literary career. He thought, correctly, that the uncultured Communists would more easily allow him to publish his artfully commercial novels. It amused me greatly to be able thus to trap the two enemy brothers in their flagrant contradictions of friendship and thought.

Once more, I was happy to find that politics had nothing at all to do with the deeper motivations of allegedly passionate militants. But, of course, while that was the real problem, Breton did not breathe a word of it that day.

Had the Surrealists Fully Accepted Dali, Artistically?

I am the most Surrealist of Surrealists and yet between me and the group there was always a deep misunderstanding. Breton and along with him Picasso never really had any taste, any feel for true tradition. They went for shock, emotion rather than ecstasy. To me they are "impotent" intellectuals. They resigned for want of ability to renew the subject from inside; picturesqueness always meant more to them than creative order, the detail more than the whole, analysis than synthesis. So, they quickly came to prefer barbaric art, notably African art, to a classicism that was too difficult to master, take on, and outdo. My painting never really convinced Breton. He could not deny its interest and importance, but he regretted it. My works were stronger than his theories. They put him in the shadow, made him turn critic rather than prophet. And when I threw *art nouveau* * at him, he was floored. He was extolling the poetry of barbarians while I was proving to him that for eroticism, delirium, biological value, disquiet, and mystery, the 1900 style was unequaled. I started a new vogue for the style of coiffures, dresses, songs, and things that had been popular in 1900. But Breton did not mention that bitterness that day either. I don't know what point of his declamation he was at when I took off my fifth sweater, to lighten the atmosphere a bit.

I had also raised my voice against the excesses of automatic writing and the relating of dreams that were getting sclerotic, like some old business with its rules, its bad habits, its self-censorship, and stereotyped images. What had set out to be an attempt at explaining the unconscious unknown ended in an explosion of the most adulterated narcissism. That was why I created Surrealist objects with symbolic connotations.

The point was to invent an irrational object that as concretely as possible would translate the raving fantasies of a poetic mind. To disconcert reason, but furnish the imagination with as many elements as possible to supply wide-awake dreams by concretely involving all the senses. To provoke a state of grace of the mind; that was the goal. Surrealist objects very quickly made the old-fashioned-seeming dream recitals and sessions of automatism a thing of the past. It was hard to forgive me for that. And still the

* By a curious reversal, this style to which we give a French designation in France became known by the English name of "modern style." (TR. NOTE)

group kept on with those old devices that produced nothing but dish-water.

I invented the idea of a bread twenty meters long that would be placed in the gardens of the Paris Palais-Royal, and Versailles, and several European capitals, and create a scandal capable of causing cases of hysteria that would challenge the rational bases of the most sacred notions: bread, the image of hunger satisfied, the Host and divine body, fruit of all work, ground of human communion. But where my symbolic objects pleased mightily, my bread shocked as did my thinking-machine garnished with goblets of warm milk that moved Aragon to violence. He condemned my eccentricity in the name of the children of the unemployed from whose mouths I was taking the food. The delirium, this time, was not mine! Aragon's tin-plate socialism became grotesque. He had no more sense of humor. I think my references to Freud—whom his friends considered counter-revolutionary—bothered him a great deal and that he was trying every which way to upset me.

What Light Did Freud Bring to Dali's Creative Process?

I had often thought about Freud before meeting him. I think he would have been the only man who could talk as an equal to my paranoia. He admired my painting greatly. I would have liked to dazzle him. When I met him in London, introduced by Stefan Zweig, I made great efforts to appear to him as I imagined he imagined me: a Beau Brummel of universal caliber. But I failed.

He listened to me talk with great attention and finally ex-claimed to Zweig: "What a fanatic! What a perfect Spanish type!"

To him, I was a case, not a person. His snail's skull had not sensed my intuitions or my intimate strength. But I did make a deep impression on him, since the next day he wrote to Zweig:

> I must really thank you for the introduction that brought me yesterday's visitors. For until then, it seems, I had tended to think the Surrealists, who apparently have chosen me as their patron saint, were completely crazy (or let us say 95 percent so, as in the case of pure alcohol). The young Spaniard, with his candid fanatic's eyes and his undeniable technical mastery, led me to reconsider my opinion. It would indeed be most interesting to study analytically the genesis of a picture of this type. From a critical viewpoint, it could however always be said that the notion of art does not lend itself to any exten-sion when the qualitative relationship, between unconscious material and preconscious elaboration, does not remain within determined limits. At any rate, these are serious psychological problems.

But what interested him obviously was his own theory, not my personality. He was no longer really in the running. I sketched him on a blotter. This was in 1938, a year before his death.

Two geniuses had met without making sparks. His ideas spoke for him. To me, they were useful crutches that reinforced my confidence in my genius and the authenticity of my freedom, and I had more to teach him than I could get from him.

I am convinced that our meeting was a turning-point in Freud's artistic conception. I am persuaded that I forced the great master of the subconscious to rethink his attitude. Before me—Dali—Freud had never met any really modern artist. Before our meeting, he thought—as he wrote—that the Surrealists were "crazy"; after me, he "reconsidered" his opinion. Freud had a hunch that the Surrealists, and the Expressionists along with them, took the mechanics of art for art itself. My work—my technical mastery—and my person showed him that his concept had been foolhardy. Yes, I am convinced that if we had met earlier, or several times, some of his views on art might have been modified. My paranoia-critical method would have opened new vistas to him. Freud thought that the unconscious was a psychic content which can no longer return to the consciousness once it has been driven out. He brought about the psychology of depths—as compared to formal psychology, which in this domain is a superficial geography of the mind—he put his finger on the reality of reason, man's invention for realizing himself in a world perpetually in confrontation and conflict. With him, we found out that the psyche is not the conscious alone, but I could have been his living and fundamental proof that paranoia, which is one of the most extraordinary forms of the irrational unconscious, can perfectly well give impetus to rational mechanisms and fertilize the real with an efficacity as great as experimental logic. Paranoia-critical delirium is one of the most fascinating formulas of human genius. Freud was probably too old to reopen his theses and make way for new experiments.

February 5, 1934: Dali's Intentions on Trial

The leaders of the Surrealist movement, to tell the truth, did not understand much about painting. They accepted it because it served their thesis. Period. And anything that upset their dogma had to be refuted. They did all they could to bring the more elaborate personalities back into line. So they planned to hold an exhibition in which everyone would be in alphabetical order, no doubt so as

to proclaim equality before the mind. It seemed to me that a revolution that did nothing but enthrone alphabetical order fell a bit short of the mark!

Their determination to clarify everything became crankiness; and Breton's logic became the Mosaic Law. But my inventions were beyond their comprehension and outside their doctrine. They outdistanced their imaginations. So, one evening when I was tired and had remained home alone—Gala having gone out with friends—contemplating what was left of a runny Camembert on the table, I got an idea a few moments later before my unfinished canvas. In the foreground of the picture I had put a leafless and trimmed olive tree in front of a Port Lligat landscape. Looking at it, I suddenly projected two limp watches over the branches of the olive tree.[1] I immediately set to work.

Two hours later the picture was finished, the fruit of wedding

[1] *Cf.* Chapter XVII.

my genius to the tender Camembert, the expression of my notion of space-time, prophetically representing the disintegration of matter. I painted the phosphenes of my intrauterine pre-childhood by reproducing the fryingpanless fried eggs with raw chops balanced on Gala's shoulder. The soft, the digestible, the edible, the intestinal are naturally all part of my paranoia-critical representation of the world and I imposed these images on everyone—Surrealists included.

My paranoia magic never ceased bothering the Surrealists, as it was too true an expression of the Surrealism they dreamt of. I am the medium of my own imagination. I need but to stare fixedly at my canvas for a new truth of reality to appear there. I can just as well make such and such object disappear at will. I make the visible invisible by eliminating it through hallucinatory force. My creative delirium has fatal power. One day in the Café de la Paix I persuaded Robert Desnos that we could make a sublime statue by filling the whole Café de la Paix with plaster; once dried, we would merely have to cut it in quarters, make a casting of the parts, and keep them for all eternity. I explained to him the paranoia-critical method that had led me from an obsession to an invention allowing for the preservation of the Café de la Paix fixed in time. Desnos decreed that my method would revolutionize Surrealism itself. For a moment, it seemed that that would be the case. I was ready to agree to many theoretical concessions, short, of course, of going back on myself or committing suicide as Crevel had done.

How Dali Remembers René Crevel

I always felt that the first name of "René" (meaning "reborn") was in direct opposition to "Crevel," which is related to the French *crever* (to croak or die). His life was set between those two poles. Gravely ill, tubercular—he had been through a pneumothorax—he often disappeared from Paris for sojourns in sanatoria from which he came back renascent with a babyish happy mien, hair waved, well dressed, optimistic, and ready to plunge immediately into the most refined kind of self-destructive existence: nights out, insomnia, opium, and especially the pathetic dichotomy of poetic and political commitment. He had been fervently Marxist since 1925, and his Communism, incompatible with his Surrealist ideas, created insurmountable contradictions that tore him apart. His destiny was a perfect incarnation of the relationship between the Communist Party and the Surrealist group, and its final outcome is symbolic.

When René Crevel, looking like a *crevé* (goner), collapsed at friends' homes and said he'd rather *crever* (croak), they would forthwith send him off to another sanatorium cure, after which he was reborn full of euphoria—and it all started again.

He visited Gala and me several times at Port Lligat, where he had periods of real joy in living. He walked about stark naked in the olive grove, like an anchorite, and while there wrote *Les Pieds dans le plat* (The Foot Stuck in It), *Dali et l'anti-obscurantisme* (Dali and Anti-Obscurantism), and *Le Clavecin de Diderot* (Diderot's Harpsichord). He adored Gala, whom he called "The Olive," and dreamed of finding and loving a woman like her. Unfortunately, all he found was Breton, the Communist Party—and death.

Within the Association of Revolutionary Writers and Artists, Crevel tried to play a useful role in bringing together Surrealists and Communists. When its big international congress took place in 1934, he hoped that Breton would speak up for such unity. But the pope of the movement slapped Ilya Ehrenburg[1] just before he was supposed to speak. That consummated the break. Crevel was deeply affected by this. He tried every desperate measure for reconciliation. A falling-out with Breton was the only tangible result of his miscarried diplomacy. The pain of this failure felled him.

One morning I phoned him to let him know I in no way endorsed Breton's stand. A voice answered that René Crevel had just attempted suicide and was at death's door. I got to his house at the same time as the firemen. Crevel was trying to fill his lungs with oxygen from the tube of a bottle of oxygen. His baby face was bloodless.

He had put a cardboard label around his left wrist with his name printed on it in all caps like an epitaph. In my memory, he still lives today like some magnificent dream phoenix ever arising anew in the name of friendship, honor, and the appellation of free man. A most terrible evidence of the fundamental incompatibility between politics and poetry.

[1] André Breton, a few days before this Congress of Writers in Defense of Culture, met Ehrenburg, who had written in his *Vu par un écrivain de l'U.R.S.S.* (As Seen by a Soviet Writer):

> The Surrealists are perfectly willing to accept Hegel and Marx as well as the revolution, but what they will not do is work. They have their own concerns. They study pederasty, for instance, and dreams. One of them does his best to eat up an inheritance, another a wife's dowry . . .

Breton slapped him. Ehrenburg was a member of the Soviet delegation to the Congress. Breton was denied the floor as a result of this incident.

But for the moment politics wrought its havoc and darkened the eyes of Breton and his group. It even blinded them to Surrealist truth. For the fiftieth anniversary of the Salon des Indépendants at Paris' Grand Palais, I had exhibited a canvas entitled *L'Enigme de Guillaume Tell* (The Enigma of William Tell) and a drawing, *Le Cannibalisme des objets* (Cannibalism of Things). Lenin, down on one knee, in open shirt, wearing a cap of melting spoon and garters, had a buttock shaped like a breakfast roll with its end held up by a forked crutch. That buttock, of course, was the symbol of the Revolution of October 1917.

I had no "Surrealist reason" for not treating Lenin as a delirious dream subject. On the contrary. Lenin and Hitler turned me on in the highest. In fact, Hitler even more than Lenin. His fat back, especially when I saw him appear in the uniform with Sam Browne belt and shoulder straps that tightly held in his flesh, aroused in me a delicious gustatory thrill originating in the mouth and affording me a Wagnerian ecstasy. I often dreamed of Hitler as a woman. His flesh, which I had imagined whiter than white, ravished me. I painted a Hitlerian wet nurse knitting sitting in a puddle of water. I was forced to take the swastika off her armband. There was no reason for me to stop telling one and all that to me Hitler embodied the perfect image of the great masochist who would unleash a world war solely for the pleasure of losing and burying himself beneath the rubble of an empire: the gratuitous action par excellence * that should indeed have warranted the admiration of the Surrealists, now that for once we had a truly modern hero!

I painted *L'Enigme d'Hitler* (The Enigma of Hitler) which, apart from any political intent whatever, brought together all the elements of my ecstasy. Breton was outraged. He was unwilling to admit that the master of Nazism was nothing more to me than an object of unconscious delirium, a prodigious self-destructive and cataclysmic force.

On the eve of the inquisitorial meeting, Breton, carrying a cane and accompanied by Benjamin Péret, Yves Tanguy, Gui Rosey, Marcel Jean, and Georges Hugnet, had tried to poke holes in my Lenin at the Salon, but their short arms had not been able to reach the painting hung high. Which made them furious. That very morn-

* *L'acte gratuit,* the gratuitous (wholly unmotivated) action, a preoccupation of André Gide in his early shorter novels, had been adopted by the Surrealists, along with automatic writing, as a keystone of their modern approach to life and its motive forces. (TR. NOTE)

ing, the "pope" had gotten a letter signed by Crevel, Tristan Tzara, and Eluard, saying that they would not vote for my expulsion, in spite of the specification of the order of the day that they had received:

> Order of the Day: Dali having been guilty on several occasions of counterrevolutionary actions involving the glorification of Hitlerian fascism, the undersigned propose—despite his statement of January 25, 1934—that he be excluded from Surrealism as a fascist element and combated by all available means.

So Breton was ready to strike hard. To ready myself for it, I removed my sixth sweater.

My thermometer firmly in my mouth, I now went over to the attack, determined to catch Breton in his own logic. I highmindedly stated that to me the dream remained the great vocabulary of Surrealism and delirium the most magnificent means of poetic expression. I had painted both Lenin and Hitler on the basis of dreams. Lenin's anamorphic buttock was not insulting, but the very proof of my fidelity to Surrealism. I was a total Surrealist that no censorship or logic would ever stop. No morality, no fear, no cataclysm dictated their law to me. When you are a Surrealist, you have to be consistent about it. All taboos are forbidden, or else a list has to be made of those to be observed, and let Breton formally state that the kingdom of Surrealist poetry is nothing but a little domain used for the house arrest of those convicted felons placed under surveillance by the vice squad or the Communist Party.

"So, André Breton," I concluded, "if tonight I dream I am screwing you, tomorrow morning I will paint all of our best fucking positions with the greatest wealth of detail."

Breton tensed, his pipe tightly held between his teeth, and grumbled furiously, "I would not advise you to, my friend." He was checkmated.

As I was removing my seventh sweater, and now baring my naked breast, he called on me to foreswear my ideas about Hitler, on pain of expulsion. I had won. Kneeling on the thick carpet now formed by my sweaters on the floor, I solemnly swore I was no enemy of the proletariat—about which in fact I didn't give a fig, for I knew no one of that name and merely granted my friendship to the most disinherited men on earth, namely the Port Lligat fishermen who were so contented with their lot that I sometimes wondered whether the Marxists knew what they were doing in pulling for the revolution.

I had transformed the grotesque occasion into a true Sur-

realist happening. Breton would never forgive me for it, but he learned from it that it would probably be better to avoid repeating such an experiment that could so easily turn against him and trap him in his intellectual braggadocio.

"BRETON WAS THE FIRST IMPORTANT PERSON WHO MADE ME THINK AND WHOSE CONTACT GREATLY INTERESTED ME. I WAS CONTRIBUTING ROTTING ASSES AND TURDS BALANCED ON HEADS —IN A WORD, A DELIRIOUS, SUPER, FIRST-RATE INCREMENT THAT GREATLY ATTRACTED HIM. THEY HAD CLEARLY EXPLAINED TO ME THAT OUT OF PURE AUTOMATISM I WAS CALLED UPON TO TRANSCRIBE EVERYTHING THAT WENT THROUGH MY HEAD WITHOUT BENEFIT OF ANY CHECK IMPOSED BY REASON, AESTHETICS, OR MORALITY. I HAD IDEAL MEANS AND POSSIBILITIES OF COMMUNICATION. BUT BRETON WAS VERY QUICKLY SHOCKED BY THE PRESENCE OF SCATOLOGICAL ELEMENTS. HE WANTED NO TURDS AND NO MADONNA: BUT THERE IS A CONTRADICTION TO THE VERY FUNDAMENTAL OF PURE AUTOMATISM IN SETTING UP IMMEDIATE TABOOS, FOR THESE EXCREMENTS CAME TO ME DIRECTLY, BIOLOGICALLY. THERE WAS A CENSORSHIP DETERMINED BY REASON, AESTHETICS, MORALITY, TO BRETON'S TASTE, OR BY WHIM. THEY HAD CREATED IN FACT A SORT OF HIGHLY LITERARY NEO-ROMANTICISM . . . IN WHICH I WAS FOREVER OUT OF FAVOR, AND INDEED BEING JUDGED, INVESTIGATED, SUBJECTED IN A WORD TO INQUISITORIAL PROCEDURE."

VALDES LEAL

IX

How Not to Be a Catalan

When we were very small, my father used to take us on out-ings to Cape Creus. I need only to close my eyes in order to recapture landscapes and scenes intact, but at the time I established the strangest kind of dialogue with myself. Every rock, every promontory of Cape Creus is in permanent metamorphosis. Each is a suggestion that prompts spontaneous visualization of an eagle, a camel, a rooster, a lion, a woman—but if you approach from the sea, the nearer you get, the more the symbolism develops and changes. It is a continual simulacrum. The bird becomes a wild animal and then a barnyard fowl. Like living in a constant mirage . . . and yet, when we land, the granite beneath our feet is hard, compact, clear, implacable—after having double-dealt us so constantly.

Likewise my thought, my mind: so wildly concentrated upon itself, a block of diamond whose multiple facets are so brilliantly shimmering that the reality surrounding it is disconcerted, deceived, snared, decoyed. Thus my strength and my strategy, patterned on a single landscape from which my roots draw their sap.

The universe is a whole. How can that be denied? Just as man

breathes eighteen times a minute, or 25,920 times a day, the equinoctial point of the sun runs through the zodiac once in every 25,920 years. Our hearts beat only one-fourth as fast as our lungs breathe, just as the speed of the propagation of air is four times greater than that of water. Our life is a mimesis of the world. Our minds are like a film that records the variety of the phenomena of the universe. I am convinced that I am Cape Creus itself, that I embody the living nucleus of that landscape. My existential obsession is constantly to mimetize myself into Cape Creus. Like it, I am a cathedral of strength with a nimbus of dreamlike delirium. My granite structure is equipped with ductilities, haze, glint, quicksands, that hide its needles, its craters, its promontories, the better to let me keep my secrets.

The north wind coming over the mountains, on this cape that the ancients dedicated to Aphrodite, sculpted the dream figures just as I model my own characters on my stage of life. To hear my secret voice, one must first have listened long to the song of the wind at the point of these Pyrenean rocks exchanging their memories and intertwining their millennial legends. The cape is the utmost point of Catalonia and one of those high places in which there blows the sacred spirit, the tidal wave that comes from the depths of the sea to conjoin with the breath descending from the sky to fertilize our earth. This is where my paranoia was born, in this cell of mystery.

One day I found a piece of wood formed by the waves and the rocks, awaiting me like a talisman vouchsafed by the gods, on a beach at Cape Creus. It was during an outing with Gala. Love guided our steps and illumined our days. All of our actions had unusual style; miracles sprang up beneath our eyes. I knew, when I saw that wood with its magical cachet, that Aphrodite herself had sent it to me. I picked it up religiously, and have never been without it since. This message from the gods is a good-luck charm. I often feel an overpowering need to touch it so as to undergo its magnetism and inhale its spiritual effluvia. The obsession is a sort of crankiness: Gala knows as well as I that our two lives are knotted through that magical wand. At times I have mislaid it; and we became desperate. I remember once in New York making the housekeeping staff at the Hotel St. Moritz go through all the day's dirty bedclothes to find the fetish I had negligently left between the sheets. For before I go to sleep it acts on me like a tranquilizer. It assures me of a harmonious passage from reality to dream. Before I had it, I was obsessed with the disorder I was leaving behind. I had to make sure all the drawers in the bedroom were closed. I made Gala leave all the doors ajar. Within the bedroom, I laid out a whole series of objects arranged in a harmonious but

esoteric order. Little by little I had succeeded in establishing a crank's inflexible code for a setting without which my sleep, if not impossible, was at best troubled and anxiety-ridden. Today I need only stroke my sacred wood to slip felicitously into a somnolent state.

I am a Catalan peasant in tune with the soul of my land. It has never happened that after a month's living at Port Lligat I did not recover that earth-force which allows me to resist all storms, all temptations, like a rock. It was at Port Lligat that I learned to forge my ideas and my style as sharply honed as Tristan's sword. In our solitude there we live according to the rhythms of cosmic pulsations. Fishing for sardines under a new moon and knowing that, at the same time, the salad greens are leafing out instead of bunching into heads. Preferring to ponder the intuitions of Paracelsus' genius rather than listen to the radio, dream with eyes open on the world of the invisible rather than allow ourselves to be conditioned by TV, fly to the highest apexes of the absolute rather than become activists in the development of a Utopian socialism. I take care of my field, my boat, that is, the canvas I am finishing, like a good worker, ambitious only for simple things: to eat grilled sardines and walk with Gala along the beach at eventide, watching the Gothic rocks becoming transmogrified into nightmares of the dark.

I made myself on these shores, created my persona here, discovered my love, painted my oeuvre, built my house. I am inseparable from this sky, this sea, these rocks: linked forever with Port Lligat—which indeed means "linked port"—where I defined all of my raw truths and my roots.

I am home only here; elsewhere, I am camping out. This is not just a matter of sentiment, but of psychic, biological—Surrealist—reality. I feel linked by a veritable umbilical cord to the living totality of this earth. I am part of the rhythm of a cosmic pulsation. My mind is in osmosis with the sea, the trees, the insects, the plants, and I assume a real stability that translates itself into my paintings. I am truly the center of a world that creates my strength and inspires me. My genius is like a proton of absolute matter, the sun of a universe that legitimizes me. This privileged place is where there is the least space between the real and and the sublime. My mystical paradise begins at the plains of the Ampurdan, is surrounded by the foothills of the Monts Albères, and comes to meaning in the Gulf of Cadaqués. This country is my permanent inspiration. The only place in the world where I feel loved. When I painted that rock that I dubbed *The Great Masturbator,* I was merely marking out one of the landmarks of my kingdom and the picture was a tribute to one of the jewels of

my crown. Yes, I am a Catalan peasant whose every cell branches on to a parcel of his earth, each spark of spirit to a period in the history of Catalonia, homeland of paranoia.

The Catalan family is paranoiac, that is to say, delirious and systematic, and the real finally ends up by conforming to the demanding will of this directed madness. Nothing stands in the way of our desires, and reality is there to fulfill them.

I ask Gala: "Heart, what do you want?"

She replies: "A ruby heart that beats," and that wish turns into a jewel that enchants the world.[1]

Chance itself is on our side: my father tosses a match up in the air after having lighted his cigar. It lands vertically on a burning slate in the roof and catches fire. I in turn throw a carafe stopper toward the ceiling and it bounces off and lands poised on a curtain-rod, where we let it remain for several days so we can admire the play of forces in objective chance. For we know that anything can happen. Will and word are kings in Catalonia. Music is spontaneously born from our belief in it, our deep harmony between the forces of the spiritual unknown and those of nature.

My friends the Pichots went out as a family group to play classical music on the rocks at Cape Creus so as to establish a dialogue with the waves. Every Catalan is an orchestra conductor who can control and direct the forces of mystery. The most humble among us is sure of his paranoiac power. I knew a shoemaker in Ortis who spent his time beating out the measure of the most secret music. No wedding, funeral, sardana, or demonstration took place without his august presence, arm raised, setting out the cadence of a harmony he alone could hear. He was the clown of every gathering, and even when he was pitilessly chased away, he would continue conducting his orchestra—until sublime darkness in the middle of the village square, where he tried to conduct the rhythms of the storm that had broken. He struggled at this until morning, and died of a thunderbolt that burst his heart.

Small Catalan peasants in the evening catch glowworms that they string into a necklace to give to the girl of their heart, who accepts it as if it were a rivière of diamonds. And as long as darkness lasts, can there be more living, more sparkling, more poetic proof of love? I like the fact that this share of childhood remains in the adult and allows him to insert his dreams into reality. Nothing is greater than keeping intact one's faith in the wondrous, in the metamorphoses

[1] This jewel was acquired by the Cheatham Collection.

of the real. One may prefer death to the renunciation of one's deepest conviction or one's absolute. An old man in Cadaqués, a sometime primitive painter, kept an odds-and-ends shop. He was in love with a young girl, but dared not confess his passion to her. His only pleasure was to watch her from behind his dirty shopwindows. One day she went by on the arm of a young lad. It was Christmas Eve. He hanged himself from the balcony and the priest who discovered the body was hard put to cut the rope, for it had dug into the folds of the scarf he had put around his neck so as not to catch cold.

One may also prefer laziness to action. No to yes. Ramón de Hermosa, a local celebrity in Port Lligat, was the most compleat do-nothing one can imagine. The mayor allowed him to sleep among the homeless cats and the fleas in a broken-down house. He scrounged hand-me-down clothes and begged shamelessly. His victims—hard-working fishermen—often later saw him sitting at a café terrace, before a steaming cup, smoking a cigar, and he answered their insults with an exquisite smile worthy of St. Francis of Assisi. This parasite had gone beyond the stage at which human words could reach him. I understood this when, having paid him in advance for pumping water for me, I found him sitting in the shade and imitating the squeak of the pump by an effortless rubbing. Ramón had turned his worthlessness into a virtue and his attitude into an institution. The serenity of his soul was complete.

The Catalans' paranoiac universe is amazing in its variety. To turn one's weakness into strength, to transcend the absurd—for a Catalan there is no joy more noble. Each of them is a hero defending his honor of being allowed to dream with eyes wide open. In my childhood I knew a huge hulk of a man who suffered from a grandiose catarrh. Living in his company meant hearing a continual and fantastic throat-clearing, but he had conceived the unbelievable idea of saving up for one single expectoration all the secretions of each twenty-four hours. So each night at 8:30 sharp he gave his performance, and the whole neighborhood gathered before his door from eight o'clock on to see the happening. He would finally come out, his face purple, apoplectic, his eyes set and popping, holding on to the door jamb, his chest congested, hiccuping, teetering, his esophagus swollen with thick viscous phlegm. And then suddenly, at the appointed time, he eructated a powerful, nauseating, huge spray, a greenish, shapeless, bloodied turd that bubbled on the ground to the great admiration of the initiates.

Every circumstance of life, every character trait, every anomaly thus turns into something exceptional, something mythic, and any

exhibitionism can be a grandiose spectacle of humanity and truth. There is no chance, no coincidence. If I was born on Calle Monturiol, it was because Narcissus of that name invented a submarine so as to go down to the green depths of a sea that fascinated him in childhood, and it was only natural that Figueras' most illustrious son be the one symbolically to welcome my genius. And from the balcony of my father's house looking down on all Figueras, I could see the plain of the Ampurdan and the Gulf of Rosas, from which the calls to my vocation came to me and allowed me to escape from the bourgeois notarial universe.

To Dali, Delirium and Dream Are Not Objectively Reality

I believe in universal analogy. There is a subtle link between the stars and the grains of sand on the beach. I believe that the delirium present in us Catalans is the blood of the spirit that develops reality as a photographic plate allows us to recognize it. Only that is true which we believe true and are strong enough to impose. Knowledge—science—is but a proposition: one of the possibles of the universe. Watching Lidia live, I often wondered whether poetic reality was not just as true as common objective truth. The widow of Nando the fisherman, madly in love with writer Eugenio d'Ors, whom she had met when he was twenty and going fishing with her husband, bound her whole life up in that passion. I can still see her sitting on the ground and reading me an Eugenio d'Ors article in which she interpreted each sentence as a secret message intended for her alone. As her imaginary romance grew, and she commented upon it to me, she would then cut the neck of a chicken that she plucked and cleaned with admirable dexterity and precision, thus living on two separate levels as naturally as can be. Of course, she was crazy, and her two sons were even more so and had to be locked up to keep them from killing her in a violent fit. But no one more than she—except for me —knew so firmly how to maintain the systematization of delirious thought within the most remarkable coherence.

And had Eugenio d'Ors loved Lidia, what would have happened? What then would be madness? And what truth?

The secret lies in lucidly keeping a steady course between the waves of madness and the straight lines of logic. Genius consists of being able to live while going constantly from one frontier to the other, grasping handfuls of the treasures of mystery that one then, like an athlete, holds at arm's end to make them shine before the

eyes of contemporaries whose imaginations suddenly recall unknown beaches they had forsaken. I am that genius. Others have paid with their sanity for the fit of delirium. I saw Ramón de Hermosa, so deep in the idleness of his dreams that he was nothing more than a pile of crawling vermin one could not even touch. I remember Lidia, naked, well set on the roof of her house with a paper hat as sole adornment. She had to be locked up. . . .

Such exploration is dangerous. It is the most terrible of navigations, with the death of the mind as the punishment for failure. I too have known those grave stormy hours of the greatest risk. Many is the time I experienced the anxiety of feeling I was slipping over to the side of the irrational. My laughing jags were atrocious times in my existence. And my murderous impulses . . . my obsessions: the time I could no longer eat or drink because I found out one of Lidia's sons, whom I had tormented a bit, had starved himself to death; the time I thought I was losing my sight for having hit a blind man; the time I believed I was Dali such as into himself eternity no longer would change him . . .*

My strength lies in the fact that I am deliberately what I am. My intelligence and lucidity are present at every moment. The delirious heritage of all Catalonia lives in me, but dominated, fertilized, fermented by the greatest intuitive genius of lucid life ever brought to earth. I have lived and surmounted all the dramatic adventures of the mind errant in the world of madness and always found my way back. I am the perpetually reborn, each time stronger, more alive, upon return from each dive into the deepest of the abysses of the unconscious. Dali is the most sublime personage there is and I am Dali.

I know and make use of all methods further to increase my genius by ceaselessly sowing the fields of the earth with the diamond seed of madness. Since the time when, like all Catalan children, I played at being Father Patufet,[1] and on all fours kept swinging my head like a metronome so as to try to create a black veil before my eyes on which were projected fantastic visions of eggs that brought the sensations of my intrauterine existence back to me, I've perfected the system. I have become a magus of delirious exploration and a sage whose secrets are part of the treasures of humanity. And this confession, these confidences are a spiritual testament capable of setting future Nietzsches on the road to the great mutation.

* A reverse allusion to the opening line of Stéphane Mallarmé's tribute to the genius of Edgar Allan Poe, *"Tel qu'en Lui-même enfin l'éternité le change"* (Such as into Himself at last eternity changes him), a favorite and almost fetishistic quotation among French literati of the '20s and '30s. (TR. NOTE)
[1] See Chapter III.

But, to be Dali, one must *first* be Catalan, that is, equipped
for delirium, for paranoia, and living in it as naturally as the old
fishermen of Cadaqués who hung live lobsters from the gleaming
baroque cherubim of their church's altar, so the death throes of the
crustaceans might help them better to follow the passion of the Mass.
But more than anything else one has to be *true*. Madness is an artificial,
rootless delirium, delirium-as-snake-biting-its-own-tail. I start from
reality and come back to reality, bringing a full sack back with me.
In that way, one becomes a medium able to project his fantasies and
a prodigious calculator of each of his gestures incessantly formed into
equations facing consciousness. I exist in the totality of my being and
each cell is on display, but this prodigious energy is perfectly orches-
trated, unified under the eyes of my lucidity. So I use each nugget to
form an ingot through force of imagination just as Gaudí stopped
passersby on the street to make plaster casts of them and turn them
into saints for the front of the Sagrada Familia. Space and time which
appear only in the forms of the world ask to be immortalized by
human genius. I am human genius, the more universal for being Cat-
alan.

Transcendence, that is genius. The palm trees Gaudí looked
at as a child with ecstatic eyes inspired him to raise the towers of his
cathedral toward the heavens. The reproduction of Millet's *Angelus*
which as a child I saw in the Brothers' school at Figueras brought
forth a tragic interpretation that became the basis for my paranoia-
critical system. Cadaqués—and all of Catalonia—left indelible marks
on me and I left the marks of my whole existence on the sands of its
beaches. We are in existential osmosis. I espied my first pubic hairs
and found expression for my narcissistic desires among the rocks at
Cape Creus. I ecstatically sowed my seed as I masturbated along the
coves, creating a sort of erotic Mass between that earth and my body.
I worked for thousands of hours at my Port Lligat window engraving
the beauties of a landscape designed by a Leonardo gifted with the
hand of God. I myself am the hand, the blood, the eye, the sperm of
this Catalan soil.

Its beauty is a magic of imponderables. Where else does one
find so desolate a feeling, such abandoned pathways, such indigent
roads, so sparse a vegetation, but also where an imagination living
with more luxury in the excellence of the line of the hills, the design
of the bay, the shape of the rocks, the fine and shaded gradation of
the espaliers leading down to the sea. Solitude, grace, sterility, elegy—
the contrasts come together as in the nature of man, and we live in a

perpetual set of miracles. O excellence of those things from which my eyes will never cease to take nourishment and which I proclaim to constitute the most beautiful landscape in the world!

One day, from Peni Pass, which overlooks the perfect lines of the gulf of my dreams, just when I had been cursed by my father, I hesitated to look back a last time and engrave each detail of the blessed place in my memory. But I stood motionless, eyes set on the road before me, for I knew my back was leaning against the land of my childhood that stuck to my skin as the bark to the tree. Henceforth, on the contrary, Catalonia lived within me and inspired my hand. Nothing could separate us, not a father's curse, nor even the revolt of a people.

Around the time when Luis Companys proclaimed the Republic of Catalonia in October 1934, I was giving a lecture at Barcelona. The savagery of mankind grabbed me by the throat at that time and I almost fell into the trap of that awful stupidity, civil war. Bombs were bursting. A general strike had the city paralyzed. The paranoia of war was in every heart. The old dealer Dalmau, who was my host, came to wake us very early in the morning, appearing to emerge from a nightmare, hair on end, beard unkempt, flushed in the face, his fly open like some wild animal who had just escaped a pack of husbands on his tail to castrate him. "We're getting out," he said, "it's civil war."

Easier said than done. Two hours to get a safe-conduct. Half a day to find a driver with car willing to take us for his weight in gold. Everywhere, wild drunken rioters. Machine guns at windows. People made dates to meet in urinals so as to carry on their business without looking like conspirators. Fear reigned, with death panting behind its throne. I can still see the little village where we stopped for gasoline. The men are carrying ridiculous but lethal weapons, while under a big tent people are dancing to the tune of the "Beautiful Blue Danube." Carefree as you like, girls and boys, in each other's arms, waltz madly. Some are playing Ping-Pong, while old men wait to be served from a barrel of wine. I look out the car door at this idyllic picture of a small Catalan village celebrating, and then I hear the voices of the four men who, over pregnant silences, are exchanging remarks about Gala's luggage, which seems provocative, offensive to them, in its ostentation. They feel inspired by an anarchist proletarian hatred. One of them looking me in the eye suggests we ought to be shot, there and then, as an example. I fall back on the car seat. I gasp for breath. My cock shrivels like a tiny earthworm before the vicious mouth of

a pike. I can hear our driver's shouted swearwords ordering them to get out of our way. They comply docilely, cowed by the tough words, the blessed paranoia of The Word!

Arriving at the French border at Cerbère, I swore to keep out of the way of revolutions. On the return trip the driver was the victim of a machine-gun burst. I can still see how he had picked up a stray Ping-Pong ball and returned it to the awkward player with great gentleness. I still shudder at the idea of the idiotic death unleashed by the wildmen on all sides.

I started to paint *La Prémonition de la guerre civile* (Premonition of Civil War; also known as *Soft Construction with Boiled Beans*), in which intermingled arms and legs choke each other, as it prophetically foretells the reciprocal killings in a Spain fascinated with the horror of self-destruction. The Spanish corpse was soon to let the world know what its guts smelled like. The severed head of an archbishop would be dragged through the streets of Barcelona. With sublime and horrible rage the children of Spain would disembowel each other with irons red hot with hatred. They would offer themselves in holocaust with admirable courage like Incas going to be sacrificed for the delight of dying. There would be killings without reason, or just for killing's sake, for monetary gain, out of derision, arbitrariness, ideal, or love. Lorca would be killed, because he was the greatest Spaniard of them all and the most symbolic of all the dead.

He was a member of no party. In August 1936, near Granada, he was literally kidnapped. Neither his body nor his grave was found, as he once had foretold in a poem. The terror of the most hideous nightmare extended its iron grip over the whole country. I closed eyes and ears so as to know nothing about it, but the stories of the most terrifying atrocities still reached me and haunted me like nightmares.

As the crowds fornicated with suffering and death under the aegis of the Marquis de Sade, I left for Italy to retrace the footsteps of Stendhal through Rome.

The Spanish sky was turning red with blood, and I told myself it was good to be alive, to feel one existed. Having thus been able to prove out the bankruptcy of all ideas, all theses, all commitments, I became irrevocably Dalinian. Knowing that out of this offal of disemboweled bodies in the ruins of its cities Spain would one day rise again, returning to its traditional truth, its great male strength, and that I, the Catalan, would be there after this episode of revolutionary confusion to recall the existence of sacred values, I painted

Paranoia, The Great Paranoiac, Le Cannibalisme d'automne (Cannibalism of Autumn)—while the fighting was going on at the gates of Madrid—and *Le Sommeil* (Sleep), which indicated the time necessary for the horror to be forgotten.

And indeed, such a time did come. Some thirty of my friends from Cadaqués had been shot. Europe was not quite cured of the "ism" illness or the basic infections of the nineteenth century, but I went back to my house in the middle of the olive trees facing the most beautiful gulf in the world. The village steeple was damaged, but the rocks of Cape Creus still went through their eternal metamorphoses in the iridescent spume of waves shattering on their backs. And in their renewed mirages I could see, as a fortune-teller reading coffee grounds, the fantastic images of the fate of human paranoia whose most perfect Catalan fruit I am.

The point is not for Spain to become European, but rather that all of my country take inspiration from the Catalan soul; that Catalonia "Geronimize" itself; that Gerona start to reflect "Figueras-ism"; as Cadaqués becomes one cell within Figueras. Then all of Europe will be Spanish. I believe only in ultra-localism.

"TO ME, SPIRITUALITY IS VISCERAL."

X

How to Become Paranoia-Critical

I am living, controlled delirium. I am because I am in delirium, and am in delirium because I am. Paranoia is my very person, though both dominated and exalted by my consciousness of being. My genius resides in that double reality of my personality; the marriage at the highest level of critical intelligence and its irrational and dynamic opposite. I overthrow all boundaries and continually establish new structures for thinking.

Long before 1933 when I read Jacques Lacan's admirable thesis, *De la psychose paranoïaque dans ses rapports avec la personnalité* (Of Paranoiac Psychosis in Its Relationships to Personality), I was perfectly aware of what force was mine. Gala had exorcised me, but the deeper intuition of the quality of my genius had always been present in my mind and principally in my work.

Lacan threw a scientific light on a phenomenon that is obscure to most of our contemporaries—the expression: paranoia—and gave it its true significance. Psychiatry, before Lacan, committed a vulgar error on this account by claiming that the systematization of paranoiac delirium developed "after the fact" and that this phenomenon

was to be considered as a case of "reasoning madness." Lacan showed the contrary to be true: the delirium itself is a systematization. It is born systematic, an active element determined to orient reality around its line of force. It is the contrary of a dream or an automatism which remains passive in relation to the movingness of life. Paranoiac delirium asserts itself and conquers. Surrealist actions bring dream and automatism into the concrete; but paranoiac delirium is the very essence of Surrealism and needs only its own force.

All I had to do was organize the conquest of the irrational in function of my gifts of genius. I always go straight to the heart of the problem in all my thoughts and all my actions. Everything that terrifies others delights me, the fears and phantasms that others commonly carefully repress are to me so many fresh sources for my critical intelligence, but one would have to be far more foolish than I to try to analyze the complexity of my intentions and motivations. I who live them am far from understanding all about them! Fortunately, there are still my works which, subjected to the most objective examination, may allow some of the truths I have been dredging up from the depths to come through.

How Dali Defines His Art from This Viewpoint

All my art consists in concretizing with the most implacable precision the irrational images I tear out of my paranoia. I have perfected the most systematic and evolutionary of Surrealist methods for the conquest of the irrational. When you consider the results obtained by the recital of dreams, automatic writing, or objects with symbolic functionings, you become aware of how easily one can reduce the rich catches of the dream world and the wonderful to commonplaces and obvious logic; even if one, certainly essential, part remains an impenetrable nucleus, it is evident that the sentiment you feel about the intrinsic value of such testimonies diminishes their bearing to the extent that we are incapable of proving them out. Poetic escape is no criterion and the fantastic remains but a literary image if it is not actually experienced.

The Surrealist artist-poet must materialize in the concrete the forms of the delirium which is the secret road leading to the unknown world of paranoia.

I conceived the experimental formula of paranoia-criticism around 1929. According to current usage, the term paranoia denotes the phenomenon of delirium manifested in a series of systematic inter-

pretive associations. My method consists of spontaneously explaining the irrational knowledge born of delirious associations by giving a critical interpretation of the phenomenon. Critical lucidity plays the part of a photographic developer, and in no way influences the course of the paranoiac force. The will to systematization being linked to paranoiac expression of which it is an integral part, what needs be done is only objectively to shed light on the instantaneous fact that arises from the paranoiac act and the clash of systematization with the real. Critical lucidity records evolution and production. On a Surrealist level, paranoia-critical activity takes the shape of the creation of the objective chance that re-creates the world and delirium actually becomes reality.

Anamorphic hysteria is one example of this. I have told how, looking for an address in a stack of old papers, I found a snapshot that I thought was a reproduction of a Picasso painting. I could perfectly make out the two eyes, the spread-out nose with the two holes for nostrils, and two mouths.

That very morning I had been giving extended thought to the deformation of faces in Picasso's Cubist pictures, in his African period.

And then, as I looked more closely at the second mouth in the face, suddenly it all disappeared and I realized I was the victim of an illusion. I had been looking at the photograph vertically, whereas it was supposed to be taken horizontally. The subject was three groups of Negroes lying or sitting before a round hut.

I was later to show this "face" to André Breton, who had no trouble in immediately recognizing it as the head of the Marquis de Sade. He could see the powdered periwig. At that time, Breton was mainly concerned with the divine marquis. We had found it amusing to point out the similarity of a detail in my *L'Enigme du désir* (The Enigma of Desire), a 1929 painting, with a photo of a weirdly shaped rock at Cape Creus. We might as well have pointed to some of the shapes of Gaudí's Sagrada Familia. The truth of it is that my paranoiac force projected a series of systematic images that I consciously apprehended and tried to concretize. I am neither copyist nor image maker, but am delirious.

I once said we Surrealists and our works were "caviar," the dialectically (Daliectically) highest quality of caviar, in a word, the greatest condensation of the mystery of the poetry of truth, truly sublime food, a bridge to the great unknown in a world turned gamy with awful technology and materialism. Our doings were in between science and art on the river of the irrational of which we are the privileged navigators.

I myself can interpret six, eight, or ten images at the same time from a single vision. My paranoia-critical capacities have few limits. In the case of some of my paintings everyone who looks at them sees something different. The paranoiac vision may come to the fore by contagion of anybody's imagination. Paranoiac systematization influences the real and orients it, predisposes it, and implies lines of force that coincide with the most exact of truths. My limp watches are not just a fanciful and poetic image of the real; this vision of runny cheese is in fact the most perfect definition that the highest of mathematical speculations can give of space-time. The image was born spontaneously in me and on the basis of this paranoia-inspired picture one can consider that I have wrested from the irrational one of the most colossal archetypes of its arsenal of secrets. For, better than any mathematical equation, the limp watches give a definition of life: space-time condensed to the highest potential, to create the Camembert whose putrefaction brings forth the mushrooms of the mind, sparks that are capable of igniting the great cosmic motor.

It is time for us, in the history of thought, to see that the real as given to us by rational science is not all of *the real*. The world of logical and allegedly experimental reason, as nineteenth-century science bequeathed it to us, is in immense disrepute. The very method of knowledge is suspect. The equation has been formulated by skipping over the unknowns and assuming a part of the problem to have been solved. In the end, it will finally be officially recognized that reality as we have baptized it is a greater illusion than the dream world. Following through on my thought, I would say that the dream we speak of exists as such only because our minds are in suspended animation; the real is an epiphenomenon of thought, a result of nonthought, a phenomenon of amnesia. The true real is within us and we project it when we systematically exploit our paranoia, which is a response and action due to the pressure—or depression—of cosmic void. I believe my paranoia is an expression of the absolute structure, the proof of its immanence. My genius consists of being in direct contact with the cosmic soul.

Dali's Reflection on the World: A True Cosmogony

I am essentially a visionary, a sort of sounding board for total truth. My intuitions are fundamental. Likewise, I believe that the universe around us is but a projection of our paranoia, an enlarged image of the world we carry within us, I think that the object our

eyes isolate from the real or that we invent is a pure expression of our delirium crystallized. A simple secretion. Objectivity is but a snare and a delusion: in truth, merely a relationship of forces in temporary suspension. Calderón speaks of the "traitorous world." What an admirable expression!

I am thinking of my eye, the only proof I can give of the brilliance of my soul, the expression of my feelings, which projects my paranoiac force and re-creates and transmits the message of the real. . . . What is this eye? A glob of humors, a knot of muscles, a film of flesh and nerves irrigated by a flow of acid? Beneath that appearance lurk galaxies of microscopic electrons, agitated by an impalpable wave, itself the fluid of a quasi-immaterial energy. At what level, then, the real? The truth, to me, to Dali, is in the magnifying-glass I aim at the world, called my eye, through which there takes place an exchange that for that moment is known as real. As for me, what I project is truer than true and it is all that is true. Real is therefore equal to unreal. An implacable syllogism.

Paranoia, moreover, does not express itself solely in a systematized projection, it is also the formidable breath of life. And this mad exaltation that drives me to exist has as much consistency as the images it animates. I know that the world is not a dream because my life is evident to me as it is to the world and my dreams arise from it. And the sole evidence of reality resides in that breath of live forces that agitate me and color all things. But what void! What disparateness! What strangeness all about us! How can we believe in substance in itself? What is substance? God? It sometimes seems to me that at the tip of my paintbrush or of my cock in orgasm—at the second when Gala's coming goes through me like a wave bounding back—I have a deep sense of infinite reality, a micron of absolute structure, the *élan vital* of becoming. And in all finality I believe that the real is but eternal becoming. Sometimes in the thrill of beauty I seem to experience that wave that comes to me in ecstasy. In an archangelical beauty, without gender, without principle, which *is like a certainty of God.*

When Dali Experiences the Certainty of God

I bend over Gala, her body a galaxy, traversed by lightning waves, swept by eruptions of desire, convulsed by tensions, erections, shiverings. I am transported to the stars of a universe in state of becoming. But this face is something quite more than just a material

trace, just a tissue of life. The lines, shapes, éclat, smile, are a *presence* of a being in its power, its uniqueness, its unity, its radiance. Here before me. It tells me it is. It awaits me, wants me. Calls to me. Receives me. This is not merely an interchange of energies, erections, sensations, a rubbing of epiderms to bring about electrical and bio-logical discharge; not just two intelligences trying to understand each other, but a ball of fire bursting out of an unknown sky. Two forces uniting to create a bit of the infinite. A spark that spreads through the universe in all its dimensions. A unique something that tran-scends our lives, and justifies, Everything—Her, Me, the Totality of the World—Gala is herself, and all women; and also the cosmos. And the desire biting at my skin, inhaling me, grabbing me, exalting me, suddenly feeds on my most intimate substance, the densest of my deepest realities. We are welded; time and space become a single reality, a fusion-point of the absolute structure. Beyond life, we pro-ject a bridge, a rocket, toward unknown wonders. We are the greatest hope of the world. All men live in me; all women under me—in Gala! The world is full, new, absolute.

I slowly withdraw my cock and look at that weeping root. My hand slowly strokes her breast. Our eyes open as the words The End fade in on the screen of the real while the picture, the chair, the bed, the curtain, the window come clear. We come back down to an indifferent earth knowing that real life is somewhere in an unknown dimension to which desire and paranoia alone can lead us. Dali means Desire, and I am the symbol of all the desires in the world. The desire to possess life in its totality, to go beyond it, reinvent it—without death. In the space of dream.

Is Science, to Dali, But an Approach to Dream?

Science—which appears to give us the key to power over the world—in fact carries us away from the power which can be born only of total intuition, flashing between mind and reality. Rationalism, experiment are merely control elements. The irrational faculties alone open the doors of the universe to us. Art is a school of depth knowl-edge and initiation. I say art and do not say aestheticism or plasticism, the model that illustrates my thought being art nouveau as the ex-pression of the delirious. Art nouveau is an expression of which—with *The Visible Woman* as early as 1929—I helped to have the characters of profound originality recognized. And it was not just for its reaction value against the right angle and golden number that until

then had ruled the plastic arts, but for the profound revolution it implies in its antifunctionalism and its extolling of the exaltation of desires. A compendium of art nouveau figures brings out soft abdomens, women's hair, aquatic plants, and limp, hydrocephalous columns. An art of metamorphosis, a materialization of smoke, wave, and the immaterial, art nouveau is both sculptured water and the most edible of cakes. It brings together the two poles of existence and its erotic expression is properly cannibalistic. Art nouveau brings out our unconscious mechanisms, our megalomania, our exhibitionistic capricious feeling. It smashes all creations of measure, order, balance, good taste, to exalt dream and fantasy and suggest that we devour our own desires. It lays before our eyes images of a beauty fed on Eros, fear, anal sadism, onanism, in other words glorifying the truths of Self. Back to one's sources so as to dip once more into the deeper truths of the Being and the All and that *élan vital* from which decadent Greco-Roman art has estranged us (when I say *élan vital,* I am not referring to the silliness of Bergsonism nor the primitive aesthetics of the lovers of African art). I say that mystery, pathos, eroticism, madness are no more found in barbaric fetishes than in the columns of the Parthenon. A race must find force of expression in its biological and psychological depths and art nouveau is the mark of that explosive reaction against all aesthetic taboos. It is time for a new cultural revolution that might bring forth a new style and reverse the degrading powers of the bourgeois who eliminated nudity, dreaminess, and lyricism from existence. Gaudí and Ledoux, I proclaim, are the great wizards of the future, and paranoia the force of exploitation of the world.

What, to Dali, Is the Greatness of Gaudí?

What I love in Gaudí is his vitality. His brain is at the tips of his fingers and tongue. He's gustative. His architecture aims to embody the sum of all gluttonous sensations. It strikes me as the idea of man's desire incarnate. The Sagrada Familia is a gigantic erogenous zone prickly with gooseflesh aching to be stroked by hand and by tongue.

I remember Lorca in front of the admirable facade of the Sagrada Familia claiming to hear a *griterio*—a cacophony of shouts —that rose stridently to the top of the cathedral, creating such tension in him that it became unbearable. There is the proof of Gaudí's genius. He appeals to all of our senses and creates the im-

agination of the senses. Gaudí researched this deeply by studying the applications of acoustics. He turned his bells into organ pipes. He applied the same attention to the color scheme for a polychrome *mise-en-scène* of his constructions. Like Catalan folk Christmas mangers, in which the characters are modeled after actual persons, each subject had its original coloring and even the roosters had red cockscombs. Gaudí had composed a chromatic palette to correspond to his polyphonic scale. Everything in his work, light as well as silence, "transports us elsewhere," and none was more adept than he at using bad taste to throw us, decondition us, tear us away from the sterility of good taste. He provokes us down to our innermost depths. Through him, everything is metamorphosis, nothing is taboo nor set any longer, the Gothic rejoins the Hellenic, which in turn merges into Far Eastern forms. He calls forth paranoiac vision and multiplies all interpretations. In Catalan, *to come* is written *gaudí*. The Sagrada Familia is the cathedral of the paranoia-critical method, thus, of the pure science of systematically creative and fatal delirium. The fact that today the Sagrada Familia remains only a "gigantic rotten tooth" should not turn attention away from its true meaning. It is a magnetic tuning-fork whose waves spread ceaselessly and penetrate all minds receptive to the irrational that often practice and live art nouveau unwittingly.

When we automatically roll a bus transfer between our fingers, making it into a tube, cutting it up, we are creating art nouveau forms! The butcher slicing calf's liver is doing art nouveau!

What the Catalan Future Is to Dali

To be a Catalan today is to have the greatest opportunity for the future. Like being a Jew in the time of Nero! One of those persecutees from Judea who in two thousand years conquered the world. A Catalan donkey in its chromosomes has the genius of paranoiac conquering power. The Catalan philosopher Raymond Lully, an alchemist and metaphysician who wrote *The Twelve Principles of Philosophy,* mystic and martyr—he was stoned to death at eighty at Bougie (Algeria) by Arabs—inspires me. Like him, I believe in the transmutation of bodies. I am sure that our capacity for delirium will one day lead the Catalan people to the highest glories through the powers of paranoiac imagination.

According to another Catalan, Francisco Pujols, there is an angel in us who sees the light of day only after a long series of

mutations—begun at the start of the mineral kingdom to reach man after going through the vegetable and animal. I am in the angelic phase of my existence. I am approaching the absolute and I have perfected a whole series of methods for completing myself, from delayed orgasm to ejaculation over the idea of my death. The world will soon see Dali turned angel! Having renounced all that he might take, burning desire refusing to satisfy or even express itself, extolling anticipation so as no longer to be anything but a blazing hearth of unfulfilled pleasures. Catalan thought will dazzle the world. It reaches the sources of the depths. And I give it the power of coming to awareness. In becoming exorcised, through the strength of Gala and her love, I found the pathways to the method of truth. Paradoxically, I channeled my delirium through reason, as in art I found my expression through classicism. I turn my contradictions into a veritable coherence. I can truly say I do not know when I begin simulating or when I tell the truth, but I do know when and where delirium ends. Through the pitiless demand of cold intelligence, I transformed part of my personality into an analytical faculty and won back from madness a domain that I turned into power and creation. The difference—need I repeat?—between a madman and me is that I am not one.

When I heard of the death of Lidia's son whom I had tormented a bit and who starved himself to death in the grip of his psychosis, I was seized with the horrors and found myself unable to eat in my turn. A terrible self-punishment drove me. That was a time when I lost confidence in my painting, feeling that Velázquez had already given all the answers. Gala, who was first to employ my method by explaining to me that my artistic death had just crystallized over the death of Lidia's son, showed that if I were to set about drawing by obeying only my talent, which was immense, I would be able to start eating again. There was some bread and anchovies on the table. While listening to Gala, whose gifts of persuasion were getting into me wave after wave, I mechanically picked up the food and started to chew. An hour later I was drawing. Introducing a ferment of consciousness into a flow of desires creates eroticism; in a paranoiac *élan* it provokes genius; in a psychosis it effects a cure by transmuting the light into a laser.

Paranoia, thanks to my critical method, develops like a cellular blossoming. It proliferates as soon as it can feed on what is called the real. I conquered my delirium. But it is necessary to know what taunted lucidity this perpetual victory requires. I am Dürer's Knight facing death, ceaselessly walking between the human and the

non-human above the abysses. My whole being is a field of work that I unify through my will. If for one second this wave of force stops, Dali no longer exists. I am the triumph of conscious life. I exist totally every thousandth of a second. I cannot be sidetracked from this existential battle under pain of death. Sitting on the pot, yawning, farting, shaving, combing my hair, bathing, I am constantly present and the slightest rumble in my viscera is as essential as the movement of the stars. First of all, because I believe that each stage of our lives, each movement of our beings, each thought partakes of the totality of the universe and its correspondence. Each wave has a corresponding star, blade of grass, breath of wind. Our freedom is a bubble inserted into the great All. A toothache is a tempest somewhere else. Moreover, nothing is more important to Me than Me, otherwise I cease to be and it is by listening to my life that I best serve and nurture my genius. Finally, body and awareness of being are the best radars of reality—the only ones we know of to tell us that a world exists outside ourselves. It is necessary to make the effort to emerge from the sleep that forces us to exist within the limits of our physical prisons. Our energy must spread its rays as does a sun. We must understand the analogical forms that shape on our inward screen like phosphenes and interpret them so as to decode the secrets of the universe. There is no such thing as chance. Everything corresponds to everything. Intelligence and imagination invent nothing. They remember and decode. Their role is not to reinvent the real but to lessen the distances between things. Genius consists first of all in putting one's finger or tongue or penis on the truth of forms. Dali's genius lies in having eliminated the appearances of the right angle, the logic, the aestheticism that lock reality into cages and returning to it the organic, malleable, limp forms on which a true network of correspondences can be established. My limp watches, for example, are the symbol of this illustration. I call for all things to be challenged by starting from sensual, carnal, erotic, existential evidence. Let us walk through the world in the image of Dali! We are at the heart of a labyrinth and can find our way while becoming labyrinths ourselves. By mimesis, my paranoia took on the analytic hardness of Cape Creus granite, my imagination acquired the power of the metamorphoses by wandering along these perpetually changing shores. My delirium battened on the dreamlike anguishes and mysteries created by the interplay of winds, rocks, and sea. I chose this place as the privileged center of my world, where the most intimate contact arises between the earth that bore me and the being that I am. Yes, I am Cape Creus and each of my rocks is a lighthouse

forming the constellation of my internal navigation. In the center there is the "Great Masturbator," with his huge nose, immense eyelids, a rock of strangeness the fascination of which still has the power of the Sphinx over me. In painting it, I attempted to tame it; I merely extolled its image and made it mythical, and its personage must now be wandering somewhere deep in dream memories since I set it afloat. For the Great Masturbator belongs to me and I alone know how to celebrate the Mass of his paranoiac passion. One has to have heard the north wind come over the mountains to play the organ in his granite portals, caressed his craters, bloodied the tips of his needles with one's feet in order to be able to speak to him and be heard. I alone can raise his closed eyelids so as to understand his gaze into eternity. He is my awareness of being, the radar echo of my self. My whole life is an alchemy that transmutes everything into gold. And as long as I remain anchored to these rocks in the heart of my Catalonia, the source of my delirium of living, inspired by my Catalan genies, I shall never cease transcending all fatalities.

Dali Must Constantly Be Dali

There is no urgency for me greater than to become Dali, that is, the center of the greatest tension of intelligence, sensuality, and power that there is. My lucidity constantly reveals to me the secrets of the world and first of all of myself, from whom all begins. I leave nothing in the shadow of the phantasms that arise, for light alone can provide my delirium with its true strength. Were I to drop vigilance for one second I might be taken unaware by a nightmare monster. I one day discovered I was attracted to Stalin because of the sphinx who was my father, the greatest of my bosom enemies, most magnificent of the tyrants of my unconscious. By a sort of projection I had recomposed the impulses of my unconscious around the image of the Little Father of the Peoples.

From this experience I understood the hold that the "Man of Steel" had over his contemporaries through the Oedipus complex. He appeared as the fatal father whose power one must endure in order to grow in one's own eyes and whom one venerated in his worst excesses because he embodied fatality. After his death, when his memory was being vomited upon and his statues were being unscrewed while street signs with his name were wrenched off, his carcass wasn't worth much. I should have bought his mummy. I would have made a Dalinian sarcophagus for it in my garden at Cadaqués. It

would have become the center of a phallic, Oedipal, perhaps orgiastic cult, a big game of the kind I like.

But I regret nothing, for as long as I can move I will be able to touch the beautymark that Gala has behind her ear, and I will have my talisman, my strength, my cathedral, my greatest attention. I have said that Picasso had the same beautymark and my greatest pleasure one day had been to touch both ears at once so as to feel the absolute beautymarks of genius and love, reflections of the internal sums of beings.

In my paranoia-critical cosmogony, the beautymark has unusual importance. I have naturally assimilated all so-called scientific knowledge about it: the fact is, there is none! I therefore imagine that it is an external sign—as folkways contend—of the internal existence of an unusual structure. A drop of absolute structure set in this body as a diamond is set in its case. Proof that a bit of the alchemist's elixir is there, that the golden number is present somewhere in the architecture of that head, an angelic spark somewhere in that soul! I find it normal that Gala like Picasso—exceptional beings—should bear the same divine seal in the same place. My passion for Gala is enhanced by the value of the sacred. This double discovery belongs integrally to the structure of ourselves; it adds the final touch to my internal geometry. Every time I touch Gala's ear, I am caressing my dead brother (my double), Picasso (who was a kind of Oedipal father)—therefore, my father, and beauty; but Gala is also my mother, since she symbolizes Leda and her divine twins. My index finger against Gala's beautymark makes me feel I am possessing my whole physical, legal, legitimate, holy, and mythical family. A sort of prodigious, paranoia-critical mammoth orgasm.

Dali Wins Out over Death

My delight in existence is on this level: to shower death with a fireworks of life. I follow death, but it fascinates me by its eternity as does the "Great Masturbator" motionless before the waves. I believe that I love it despite my fear, but I cannot picture myself dying. If something were one day to finish, it could only be in one giant orgasm. A cosmic coming. That thought excites me as it used to transform Lorca who hid his anxiety by mimicking his death and then got up laughing and transfigured. I have only to think back on the picture of my dead brother placed alongside the reproduction of the Velázquez Christ in my parents' bedroom, and I get the shivers.

I feel surrounded by all the departed I have accumulated during my lifetime. I expect the obsession to make me dizzy. Then I tell myself that each of them is at work for me, forming the humus of my own spirituality, nourishing my genius, and I suddenly become a superb cannibal battening on the angelic corpses of all his dead friends. They all contribute to my glory. My true glory: the one that warrants lasting—not only in memories but as an eternal Dali.

I believe that all these departed solidify my life like so many buttresses. I take unheard-of strength from them. I have an answer to all challenges, and my ability to overcome all obstacles is prodigious. I am like that *phyllomorpha laciniata* of my childhood discovered when I was nine on the paranychia of the hills of Cadaqués. A mimetic magician, it disappeared beneath the leaves of the shrubs and made one think they had come alive. And when, to the amazement of the fishermen, I amused myself by setting them down on a table and ordering them to move, and they soon started moving, I was taken for a wizard. No one else had noticed this phenomenon. I gave my pal the phyllomorph the name of the Catalan expression for deception, *morros de cony* (cunt-lips). I admired its prodigious capacity for hiding to the point of invisibility, the better to exist. Then I discovered that the *morros de cony* had on its back a parasite which in turn was covered by a pyramid of eggs chiseled like golden diamonds—themselves probably endowed with even more amazing virtues. I asked a biologist to study whether these polyhedrons were not the expression of the germ of pure life that might, say, be the cure for cancer. This intuition deserves to be checked out.

Paranoia-critical logic leads me to divine and find the road that, from Cadaqués, an exceptional place, by way of the *morros de cony* and its parasite, revealed to me the golden eggs and the absolute structure in which my genius can see itself reflected in the mirror of the unity of the world. My oeuvre since then merely translates the transcendent mimesis of the *morros de cony* as crystallized and sublimated, as illustration of the paranoia-critical adventure.

The basic knowledge about the truths of life comes to us by the paths of reason, but what comes by intuitive flashes requires our being available before the world. The state of half-sleep is one of the privileged moments with a value similar to that of the openness of the soul in childhood, in which deep communication can take place. If I were able to remember or photograph the hypnagogic images that run across the screen of my eyelids before I doze off, I am sure I would discover the greatest secret of the universe. A machine ought to be invented which, like contact lenses, would

record the input of dreams and allow their retrieval. A successful painting is nothing but a recollection of one of those prodigious moments. It includes all the bits most essential to the human being. To look at a painting is to receive messages from the absolute. Fifteen years before Crick and Watson I drew the spiral of the structure of DNA (deoxyribonucleic acid, the basis of all life), at the urging of a psychoanalyst, because I had always known what it was, deep in my dreams. In 1931, I painted *The Persistence of Memory,* containing all biological knowledge in its intuitive truth. Someone someday will have to wind up my limp watches so they can tell the time of absolute memory, the only true and prophetic time.

A Few Examples of the Paranoia-Critical Method

The genius of paranoia-critical activity is to associate limp paranoia with tough criticism; the gooey with the sharp; force of life par excellence with mind; to reach the deepest intuition. Two fundamental examples: the tragic myth of Millet's *Angelus* and the railway station at Perpignan.

I have always been obsessed by the image of Millet's *Angelus,* which I discovered in early childhood, and I felt an inexplicable malaise at seeing the peasant man and woman facing each other motionlessly. I looked at the solitary figures, wondering what bound them together. *The Angelus* through the years gradually became the most internally puzzling, the densest work of painting I know.

In June 1932, the image of the picture suddenly appeared in my mind with phenomenal power. I could not stop talking about *The Angelus* with unbelievable constancy and admiration. The picture appeared with urgent insistence not only in what I said but in what I dreamt—although I did not dream the picture itself—but to me it was somehow *different* from everything else I had ever seen, somehow *exclusive,* and it moved me to excessive emotion, quite without logical explanation. It became the source of delirious images not through its intellectual or artistic value but by its psychic significance which had a whole world of associations that sprang up instantly and took on their own life, revealing the existence of a drama far from the official version of calm and rest that the subject is supposed to mean.

My attitude at this time is induced by that paranoiac power of interpretation, and objective chances increase: I play with some pebbles I picked up on the beach to make objects out of them, at-

tracted by their unusual shapes. I mechanically put two of the stones facing each other, and suddenly their position brings the *Angelus* couple involuntarily back to my mind, to the point that they become unbelievably precisely transformed into each of the characters. The man's figure seems deformed to me, eroded by the mechanical action of time and tide, and becomes an anxiety-ridden silhouette. I understand the association to be clearly delirious.

Returning from bathing, I go through a field, trying to avoid the grasshoppers that I have feared since childhood. I can clearly see a fisherman coming in the other direction toward me. Just as we are about to pass each other, I jump to one side to avoid him, but by some sort of awkwardness I bump into him violently, and at that very moment the image of Millet's *Angelus* flashes through my mind.

In one of my daydreams, going through the Madrid Natural History Museum with Gala at twilight, I see among the shadows thrown by the gigantic insects the terrifying form of the *Angelus* couple. Leaving the museum, I feel an overwhelming urge to bugger Gala in the deserted entryway and do so with wild delight.

Some time later, motoring through a street in the little Port of La Selva, near Cadaqués, I see a window display of a full coffee service, each piece decorated with Millet's *Angelus*. Enough to drive a person wild! Of course, statistics could show that there was a good chance I would come across such a set in a window, considering the frequency of reproduction of *The Angelus,* which has always exerted a fascination of virtually epidemic proportions. And one might ask how such a picture, which appears to be quiet, insipid, insignificant, and conventional, could so grip imaginations.

Just what does this picture try to *say,* that it should so be heard? What is there behind the appearances? What is the meaning of that man and woman, standing, motionless, facing each other, stuck there without a gesture, or a word, or even a movement indicated?

When I look at Millet's *Angelus,* the first recollections to come out of my store of memory bring back the twilight and elegiac feeling of childhood: the evensong of the locusts, the last daydreams at nightfall, the poetic declamations I recited at fourteen. What I might call the atavism of twilight, imbued with a feeling of the end of the world.

The woman with her hands together, in the same position as those on the postcards praying to St. Catherine to "send me a husband," strikes me as symbolic of the exhibitionistic eroticism of a virgin in waiting—the position before the act of aggression, such as

that of the praying mantis prior to her cruel coupling with the male that will end in his death.

As for the man, he is riveted to the spot, as if hypnotized by the mother—wiped out. To me, indeed, he stands in the position of a son rather than a father. It may be noted that in Freudian vocabulary his hat stands for the sexual arousal being hidden to show his attitude of shame over his virility.

The erotic significance of the wheelbarrow is as undeniable as that of the pitchfork driven into the plowed earth. The two sacks set in the barrow also have a meaning, as is evidenced by the general connotation given the popular postcard with the legend *Baisers en brouette* (Kisses in barrowfuls). Anent the fetishistic aspect of the wheelbarrow, I noted the fixation of the illustrious Postman Cheval, who also accorded a choice place in his ideal, delirious, and poetical pantheon to the wheelbarrow, having it speak thus:

> Now his work is at an end,
> He enjoys his rest with grace;
> And I, his humble little friend,
> Am given a most honored place.[1]

I collected materials on peasant eroticism in view of a film to be entitled, *La Brouette de chair* (The Flesh Wheelbarrow). My intention was to show that peasants worn down by overwork eroticize their work instruments, and that the wheelbarrow was the very type of symbolic instrument par excellence. In a nineteenth-century American folk picture there is a woman holding her husband's feet in her hands and pushing him ahead like a wheelbarrow, he holding a wheel between his two hands, while his rigid sex organ becoming an actual tool plows the earth and his balls appear as two cacti. The interpretation is obvious: as the Egyptian phallic mother with her vulture's head, the American mother—here also representing the life-giving earth—gets fertilized, at the same time castrating her husband whose virility is reduced to no more than a reproductive role. In that picture, a happy sun looks down on the scene—the sun of absolute matriarchy.

[1] Ferdinand Cheval (that is, Horse, in French) (1879–1912), a mail carrier by occupation, lived at Hauterives (Drôme) and with his own hands built an Ideal Palace. He wrote:

> One day I stumbled on a stone and almost fell. This stone was of such a strange shape that I picked it up and carried it home, [thinking], if nature turns sculptor, then I can be bricklayer and architect . . .

[It may further be noted that *brouette,* French for wheelbarrow, is of the feminine gender. TR. NOTE]

That same summer, 1932, a madman in a fit punched a hole in Millet's *Angelus* at the Louvre, after having long hesitated, he later stated, between it and Watteau's *Embarkation for Cythera* or the *Mona Lisa*. (Freud's demonstration of the incestuous attraction of that Da Vinci work is well known.)

I expressed my ideas and gave a detailed analysis of the whole set of delirious phenomena evoked by the tragic myth of *The Angelus,* but mislaid the manuscript at the time the Germans overran France in 1940. Twenty-two years later, I came across it again. In the interim I had found out that Millet had originally painted between the characters of father and mother a coffin that held their son's corpse, but had later altered the picture for fear it might appear overly morbid.

In 1963, I requested Mme. Hours, who runs the Louvre laboratory, to have the painting X-rayed. The radiograph did bring out a geometrical shape at the mother's feet. All became clear. My paranoia-critical genius had sensed the main point. No other interpretation could account with such truth for the spell cast by *The Angelus,* and even if my vision was but mental intuition, this interpretation was all the more sublime—as Gala was to say!

That study is one of the fundamental documents of the Dali cosmogony. It is as important as the Perpignan railway station.

Every year, when we leave Cadaqués for Paris, our old Cadillac takes us to the station at Perpignan, where I wait in the waiting room while Gala checks the baggage. There are people all around me. I feel as if isolated and that is when I have an instant of absolute pleasure. I have just left my Cadaqués studio and its stimulating climate of creative work in which I live in a state of perpetual alert, and am on my way to Paris with its gastronomical feasts, its erotic celebrations. I sit on my bench as at a border crossing, I feel myself available, and intense jubilation invades me, a monumental joyfulness.

At this precise moment I visualize the painting I ought to have painted during the summer. I buy a scientific journal at the newsstand and read that, in operating for glaucoma, the eye anesthetic used is a "diffusion factor" made from wasp venom. I immediately recall that one day a wasp fell into my paint-pan and the fusion of the color pigments took place with miraculous flexibility and ductility. I wonder whether wasp venom could not be used as a color solvent. Since then, based on my intuition, I have had such a medium made and it is one of the secrets of my art of painting.

So, for years, the station at Perpignan has been a source of enlightenment, a cathedral of intuition to me. I long thought it was

because genius needed a trivial place in which to assert itself. The Parthenon and Niagara Falls are too overwhelming! The absurd and the anodyne are better handmaidens to enlightenment. The memories of the unconscious let their passages get through only when the mind is vacant, and toilet seats are a high place for the state of grace, quite as good as the Perpignan station.

Then, in 1966, I found out that it was at Perpignan that the measure of earth, the standard meter, had been established. On a straight line twelve kilometers long, from Vernet to the outskirts of Salses, north of Perpignan, Pierre Méchain, in 1796, set the bases for the triangulation that led to determining the standard meter. I understood the fundamental metaphysical significance of this research. The standard meter is not only one ten-millionth of a quarter of the earth's meridian, it is also the formula for the density of God, and this place appears to me privileged among all places. The Perpignan station becomes a truly high place.

I then took a taxi and went slowly around the station, inspecting it as if it were some esoteric monument of which I had to find the meanings. The setting sun was ablaze and the flood of its light created flames on the facades and especially the central skylight of the station that seemed to become the center of an atomic explosion. About the station I could see a radiating aura in a perfect circle: the metal trolley cables of the streetcars that ringed the edifice and gave it a crown of glinting light. My penis sprang to attention with joy and ecstasy: I had seized truth, I was living it. Everything became overpoweringly evident. The center of the universe was there before me.

Physical, mathematical, and astronomical sciences are split over whether the world is finite or infinite. No one has yet answered that key question. At that moment, I knew that the world is limited on *only one side,* which is its *axis.* I cannot put into words the vision and certainty I had, but from that moment on there was no longer any doubt in me: cosmic space began in front of the facade of the Perpignan station in the area marked off by the circle of cables, and the universe ended at the same point.

This very limit was the proof of the existence of the universe; it showed that the hypothesis of permanent expansion was erroneous. Non-Euclidian space stopped at the point where it met the dimension of the mind. This limit could not be defined but could appear only as a vision, a snapshot of absolute time-space that illuminated me viscerally. I decided to have the Perpignan station cast in gold as a transcendent image of truth. To me it is the laboratory in which the

absolute values of the universe can be followed, and I inspect it with
passion. Under the impulse of my paranoiac delirium, I have had at-
tentive analyses of the monument made. All its measurements have
been noted. Not only the general dimensions, but those of windows,
doors, ticket windows, benches. I have had the posters photographed,
and the timetables which in enlargement show me all the shapes of
objective chance, and starting from my delirious impressions I will
be able to set up a kind of seismographic system of the relationships
of the universe with itself. The point is to bring total truth out of this
microcosm of the universe. I am persuaded that the bible of the world
is symbolically represented in the Perpignan station; I know this in
my innermost self: all that is needed is to find the decoding key.

Each year supplies me with new proofs. Do you know that the
only drawing Sigmund Freud ever made is a sketch of his student bed-

room, which is exactly the same shape as the waiting room of the Perpignan station?

I am like the alchemist trying to apprehend the non-measurable through the measurable, and the power of my paranoia-critical delirium will see me through. A meter is now defined as equal to 1,650,753.73 times the wavelength in a vacuum of the difference between the levels of 2 P 10 and 5 D 5 of a krypton atom, or the orange-red radiation of krypton 86, but this precision to the thousandth of a micron is insignificant compared to my ability to conceive that the x of the radiations of krypton is an equivalence of God, whose temple is the quite derisory, anodyne Perpignan station, so made in order that none may suspect its importance, but which I have now designated as the focal point of all universality of thought.

Dali, who was capable of conceiving the discontinuity of matter by watching flies fly and understanding the significance of their Brownian movements, who drew the structures of life, who gave the closest equivalencies of time-space in his limp watches, now reveals to the world the most essential of knowledge with the revelation that the world is limited on only one side. Dali is a radar of the mind of greatest genius, whose painting is only a sign, and whose delirium is more holy than the ramblings of the antique Pythoness.

Paranoia-criticism will illumine the world.

"MY LIFE IS SETTLING BACK INTO A KIND OF CLASSICISM. . . . I THINK I SHALL SUCCEED IN BEING A CLASSICIST WHILE STILL REMAINING PARANOIAC."

XI

How to Make Money

I believe in the humanism of the arsehole. Neither shit nor death should be hidden, and gold exalts and transcends man.

Gold has always seemed to me of hallucinating beauty. As a child I liked gold-braided costumes and for a long time I had a king's cape with a gold crown that inspired many of my daydreams and characters. In the millennial memory of peoples, gold is connected with the sacred. Priests always associated it with divine power. But more than its rarity, its quality is in its essence itself, the perfection of which is the expression of the cosmic spirit. Gold is endowed with a fascinating magic, like that of purity and transcendence. I believe that gold is the most beautiful image of the soul. If I were not careful, I could easily succumb to the temptation of the golden metal that subjugates me and paralyzes even the highest faculties of my paranoia-critical system. For instance, one day an American publisher came to offer me a deal. I listened with proper detachment, baiting him on, tormenting him by turning down what I had accepted just a moment before, putting the irons to him, and finally getting him where I wanted him: he raised his offer 100 percent. I looked over at my chamberlain, Captain Moore, to savor the victory. He nodded to show

his admiration. And then suddenly, the publisher opened his black case, removed a slipcover, and I saw the bright glint of four beautiful gold ingots. The publisher raised the tray they were on and four more bars of the pure metal met my eyes. My hands, naturally, went forward and I grabbed two blocks of the gold. I voluptuously let the light shine on them.

"They're yours," the publisher said. "I was told, master, that you like gold and I thought you'd enjoy being paid with it."

I held on to my two ingots and nothing in the world could have gotten them away from me. In my excitement I pressed the cheeks of my arse together as if I had the colic.

"You can touch the others, too," he said. "They're all yours."

In any other circumstance, the genius of my critical mind would have immediately reacted, but I was in a real state of euphoria at the idea that all that shiny gold was mine. I balanced one ingot on each of my knees and would have tried one on my head if I had not been afraid that it would fall. The publisher took out his fountain pen so we could sign the contract, when Captain Moore coughed discreetly.

"Before you sign, divine master, perhaps you will permit me to weigh those bars of gold. A simple precaution that my position in your employ requires," he said with an Irish smile.

And he did. I was being gypped out of 50 percent of the sum agreed on. Hard as it was to do, I tossed the gold bricks back at the greedy doubledealer who had tried to cheat me by playing up to my oldest passion.

The reader knows that the great game in my childhood was to hold in the treasure of my bowels as long as possible. A pleasure that came close to ecstasy. I squeezed my buttocks together. I danced on one foot. I turned red, pale, and contorted with spasms. My guts tied in knots. I derived masochistic enjoyment from my pains. Then, having reached the limit that revulsed my whole body, and my anus being painful with the tautness, I went on to the second phase: the tormenting of my family. Eyes wet with painful tears, I went from room to room looking for some unexpected corner. When at last I had found it, I made sure no one could see and with a thrill of profound delectation dropped my pants as I savored the shit that was finally being molded out through my voluptuously distended buttocks.

Similarly, until the age of eight, each morning I pissed in bed after a fascinating speculation on the pleasure I was going to derive from this vengeance, while the urine ran down along my legs and I thought of the fact that I was rejecting the deep satisfaction I could

have had by coming into possession of the very fine tricycle my father had set up on top of the wardrobe, directly across from my bed so I might not lose sight of it—to be my reward for deciding to piss in the pot. But I was not letting them have either my piss or my shit. My anus and my penis were gates I closed to protect my treasures. A psychoanalyst, knowing that gold and excrement are akin in the subconscious, would not have been surprised that Salvador Dali turned into Avida Dollars and that I used my shit—like the hen's golden eggs, the droppings of the golden ass, or Danaë's divine diarrhea—to perform a phenomenal transmutation through the application of my paranoia-critical method.

It was André Breton who had meant to denounce my taste for gold by pillorying my fine name into that anagram of *avidadollars.** All he achieved was to compose a talisman that saw me through the doors of banks and safes. America recognized me as its prodigal son and threw dollars at my head like handfuls of confetti. Breton is responsible for my financial success. I have every reason to thank him for inventing that beneficent distinguished image.

Gold dazzles me and bankers are the high priests of the Dalinian religion. Auguste Comte was quite right to put them at the top of the hierarchy in his positivist society. Gold is the keystone not only of economy but of humanism. It ennobles all it touches. A Sartre thinks only of the dark and negative side of man, who seems in his eyes no more than a "useless passion," and believes that the possession of gold is degrading. To me what is degrading is to die in poverty as Cervantes did after creating the immortal Don Quixote, or as Christopher Columbus did despite his discovery of America. Success through gold is proof by casting out nines of quality. To each his own criteria.

How Dali Sees Man Through the Prism of Gold

I have an alchemist's view of the human being. I do not believe in an abstract notion of man—his genitals, his odors, his excreta, the genes of his blood, his Eros, his dreams, and his death are an integral part of existence. I believe on the contrary that the "substance being sought is the same as that from which it must be derived," which is the basic principle of alchemy. Every element of matter has a treasure within it. And man to me is alchemical matter par excel-

* French homonym for *avide à dollars* (greedy for dollars); the name might be anagrammatized in English as *Idsavadollar*. (TR. NOTE)

lence: the well from which wealth must flow, the gold mine of the absolute, provided you know how to transcend it. Gold is the true proof of knowledge, of God, of the laws of life, and the deeper morality.

All great men have always affirmed it. Lenin dreamt of setting up a golden urinal as a symbol of the success of the Revolution; St. Ignatius of Loyola at the height of his mystical ecstasies created the Jesuit style, characterized by the display of gold in all churches. In all domains, gold glitters. Gustave Moreau had gilt glinting all over his pictures. Paul Verlaine, eaten away by the pox in the last days of his life, spent all of his time painting in gold the chair on which he set his arse and his chamberpot. I would wish, moreover, that the kinship of excrement and gold not cease in the deeper vision of human reality. Guy de Maupassant in the asylum practiced holding back his urine so as to avoid the loss of his precious piss which, in his hallucinations, he said was a river of diamonds; those obsessed with the pee-bread from public urinals believe that the food they soak in the urine there is the expression of absolute wealth, collective gold. Between the dreams of Lenin—who like all syphilitics was obsessed by golden stools as a result of his treponemata—and those tormented by the pee-Eucharist, there is a common denominator: the inner conviction that the vilest of matter is the sanctuary of hidden gold. Personally, I prefer avariciously to hide my wealth the better to enjoy it.

Thus, I would love to live in a house entirely made of gold but have it hidden under the tiling of the bathroom, the porcelain of the tub, the steps of the stairs. That would be a matter for profound enjoyment! Being the only one to know that everything one is touching is made of gold, and that each and every one is trampling a fortune underfoot without any idea of it! The topper, of course, would be to have the bowl of the toilet visibly made of gold so everyone was obliged to shit on the noblest and dearest matter in the world.

What Dali Calls Humanism of the Arsehole

This is not said derisively but, quite the contrary, to celebrate the high notion of man. All great painting comes out of the gut. Chardin, Gustave Moreau illustrate the shit palette. To depict gold or food or still life there are only sienna, ocher, brown, yellow, chestnut, in a word the excrementitial colors. The great plastic subjects are all haunted by scatology. And any time I see a wealthy woman covered with diamonds, I cannot help mentally transforming each of those

precious stones into so many turds decorating her neck, her breasts, and her hands, laying bare what she tries to forget in human nature.

The Americans have gone to great lengths to try to pasteurize the fundamental elements and wipe shit and death right out of their concept. They invented UNESCO, which is a theoretical idea of man and society, and made a bonbon-pink and pistachio setting to wrap around realities. But I believe they are not squarely seated on their arses. They shit in their pants and spread their fortunes around like useless diarrhea. Dali believes on the contrary in rot, in the smell of life, and in painting with the magical excrementitial palette. Anti-shit colors and fake gaiety fill me with horror. All great art is born of alchemy and going beyond death. But I make gold by transcending my innards through hyperconsciousness.

I have always had a genius for making gold pop out. My switch strikes the ground like Moses' stick and the source of life miraculously appears. Naturally, ascesis is not all it takes. The ruse of high priests is also required. My pleasure, to be sure, is redoubled by the quality of my inventive genius and I delight in my strategic and bargaining skill. In that way, I have a real orgasm when I succeed in making a multimillionaire spend twenty times the money he ought to. That's a record. Especially if I can convince him he got the better of the deal. It's like cuckolding him and making him enjoy it.

One day a sumptuous yacht hove in to Port Lligat. A braided captain came ashore in his dinghy, and called on me. He was the bearer of a message that his boss would come the next day, if agreeable to me, to collect a watercolor for which, sight unseen, he had paid me $10,000 a few months before. We made a date for five the next afternoon at my studio.

Ten thousand dollars seems too little to me, I reflected, as I looked at that yacht. This was a time when I was deep in the study of the ways of sea urchins. I put one of them on the lip of a vase, attach a paintbrush dipped in paint to one of its bristles, and titillate it. Each movement it makes is recorded by the brush against the canvas. Two hours later, my sea urchin is exhausted from playing Rembrandt, and the watercolor is finished. I sign it, after adding a big spot for greater effectiveness.

When the yacht owner comes in, I present him with the watercolor and his face falls with amazement. The more so since he has just glimpsed one of my own masterpieces—that I had just finished and allowed to hang covering a whole wall of the studio.

"This is a remarkable watercolor," he says, "but my taste, dear master, does not run to your current experimentation. Your

Surrealist imagination was always what I loved. That painting, for example, is a true wonder."

When he left, he was out $200,000, but owned a painting he never would have dreamt of buying had it not been for the cooperation of my sea urchin.

My elegant manner of dressing conceals my serious side just as my exhibitionism is the visible part of the iceberg. Some day, the whole thing will capsize and it will become clear that a revolutionary power is lurking in my painting, behind the outer *pompier* coat of classicism. Prudery and great art join together to make me adopt the formulas of tradition. My triumph will lie in the fact that I was able to overwhelm my period and at the same time achieve immortality. My triumph is the gold that accounts for my present-day success and nurtures my eternal genius.

Luck, moreover, has put many happy adventures in my path, to such a point that I sometimes feel that paranoia-criticism is conquering the world through contamination.

A New York department store ordered a series of frescoes from me to ornament its facade at its opening. The press made a lot of copy of it. I turned the sketches in just in time for the deadline; unfortunately, the contractors were further delayed in their work and, a week before the great date, I was informed that my sketches would not be used.

I flew into a Dalinian rage, claiming I had been publicly humiliated and, in view of the damage done my reputation, demanding to be paid a second time. They complied.

A few days later, going by the now-open store with its bare facade, I got an idea. I rushed inside to see the big boss and suggested we play a game. Each day, one element of my décor would be placed in a window, with passersby asked to guess what was to follow the next day. It would be a real jigsaw that would have the whole town talking. Naturally, I demanded a third payment for the right to use my work in this way.

I convinced the owner, but unfortunately his board threatened to kick him upstairs if he gave in to my demands. I know that to this day he is sorry that he did not do it, but every time he looks at one of those drawings of mine that he keeps in his office as mementos he sighs mightily. His friends say: because he remembers that he had to pay for them twice; his enemies add: because habit, which is second nature, has set in, and he feels terrible that he was not allowed to pay for them a third time. That is probably true, but his record was broken two years later. I copped a triple crown, under circumstances the more

unusual in that my basic client was none other than the Italian government.

The then-Minister of National Education commissioned me to illustrate Dante's *Divine Comedy*. I made the plates for the government printer, and was paid—which was a good thing. For a scandal broke out in Rome: a member of the opposition took public notice of the fact that a foreign artist, a Spaniard—Dali, truth to tell—had been commissioned to do the illustrating of the most honored poet of Italian history. And in their ultrachauvinism, the deputies took up the cry of betrayal of the Italian soul. The government was imperiled. Feeling insulted, I decided to have some fun out of it. The Minister, now at wit's end and fearing a hail of rotten tomatoes, came to beg me not to reply, saying that I could keep both the money and the plates I had already done, provided no more was heard in Italy about Dali's illustrations for *The Divine Comedy*. I kept my word—and sold the rights at twice the price to a French publisher.[1]

Every morning I need to have the golden diarrhea rain down on my head, and for each of my drawings to turn into legal tender, so my gold can go and multiply incessantly in the bank. All I say, or do, turns into gold. I become one fantastic transmutation machine; the Pope of a Church in which the ingot is the basis of salvation; and I would gladly teach my flock Quevedo's work in praise of the arsehole as the gospel of the new humanism.

However, make no mistake about it, money is merely a symbol to me, and my interest in it is of a paranoia-critical nature.

Captain Moore one day handed me a $50,000 check that I put in my pocket. We were waiting for an elevator at the Waldorf-Astoria. I took it, but going up met some friends who invited me to their suite. When I left them, I went back to Gala who was waiting for me.

She asked for the check. I searched my pockets. Nothing.

Gala phoned the captain, who assured her he had given it to me. He remembered that I had a copy of *Time* in my hand, probably the one I had thrown into the trash container on my friends' floor. He went from trash container to garbage pail, till he reached the main dump, which was searched and the copy of *Time* and my check found. I was no happier for that, since the mere knowledge that that small fortune was mine was all that I needed.

[1] Joseph Foret, the same publisher who later was also to bring out *The Apocalypse*, the most expensive book in the world.

How Salvador Dali Scorns Money

One of my adolescent pastimes consisted of dissolving a bank note in a glass of spirits while sharply bargaining with a whore over her price. The money doubled in value in that way and gave me a sadistic power that brought priceless pleasure!

I had also pretended to my Figueras schoolmates that I had a system that allowed me to make a profit by paying them twice the value of the coins in their pockets. After that, I made endless complicated computations that filled me with jubilation, while they mumbled that I was crazy—quite unaware that their scorn was exactly what I was after!

Needless to say, I never have a dime on me. One day, in New York, Gala gave me five $100 bills. So as not to lose them, I pinned each one with a separate safety pin to my shirt, under my jacket, and with this ammunition ventured confidently out into the street. When I got back at the end of the day, she asked for her change. I had none. I had taken five taxis.

Yet, I have always known what superiority money affords. My father, as *notario,* was the keeper of the people's money, or the "money doctor," as they called him, but gold is merely a way to reach a certain level of possession, which is all that counts. I remember spending my last hundred pesetas one dawn in Madrid, after a night of carousing, to buy a basket of gardenias that I presented to a speechless beggar-woman, whose dismay delighted me. My promiscuity, my dandyism are both results of the imperative law of my paranoiac desire.

I had told the Vicomte de Noailles that I would make him a painting for twenty-nine thousand francs. Why that figure? Because it was commensurate with his prestige and his wealth. He gave me a check that I gazed upon in admiration as a treasure and inspected with such intensity that I actually assimilated it. When the time came to turn it in to the bank, I felt almost unbearable reluctance that evoked a series of defense reflexes in me.

First, when the bank teller called my name I was very much surprised and immediately mistrustful, since I had never seen him before, and as he reached for my check I put the pink treasure back in my pocket.

"When he shows me the money, I'll give him the check. Not before," I said to Gala.

"What are you afraid of?"

"That he may swallow it," I answered, "which is what I would do if I were in his place."

She had to set about convincing me, to the young bank clerk's utter amazement, that he had no taste for eating paper, that his paranoia-critical passion was of such meager intensity that I need not fear any possessive provocation. I would gladly, after that, have eaten each of the bank notes of my roll of twenty-nine thousand francs, just to be sure I could keep them forever.

Power, money, and gold are a sovereign remedy for the terrifying fear that scatological elements as well as grasshoppers long inspired in me. The Surrealists believed I was a shiteater because I showed shit in my pictures. What I was really doing was trying to exorcise it, but gold was the sovereign balm that drove away my phantasms.

Lack of money can give me fears and fits of fantastic intensity. One day, on the Málaga-Torremolinos road, I went through some atrocious minutes. Gala and I, at our wits' end, had gone to borrow fifty pesetas from a friend, who put us on the return bus as he slipped the folded banknote into my hand. We were already on the way when I unfolded the pesetas to discover they were merely a receipt for a telegram he had sent. My blood ran cold; I was furiously choking at the idea of his ignominious trick, the humiliation he was subjecting me to. I could already see myself serving prison time for "theft of service." I looked hatefully at the approaching conductor. I was by now visualizing how I would kick him mightily in the groin before running away. I was boiling mad.

Gala, with her wonderful intuition, grasped my hand, ready for the worst. Suddenly, the man pulled the emergency cord and the bus stopped. Our friend hopped aboard. Seeing the mistake he had made, he had grabbed a taxi and caught up with us. I think that that day I could have committed murder: I swore I would never be short of money again.

Having gold often dulls the intelligence. But I have remained a cunning Catalan peasant, with his royal sense of innocence and his mystical hunger for power. The love of gold and God are an integral part of my soul. Very few people are thus as well equipped as I, and most of those "made of gold" become totally dull-witted as a result of the struggle they have had to put up to get their money and keep it.

Ever since I have been living in the U.S., I have been happy to pay my taxes. For, since I have been paying them, I have been rich. The more I pay, the bigger my fortune grows. That is a truly paranoia-critical reaction. The same applies to my chamberlain-agent,

who gives me 90 percent of everything he makes. Of course, I might hold against him the fact that he keeps 10 percent, but that is something I do not do—for you have to know how to throw money out the window if you expect it to come back in through the door. Moreover, I always work it so that continual gifts add still more to my profits, while reducing the others' shares.

What really counts is only to have as much money as possible at the time one happens to need it.

From Madrid, where I am staying in a hotel, I phone the concierge of our usual hotel in Barcelona. "I need five hundred thousand pesetas," I tell him, and go take a leak.

The last drop has barely dropped off my aristocratic penis when there is a knock on the door of my suite. A bellboy is holding out a tray with a hillock of bank notes on it. The concierge phoned his opposite number in Madrid and the latter sent them up. The time it takes to have a piss and fortune is at my door. Wealthy and free, is the best policy.

The Surrealists, in my eyes, have the opposite failing. They pretend to scorn money because they are not able to make it. They build up truly paralyzing inhibitions. They react to gold as they do to crap, anus, or pederasty. The truth offends them. They would like to re-create an ideal man, sans arsehole, or genitals, or appetite, living out in dream a scenario written by Aragon and directed by Breton.

My whole life has been an alchemist's work. My secret resides in the paroxysmically acute intelligence that comes to the support of my paranoia and reveals the secrets of the world to it.

Gala and I long made a secret of our secret, that we were short of funds. At the worst times, even as we wept over not knowing what today's day would be made of, we always found courage enough to hide our shortness of funds, not to say our dire poverty. Pity is the virtue of whores and we could do without the charity of outsiders. In Catalonia, we are taught to maintain our genius and our dignity till death do us part from them. And dying of hunger is nothing, provided everyone else thinks you are dying of indigestion.

I solemnly affirm that I refuse any concession to gold just because I am very rich. Which also means I do not have to prostitute myself to earn a living or serve my ideas; for, commitment, in an intellectual or an artist, is what the "trick" is to the whore. They degrade themselves, in order to be able to rationalize that what they are doing makes them socially useful!

I like the bread-and-butter of reality only when it is spiritualized, that is, spread with a good layer of gold. The tip of my brush

brings forth the double treasure of my genius and my fortune and defines my fate, making my most dangerous ideas tangible and creative. My best days are those on which on awakening I earn $10,000 before breakfast by engraving a plate for my own enjoyment, and which end with a $50,000 check that I pocket without a murmur after a fine gourmet supper. I am known to be a man of gold. And gold beckons to gold. My treasury keeps increasing as each day I become more spiritual, each day growing closer to angelicism.

So that now I hardly ever fart any more and my stools, as my fortune increases, become more odorless and beautifully formed. When I was poor and dissipated, they were awful and stank to high heaven. The honey of gold turns me suave while my paranoia increases even more. Alone, immutable, there remains my love for Gala, whom I continue to love more than my mother, more than my father, and even more than money.

"I NEVER KNOW WHETHER I AM RICH OR POOR: MY WIFE KEEPS ALL THE ACCOUNTS."

XII

How to Conquer America

To get away from Europe, and France, obsessed me, as the floodtide of hatred and violence rose. I had lived through the "night of the Catalan uprising" on October 6, 1934, at Barcelona, and almost been shot, and had sworn to myself I would never again be party to any historical events I did not myself create. My hopeful and envious eyes looked beyond the ocean to the honeyed shores of the American cake. And, like an athlete, I went into training for that broad jump.

America was the first country, outside my native Catalonia, to recognize me. Since 1927, my *Basket of Bread* was part of an American collection, so I had half a loaf in Uncle Sam's larder. But the crossing was a long one for me, not to be "undertaken without bread." The main thing was to have one's way paved in advance. . . .

In my corner, I had ideal seconds to help force the locks of America's strongboxes, the best-mannered assistants in the world, the most authoritative voices, the biggest names: all those international snobs who had adopted me, as Francis the First of France had believed his court jester indispensable to his majesty. All of that year, I played every card I had in the social whirl. I was front and center at every snazzy gathering. The Vicomte de Noailles saw me as a very

171

frequent dinner guest. Several of my pictures hung on his walls, notably *The Lugubrious Game* and *Dormeuse-Lion-Invisible,* alongside the greatest names in painting: his 1923 Châteauneuf-du-Pape was a wine worth the effort. I placed my *Tour du désir* (Tower of Desire) at Prince de Faucigny-Lucinge's, certain that the nude couple embracing in it would cause tongues to wag. I went to the Comtesse de Polignac's concerts, knowing I would see the finest social poll-parrots of Paris there, ready to go croaking in all the salons of the city, spreading the image of my distinction.

I made up and told fantastic stories that charmed them. At Comte Etienne de Beaumont's I rubbed elbows with the Maharajah of Kapurthala and a few Surrealists, erstwhile chums who turned up only for the petits fours and other sweets being served. Bébé Bérard's beard got caught in my vest buttons several times. He looked remarkably like a houri, and his intelligence reached right down to the tips of the pudgy fingers he waved incessantly the better to draw attention to the dirt under his nails. His filthiness fascinated me quite as much as his mind.

Bettina Bergery, and her husband Gaston, then ambassador of France to Moscow and later to Ankara, somewhat like a praying mantis married to a Stendhal, appealed to me as the solution to an impossible equation. Coco Chanel and Misia Sert, alongside Bettina, were the favorites in my gossip-harem. Marie-Louise Bousquet's salon was often the laboratory for the concoction of unbelievable stories that were soon circulating all over Paris. I used everything and everyone as messengers: the old couturier Paul Poiret, sleepy dealer Ambroise Vollard, sprightly Jean Cocteau, Marie Laurencin, Serge Lifar, Leonid Massine, Boris Kochno, one of the lighting artists of the Ballets Russes whose skull shone like a billiard ball. My mustache was a woman-trap at Arturo Lopez' dinners and Reginald Fellowes' dancing soirées. I became an indispensable character at all the ultra-snobbish parties, and my walking stick set the tone of successful affairs.

I sent up several of my most brilliant bubbles to burst amid laughter and cheers: artificial fingernails of mirror glass to reflect the glint of one's eyes, erotic gowns with special upholstering that could be moved about to suit the masculine imagination; additional pectoral falsies that could be blown up so as to have breasts all the way around in back. One day I walked in carrying a transparent mannequin with goldfish swimming inside. Each of my appearances was an awaited event, which ultimately had to be heard about overseas. My tall tales were already the talk of Paris, and one of them,

the one about the revolutionary bread, was even a bit later to inspire one of my most noted paranoia-critical acts.

At the time, I was surrounded by a bevy of the most elegant women. It was an evening at the Polignacs'. Diamonds like turds out of a geometric arsehole were cutting a swath hundreds of carats wide across the bosoms of the crème de la crème. The concert was over and it seemed like the hanging gardens of Babylon with a decadent atmosphere suspended in the air. I announced, enunciating each word, that I was about to start a secret revolutionary society: the Order of Bread, that would be the starting point of a revolution in mass sensibility and cause the systematic requestioning of social logic and world order. Nothing less.

I explained my plan as follows:

We were going to bake a bread fifteen meters long in a special oven, which of course would require a heavy investment to build. But the sale of just a few of the diamonds bunched about me would be amply sufficient for the first costs. My eye caressed the pearl necklaces and jewels already heaving over shivers of apprehension and excitement, and I went on. The well-baked bread, made according to the best traditions of French bakeries, would then be wrapped in old newspapers and tied with string. One night, the members of the Secret Society of Bread, dressed as workers, would steal into the Palais-Royal gardens on the pretext of bringing in a new water main, and place their fifteen-meter bread in the middle of the garden. It would be just a matter of time till someone wondered what it was, undid the strings, opened the papers, and took fright. Of course, at first the reality of the bread would be doubted. The police laboratory would be called in; bomb-disposal squads would have to make sure it was not explosive; chemists would test it for poison! But when no one claimed the bread, and it appeared to present no danger, questions would pop up everywhere about why the waste.

A few days later, a fifteen-meter bread would also be found in the courtyard of the Versailles château, then in the Place de la Concorde, at the foot of the Obelisk, in London's Hyde Park, Brussels' Place Ste. Catherine, Rome's Capitol—always without any message or provocation.

The entire world press would now be on the alert for new appearances, and knock itself out in speculation. Who was financing the campaign? What high connections could such an organization have? What were its aims?

The bakers' union would of course feel that it was under direct attack; political parties, especially the Socialist and Communist,

would be humiliated by the provocation of this gigantic bread left out in the open when thousands of undernourished people needed it, and would send delegations to government heads demanding an investigation. There would be questions in the Chamber of Deputies. The religious authorities would make lengthy commentaries on the senseless act and try to reinvest bread with its sacred quality and high dignity. But in vain!

The provocative poetic import of the giant abandoned bread would create total confusion leading to mass hysteria. The more so since the Secret Order of Bread would repeat its placements. The breads would get bigger, reaching as much as forty meters. By a kind of natural sense of emulation, the process would be picked up little by little by all sorts of nameless groups, students out for pranks, visionaries, logicians, revolutionaries, protesters. Abandoned breads would be found on every sidewalk, before monuments, on the laps of statues of great men. Bread crusts would be thrown at passing politicians, and on parades. People would pelt one another with bread on the flimsiest of pretexts. Dull-wittedness would invade the whole world like a kind of delirium. . . .

I spoke in a very loud and peremptory tone, very convincing, prophetic and magnetic. The shining eyes of the women reflected my assurance and my hold on them. It was a radiant evening. A few of those beautiful creatures, falling for my genius, naturally went about repeating my story and even sending written accounts of it to their friends scattered all over the world in the international snob mafia. The yeast was thus already introduced into the American bread that I was about to gobble.

René Crevel introduced us to Caresse Crosby, an American woman whose wealth suited my purposes perfectly. She lived at the Mill of the Sun in Ermenonville forest. She might have chosen a place less consumed with greenery, for to her the world was all white. Dressed all in white, she drank milk, walked on white rugs, and everything possible from telephone to curtains was spotlessly white. But, when the table was set, the cloth and plates were black.* I talked Caresse into building an oven for the fifteen-meter bread. Pending the secret society coming into being, Gala and I spent our weekends at Ermenonville preparing for our American campaign by listening to Cole Porter's "Night and Day," our hostess' favorite song, and riffling through *The New Yorker* with fingertips dipped in champagne.

* Carrying forward the tradition she had shared with her late husband, Harry Crosby, her co-publisher of the experimental Black Sun Press. (TR. NOTE)

Dali's Means for Conquering America

I grew daily more impatient because of my lack of the salt of the earth, that is, money. I kept kicking out in all directions to calm my fury. That was how one night the deformed buttocks of a legless man found themselves to be my target. I would never have paid any attention to this miscarriage of nature on his little wheeled platform at the corner of Boulevard Edgar-Quinet, had he not tapped on the ground with his stick to ask someone to help him across. The street was empty. Only a whore stood guard at the other end of the block. The man could be calling to no one but me. Such presumption made me furious. I rushed over to him and with one huge kick sent him flying across to the other side, where his undercarriage hit against the curb. With fantastic skill, the legless wonder held on to both sides and was in no way thrown by the shock. He just stayed motionless and speechless, completely taken aback on his shaken-up transportation. I crossed over quickly to look my victim in the eye. Then I realized he was also blind and could not see me, which cut down somewhat on my enjoyment. But he had a sharp ear and, hearing me approach, took on an attitude full of humility and submission that pacified me. I went off whistling happily. A short time later, I felt terrible at not having relieved him in turn of the contents of his pocketbook; such a blind legless man had to be one of those beggars who shamelessly exploit public charity. With the profit of his collections I would probably have had enough for a good down-payment on my ticket to America.

Meeting Alfred Barr, director of the New York Museum of Modern Art, at the Noailleses' was what moved me to action. He was a nervous young man of cadaverous paleness, but fantastic plastic culture, a veritable radar of modern art, interested in every type of innovation and disposing of a budget larger than that of all the museums of France combined.

"Come to the States," he urged me. "You'll be a lightning success." In which, he merely echoed my own sentiments.

My father, on the other hand, was making things more and more difficult, so that living in Cadaqués was becoming impossible. He was trying to shame me. All I wanted was to get away. For a while I took refuge in painting, doing a self-portrait with a chop on my head, which psychoanalytically meant I was telling the old man to eat the chop instead of eating away at me.

In Barcelona I made a scandal, the reports of which must have appalled him. I had been invited by that city's Ateneo Enciclopédico Popular to extol the virtues of the Catalan soul, and used the occasion to speak in praise of the Marquis de Sade and denounce the baseness and intellectual inertia of the city's idol, Angel Guimera, whom I referred to as a "faggot" and "crumbum." Every chair in the place got smashed, several people were hurt, and the organization's president was forced to resign. The next day, at a meeting of anarchists enthused by my daring the day before, I made a first public experiment with bread, even though this loaf was only two meters long.

I opened the session by voicing in a level tone, like any smooth lecturer, the worst insults, obscenities, and blasphemies of the Catalan tongue. I was dealing with experts, and, first interested by my words, then whipped into protest, the audience, which included many women, was soon thrilling and rumbling like a wild animal stroked by its tamer. That was the point at which the bread was placed on my head, held on by straps, as I continued to roar my obscenities. I suddenly felt the whole hall rise as the level of a river does when it meets the ocean. The bread was the catalyst. All the insults solidified and became palpable. The male and female anarchists were turning into hysterical beings, some even falling down in fits of D.T.'s; the shouts and blows became deafening. I slipped away, the bread now under my arm, leaving them in total confusion.

Reading the next day's papers that filled me with jubilation must have sent my father to his bed, but I was forever cured of my pathological shyness.

In New York, a showing of my *Limp Watches* had been encouragingly received by the critics. Much was written excitedly about my original vision of the world. I seemed to be the most modern novelty out of the old world. In Paris, there was little left for me to look forward to. I had made my hole. Like Alexander slicing the Gordian knot, I had left an ineradicable mark on Surrealism as I went through it. I had transformed its structures by injecting them with goo, rot, the bizarre, the disturbing, and the impossible. But now everything was turning into Byzantine sniping and scholasticism. My name was a kind of scarecrow. French common sense was somewhat narrow for my dimension. I was hungry and thirsty for a continentwide area of edible glory and potable success to sate me. Only America was wealthy enough, had enough fresh intelligence and available energy to fulfill my hypertrophic self and put up with my whims.

How Dali Decided to "Make the Leap"

Truth to tell, Gala and I were quietly drying up for lack of funds. Gala sewed her own frocks and made our meals—when we were not being fed by Paris' supersnobs—and I worked incessantly: even a deep-mine miner would not have put up with my strenuous schedules and backbreaking work. I was being robbed, my ideas were being turned to profit by others, and I was getting nothing out of it! To top off my troubles, my dealer Pierre Colle dropped his option on me. It was time to head in a new direction.

The kick in the arse I had given the legless blind man showed me how completely free of taboos I had become. Nothing stood in my way any longer. Gala scraped our savings together and reserved two berths for us on the *Champlain* to New York. We had three days left in which, with Nietzschean audacity, to scrounge some of the wherewithal for living from my best-heeled friends. But I must have looked like a mad tiger, for many doors were closed with relief after I left, without the people behind them having given me even the price of a taxi fare. The only one who welcomed me at that time, with the sovereign demeanor of a lion, was Picasso, who broke Daddy's legendary piggy bank open for the benefit of the prodigal son. That was how I was able to leave for America.

I was feverish. I had spent three terrible days wondering where I would find the five hundred dollars we needed to leave. On the way from Paris to Le Havre, I was terrified that the train might be delayed and we might miss the boat, and had even refused to let my picture be taken at the Gare St. Lazare, in front of the locomotive, before we pulled out, for fear the train would start without me. I could not get aboard fast enough and kept nagging at Gala. We were on deck three hours before the first whistle blew.

During the whole crossing, I was still continually worried. My fears turned into terrors. The *Champlain* was creaking all over, its immensity struck me as making it vulnerable, fragile, and hard to handle in case of a catastrophe, especially since the officers I bumped into in the corridors seemed unconcerned to me, with their caps pulled over on to one ear, making small talk, while our safety depended on their reliability. I absorbed phenomenal quantities of champagne trying to calm myself, and never took off my life belt. Even in bed, I remained surrounded by cork, ready to float away on an ocean of despair, and when emergency drills took place I was

always right up front, in rapt attention, cane in hand and ready to beat off women and children so as to be first into the lifeboat.

On deck, the endless expanse of ocean only increased my malaise. I did not dare look out to the horizon. The victory bulletins posted aboard to show the exact distance between us and each of the coasts only led me to somber calculations about how many strokes of the oars it would take to reach land in case of shipwreck. Anxiety and terror were my constant companions. Had it not been for my bread, this ordeal would have been a nightmare, but its yeast happily occupied my mind and gave rise to new ambitions.

We had chosen to cross on the *Champlain* with Caresse Crosby who was returning to the U.S. and was to act as our mentor. I reminded her that she still owed me a fifteen-meter bread she had promised to bake at Ermenonville. She tried to get the captain to have it made, but there was no oven aboard that could handle it, and I had to settle for one that was two and a half meters long— which at that could only be held together by a wooden backbone. But to me it was a magic wand that restored my joy. Before, I had felt emasculated, impotent, bereft of my umbilical cord. When the chef, with pomp and circumstance, came and presented me with my bread wrapped in cellophane, I was a changed man. I took it in hand, as one does a cock he is about to masturbate, and stroked it with the purest pleasure. It was slim and hard, slightly flexible and cartilaginous like a real prick, with a well-formed crust. I felt the saliva of desire moistening my throat. I took it solemnly in both hands and waved it overhead. I had just gotten back my phallus.

The first thing I did was to put a pair of pants on it, meaning that I wrapped it in newspaper to hide it from eager eyes and increase their desire. I then laid it out in the middle of my cabin to await the great day: my marriage to America! I would land, a young bridegroom carrying his conjugal tool outstretched and inviting the whole world to attend our union.

I was on the upper deck when New York hove into view. I suddenly saw a dark mass emerge from the haze and understood that our Lilliputian shell had made it and was about to land us on the back of a sleeping monster whose variformed hard-ons we could see. Like body crabs, we would latch on to those hollow pricks looking for a niche. When the sun broke on the thousands of glinting windowpanes, a shiver seemed to go up along the skyscrapers, as if some libidinous massage were sustaining the erection of the enormous hulks plunging into the vaginal sky.

The *Champlain* was moving ahead very slowly, borne by the swells, and I had the feeling we were participating in the slow penetration of earth and clouds. The siren whistled to proclaim coitus. I felt my cock shrivel between my legs and rushed down to the cabin to get my well-baked, edible bread-prick.

A mob of newspapermen had already taken over there without invitation, showing that I was already well known. They stood, sat on the couches, the bed, chairs, or the floor, chewing gum, hats on their heads and copy paper in hand. Amazingly, my bread, set up on four chairs, had withstood their onrush and none seemed to be aware of its presence. I grabbed it without further ado and stood it up like a bishop's crozier or Moses' staff. Questions popped at me: my age, my father, my mother, the Limp Watches, paranoia-criticism, why I had ever thought of painting Gala with lambchops on her shoulders . . . but not one mentioned the bread! It could have been the invisible baguette, a magic wand. I raised it toward the ceiling, took it under my arm, ran through the corridors, went up on deck, passed the customs people, still trailed by the reporters. Not a word!

They wanted to know all about me, and I gave them stories that would make good copy and even better headlines, but not one of them could see what I was displaying in front of their eyes. So, I understood that I had just "cuckolded" them and that these suitors, who wanted to cut me to bits so as to feed me to the swine, had not been able to see through Ulysses' cunning. My bread was the image of my untouched strength, my virile phallus. Throwing crumbs and confetti into their eyes, I had hidden my Truth from them. To them, I was the King of Non-Sequitur, the clown, as they might say, the *tummeler;* not one of them had divined the terrific pressure, the Nietzschean will pent up behind the appearances. I set my erectile bread down on American soil as one plants a tree, slowly unwrapped the newspapers covering it and discarded what was by now yesterday's news. The golden crust shone in the sun. I lifted my bread like a flagstaff, and phallus to the fore I was off to the city. . . .

The hardest part was getting it into a taxi—despite its invisibility, which only grew increasingly greater. I went all about in New York, bread in hand, pushing passersby out of the way, without anyone mentioning it. I stopped on the sidewalk, leaning on my bread, and windowshopped. Pictures were taken, but since the bread bled out at either side, no one saw what it was.

Yet on the last day there was a miracle. As the aging bread began to crumble, I decided one morning to eat it. Having coffee at

the counter of a drugstore on 50th Street, I started to break an end
off my bread to go with my fried eggs. The counter crowd had soon
gathered around to watch me. There were a lot of questions, but being
by myself and unable to speak English, invisibility now was replaced
by incomprehension and the mystery of the bread remained unsolved
for Americans on that November day in 1934.

As I was crossing the street, I slipped and lost hold of my
bread. A policeman helped me to the sidewalk. When I looked back,
my bread had disappeared—become totally invisible—even to me. I
knew it had been assimilated, digested by the city, and that its yeast
was even now making its way through the bellies of the immense
phalluses all around us, already manufacturing the Dalinian sperm
of my future success.

Dali's First American Success

The very next day, I had a triumph. My dealer, Julien Levy,
sold almost half the show in the first three days it was open. The pa-
pers lauded my imagination and Caresse Crosby threw a big party for
me. The elite of American society came to the Coq Rouge for the
event, which had as its theme "A Surrealist Dream." The idea was to
show what oneiricism could make of the challenge of European Sur-
realist imagination.

I had dreamed up an "exquisite corpse" costume for Gala.

On her head, she had a nude doll whose guts were being eaten
away by ants while a phosphorescent lobster's claws clutched its head.
And I greeted visitors standing next to a flayed bull, held up by
crutches, its belly full of big-horned phonographs. My mustache,
standing out like two aerials, radiated magic fluid. It was a wonder-
some evening.

The first lady to arrive came in entirely naked, with a bird-
cage over her head. Her escort was dressed in a nightshirt and had a
nighttable over his head for an umbrella. When the party was at its
height, he opened the door of the chamberpot compartment and let
out swarms of hummingbirds. There were eyes everywhere, on a pretty
lady's lower abdomen, on tits, backs, crotches, and foreheads. Tumors
bounced around like globulous bosoms. Huge safety pins hung from
the most beautiful hunks of flesh in New York. From time to time,
with my switch, I would tap at a filled bathtub that teetered more
and more precariously at the head of the stairs, threatening to douse
the whole assembly. . . .

It was a soirée that would have turned my little Surrealist pals green with envy as they sat around their marble-topped café tables in the Place Blanche, masturbating in the name of Lautréamont!

The next morning at ten we were aboard the *Normandie* heading back to Europe, where I found the jealousy and mediocrity of the Surrealist crises unchanged. No sooner had I landed, than my old friends filed a ridiculous lawsuit against me. They accused Gala—on the basis of an article in the notoriously pandering *Le Petit Parisien*—of having created a scandal at our dream ball in New York by wearing as a headpiece the provocative symbol of the dead Lindbergh baby—whose kidnap-murder was then the big headline story—and the whole thing was odious. The truth was that they were losing sleep because I was getting ahead. Especially the little group of Communists led astray by Aragon. This sounded to me like the last fatal crisis, and that was just fine with me.

Hitler was beginning to yell very loud. With his Sam Browne belt, his forelock, and the tight little cheeks of his arse, he impressed me as deeply as the American telephone that had inspired my *Violettes impériales* (Imperial Violets), *Le Moment sublime* (The Sublime Moment), and *Cheval aveugle mâchant un téléphone* (Blind Horse Chewing a Telephone). To announce my return, I published *La Conquête de l'irrationnel* (Conquest of the Irrational), in 1935, causing a sensation in artistic circles. But I almost let my dreams destroy me, in the way that you are liable to let a sharp pickpocket who steps on your foot get away with your wallet.

The first blow came from Franco's uprising in Spanish Morocco, leading to the siege of Madrid and the tragic news of Lorca's being executed by mistake. The chaos in Spain undid me, and the monsters of civil war found their way on to my canvases. The double being of the "cannibalism of autumn" was eating itself up and sucking my blood. My father was to be persecuted, my sister almost lose her mind, my church steeple would be razed, and countless friends would die! Death, nothingness, and the abjectness of hate were all about me. My paranoia-critical system was going full blast. In the depths of despair, I continued to paint, turning vertigo into virtue. I produced the *Vénus de Milo aux tiroirs* (Venus with Opening Drawers) and the *Cabinet anthropomorphique* (Anthropomorphic Cabinet; also known as *The City of Drawers*). The richest collector in England, Edward F. W. James, gave me a dazzling commission. London was the scene for a Cézanne-Corot-Dali exhibit, at which I showed my *Veston aphrodisiaque* (Aphrodisiac Jacket), made of ninety-eight liqueur

glasses filled with green crème de menthe, each penetrated by a cocktail straw.* The success of all this would be sweet to think back on, were my memory not tainted with a horrible sensation.

I had decided to make a speech at this exhibit, but from inside a deepsea-diver's suit, to symbolize the subconscious. I was put into the outfit, even including the leaden shoes that nailed me to the spot. I had to be carried up to the stage. Then the helmet was screwed and bolted on. I started my speech behind the glass facepiece in front of a microphone which of course picked up nothing. But my facial expressions fascinated the audience. Soon they saw me open-mouthed, apoplectic, then turning blue, my eyes revulsed. No one had thought of connecting me to an air supply and I was yelling that I was asphyxiating. The specialist who had put the suit on me was nowhere to be found. I gesticulated in such a way as to make friends understand that the situation was becoming critical. One of them grabbed a pair of scissors and tried in vain to cut a vent in the fabric, another tried to unscrew the helmet—and, when that did not work, started banging at the bolts with a hammer. My head pounded like a ringing bell and my eyes teared with pain. I was being pulled and pushed every which way. Two men were trying to force the mask off, while a third kept striking blows that knocked me out. The stage had turned into a frenzied mêlée from which I emerged as a disjointed puppet in my copper helmet that resounded like a gong. At this, the crowd went wild with applause before the total success of the Dalinian mimodrama which in its eyes apparently was a representation of the conscious trying to apprehend the subconscious. I almost died of this triumph. When finally they got the helmet off I was as livid as Jesus coming out of the desert after the forty-day fast.

This horrible sensation of angst was to leave traces that were long in healing and made even worse by the tragedy of the Spanish war. The pestilential odor of death was rising from the charnelhouses of old Europe in which Lorca was one of the first cadavers, the very image of the hero struck down by blind hate. Stupidity had even joined the Surrealists. They wanted to expel me as a Hitlerite provocateur, suspected of having stolen milk from the children of the unemployed because I was more concerned with my thinking-machine that I fed with warm milk.

* In France, green crème de menthe (or Pippermint) is generally recognized as the most aphrodisiac of liqueurs. In areas where public soliciting was discouraged, as in university towns, prostitutes would advertise their availability by sitting at café tables with a glass of green crème de menthe before them. (TR. NOTE)

How Dali Chose Success Rather than Stupidity

I turned my back on Europe to escape the hateful birdlime that it exuded like snot. I did not yet know that my back was as transparent as my infant-nurse's had been. When I got to New York for the third time, in 1936, glory was waiting. The penicillin of my bread had spread and done its work elegantly. America was prey to acute Dalinitis.

Time magazine greeted me by printing Man Ray's photograph of me on its cover. Since I had no idea of what the magazine was, I could not appreciate the importance of this fact, and my blasé air about it was not in the least affected. But I was soon to learn the breadth of that publication's influence: I could not cross a street without being recognized and my arm was soon sore from autographing every weird bit of paper shoved under my nose. Glory was as intoxicating to me as a spring morning. I sold all my pictures on opening day of the show and Bonwit Teller commissioned me to do a Surrealist store window.

I decapitated a mannequin and replaced the head with a bouquet of red roses, extending the length of the fingernails with ermine hairs. A lobster made into a telephone and my green-crème-de-menthe Aphrodisiac Jacket were the other two characters of my grouping, which was a big hit. But these little games, and even the incense of glory, were not satisfying. I stayed up on my balcony watching life go by without being a part of it, ill at ease.

Gala, ever attentive, tried to keep me happy with the fine idea of going back to Spain to add a story to our house at Port Lligat, but clinking glasses with the bricklayers and roofers did nothing to reassure me about the quality or future of men who were always ready to disembowel each other for the artifice of a cause. Listening to them, I knew civil war was inevitable and horrifying. It was catastrophe eve, time to flee from Spain. So Gala took me to Italy, there to pick up the traces of Andrea Palladio, the architect of the Foscari Palace, whom I admired, and Bramante. I wandered through Rome, and visited my friend Edward James, and then Lord Berners, and painted *Impressions d'Afrique* (Impressions of Africa). All the while, from my window opening on the Forum, with one ear I could hear Mussolini shouting his speeches to the people of Rome.

This was a strange period of my existence, comparable to the painful state of a gestating woman—but with a kind of nervous preg-

nancy. I felt heavy with the sufferings of my world. I was like one persecuted. Illness haunted me. All the upsets, the tragedies, murders, crises, troubles that rang out through news reports translated themselves in me into one obsessive anxiety: germs.

I had just heard that some thirty-odd friends of mine had been executed by anarchist firing squads, when Gala took me to Tre-Croci at the Austrian border, to try to find some peace of mind. She left me there alone. My obsession grew worse. I felt surrounded. I spent my time with my nose stuck into the toilet bowl inspecting my stools, peering into my handkerchief to analyze my snot. I was back with the hallucinations I had in the time before Gala cured me through her love. I understood that I was living through an unusual phenomenon of my paranoia-critical becoming.

Gala's return freed me. Just before she got back, I had an unusually rare Dalinian experience. For a week, every time I sat down on the throne, my eye was attracted by a kind of greenish snot that was stuck on the porcelain wall-facing between the windows and seemed to be daring me. That day, I took a sheet of tissue and sharply swooped down on the snot.

Far from yielding, the point of it went through the paper and stuck me between nail and flesh, right down to the bone. I started to bleed. I gazed in terror at this unbelievable cut and my imagination quickly informed me that soon my finger would doubtless have to be cut off, as might even the whole hand that was turning purple under the pressure I was applying to keep the germs from moving in! Tetanus had surely taken hold of my body.

Would I be able to survive with a hand cut off? With a dead hand rotting underground? The very idea made me shiver. I fell to my knees. At that moment my eyes caught the base of the shining stalagmite of snot. I grasped that it was a fleck of hardened glue. In a fraction of a second, my lucidity wiped the terrors away. Snot alone could have been fatal to me! I had nothing to fear from glue! I pulled the sliver out of the bleeding wound. I was cured.

Gala was the one who showed me what had happened to me: just as the deep crisis that was convulsing Spain and Europe was the result of insurmountable contradictions into which society had boxed itself, so my American success had imprisoned me in a Surrealist image of myself which corresponded exactly to what I had dreamt. My head was banging against the ceiling and the blows I could hear resounding were being made by my forehead bumping into the "successful image of my distinction." I absolutely had to break out of my armor and set myself a new mental model. Only my work could give me the strength

and stature demanded by events and this selfsame success. That was why Gala had left me alone so I might find myself.

My metamorphosis became the keyword of my *gravida,* which once more opened the doors of deliverance to me so I could live again. Gala showed me that the essential for me was henceforth to find the path of great tradition, give my work the classical virtue of an architecture. Then everything I had believed for the past months crystallized in me with miraculous force and divine instinct. I painted *Le Corridor de Palladio* (Palladio's Corridor), *Plage enchantée avec trois grâces fluides* (Enchanted Beach with Three Fluid Graces), and especially *Gala Gradiva* for the greater glory of my love.

Yes, I understood that I was "the savior of modern art," that in this day of philosophical and artistic nearsightedness I alone was capable of sublimating all the experiments, all the contemporary values by giving them their true classical meaning—in an atomized world what was needed was synthesis, in an incoherent world the affirmation of the line of force, in a skeptical world to be a man of faith. The conquest of the irrational assumed its fullest meaning. I was moulting. I was saved! Nothing—not America itself, not success nor money—would ever again be able to affect me.

I was not unhappy to check out this new strength of mine by meeting Sigmund Freud. When Stefan Zweig introduced me to him in London, the fanaticism of my personality deeply impressed the father of psychoanalysis. That autumn, too, was when we had a villa in Florence which we left to be with Coco Chanel ill in Venice and then convalescing at La Pausa at Roquebrune on the Riviera, where I met Pierre Reverdy. I applied my newfound power to the Cubist poet, the glorifier of modern art. We had a fine set-to. Now I knew I was ready to launch my great challenge.

How Dali Challenged America

By overturning a bathtub I threw down my gauntlet to an America vaingloriously parading its self-sufficiency.

The success of my first Bonwit Teller window inspired all kinds of plagiarism up and down Fifth Avenue. I could not resist the pleasure of demonstrating what Dalinian inspiration was, and accepted the Bonwit order for two more windows.

I had not the least intention of using the usual awful mannequins. In the attic of the department store, I found two waxwomen with long Ophelia hair, both covered with spiders and their gossamer

webs. Accumulated dust gave them a patina as superb as that of an old bottle of *fine champagne* brandy. On the theme of Day and the Myth of Narcissus, I laid out the rugs and furniture and put one of these old dolls in a karakul-lined bathtub filled with water. As a counterpart, there was Night in the other window huddled into a canopied bed covered by a sheet of black satin with holes burned in it through which could be seen the other old figure, her head on a pillow of burning embers—artificial, to be sure. A jewel-covered phantom hovered at the sleeping woman's bedside.

After an exhausting night of work, that lasted until two in the morning, the whole thing looked most smart. But when the next afternoon at five Gala and I went by and saw that the second figure had been withdrawn and the canopy no doubt sent back up to the attic, my fury was just as superb.

I went to the main office and had myself announced. Disregarding the compliments the director was attempting to pay me, I demanded that my whole décor be restored as I had done it, or my name taken off. My proposal was haughtily rejected. When I understood that I was not to get anywhere, I said good-bye and walked out very calmly—with the power of a rhinoceros trotting meekly along before he attacks.

With the same quiet assurance, I marched right in to the window that had Beauty of the Day in it, and stood there motionless while a host of gawkers was attracted outside. When the crowd was large enough, I put both my hands on the brimming bathtub and tried to lift it, intending to spill it over, but it slipped from my grasp and with great force slid forward into the windowpane, much of which went noisily flying. Water and glass showered down on the howling mob. As for me, my light cane over my shoulder, I briskly jumped out into the street through the opening. I had hardly gotten through the jagged glass when another huge hunk of it broke off and smashed to the ground. I turned around to see a detective putting a plump hand on my shoulder and telling me to follow him.

I spent two hours in a police detention room with drunks and bums before the judge announced that I could be released if I paid for the broken pane. But the next day the papers made a hero out of me. From that day on, in American artists' eyes I was the incarnation of the creator's defense of his work. The broken window did more for my glory than if I had eaten up all of Fifth Avenue.

I was still not finished, however, with the tribulations of the artist coming to grips with American commerce.

I was asked to do a pavilion at the New York World's Fair,

The Dream of Venus, with full freedom guaranteed. But this was a trap intended merely for the exploitation of my name. I was suddenly told what materials and what styles I had to use. I resisted all pressures, reacting with such violence that my adversaries begged for a truce, but they sabotaged my work and I had to resign. It was a salutary experience.

I immediately wrote a *Declaration of Independence of Imagination and of Man's Right to Madness,* which appeared in New York in that same year (1939). This was my own personal declaration of war against stupidity. I had just given the powers of the irrational their standing in America. A Dalinian victory.

"I HAVE NEVER BEEN ABLE TO LET MORE THAN ONE NIGHT GO BY WITHOUT SOLVING A PROBLEM THAT DEEPLY PREOCCUPIES ME."

XIII

How to Dominate Men, Subjugate Women, and Stupefy Children

I am not *a* Surrealist; I *am* Surrealism.

Surrealism is not a party or a label; it is a state of mind, unique, to each his own, that can be affected by no party line, taboo, or morality. It is the total freedom to be and the right to absolute dreaming. So when, on returning from the U.S., I again confronted the puerile arrested-adolescents' attitudes of the Surrealist group, my stomach turned. Now they wanted me to take part in a Surrealist exhibition in which the participants were to be displayed alphabetically. Allegedly to avoid any kind of hierarchy! This meant imposing the rule of mediocrities, of the greatest number, and drowning the essential on the pretext of a simple-minded purity. The Surrealist hell was paved with good boy-scout intentions.

On board the *Champlain,* I had spent the return trip in going over my ideas and positions, so as to work out a line of behavior as hard as the tip of a diamond. I was now past thirty-three, Christ's age, and my cosmogony by now really had to have taken shape. First of all, while I conquered America, it had grabbed me with its sense of adventure, which was likely to erupt at any street corner with the

most extravagant ideas—in the U.S., there is always someone ready to go along with the most amazing of suggestions; and the youthfulness of its ever curious, avid, and imaginative minds, its sense of freedom and playfulness, yes, with this America had also conquered me. Its virtues were in sharp contrast with the superannuated European style in which the spirit of tradition I so cherished was itself choked off under narrow formalism, verbiage, and artifice. I decided, once and for all, that I would shake up that dust and, without taking any other consideration into account, allow only my own caprice to rule as law. So I forced my European contemporaries to react, in violation of their moral comforts and their bad cultural habits. It would be me, Dali—against the world!

Henceforth I knew it was possible to mobilize a whole city and the press and the finest minds around an artist's gesture. America had proved that to me. That experience had to be turned to my advantage. Yes, enough of the fake democracy based on so-called equality. Hierarchy to the fore! Respect for the conquest of genius! Out with the neighborhood poetasters, the palette errand-boys, collectors of crumbs at the dining board of art! To each according to his merits. It was too easy to merge into a society, palaver, and pillage one for the benefit of the rest. I recognized Picasso alone as among my peers. The others smelled of regimentation. Moreover, the little suburb pirates who called themselves Surrealists and who set up a new play-society while dreaming of glory had been made well aware of the enormous difference between their daring, their concerns, their passion—and mine.

The International Surrealist Exhibition, which I had taken part in shortly before my departure for the U.S. in 1938, had been to me one of those secret events that indicate a breaking point. My trip to the U.S. had deepened the gap. And now Dali was coming back with a "Europe, I am here!" born full-blown so to speak from the thigh of the Statue of Liberty.

How Dali Considers the Surrealist Exhibition of 1938

Georges Wildenstein had agreed to put on an International Surrealist Exhibition at his Galerie des Beaux-Arts, 140 Rue du Faubourg St.-Honoré, which usually was reserved only for the classics and had had the honor of presenting El Greco. The gallery had also shown Seurat and friends, Gauguin, Fauvism, Cubism. Raymond Cogniat, its artistic director, wanted to give the Surrealists full free-

dom to show their power of revelation, by going after international quality and variety. Breton and Eluard took charge of the thing, but had the good sense to call in Marcel Duchamp as permanent arbitrator. It was he who got the idea of completely camouflaging the gallery: it would be entirely hung with dirty coalsacks so the exhibit would be held in the dark, each visitor carrying his own flashlight the better to make the discovery of the meaning of things for himself. It was as hard to round up the twelve hundred coalsacks needed as it was to get insurance against a firedamp explosion that might have made an apocalyptic fireworks of the 299 works by sixty-odd participants and the roster of Tout-Paris who would attend the vernissage. That might not have been such a bad way to wipe out the recollection of all the unlikely allegedly Surrealist hardware that had been gathered in the venerable locale.

Until then, it had been possible to ask: "What is Surrealism?" Now, there it was: a claptrap collection of jokes and tricks in which the gimmick too often stood in for deficient imagination, the quick hustle was supposed to be as good as a mystery, noise was to take the place of music, and Breton's moods were dubbed "solemn wraths." The display was on the pauperish side. It might bring gasps from the bourgeoisie, but not from a De Sade, an Edgar Allan Poe, a Baudelaire, or a Nietzsche, who after all were the very frame of Surrealist reference. They all would have remained ice-cold before these pleasantries jokingly baptized "revolutionary Surrealist works."

Four Louis XV beds covered with jonquils, four revolving doors, sixteen costumed mannequins, a satin-upholstered wheelbarrow, a tabernacle mounted on women's legs, a table trimmed in velvet with a female bust on it, a brazier, an imitation low bathtub, a monster pair of French cancan underdrawers big as a whole room—these were the main décor along with a puddle of water and a bit of moss.

The creation of the Olympus of Surrealism desire had given rise to some scenes of a curious morality. Breton had unflinchingly accepted Duchamp's mannequin wearing a man's hat and vest and jacket with pocket kerchief that lit up. Across its pubis was written in crayon, *rrose sélavy*.* Likewise, André Masson's dummy with its head inside a birdcage, but when Max Ernst wanted to set up a couple in which a lion-headed man was shown embracing a woman in deepest mourning, whose uplifted skirt revealed a pair of pink silk panties with a lighted electric bulb inside, there was a scandal. "No fire in

* A favorite slogan of Duchamp's, which he often used as a pseudonym; the first *r* being pronounced separately, it sounded like *Eros, c'est la vie* (Eros is life). (TR. NOTE)

the underpants!" came Breton's ukase. And poor Max Ernst had to put out that flame of immoral desire. The "head" of Surrealism reached the colors of apoplexy one morning when he discovered I-forget-whose naked mannequin with a bowl containing one goldfish in its crotch. His howls filled the gallery till the bowl was shattered. After fire, water and fishes had been consigned to the Hades of good bourgeois morality. Each of the mannequins and dummies had a street sign over it: Weak Street, Vivian Street, Lips Street, Bead Street, Blood Transfusion Street, Cherry Street—to make a sort of idealized Paris. All that were needed now were a Bishopric Street and a Confessional Way!

It was in this climate that I was moved to suggest the creation of a "General Commissariat of Public Imagination," which would have been immune to the thunderbolts of a bilious and touchy Breton, to my mind far too conditioned to nice quiet reasonable dreams. I had already set up a dummy with a toucan head made of black cardboard embellished with an egg between the tits and dressed in a multitude of assorted little spoons. My aphrodisiac telephone with the boiled-lobster receiver stood on a straw stool beside it. Naturally, I had been allowed to participate only to the extent of this stylistic exercise plus my *Great Masturbator* and the *Girafe en feu* (Giraffe on Fire).

Striking a big blow, I asked that in the entryway in front of the gallery there be erected a monument made up of a taxi with a roof full of holes that would let a continual rain seep through on a Venus lying among the lichens, and driven by a monster. I thought Breton was going to explode with repressed rage. It was the day before the unveiling, and I was upsetting his plans. But I was convincing. All those present voted in favor and I forthwith set down a description of my "rainy taxi" for snobbish Surrealist ladies, which was to have a vegetable carpet with installation of internal rain, two hundred Burgundy snails, twelve Lilliputian frogs, each wearing a very fine crown on its head. The chauffeur to wear a helmet made of the jawbone of a shark. The lady was preferably to be dressed in a sordid cretonne print, displaying Millet's *Angelus* and his sensational *Gleaners*. This was embodied in a resolution, which I signed.*

We never were able to find the frogs, but when the show opened on January 17, 1938, it was suffused with a strong odor of French-roasted coffee accompanied by the cries of dog-faced baboons

* The original Dalinian text of the description given here abounds in his frantically phonetically punny "Gallic Espanishisms," ending *Bon pour toute l'Ané 1938*, roughly: "Good for the hole (donkey-born-) year 1938," but otherwise untranslatable. (TR. NOTE)

amplified from an electric phonograph. Max Ernst and I were listed as Special Advisers—Very Special Indeed.

The announcement poster read:

> The authentic descendent of Frankenstein, the "enigmariddle" automaton constructed in 1900 by the American engineer Ireland, will walk through the hall of the Surrealist Exhibition at half past midnight in fake flesh and fake blood. At 10:00 PM, André Breton will sound the opening signal.
>
> Appearance of object-beings—Hysteria—The Clover Incarnate—Hélène Vanel presenting The Incomplete Act—Cocks at Hand—Fluorescent Clips—Bedside Rugs of Woven Toebiters—The Most Beautiful Streets of Paris—Rainy Taxi—Under the Roussette Sky . . .

How Dali Remembers the Surrealist Soirée

In point of fact, it was Eluard who gave the opening signal—Breton having gotten peeved at who-knows-whom over who-remembers-what and forfeited the honor—and then, illuminated by the pocket flashlights carried at arm's length by Everybody Who Was Anybody in the Paris of the Day, the show was opened.

The big event of the evening was Hélène Vanel's spectral appearance dancing dressed as a doll or a witch out of Macbeth. I had personally arranged her entrance and the Surrealist choreography. As Breton understood nothing about music or the dance, it had taken some doing to get him to agree to the scene that the ballerina Hélène Vanel was so masterfully to bring to life with her Dionysiac fervor.

At midnight, she burst from the wings like a whirlwind, in a fantastic movement that carried the whole audience into demential delirium. She stirred them up violently with her abrupt entrance, leaping onto a bed, holding at arm's length a live rooster that started to cackle with fright. She herself then began howling in a hysterical mimodrama, rolling and disporting herself on the bed. She rose to a climax by throwing herself into the pool we had set up in the middle of the room, surrounded by reeds, and her coming—and going—ended with the splashing of water over the motionless, haggard spectators, as with their flashlights they tried to make out the zigzagging peripeteias of the inspired ballerina, who was responsible for the collapse of a good part of the terrified audience, returned to its prudent dull-wittedness. The only virtue this exhibition had in my eyes was its insolence. And on that score I knew it was second to none. Nor was

I willing to be limited in my acts and tastes by the fiats of a Breton or by any arbitrary conformism.

When, on my return from the U.S., I was asked by the Ballets Russes de Monte-Carlo to lay out the scenario for a ballet, I accepted. The Surrealists, on the other hand, mired in their political pathos, had their minds mainly on writing manifestos and accused me of flightiness, whereas I was thinking only of the essential—the main chance with myself. I would have liked to put on my *Mad Tristan,* which I had conceived several years before, but the laws of ballet forced me into one transformation after another, to create a Venusberg that finally turned into a bacchanale. Leonid Massine did the choreography, Prince Chervachidze the settings, Coco Chanel the costumes—all marvels. We were in the full flush of Dalinian creative delirium when events caught up with us. The Monte Carlo Ballets were afraid of war and flew the coop to the United States. The Metropolitan Opera put on my bacchanale and, despite improvised costumes, the ballet was a big hit. The New York applause for a while drowned out the sound of the first jackboots trampling the frontiers. Hitler had just invaded Poland.

How Dali Reacted to War

History does not concern me. It scares me as much as grasshoppers. Wars to me are the quarrels of nasty children to be avoided by making a detour. My work, my worries, my problems consist of knowing how many drops of oil are required in a color mixture, how long it should be allowed to stand, and what technique Velázquez used for his grounds—not the size and armament of a fighter plane nor the tempo of a machine gun. Military strategy, for all the holy seriousness with which it is surrounded, seems to me of a stripe with the argumentation in smoke-filled back rooms and generals' leather trousers forever smell of the blood and sweat of those they send to die in vain. I find it highly symbolical that circumstances at the start of the war found me sleeping in the very bed of the generalissimo of the French Army, Gamelin.

We had been planning a few days of relaxation at Font-Romeu, in the Eastern Pyrenees. But when we got there, our suite at the Grand Hotel had been requisitioned by His Generalissimoship who was making an inspection tour. The next day, however, I made love to Gala in that strategist's bed. I felt like Napoleon and conquered accordingly.

The following day, Gala read the cards for me and told me the exact date on which war would be declared. So I was not surprised when it happened. As the hotel was closing, I stuck my finger on the gastronomical map of France to find the place where I might best expect to keep body and soul together, eating high on the hog, in anticipation of the later perpetually identical days to come. Duck's liver with raisins, oysters, and wine suggested the Bordeaux area. I chose Arcachon.

It was a happy period. Europe, allegedly civilized, was chopping itself to bits and burning its ships in the kind of bellicose orgy that periodically in the name of the most threadbare ideals immolated the surplus of its ideas and the noblest of its men and brought the masses back to their congenital stupidity. And I, Dali, in this atmosphere of bloody rot, set up in my studio, facing the admirable vision of the Arcachon basin, took delight in myself, and was jubilant at the idea that in a world racked by paranoiac madness I was the only critic, master of the situation, inoculated against all propaganda undertakings and petty passions. I walked along the deserted beach dreaming of the end of the world and declaiming Lorca to the waves:

> *El rio Guadalquivir*
> *tiene las barbas granates.*
> *Los dos rios de Granada,*
> *uno llanto y otro sangre.*
> The River Guadalquivir
> with garnet-colored beard appears.
> The two rivers of Granada,
> the one of blood, the other tears.*

I felt the blind forces of fury, destruction, and death rising to convulse all of Europe. When, three days later, the war was officially on, Gala, wise as ever, immediately set to organizing our departure, but I wanted to carry on with the wonderful feeling of being the wisest of men in a world gone mad. And I noted, with the same jubilation, that the big difference between madmen and me was that I decidedly was not.

Coco Chanel had come to join us. Her presence always added to my pleasure. When one morning Marcel Duchamp in his turn arrived at Arcachon, it was a real time for celebration. After Coco, who was totally opposite from me, for her manner of dressing people

* "Little Ballad of the Three Rivers," *Antología Bilingüe de la Poesía española moderna,* ed. & trans. by Helen Wohl Patterson, Madrid: Ediciones Cultura Hispanica, 1965, p. 113.

kills all exhibitionism, Marcel Duchamp I felt was the most anti-Dalinian of beings, through his refusal to live in the present, his deep hermeticism, his determination to stay in the shadows and contact reality only through humor. Their presence triggered the most phenomenal psychic provocation and I threw myself headlong into work intended to allow me to get back to my most life-giving sources. With the world going off to war, I was retiring to a cram session.

Had I listened only to Duchamp, I should have burnt my brushes. He had already sent art and anti-art to blazes. He had solved his problems like the chess teacher that he was. The only solutions that interested him were imaginary. His irony was enough for anything. He felt he had already experienced every pleasure once and for all and repetition would inhibit orgasm. His career from the start had been that of one blasé. He had toyed with Impressionism in painting a *Courant d'air sur le pommier du Japon* (Draft on the Japanese Apple Tree), flirted with Cubism, assimilating it and going beyond in eight months with bewildering skill. His *Jeune Homme triste dans un train* (Sad Young Man in a Train) is somewhat himself, saddened by being on top of everything, so fast and so well. He and I were alike in our relations with matter and anti-matter. After exhibiting the *Nude Descending a Staircase* in Europe in 1912, which made him famous, it is well known that he canceled all his contracts and started giving French lessons in the U.S. to all comers at two dollars an hour—just enough to keep him in bread and beer, so, as he said, that he might "live in freedom." He had chosen to be nothing when he might very well have been all. A mentality of penniless nobility. We shared pride and genius. That's nothing to sneeze at. But he belongs to another planet, as does his *Bride Stripped Bare by Her Bachelors, Even,* in which the priest, the soldier, the policeman, the trooper, the errand boy, the deliveryman, the undertaker, the lackey, and the station master dance a ballet of inhuman mechanical love on a scenario conceived from the vantage point of Sirius. His very presence created a gap, the best part of him being his *secrecy*. He was so detached that sometimes I felt I was talking to his shadow. He had the cold eye of his "ready-mades" and my Catalan passion had little tolerance for his sovereign indifference.

I was passionately involved in the art of painting. I had always been possessed of a drive to draw and paint like the masters of old because that was the only way to translate the visions the brain imagines. The point was to equal the craftsmanship of a Vermeer or a Leonardo da Vinci. A painter in the first instance is someone who

fights his laziness by studying anatomy, drawing, perspective, color. Genius comes later—when it can. Honesty means not painting dishonestly.

The climate of decomposition that was all about me led me to crystallize my art with so exclusive a passion that I forgot the rest of the world. Which was one of the aims. The other was to discover the secret of Gala's face. First, the marvelous hazel color of her eyes, like the waters of the depths of the sea, and then the ecstasy of the transparency of her cheeks. I tried to capture an equivalency by painting lickety-split in a sort of possessed frenzy. Like an alchemist, I was trying to find the exact chemistry of the combinations of colors, meticulously counting the number of drops of oil and mixing my colors grain by grain as the masters of yore had done. I am often ridden with despair when I realize that I, the greatest painter in the world, have no idea how one goes about painting. Gala helps me and consoles me. Always her love is there, even at the bottom of the cups in which I crush my pigments. I use amber, and others of the wildest bases for fixing my colors, even potatoes; each mistake is a step forward. I spend entire days in painting and move on into sleep totally exhausted, as into death.

Gala's solicitude never falters. She bought the best Bordeaux wines and made me go along with her to Le Chapon fin or Le Château Trompette: I left my El Greco and Velázquez studies to go after jugged hare, orange duck, duck liver with raisins, garlic mushrooms. I came back to earth through gastronomical sensuality, leaving my paintbrushes in the cloakroom to pick them up again after coffee, for I was not going to let distraction take me away from the essential. The imbecility of my contemporaries seemed contagious to me and I ruled out reading the papers or listening to any radio. History disgusted me more and more. Yet, one morning, it bumped me as it went by. With a great hubbub of tired motors, trucks camouflaged under branches hiding poor dirty devils with unseeing eyes came by announcing defeat, rout, exodus, and rapine. This was too much. Our luggage was shipped Lisbonward. The Germans closed the Hendaye bridge two days later. Fortunately, Gala had put a border between them and us.

At two in the morning, I knocked at my father's door. I had crossed ten ruined villages the ghostly walls of which stood out in the moonlight like drawings out of "Goya's horrors," and my heart tightened at going through this maze of the miseries of war. My knocks must have hung out like a nightmare gong, for it took a long time before a troubled voice called out, "Who's there?" Not so long ago such a brutal awakening in the middle of the night would have meant

VELASQUES

arrest and death. In the aching memories, my intrusion awoke a fear.

"Me, Salvador, your son."

However firm my voice, my figure still seemed to be out of Dante. And my kin, motionless, eyes big and staring, stayed grouped together in the dark, confronted with the intruder in the night, fanged mustache and all, appearing like a ghost. They were all looking for a footing in the shifting ground of what attitude to take. Our love overcame it.

They welcomed me with kisses and hugs.

Quickly, a table was set, on which my sister and aunts laid out anchovies, tomatoes, and oil. My father sat opposite me, still formidably large. Drinking me in. We exchanged few words. The anxiety of the war had gripped me.

I crossed the house to get to my room. I was shown where the balcony was missing, knocked off by a bomb. Under the dining-room table they had shown me the spot on the floor blackened by the fire over which anarchists had prepared their meals. There was a chink in the wall. But in my room nothing had changed. The spot on the drapery was still the same and my ivory rabbit sat on the dresser. A key was getting rusty. At the bottom of a drawer, I found my old buttons. The window—from which on a certain morning I had glimpsed a sublime vision of woman—opened on to the night.

There was I, Dali, as living as if time had never existed. All the things around me, as real and indestructible as my soul, were in their places. All the executions had been for *nothing*. The tortures for *nothing*. My sister had almost lost her mind, but she too had come back to sanity. And *nothing*, not even death, could change this reality forever engraved in me with the strength of tradition. My father was asleep on the other side of the partition, or perhaps he lay awake, thinking of the prodigal son who came home as if *nothing* had ever separated them. The fury of men had come breaking through like angry waves against the stone piers of time, leaving a few useless, nauseating deposits.

The next day, I went to my devastated house at Port Lligat. The shutters hung askew, the doors were off their hinges. Nothing remained of the furniture or dishes. Everywhere, on the walls, graffiti which in their challenge-game recorded each passage of rival armed troops, shouting their arrogant certainty of victory. I could follow the progression of the war as on a general-staff map. Anarchists pushed out by Communists, return of the Trotskyists, the Separatists, the Republicans, and finally the Francoites with their "Arriba Es-

paña!" covering a whole panel. I kicked the débris out of the way and went out.

Lidia, the well set, was waiting for me in front of the house that for so long had been hers. She laughed with her toothless mouth as she saw me. I kissed her, and she told me of her war. With her noble madness, she had always bet with the surest instinct. Each evening, at the worst moments of wartime fury, she sat on the beach at Cadaqués and built a big fire that she methodically kept going. When the tired, chilled, and hungry soldiers emerged from the night and the cold, they came over and opened their packs; Lidia was their canteen-keeper. When they had nothing left to devour, they went out foraging, and Lidia became their fence. The next day, they got killed or driven off by the others. Lidia rebuilt her fire and resumed her role as provider. They all went through that way, the fanatics eaten up with their hatred, the argumentative revolutionaries, the cruel military men, the harmless dreamers. At Lidia's fireside, ideas, passions, disciplines melted away. They all held their hands out to get warm and paid tribute so as to eat. That is how revolutions work out.

As Lidia said, "There is always a time when they have to eat." I like the idea that kitchen fires win out over the fires of war.

On the way back, I went through Madrid to bring news of Lidia to her master, Eugenio d'Ors, who had immortalized her in *La Bien Plantada*. We embraced as if we were never to see each other again. He introduced me to his companions, the philosopher Eugenio Montès, the poets Marquina and Dionisio Ridruejo. I spent a week at the heart of this Platonic banquet, answering the questions of my friends, curious and avid to find some bearings. All of them had been marked by the civil war but they were more than ever determined to live by the power of the spirit.

To hold on to oneself! Not to give in to the attractions, the tumults of artificial interests in the idea of collective murder that was dominating Europe and which my country had just lived through —there could be no other goal for an artist. Gala was waiting for me in Lisbon with a veritable turnout of the International Who's Who. In Praça del Rossio, famous for its Inquisitional stakes, the dog-days sun was burning down on the most famous creative movers of the flight drama, the last act of which ended in a visa: Schiaparelli, René Clair, the Duke of Windsor, Paderewski were mopping their brows as they dreamt of good old American refrigerators. Meantime, they had to make do with overcrowded hotels, stopped-up toilet bowls,

and the dankness of police offices in which blind and unfeeling public servants parsimoniously meted out rubber stamps that spelled heaven or hell. The streets were full of friends with so much anxiety in their eyes that one wondered whether it were better to recognize them or let them forget you. Dali did not wait to find out, and the *Excemption* carried me off toward freedom. I was never so happy for my egotism that kept me from looking back and avoided my being turned into a statue of the salt of pity and compassion. Unhappy the poor of mind who let themselves be tied up by noble feelings!

I was abandoning the old cracked face of a senile, lazy Europe, purulent with its contradictions, gnawed by skepticism, drunk with materialism. Leaning on the rail of the *Excemption,* I watched as the outline of a continent that was soon to be nothing but a symbolic line melted away into the hot haze—and, like a powerful nostalgia, the memory of my youth surged up in my heart. I discovered a thousand reasons for loving the continent that had given me so much. But it was probably necessary for fate to have its way, for the great blood purge to drain the abscesses, for suffering and tears to enlighten intelligences. I would come back, I told myself, when Europe had again found faith in man. It was a blue dream, such as all exiles have.

Fortunately, I had Gala at my side, with her eyes and her skin and her strength. All the rest, after all, meant less than one of her smiles.

How Dali Lived Five Years in the United States

At Hampton Manor, Caresse Crosby was awaiting us with all the hospitality of a wealthy American woman, and with her we found a bit of the charm of the Ile-de-France and her Mill of the Sun. We had barely gotten there, when I put two big canvases on my easel and started to paint *Araignée du soir, espoir* (Daddy-Longlegs of the Evening—Hope)* and *La Résurrection de la chair* (Resurrection of the Flesh), that I was at for five years before finishing. On the first of these, the mouth of a cannon, supported by a crutch, vomited a spirited horse and a tongue turned into a breast-foot-victory. Mean-

* The title of this work, translated in this way in the A. Reynolds Morse Collection at the Salvador Dali Museum at Cleveland (Beachwood), Ohio, is intended in the artist's original to have the ring of a rhyming proverb or talismanic adage. It might therefore better be rendered in English as: *Spider at Eventide, Hope Betide,* or *Evening Spider, Hope Betider.* (TR. NOTE)

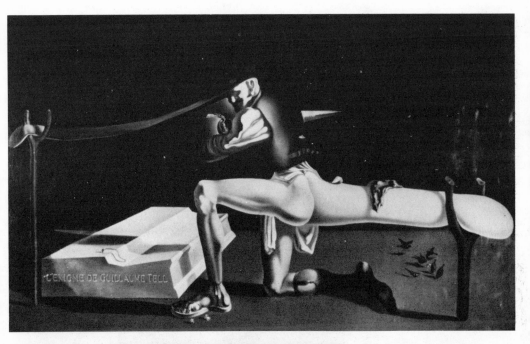

The Enigma of William Tell (1933, in the Stockholm Museum) illustrates the myth of the game dominated by the son's stoicism.

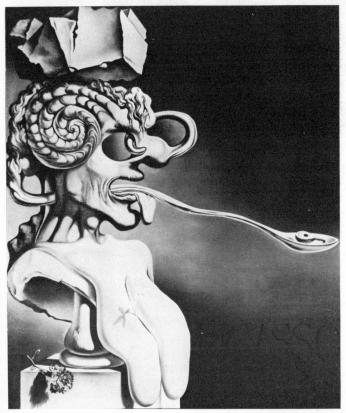

The *Portrait of Picasso* brings together all the elements of the Dalinian plastic palette.

The railroad station at Perpignan, center of the Dalinian world.

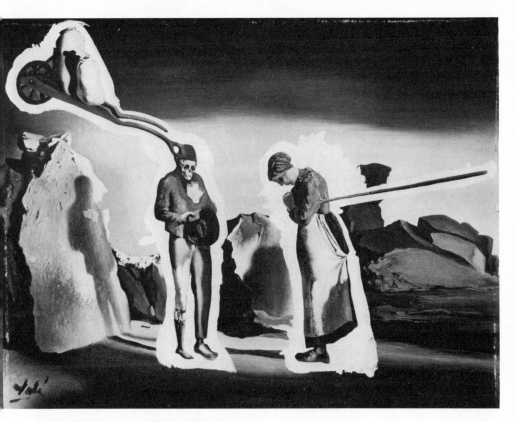

The two characters of Millet's *The Angelus,* as reconceived in one of Dali's works, *Atavisme du crépuscule* (Twilight Atavism) (1933–1934), stand like the two markers, which, from Perpignan to Salses, measure the base of the earthly meridian. This is where the whole mystical universe of paranoia-criticism begins.

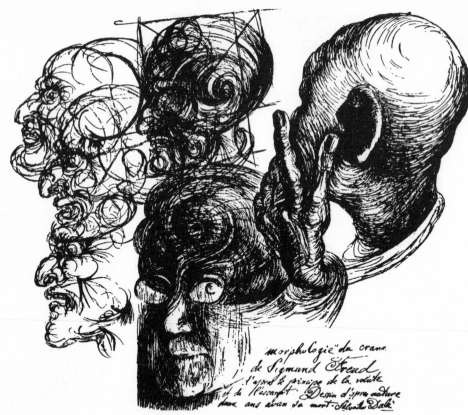

The inscription in Dali's hand reads: " 'Morphology' of the skull of Sigmund Freud, according to the principle of the helix and snail. Drawn from life two years before his death. [signed] Salvador Dali"

The "anuses" of Castor and Pollux, sculpted by Dali as images of eternity, to illustrate one of his *Ten Recipes for Immortality*. They are the symbol of his dead brother, but also of Gala, his double. To Dali, "the body's principal zone of hibernation is the arsehole."

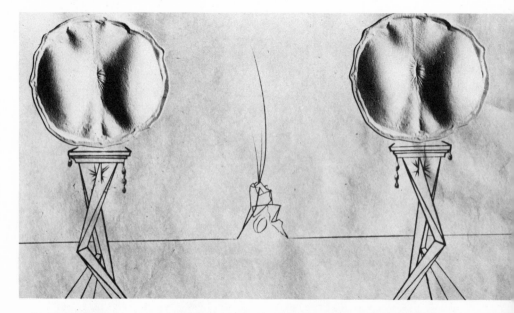

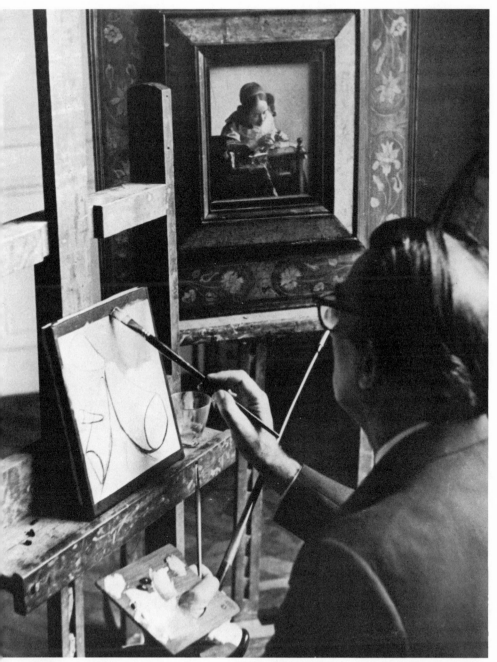

After an hour of meditation and very careful measurings of Vermeer's famous painting of *The Lace Maker* at the Louvre, Dali suddenly starts to paint rhinoceros horns.

A royal pin: "I am a Monarchist in a morphological manner," says Dali.

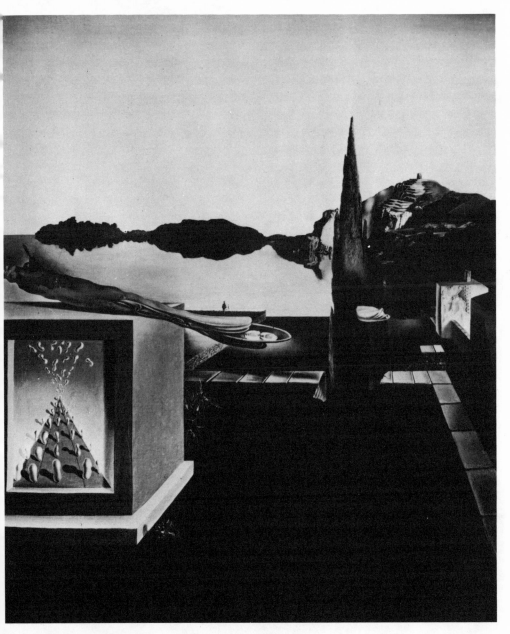

The sublime landscape at Port Lligat, the Dalinian setting par excellence, from one of his works, *Objet surréaliste de la mémoire instantanée* (Surrealist Object Indicative of Instantaneous Memory).

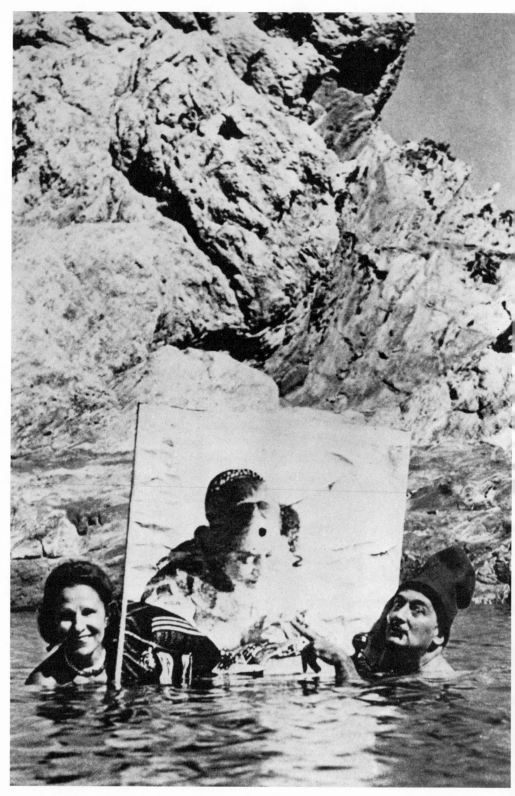

Gala and Dali bathing near Cadaqués, at Cape Creus, in Culip Cove, while holding one of their ubiquitous reproductions of Vermeer's *The Lace Maker*.

while, a runny woman's body is playing a living violoncello in front of an angel hiding his face.[1] The *Resurrection of the Flesh* is a kind of Doomsday in which gold, power, thought, love, and death are all brought up for judgment before life.

The Germans were parading through Paris when I applied the first brushstroke, and leaving it when I signed the picture after having registered in it as in a seismograph all of the fever of those terrible years which with Catalan fanaticism I refused to take any part in, but of which my genius recorded all the variations. I had in the interim had the fun of painting my *Autoportrait mou avec du bacon grillé* (Soft Self-Portrait with Fried Bacon), which translated my new way of life at Pebble Beach, California.

America had quickly adopted me with the luxury it reserves to its chosen. The New York Museum of Modern Art in 1940 gave a retrospective show of forty-three of my paintings and seventeen drawings, to great success. When I traveled, it was like a Roman emperor going up to the Capitol. For two years, this exhibit toured the United States, appearing in eight of the largest cities. That constituted consecration. Then the Knoedler Gallery for a time took over handling my interests, presenting twenty-nine pictures, all of which were sold.

Europe was being put to the sword from Glasgow to Stalingrad and going through convulsions of rage. This flower of civilization had engendered the miasmas of a political line now devouring it. Nothing was being left of what had been the pride of its noble, prodigal races. An iron collar around its neck was crushing it. I now felt that I had been chosen by God's angels to keep the great tradition intact and bear witness to the genius of a continent. This certainty gave me great courage and genius-inspired intensity of concentration and creation. I felt the time would come when, on a ravaged earth, reconstruction would be needed and that I owed it to myself to be there with all the gloriousness of my genius to insure a new renascence.

Between the ballet *Labyrinth* and the illustrating of Maurice Sandoz' *Fantastic Memories,* I started to write *The Secret Life of Salvador Dali,* so as to bring my truth to the world and open the doors of knowledge on the vertiginous depths of my life. I knew that through my experience I was answering the basic questions of people of today and giving current responses to the feeling of death, the great time-space crisis that was unsettling sensibilities, the sublimation of sex instincts. I revealed the sources of a method that allowed

[1] See Chapter **XVII**.

for the taming of madness, all madnesses, and offered the infinite resources of childhood joys and nobility of living. Never had a human being so revealed his intimacy and the depth of his being. And if, thirty years later, I now go back over those pages of my life, it is not to retract anything, but to add, with the benefit of greater distance in relation to people and things, the wealth of a new season of my life and the light of my ever sharper and more penetrating genius.

The bomb at Hiroshima exploded in an immaculate sky. *"Pikadon"* (Light and noise), was how the few surviving Japanese described it. I was painting Gala in a nude rear view and Galarina, engrossed in my love and the charm of sensual fulfillment, when I felt the seismic shock of the explosion that filled me with terror. Not for a second did I imagine the two hundred thousand dead, who, being reduced to ash, were not easy to apprehend, anyway, but I thought with horror of a chain reaction that might have ignited the whole world before I finished the perfect bosom of my Galarina, compromising my immortality. The fact of being thus dependent on the hazards of history disquieted me. No one was safe in whatever corner of the world. I resolved to study without delay the best way to preserve my precious existence from the inroads of death and began seriously to be concerned with formulas for immortality. The *Melancolia atomica* that I then painted expresses the doubts and uncertainties born in me on August 6, 1945.

My success did not end, and my genius, surprised for a moment by the atomic explosion, was quickly called upon again. I was asked to illustrate *Don Quixote,* and dove into the lithographic plates certain that I was going to renew the whole technique, but never guessing that I had selected a road that would take nineteen years to lead me to Dulcinea. Publishers, who are like flies attracted to honey, now filled my house; one jumped out the window with the proofs of *Macbeth* while another was coming in the service entrance to propose that I illustrate *Montaigne,* or else they were trying to whet my appetite with the fifty secrets of the art of magic or the autobiography of Benvenuto Cellini. I had one answer for all of them: "Cash in hand."

I am a goldsmith; gold alone inspires me. The richness of the American soil was causing the golden corn of old Europe to rise for harvesting by the Catalan Dali, in whom desire alone grew more intense—in keeping with his name. It could not be that the sordid massacre which on the other side of the Atlantic was decimating the most noble humanity did not serve some purpose. Preserved, cherished, sated, I stood witness against the generalized stupidity and

dominated my period with all the glory of my genius, untamed, haughty, indestructible.

During this time, I truly felt that I did not belong to the race of masochistic insects offering themselves as a holocaust to barbarous gods when they had at their disposal all the possibilities of faith. Yet, I drew from it all a few useful conclusions on how to dominate men, subjugate women, and stupefy children. I think I have shown how my cynicism and genius have been able to make the most of these observations.

"EVERYONE IS A PACIFIST; GOING AGAINST ALL THE PRINCIPLES OF OUR ACTIONS SINCE ANTIQUITY, THE RENAISSANCE, THE MARVELOUS SPEECH BY MICHEL DE MONTAIGNE ON THE ART, THE NOBILITY, THE GRANDEUR OF THE MILITARY ARTS—EVERYONE, WHETHER SOVIET OR AMERICAN. THIS IS THE GREAT DECADENCE! JUST AS IN A MONARCHY I FEEL THAT THE ANARCHIST WHO WANTS TO KILL THE KING IS ULTRA-RESPECTABLE, SINCE BY HIS ACTION HE GUARANTEES THE MAXIMUM OF DIVERSITIES THAT A PERFECT SOCIETY—WHICH IS WHAT ABSOLUTE MONARCHY IS—MUST CONTAIN, SO, IT IS MONSTROUS FOR A HUMAN BEING TO CONTEMPLATE A HUMANITY WITHOUT WAR."

XIV

How to Become a Super-Snob

When I first met Helena Rubinstein in New York, all I saw was the majesty of a Bourbon nose, as huge as a plowshare, coming toward me, carried hoppingly on short legs, while under the light of the chandeliers there shone a constellation of emeralds that gave one the impression that her fingers were carrying torches while her neck was girt with flames. This burst of luster told me she had multimillions. When she laughed, her eyes remained as cold as high-shoe buttons and her skin—as parchmented as the face of Tz'u-hsi, the last Dowager Empress of China, whom she resembled—was furrowed with colored wrinkles, as with the war paint of an old Sioux chief.

In 1942, Helena Rubinstein was worth a hundred million dollars. She had apartments in New York, London, Paris, and Grasse on the Riviera. She ruled over a factory and a string of stores in New York, Chicago, Boston, San Francisco, Australia, Europe, from which flowed rivers of beauty creams, ointments, cleansing creams, and clouds of powder. She plastered more than 50 percent of the feminine sex in a carapace of illusions that remade their faces as well as their souls. This noble enterprise had given Helena Rubinstein the character of an unyielding corset.

As an emigrant from Poland, the eldest of eight children, she

landed in Australia at age sixteen with a dozen jars of her mother's beauty cream in her trunk, bent on conquering the leadership of an empire. She directed men and women with an equally iron hand, yet she did not know how to use a telephone: she could not dial a number and screamed into the receiver with Dalinian fieriness. I impressed her mightily and returned the compliment with my royal hauteur.

"You know," she told me, "that I own the building we are in." Then, as I did not seem to react, she added: "I liked the apartment, but the landlord would not rent to Jews. So I bought the whole thing."

She showed me through thirty-six rooms of a triplex on the fourteenth floor of the building. The entryway had been made into a jungle right out of Douanier Rousseau. From sitting room to picture galleries, it all finally led to her own bedroom. There she nestled like the minotaur in the heart of the labyrinth and waited for her prey in an immense transparent bed, the legs and incurved half-canopy of which were fluorescent. Helena, lying there, seemed to be floating on one of my limp watches, and she strewed about her emeralds, pearls, amethysts, pell-mell, before going to bed, accumulating the rivières of diamonds night after night, until some mornings her room was a bright galaxy of the first magnitude, blinding in its splendor. Then Helena seemed less wrinkled than usual.

The morning she received me in her bedroom, she wiped her nose on the satin sheets.

Helena Rubinstein had just gotten this new apartment on 65th Street in Manhattan—the thirty-six rooms on three floors— when she ordered three frescoes from me for the dining room. As Princess Gourielli, privately often referred to as the Sarah Bernhardt of the beauty world, but Madame to her intimates, she was a Dalinian personage. Her love of jewels and money, her caprices, her demands were deserving of my full attention.

The dazzling jewelry was intended to make her age go unnoticed. Each of our encounters was an occasion for me to see more crystalline bottle-stoppers around her neck, hanging from her ears, or ringing her fingers. She was a shrine, a totem, a Javanese goddess. . . .

That was how she went about the world—carrying Ali Baba's treasure in her hatbox. I, at least, never saw her with less than eight strings of pearls, but she traveled only by taxi.

"Chauffeurs are all robbers," she said. "The last one stole my Rolls-Royce."

Her husband, Georgian Prince Gourielli, never opened his

mouth except to blow smoke rings; her son by her first marriage, Horace Titus, somber as a character out of a Racine tragedy, seemed always to be reciting the verse reply to some speech of Athaliah's; Oscar Kolin, her nephew, nodded his head like a metronome set to say only yes. Her niece Mala was a shadow. But her left hand—who knew everything that her right hand did—was a Miss Fox, her secretary, who kept her totally informed like the number one eunuch of a harem reporting to the sultan. Madame was supposed even to have taken Miss Fox along on her honeymoon in 1938—at any rate, she was there when Helena emerged from her tub in the morning and at night before she got into bed.

She was to hang my three paintings not far from seven Renoirs, two Modiglianis, and a Toulouse-Lautrec that decorated her salon. I was not too happy being in such a neighborhood, but what was much worse was the presence of works by the sculptor Nadelman. In 1930, she had met this Pole in Paris; wanting to do her *landsman* a favor, Helena, who could sometimes be stupidly sentimental, had set up a New York show for him that was a flop. So she bought the thirty-six pieces that were now in the apartment. Walking along on a Miró tapestry, I glanced about at the Braques, Chagalls, Derains, Juan Grises, Matisses, Picassos, Rouaults, and commented mentally that apart from mine she had only minor works by the most important artists of her period.

In the same way she had bought an icon in Moscow, where at the same time she had married Gourielli, and a carload lot of African sculpture acquired from a German Jew who had had to flee from Hitler.

"But you haven't seen anything yet," she told me. "The finest things are in Paris. I hope the Germans are looking out for them. Come see my wardrobe."

There were a hundred dresses in her closet, and as many coats, pairs of shoes in a row, hats on papier-mâché heads that Folies-Bergère showgirls would have turned their noses up at, furs that seemed sleeping animals. She ticked them off: Molyneux sable, Somalian leopard, tourmaline mink. In a special small closet there was a minicollection of Poiret, Doucet, and Lanvin creations, draped and beaded, reminiscent of the fashions of 1914.

"Those must be your grandmother's gowns," I said. "What a wonderful sense of family loyalty!"

The laser she shot out went right through me. My mustache bristled with delight.

"Vertès designed my hat molds for me," she said. "You know, I never wear them. I just buy them to look at."

Helena Rubinstein slid back the glass panels that protected her millinery display. "I often entertain myself by imagining what I would look like if I wore them. Then I take my little topper," she added, pointing to the simple cloche she wore all the year around, "and go back to work."

It seemed to me indeed that the difference between the Madwoman of Chaillot and Helena Rubinstein might well be just a hat. Both were weavers of illusions who could easily engulf us in their worlds if we were not careful.

Conversation with Helena Rubinstein was a Napoleonic monologue. She announced her victories, dictated her decisions, and always came back to money.

"I came to London in 1907. In Australia, I had earned half a million dollars. I opened a shop in Paris two years later. That was the time of the great couturier collections. I created tubes of lipstick, tinted powders. I was asked to make up their models. It was a triumph. Poiret created his loose gowns and threw corsets to the dogs. My beauty institute was the ideal solution for superfluous fat."

But I was no longer listening as she enumerated the three mammaries of her fortune: massages, showers, and colonics. No one could resist her free "consultations." The famous novelist Colette was the first butterfly caught in her net. Helena Rubinstein got her to make a statement that carried tremendous weight: no woman, she said, could hope to keep her lover unless she knew the magic of massage. This, it seems, created much merriment in stag circles.

Helena Rubinstein spoke of love as I did of the press:

"I have always treated men the way they deserved." Then, dreamily, "I used to have suitors in the old days, in Australia, who wooed me very ardently. When the fellow was really on the hook, I let him come home with me—to spend part of the night helping me fill the jars of cream, and packaging them, and in the morning I would send him out to make the deliveries."

A multimillionairess, Helena Rubinstein had a Dalinian sense of money. Her favorite statement (to others) was: "Keep the expenses down; little pennies saved add up to great sums."

Beyond that, she liked to tell of how she had sold her business to the Lehman Brothers, then patiently, writing privately to hundreds of women who were small stockholders, accumulated proxies—so that, after the 1929 market crash, she was able to buy 50 percent of

the stock back from the Lehmans for two million dollars—four million less than she had sold it to them for a year before.

Making money was a religion to her; no profit was too small. One of her secretaries told how when they traveled together, she paid all their joint expenses out of an advance taken from one of her companies, then filed the vouchers with another of the companies, so as to collect twice for the same outlays.

Money to her was the only criterion of success and I could readily have made her my vestal virgin. At the time of one of our first meetings in 1942, she had just launched a new scent with thousands of blue balloons released over Fifth Avenue, carrying samples of the perfume and her card with simply the name of the new product, "Heaven Sent." Was it a good idea? she wondered aloud, and asked my opinion.

Later, she told me, "It *was* a good idea: a million-dollar good idea."

Does Dali Consider Helena Rubinstein Dalinian?

I think that except for me and Picasso, whom she referred to as "the devil," she was continually picking everybody's brains.

She loved to tell how she pirated her best ideas after a good meal, and how Colette, Marie-Louise de Noailles, and Louise de Vilmorin, "over their dead heads," so to speak, had given her some of the ideas that had made their way as Rubinsteinian slogans. While I kept my mouth tight shut, lest she swipe some Dalinian idea, she evaluated just about everybody, commercially speaking: Modigliani, whom she had known, was "nice but not clean"; Matisse "a rug peddler," because he bargained too sharply; Hemingway "a big mouth with filed teeth"; Joyce "nearsighted and smelling bad"; D. H. Lawrence "timid, and dominated by women"; while she remembered Proust as a "little Jew in a fur coat smelling of mothballs."

The value of a work depended on the difference between what she had paid for it and what it seemed she might sell it for now. "I'm a businesswoman," she constantly repeated. Max Ernst she saw as a twenty-thousand-dollar profit. So she liked him. But when she tried to buy another of his paintings, and now was asked the going price, she balked: that would not be getting a bargain.

One of the subjects of real pride with her was her title of Princess, but she was deeply hurt when one day she overheard one of her lady guests saying: "In Georgia you're a prince if you just own

some sheep." While the Prince's title might have been suspect, the Princess' bank account was coat-of-arms enough. But as patron and collector of art she did not reach the caliber she had as business-woman. She needed the paranoia-critical method to round her out. The jewels that she ornamented herself with as with holy turds satisfied her pride and her thirst for living. But she tried to be "different." Misia Sert had wanted to help her toward this end. They had met at the turn of the century, when Misia was one of the queens of Paris and Helena was just getting started. Both being Polish, the language was a link between them. Misia had just married Thadée Natanson, son of the publisher of the intellectually and socially prestigious *La Revue blanche,* and was well suited to be her cicerone: in her salon, one met Stéphane Mallarmé, Renoir, Vuillard, Dufy, Helleu, princes, kings, and Marcel Proust who grilled Helena about "how she thought a duchess would make herself up."

How Dali Remembers Misia Sert

Misia's third husband was the Spanish painter José Maria Sert, who lived on the Ile Saint-Louis in a dilapidated eighteenth-century townhouse. Misia later sold it to Helena "for a song," but "it cost me a whole opera to fix it up," she said. Adding, "Fortunately, I had made those four millions from the Lehmans in the meantime."

All of Misia's painter friends did portraits of Helena. "It's excellent publicity and a good investment," she told me, looking me cynically in the eye. I did not blink. But somewhere fate was preparing a revenge for Misia, her friends, and a few others—a fate signed Picasso.

One of the pleasures I was looking forward to in going back to Paris was seeing Coco Chanel again; Misia was her best friend and a true sorceress of charm and intelligence. Misia was a natural-born musician. Liszt had taught her her scales, Fauré had been her professor, Debussy later sang *Pelléas et Mélisande* to her and Grieg *Peer Gynt.* She was almost the perdition of old Renoir, who was in love with her breasts and did eight portraits of her that are today in either the Barnes Collection or the Leningrad Hermitage. She set them alongside those done by Vuillard, Bonnard, Vallotton, and Lautrec.

The Symbolist poet Mallarmé had been her neighbor at Valvins, on the banks of the Seine, and used to drop in on her in his

wooden country shoes. He wrote a tricky quatrain for her, on her fan.[1]

Paul Morand, in his *Venice,* described her as "a genius of perfidy, refined in her cruelty." [1]

Her second husband, Alfred Edwards, owner of the mass-circulation newspaper *Le Matin,* gave her the other part of the social world after her divorce from Thadée. The third was a Catalan. Sert was a giant with huge appetites who mainly taught her how to go through a fortune with nonchalance. His painting was monumental, too, "but shrinking," people said at the time.

The big event in Misia's life was her meeting with Coco Chanel. The war had smashed all corsets, both the actual, physical ones, and the comparable symbolic taboos. "In 1919, I woke up famous," Coco Chanel said, "and with a new friend who was to give its full meaning to my success."

Did Dali Feel Friendship for Coco Chanel?

I look like all the characters I paint and my pictures all hang from my mustache. In the same way, Coco was bobbed hair, costume jewelry, black tailored suits, sweaters, suntan, white pajamas. Her existence too was an uninterrupted monologue in which she told everything, and the disorder of her existence became a magical stability. To go into her salon was to discover the Surrealist Golconda. The first time she invited me, I immediately recognized who she was. In the midst of her mother-of-pearls, the ebonies, golds, crystals, masks, mirrors, perfumes, in which lions, does, and a charging wild boar were her mythological flock, Coco Chanel, never without a hat

[1]
> *Aile que du papier déploie*
> *Bats toute si t'initia*
> *Naguère à l'orage et à la fois*
> *De son piano Misia*

[Virtually untranslatable, this might be approximated in English as follows:

> Wing that paper doth unfold
> Beat full strength if hast been told
> Lately of the storm so bold
> Launched as Misia's piano tolled

TR. NOTE]

[1] Misia, "who harvested geniuses who were all in love with her, collected hearts and pink Ming trees: launching her fads that became fashions . . . imitated by the empty-headed women of high society, Misia was the queen of modern baroque . . . Misia sulking, pretending, a genius of perfidy, refined in her cruelty . . . unfulfilled, Misia whose piercing eyes were still full of laughter when her mouth was already turning into a pout."

on her head, smoking incessantly, talked, talked, talked—imperious, innocent, terrifying.

She would say,

"Celebrity is loneliness, isn't it, Dali?"

"People like us don't need advice; we need approval."

"My friends, there's no such thing as friends."

In which she was not mistaken, since to me being incapable of friendship is my pet luxury!

She would say,

"People with a legend end up being like their legend, so as to reinforce their own celebrity."

And that was how she had manufactured everything she had: family, childhood, age, and even her given name.

My paranoia-critical mind in its genius perfectly understood Coco Chanel, who had suffered from being ill-loved. Her father had betrayed her after her mother's death, allowing her to believe he was preparing a new home for her in the South, when he was leaving the same day for the Americas, never to return.

From that day forward, she was never again to trust a man. She read cheap romances from which she could borrow a different family and imagine herself a heroine. At twenty, she was swept off her feet by a rich, titled lieutenant of the hussars, who took her to Paris. She made an entry at Maxim's and made friends with Emilienne d'Alençon, one of her handsome horseman's official mistresses. Humiliated, she looked daggers at those corseted, proud-busted beauties of the night who ruled over bodies and hearts, sweeping the dust with their long-trained gowns and dancing with wide wiggling of their arses, on their high heels. It was *against them* that she first invented the men's felt hat with split crown, one rim down and the other up; *against them* and their sexy plumed hats that she created this new fashion that was launched by the actress Gabrielle Dorziat. *Against them,* too, like a bomb she exploded her fashions of the tailored suit, the knit frock, reducing them to *nothing.*

She had known how to turn every event of her existence to her advantage so as to grow ever more important. "I was able to open a high fashion shop," she said, "because two gentlemen were outbidding each other for my hot little body." In the paranoiac Parthenon, she deserves a special mention.

"I don't know what I'm trying to forget," she would say; "maybe that I'm alive. And I keep moving to pretend that I'm trying to catch up with time."

She was very proud of her neck, "the longest neck in the

world," as she called it, and to keep it in shape, she kept her head high when she ate. She massaged it constantly, as if it were an enormous penis that she was masturbating.

She walked in her sleep, "all night in the middle of gardens." One morning, at the Ritz, the chambermaid found a tailored suit cut out of a terrycloth robe during the night with a pair of scissors. "In the lapel, the suit had a gardenia fashioned from a hand towel."

She told a funny story about her first evening at Maxim's: an Englishman and his lady had just sat down, when a woman broke in, grabbed a glass and smashed it, and with the jagged stem cut up the gent's face. "I ran away," she said. "I climbed up the stairs and hid under a table covered by a tablecloth that came all the way down to the floor. I am terrified of blood.

"The second time, at Maxim's, we had hardly sat down when a man came in waving a revolver and forced us all to get up and stand with our hands up. You can understand why it took me thirty years before I ever went back to that restaurant."

Coco Chanel considered herself an artist and spoke of herself in the third person: "She took the English masculine and made it feminine. All her life, all she did was change men's clothing into women's: jackets, hair, neckties, wrists. Coco Chanel always dressed like the strong independent male she had dreamed of being. She set women free because she had suffered too long from not being free herself. Showing what so-called meaningless fashions can sometimes be due to!"

Was Coco Chanel Capable of Friendship?

I think Coco Chanel gave her friendship not to beings but to entities. I was *genius* as Diaghilev was *dance* and Coco was *fashion*. She liked herself very much and talked about herself tirelessly.

Misia Sert had introduced her to Diaghilev. He treated her as a sister, though he was in love with her. When he was broke in London, after *Sleeping Beauty,* which was a resounding flop, he took refuge in Paris, at Misia's at the Ritz. Coco was there. The next day, without telling a soul, she gave him a big check that allowed him to get started again, on the sole condition that Diaghilev was to keep her generosity a secret. This silence completely upset Diaghilev, who always expected his angels to be in love with one of the ballet members, male or female.

She backed Stravinsky's *Rite of Spring* and *Noces,* and Diaghilev tried to pay court to her, but she sent him back to his pas de deux. She was doing it out of something quite other than love, perhaps to prove something to herself—her freedom, her power, her masculinity. The money she had acquired let her prove her reality in her own eyes. While at sea on the *Flying Cloud,* the yacht belonging to the Duke of Westminster, one of the great loves of her life, she heard that Diaghilev, diabetic, was on his deathbed in Venice; she forced the yacht to set sail for Venice. She got there after he died, just in time to see Diaghilev to the cemetery. Serge Lifar and Boris Kochno wanted to follow the cortège on their knees. Coco told them to follow her, and led the procession of mourning friends followed by her two pages. But she was not one for gratitude, and paid no tribute to memory.

"Every morning, the bag of the past ought to be emptied," she used to say, "else the weight of life drags you down and soon you're in the dust, with the ghosts and the idiots."

She loved Pierre Reverdy very much, to the point of hating Jean Cocteau, because he was so successful a poet. "Thank God, the future will change all that," she would say, "and only Reverdy and Blaise Cendrars will remain."

In Reverdy, she loved his saintliness—but he preferred the peace of Solesmes Abbey to a great love. Coco was also long fascinated by the fact that the Duke of Westminster did not mail his love letters to her, but sent the daily missive with a messenger specially dispatched from London. They did not marry because the House of Chanel could not enter into alliance with the House of England. But there was true luxury in their relationship.

Once, to apologize for having made her jealous, the Duke, during one of their yacht cruises, gave Coco an emerald; she leaned against the railing, admired the light playing on the gem, and then, having seen it, let it drop into the sea. She was being Cleopatra who, to stand up to Caesar, took the pearls the Imperator gave her and dropped them into vinegar to dissolve them.

I was often her guest at La Pausa, her villa on the Riviera. The whole *Almanach de Gotha* went bathing there, without formality. Around the Duke were Cocteau, Georges Auric, Prince Kutuzov, the Beaumonts, Serge Lifar. Back at the house, there were two huge buffets on the terrace, with cassoulet, risotto, stew, fishes in aspic. Hot and cold in profusion for all tastes. After that, we would go inside. Over her gilt iron bed, Coco had hung some useless fertility amulets.

Winston Churchill forced the Duke to marry the daughter of the royal palace's chief of protocol. In one night, a memorable rupture scene sent all the appearances of happiness flying in smithereens. The sun disappeared; it was the ice age.

The last time I had seen Coco Chanel was at Arcachon just before the great exodus to the U.S. when the war was on. She spoke of the vacations of her girlhood at an oyster breeder's; he took her out on his boat in the morning and gave her fresh-gathered oysters to eat. "I would spit them out disgustedly," she said. "Later, I was sorry I had not learned to like them. When I lived at the Ritz with my fine officer, I used to have them sent up to my room and, trying to get myself to like them, invited the chambermaid to share them with me, but she unfortunately had no taste for them either. How about you, Dali, do you like oysters?"

I like tearing the oyster out of its shell as I like crushing bones so as to suck out the marrow. Whatever is sticky, gelatinous, viscous, vitreous, to me, is suggestive of gastronomical lust.

As Gala and I were about to sail again for Europe, I thought back on that conversation and my mouth watered with pleasure at the vision of the friends and the meals that lay ahead.

From the boat deck, I looked at New York with satisfaction. Helena there, Coco in Paris. One of the queens of world snobbery in each capital, to say good-bye and to welcome me, and Gala in my heart and my bed. What luxury! But what happiness to get back to the transcendent beauty of Port Lligat, my kingdom, my Platonic cave.

As soon as I get back, I dip again into the splendor of the gulf, become intoxicated with the sacred landscape that encloses the horizon. I walk on air. I forget the haughtiness of the skyscrapers and the agitation, the noise, the excitement of America. There is no way out, at the point of hypersnobbery I have reached, but to become a mystic.

I allow the sun to seep into me and I experience the Mediterranean light. Like a burning arrow, I receive the certainty of my communication with God whose elite creature I am. My return from America is consecrated by this solemn event: after success, money, the greatest hit of snobbery, God brings me His witness. I feel I am the divinely chosen.

That is the time the government decides to declare Port Lligat "picturesque, of national interest," thereby turning this corner of the world into a Dalinian church. I feel assured of the triumph that awaits me in Paris.

*"I AM VERY FAITHFUL TO MY FRIENDS, BUT
ALWAYS REASONABLY. I DO NOT EXPERIMENT WITH
MY EMOTIONS WHERE THEY ARE CONCERNED.
CREVEL HAD A BREAKDOWN IN A LITTLE VILLAGE
WE LIVED IN AND WAS AT DEATH'S DOOR AND I
COULD NOT EVEN TOUCH HIM. I ACTED AS I
SHOULD HAVE, IN A WAY THAT EVERYONE
CONSIDERED THE MOST DEVOTED POSSIBLE, BUT I
COULD NOT BRING MYSELF TO TOUCH HIM IN
ORDER TO HELP HIM. ANYTHING THAT IS
SENTIMENT IS STRICTLY CHANNELED TO MY WIFE
AND ALL OTHER BEINGS LEAVE ME ABSOLUTELY
INDIFFERENT BUT I ACT TOWARD THEM WITH
INTELLIGENCE AND REASONING."*

XV

How to Pray to God
Without Believing in Him

The atomic explosion of August 6, 1945, shook me seismically. Thenceforth, the atom was my favorite food for thought. Many of the landscapes painted in this period express the great fear inspired in me by the announcement of that explosion. I applied my paranoia-critical method to exploring the world. I want to see and understand the forces and hidden laws of things, obviously so as to master them. To penetrate to the heart of things, I know by intuitive genius that I have an exceptional means: mysticism, that is to say, deeper intuition of what is, immediate communication with the all, absolute vision by grace of truth, by grace of God. Stronger than cyclotrons and cybernetic computers, in a moment I get through to the secrets of the real, but only facing the landscape of Port Lligat will this conviction become certainty and my entire being catch fire with the transcendental light of that high place.

On the shore at Port Lligat I understood that the Catalan sun which had already engendered two geniuses, Raymond de Sebonde, author of *Natural Theology,* and Antonio Gaudí, the creator of Mediterranean Gothic, had just caused the atom of the absolute

to explode within me. I became a mystic as I watched the swallows pass by outside the window. I understood that I was to be the savior of modern painting. It all became clear and evident: form is a reaction of matter under inquisitorial coercion on all sides by hard space. Freedom is what is shapeless. Beauty is the final spasm of a rigorous inquisitorial process. Every rose grows in a prison.

I had a sudden vision of the highest architecture of the human soul: Bramante's Roman *tempietto* of San Pietro in Montorio and the Spanish Escorial, both conceived in ecstasy.

"Give me ecstasy!" I shouted. "The ecstasy of God and man. Give me perfection, beauty, so I may look it in the eyes. Death to the academic, to the bureaucratic formulas of art, to decorative plagiarism, to the feeble aberrations of African art. Help me, Saint Teresa of Avila!"

And I plunged into the most rigorous, architectonic, Pythagorean, and exhausting mystical reverie that can be. I became a saint. I might have become an ascetic, but I was a painter. I made myself a dermoskeleton of a body, shoving my bones to the exterior like a crustacean, so that my soul could grow only upward toward heaven; working at it from awakening till slumber, putting to contribution the slightest digestive incidents, the least phosphenes, I succeeded in exploring myself, dissecting myself, reducing myself to an ultragelatinous corpuscular wave so as the better to reassemble myself in ecstasy and joy.

It was in this state of intense prophecy that I understood that the means of pictorial expression had been invented once and for all with maximum perfection and efficiency during the Renaissance, and that the decadence of modern painting came from the skepticism and lack of faith resulting from mechanistic materialism. I, Dali, by restoring currency to Spanish mysticism, will prove the unity of the universe through my work by showing the spirituality of all substance.

I feel, sensorially and metaphysically, that the ether is nonexistent. I understand the relative role of time, Heraclitus' statement, "Time is a child," appearing to me in blinding clarity with my limp watches taking on all their meaning. "No more denying," I shouted at the height of ecstasy, "no more Surrealist malaise of existential angst. I want to paint a Christ that is a painting with more beauty and joy than have ever been painted before. I want to paint a Christ that is the absolute opposite of Grünewald's materialistic, savagely anti-mystical one."

The way was laid out for me!

In an ebullition of ideas of genius, I decided to undertake the

plastic solution of the quantum theory of energy and invented "quantified realism" so as to be master of gravity. I started to paint the *Leda atomica,* which exalted Gala as goddess of my metaphysics, and succeeded in creating "suspended space," and then *Dali à l'âge de six ans quand il croyait être une jeune fille en train de soulever la peau de l'eau pour voir un chien endormi à l'ombre de la mer* (Dali at the Age of Six when He Thought He Was a Young Lady Raising the Skin of the Water to See a Dog Sleeping in the Shadow of the Sea), in which beings and things appear as foreign bodies from space. I plastically dematerialized matter, then spiritualized it in order to create energy. Each thing is a living being by virtue of the energy it contains and radiates, the density of the matter that makes it up. Each of my "subjects" is both a mineral subject to the pulsations of the world and a piece of live uranium. I succeeded through painting in giving substance to space. My *Coupole formée par les brouettes contorsionnées* (Cupola Made of Contorted Wheelbarrows) is the most striking demonstration of my mystical vision. I solemnly affirm that heaven is in the center of the believer's chest, for my mysticism is not religious alone, but nuclear and hallucinogenic; and in gold, in the painting of limp watches, or my visions of the Perpignan station, I discover the same truth. I also believe in magic and in my own destiny.

I decide to paint the *Mystical Madonna,* later to be known as the *Madone de Port Lligat* (Virgin of Port Lligat), which Pope Pius XII was to admire. But first I must get away from any religious formulation. The Renaissance cupolas that corresponded to the cupola of heaven in a flash of genius appear to me as the receptacles of conscience. I go back to that theme in *Tête raphaelesque explosant* (Raphaelesque Head Exploding) and express a transcendent metaphysical message in my *Mystic Manifesto.*

I try to restrict myself to a monk's work, and, when the Italian government commissions me to illustrate *The Divine Comedy,* I dedicate myself to that work, which is to include two hundred watercolors. I start by making a bust of Dante to spoon up all the soup of my vision.[1] I have already related how human stupidity kept me from giving Italy the benefit of this Benedictine work. No matter; the work blossomed out in its sublime grandeur and it was enormously successful. The Rome exhibit in 1954 was a major event. Works were being born from my brush in the lushest of mystical ecstasies. The *Christ of St. John of the Cross* was its apotheosis. I created *The*

[1] In Dali's sculpture, Dante's laurels are made of small spoons.

Royal Heart of gold and rubies in memory of my mother, who used to ask, "Heart, what do you desire?" as she bent over me. I asked Gala that question in turn and she answered, with that assurance always prescient of my own most secret desires: "A ruby heart that beats." I gave it to her with outstretched hands. Then, for her, I painted *Galatéa aux sphères* (Galatea with Spheres), synthesizing all of my new mystical science of painting and my technique of quantified realism, in which each element of the picture exists by itself but contributes to creating a cosmogonic whole that transcends it. The face of my beloved Gala was born of the universal Brownian whirlpool, as the sacred image of the divine.

Crazy for God, Was Dali Still Interested in Mankind?

Back in Paris, I decided to become a little less holy. Coco Chanel was in the midst of a sensational comeback. Her sayings were being repeated everywhere:

"Where should a girl perfume herself, mademoiselle?" "Anywhere that she may be kissed."

"Fashion is architecture: all a matter of proportions."

"In fashion, only imbeciles never change their minds."

"Be irreplaceable by being different."

Marie-Hélène, the Baroness Guy de Rothschild, was sponsoring her return. Coco Chanel had made her a sensational ball gown out of a red taffeta curtain. Everyone congratulated her. Coco Chanel was back in business at the same old stand, intending to industrialize fashions. She was seventy-one years old. The décor had not changed since 1925; Coromandel screen and mirrors, a hundred and thirty models, according to the columnists. "A flop," was the least unkind thing said about it.

In the U.S. she was feted. She Chanelized America with her tailored suits and No. 5, plugged by Marilyn Monroe ("What do you wear in the morning, miss?" "A skirt and sweater." "In the afternoon?" "A different skirt." "In the evening?" "The same thing, made of silk." "And at night?" "Five drops of Chanel Number Five."). No. 5 was to Coco Chanel what my mustache was to my character. We met again as two legendary companions, and she told me all the latest Parisian gossip.

Helena Rubinstein had come in with a maid who never left her side, and who was, as everyone in the rag business knew, a very talented copyist. She looked over all the collections, while the maid

mentally made notes of all the hems and sleeves. She stole ideas shamelessly, buying only those gowns that could not possibly be plagiarized. "Sometimes we got part of the theft back by selling her two numbers," Coco Chanel said. "But after all she was just an American taking back her share of the Marshall Plan."

Helena's big disappointment was Picasso. For years, she had wanted him to paint her portrait. Her friend Marie Cuttoli one day informed her that he had agreed to do it. She came over from New York, all excited.

For days, she kept phoning; Picasso never took the calls. He was asleep, or out, at the beach, playing boules, or up in Paris. . . . Actually, it was Picasso himself on the wire, faking his voice.

So one morning Helena Rubinstein just presented herself at La Californie, overlooking Cannes. And got in. That day, among the guests was Gary Cooper, with whom Picasso was playing cowboy. They finally made a date for the next afternoon at six, and for days on end she posed for Picasso. One evening, he told her, "That's enough." He had done over forty sketches of Helena, but not one complete: just her hands, her neck, her mouth, her chin, her eyes. But never together.

"What about my portrait?" Helena asked.

"It will have to be a posthumous work," was Picasso's reply.

"Damn that devil," Helena Rubinstein would say after that whenever she was asked about the portrait.

And she was furious to learn that Picasso had added, "I only do portraits of the women I sleep with."

What Relation Does Dali See Between Eros and God?

I go deeper into mysticism through erotic delirium; perversely polymorphic, I translate each new awareness into gluttony. Eroticism is a royal road of the soul of God. It flows in the molecular structures. To me, it is the foundation of heterosexual urges. In exploring my desire, I explore my life.

I start to write my play, *Le Délire érotique mystique* (Mystical Erotic Delirium), which was to become *Tragédie érotique* (Erotic Tragedy), and can never be performed except for Dalinian initiates. I also write *The Divine Marquis' 120 Days of Sodom Upside Down*, as a tribute to the Marquis de Sade. And I paint *The Two Adolescents* and *La Jeune Vierge autosodomisée par les cornes de sa propre*

chasteté (Young Virgin Self-Sodomized by the Horns of Her Own Chastity).

Painting, like love, comes in through the eyes, and goes out through the short hairs of the brush. My erotic delirium leads me to extol to paroxysm my sodomizing tendencies. The long masturbatory discipline that for more than half a century has led me to the creation of a veritable cult of my own cock which I never ceased celebrating in all my work and actions, essentially notable for their aggressively phallic value, such onanistic ascesis could find its full flowering only in mythical sodomization.

I surround myself with the most sublime arses imaginable. I get the most beautiful women to strip. I always say that through the arse the greatest of mysteries can be plumbed, and I even succeeded in discovering a deep anal-ogy between the buttocks of one of my lady guests at Port Lligat who had stripped for me and the universal continuum that I have named the four-buttocked continuum. I think up the most superb and wildest positions so as to keep myself in a state of paroxysmic erection and my happiness is complete when I am able to be present at a total sodomization.

To me, the essential is what the eye sees. I succeeded in persuading a young Spanish woman to allow herself to be sodomized by a lad of my acquaintance who was courting her. A girl friend and I—for witnesses are important in my theater and act as accountants—settled down on a sofa in the bedroom. The two partners entered from opposite doors, she naked under her dressing gown, he without a stitch on and his tool at the ready. Immediately, he turned her over and without delay started going about his penis-tration. It was inside so fast that I got up to go over and inspect, to make sure they were not just putting on an act. I hate to be taken for a ride.

At that point, she exclaimed ecstatically, "It's for Dali, for the divine one!" This statement rubbed me the wrong way, for I immediately sensed how phony it was, the more so since the young stud was wildly furrowing her foundation and she was groaning with delight. So I demanded, "Admit that you adore that thing that's up your arse!" And her playacting stopped. Without further dissimulation, "Oh, yes," she shouted, "yes, I adore it!"

And then I witnessed the most amazing thing one could dream of as an expression of phenomenal beauty: the young woman held solidly by the hips and screwed on to the man raised both her arms which she threw back, arching out her splendid bosom. Meanwhile her head fell back and her lips rose to meet those of the male who

was making her come in such pain. It was a sort of perfection in gesture that turned the animal couple into a vegetable liana, thus providing an angelic vision. I have never been able to tell this story without each time having the wonderful feeling that I had violated the secret of perfect beauty. A miracle that I have never again found in such fullness.

I asked the partners to do it over again, but satiation, and perhaps an edge of nerves, kept them from reliving the grace. They did their best in trying to satisfy me, but finally collapsed on the bed.

He who tries to play the angel, plays the brute!

I have deep appreciation for erotic strategy. Nothing is better than the conception, and to bring a couple to ecstasy fulfills me entirely. Everything is in the imagining and the regulating of the conjoining. I usually choose young, good-looking partners, in love with each other—or able to simulate it at least, for without passion coming through their coupling is a mere clinical experiment—and enjoy using the end of my cane switch to regulate each detail of the action: hand gestures, caresses, finger movements, stops, starts, penetration, rhythm, even including positions of bodies, legs, hair. I become the director of a play with two characters whom I inflame with desire and lead to ecstasy at will; and in their panting, their breathing, their whispering, their exhaustion, the outbursting of their joy, I seek an image of total life, as I bend over the couple, attentive to their every moan, to try to catch the secret of the shared paranoia we call love's desire.

Which, of course, has nothing to do with my love for Gala, who remains to me unique, the only one in whom I can come by extolling the most sublime images of my architecture of beauty. She is my intimate truth, my *double* and my *one*.

My eroticism is a game with precise rules and a discipline as rigorous as an initiation rite. The first thing is to select a series of beings who are among the chosen for their beauty and their sexual proclivities, then, having made the selection, to form them mentally into couples who do not know each other, bring them together through a network of contacts, dialogue, and situations that little by little will surprise, seduce, and convince the actors to submit to the rules of the Dalinian game, of which of course they will never appreciate the subtleties but in which they will be consenting and submissive slaves. My ambition is to make a lesbian out of an *enfant de Marie* and a pederast out of a crosscountry runner. I have a knack for arousing curiosities, creating legends, establishing unexpected connections. This erotic diplomacy delights me up to the moment when, having

aroused the passion of the two beings, I take them in my test tube and dip them into my basin, so that, bodies naked and desires exacerbated, they deliver themselves for my delectation to the pleasure of caresses orchestrated by the genius of Dalinian authority.

The height is reached when I have woven such a network of complicities around the couple, all of whose resistances have been wiped out or broken down, that they become the center of a sort of Mass, as in magical anticipation. I of course remain the one fixed point and in this spiderweb can entangle any of them I wish, whenever I wish, the anticipating being so acute for all of them, and my will emerges as the determining element of their metamorphosis. That is when I conceive a truly erotic ceremony.

It happens at such a period that I spend quite considerable sums in dinners, gifts, costumes, parties to achieve my own ends and subjugate and fascinate my actors. The preparations sometimes take months, as I put all the pieces of my jigsaw carefully together.

I invent the most involved perversions, impose my most extreme whims on them, convince each of the participants to do the maddest things, and extract the fullest admissions from them. I make each one go through the imagining of his behavior in every last detail: you lie down like this, let yourself be stroked like that, with your legs at such and such an angle, the whole thing to start by the insertion of a straw that will be lighted and which you will withstand without blinking until the last possible limit. . . . When each of them is thus perverted, converted, subjugated, exalted, I one day bring the whole Eros Battalion together in a place carefully conceived to raise their instincts and desires to the utmost paroxysm: mirrors, padding, light, rugs, suggestive scents. I insist that the whole rite take place with absolute precision, in a hierarchical rigor that determines not only the movements, but the positions, the attitudes, noises, clothes, the last detail of each operation. When I finally make my entrance, everything must be in place, under the management of a master of ceremonies, whom I call the notary—in memory of my father.

My rod is now stiff inside my trousers with a wonderful hard-on that swells the glans, and my balls become like two little metal bearings. I feel that the fantastic pleasure of fulfillment is about to possess me. Everyone is in his place, motionless, awaiting the signal that will start the event unfolding, toward which all of their wills have been tautened. I am the omega point toward which the whole panoply of desires converges.

And suddenly—inexorably—there is always one there who has gone against my inflexible law, some detail that abruptly refutes

the regulation of the whole, a discordant note marring the harmony—or else I am the one who discovers like a catastrophe the item that makes it impossible to go through with my erotic Mass. And with one word I smash the complicity of all of them, wiping out all those efforts, sabotaging my own work. Everyone freezes, shocked, petrified in the horror of my displeasure, as if thunderstruck at having betrayed me. At the very moment when delirious, orgiastic life crowned by ecstasy was about to break out, the high priest that I am declares the holy group dissolved. Their blood running cold, wiped out, broken, everyone leaves, and I fall to my knees overwhelmed with joy, weeping over this sublime setback. All of my Catalan soul is whipped to exaltation by the absurd and magnificent gesture of renunciation. The intended, calculated setback occurring as the logical conclusion of lengthy research is the solemn *proof* of my will. The supreme reward to my pride, my outsizedness! The gesture of going beyond the simple consummation of the senses . . .

Then I am in an unaccustomed dimension, an absolute where only the *quality of God* reigns: a totally irrational universe in which everything is sublime and transcended, and my joy itself is a mystical delirium. There is no longer any vice or virtue, good or evil, flesh or spirit—orgasm becomes ecstasy and fulfillment of mind. I attain a harmony that is located in the very space of the soul. In my own way I doubtless rejoin the path of high tradition which, from knightly love to the Cathars, the Hindu sages, the anchorites of the desert, allowed the transmutation of sexual energies by provoking the dazzling of the mind. The barriers of desire abruptly broken provoke an ejaculation of non-consummation. I have then only to pick up my brush and allow it to channel the outpouring of my genius which flows from the sources of the absolute.

I do not seek to be any better understood. My secrets are too grave, and reserved for a Nietzschean élite. The rules of my chess game are one of the disciplines that lead me to pray to my God and to increase my genius.

Are Dali's Games All Innocent?

Erotic fantasies take up much of the time I do not devote to painting. My pleasure is in constantly renewing the details, the props, and the people. I have only an embarrassment of riches, taking my pick from the humanarians of New York or Paris where a hundred society women itching with erotomania are always ready to submit to

my whims. Not to mention the high-class professional ladies of pleasure, whom I call "Danièles," and whom I sometimes use for the structuring of my acts. The rule is that the Danièles are never to take any initiative in word or in gesture. Their total passiveness is de rigueur during rehearsals. But while my devotees are working at arousing them, during these preparatory exercises, it happens I sometimes do not pass up the opportunity: a bit of voyeurism, skillful handplay, lusting lips may tempt my sap, but never as much as the brutal renunciation of pleasure that I dream of inventing.

Why Dali Keeps Gala Out of His Erotic Orgies

Gala is the kind of Puritan the Surrealists were. She really suffers from knowing the details of my erotic Masses; and I wish to cause her no pain, not even the slightest. She is not jealous, merely sensitive. And I have to make an effort to overcome my tendency to speak contentedly about my vices. With her, I never make more than allusions. Our love remains the symbol of passion, purity, self-forgetfulness. Eroticism is for others. Gala and I are but one. The screen of my love's magic circle isolates her from any erotic fantasies. And moreover I only love her the more for her intransigence and purity. A great love, like a great painting, can be successful only if rid of all overflow and all distracting elements. When I paint, a part of my self is happily elsewhere. I hear a conversation, dream of an invention, my memory speaks to me, and between eye and arm the way is absolutely clear. The picture takes shape according to its own laws born of an automatic reflex, but my erotic imagination is indispensable to my health. My work is but the setting of my erotic theater of which Gala is the soul.

Eroticism is a way of setting up a barrier against the sense of death and the anxiety of time-space. I feel a Dionysiac rage to celebrate life but refuse to be the dupe of the senses, the obsessions, the instincts of life. I am determined to try all of its possibilities without letting myself be conditioned by appearances. To fulfill its eroticism would be a way of making myself submissive. Toying with it and going beyond it is a strength I turn to advantage.

Fifteen years before Crick and Watson, I drew the spiral of deoxyribonucleic acid through the genius of my intuition, which shows I am in tune with universal structures; likewise, I know that eroticism is the generating principle that animates molecules, and it is my conviction that, in celebrating eroticism in disregard of all traditional

morals and beyond all sexual appetites, I am serving the principle of all life by bringing together creature and creation. And when the atavistic thirsts arise within me and I transcend them, that is when I am in the epicenter of my love for Gala.

I discovered the great unity of the universe. My love for Gala is the spiritual energy that brings together all possible Dalis and all the cells of my being in one single Dali just as deoxyribonucleic acid is the memory of God in the service of every element in the world.

Eroticism, like hallucinogenic drugs, like atomic sciences, like Gaudí's Gothic architecture, like my love of gold, comes down to a common denominator: God is present in everything. There is the same magic at the heart of things and all roads lead to the same revelation; we are children of God and the whole universe tends toward the perfection of the human being. For having understood this, divine justice helps me in the shape of objective bits of luck in my most everyday gestures.

I discovered the laws of painting when I understood that the human mind evolved in function of its ideas about space. To Euclid, the plane, the point were idealized objects having roughly the same consistency as cold tapioca. Descartes, on the other hand, manufactured a kind of bare cupboard with three theoretical dimensions in which Newton placed a dream apple. Einstein, with relativity, uncovering to us the fourth dimension of time, gave us the means to a delirium in which we could meet God. Rationalism went right back to its place.

All mystiques, whether religious, nuclear, hallucinogenic, or of gold, have the same divine heaven as my painting celebrates, which found its expression in the *Sacrament of the Last Supper* that I did for the famous collector Chester Dale, who donated it to the National Gallery in Washington. In that picture can be read all of my cosmogony: the union of time and space which is the secret of God.

"TO A PAINTER, EVERY BRUSHSTROKE IS THE EQUIVALENT OF A TRAGEDY EXPERIENCED."

XVI

How Dali Invents a Paranoia-Critical City

I am a pig. A divine pig brought up in society and "possessed by desire"—which is the Catalan translation of my name. Human beings have little effect on me, but I need to make use of them, and, snout foremost, I charge, sneak, gluttonously swallow anything before me while perfectly knowing which cesspool to avoid. I have paranoia-critical printed circuits that act as antennae and my delirium is one of pure lucidity.

The best of all worlds to me is the one in which I can wallow with the greatest delectation, the one that has the finest garbage heaps and the most perfected bowels of mental constipation—through press, TV, and radio. But my veneration goes to hereditary monarchic so-ciety in which the most rigorous moral order reigns, on condition of course that I be its great man. Spain, which awarded me its Grand Cross of Isabella the Catholic, is entitled to all my gratitude—I know no gratitude, nor admiration nor feeling, other than for Gala, but Gala loves Spain which is where she has her castle and I love Gala, so the syllogism is implacable.

Monarchy is the father recognized and celebrated, the dome

of God upheld by the pillars of wisdom, it is the order that covers all disorders, the individual in his spiritual family. All regimes merely ape the monarchic order with more or less demagoguery and efficiency. They are all hierarchical monarchy in disguise. They are decoys used to introduce into people's mental circuits the impulses, orders, and norms that they would otherwise not accept. But, make no mistake about it, monarchic order runs the world.

I would even say a gerontocratic monarchic order. There was a time when Mao in China, Stalin in the USSR, Eisenhower in the U.S., Churchill in England, De Gaulle in France, De Gasperi in Italy were masters. They were all over seventy! The ages since then have changed, but not the methods. Political hypocrisy is on the wane. Peoples get used to realities. They end up by seeing that nothing, except electricity, running water, and penicillin, has truly changed since the Bourbons. Not even in the various countries. That is why I expect to see Rumania with a king again, Russia with a czar, and China an emperor. America has no tradition, which is too bad. With

all of its kinglets of oil, crime, and deep-frozen foods, the vassals are ready for a suzerain.

One or two revolutions will allow us to see the light of day some time soon.

The monarchic order, like Eros, is established in deoxyribonucleic acid. Our Brownian motion cannot change that. There is an immanence that brings us back to the truth. Who the king is hardly matters; what counts is the order.

Take Monsieur Le Corbusier's abject architecture, the Swiss heaviness of which gave indigestion to thousands of young architects and artists. For a time, it was possible to believe that it would rule over the city of men. But how now? The weight of his cement dragged him down (Le Corbusier died of drowning), and his work, which had been intended as "functional," turned out merely to be simple-minded. Now people just yawn at it. Even the big complexes that were the basis for his architectural vision have been abandoned in favor of "individual folly." The world has had enough of logic and rationalism

as conceived by Swiss schoolmasters. I have nothing against Swiss bankers or cuckoos, on the contrary, but the country ought to stop exporting architects!

Gaudí, the admirable, creates beauty which is the sum-total conscience of our perversions. Gaudí, Catholic, apostolic and Roman, knew how to translate into stone his religious vision which "jibes" with the people's soul. Look at the expiatory temple of the Sagrada Familia, the most perfect iconography of folk Christianity and piety, not only because Gaudí immobilized in the mineral a blade of grass, a flock of fowls, and even the sheepherder on whom he modeled Judas —in other words, the world and the people—with naïve truthfulness, but because he exactly translated and extolled the remorse of conscience, that great Christian concern, on which the whole of civilized intelligence of the twentieth century is based, as is everything great that has been accomplished in the past two thousand years. Take away the remorse of conscience, society will crumble! It is the fuel and the motor. It explains our morality and our subconscious, our vocabulary and our silences, our vices and virtues, our ambitions, dreams, ideas, and faiths.

An architecture must make its time explicit and especially dress it up. Monsieur Le Corbusier's geometry is a small bit of homework by a schoolboy trying to solve theoretical problems, not the expression of the vital needs of a period.

We have to return to sense. Gaudí's fingers were at the tip of his brain. I believe in erogenous architecture, not ideological. I believe in polychromatic architecture that satisfies the eye as does a mosaic. I believe in an architecture that takes sound values into account, I mean the harmony of the spheres. Total visual decoration must indeed take into account harmonic resonances.

I believe in an architecture of bad taste, to the extent that good taste is castrated!

In 1925, I met M. Le Corbusier, who told me that Gaudí was the shame of Barcelona and with Swiss oafishness (I have nothing against Swiss bankers) asked my ideas about the future of architecture. I told him I thought it would be "soft and hairy." I have not changed my mind and am just waiting for technique to catch up with me, for I am still a little ahead of it. In the interim, M. Le Corbusier confessed his errors about Gaudí, but he betrayed his own soul!

The divine pig that I am—did I forget to mention it?—has a rhinoceros horn. Truth of the matter, I am a rhinoceros, with mustache.

In 1954, in the midst of my mystical phase, I discovered that for half a century I had been painting rhinoceros horns without even

knowing it. I attach great importance to such attributes as beard and hair, all hairiness in general which always carries essential social significance. Hirsuteness, even before Samson, was identified as a sign of virility and strength, and my mustaches are the fangs of my personality. In popular parlance, *avoir un poil sur la langue* (to have a hair on one's tongue) means "somesing is in ze way," whereas a hair on the soup designates unwelcome out-of-placeness. The slang *c'est au poil* (it's hair-perfect) means a situation or thing is exactly right, and many is the mechanic who has thus been heard describing a piece of precision work as fitting "down to a cunt hair."

To have a mustache, a beard, long hair, to me seem to be essential conduct in a self-respecting society. They should even be a sign of social standing—with a special tax for fraudulent wearing by the classes sporting them without the right. Servants, in the nineteenth century, were forbidden to grow mustaches, which were the exclusive preserve of masters. Only after the 1914–1918 war, when trench soldiers became known as *poilus* (hairy ones), did house servants acquire the right to be facially hirsute. Indeed, there is no reason to make a display of one's beard or hair as aggressive antennae if one has nothing to say, or protect, or go after. My mustache heretofore had hidden my (rhinoceros) tooth. I had just finished doing *Dali's Moustache* with Philippe Halsman, and was in New York for the retrospective exhibit of my two hundred *Divine Comedy* watercolors, when, going through Paris, I had happened on Vermeer of Delft's *Lace Maker,* and discovered the importance of the rhinoceros horn.

How Dali Established a Connection among a Crust of Bread, The Lace Maker, *and a Rhinoceros*

At age nine, in Figueras, pretending to be asleep, head down on my forearms leaning on the dining-room table, I tried to capture the interest of a young servant girl. That was when I experienced a strange pleasure: the crumbs of bread crust that were scattered on the tablecloth dug painfully into my elbows, but I could not register the pain if I were to remain motionless while the girl with the crackling skirts moved about me. At that moment was heard the song of a nightingale that moved me to tears. The pain and joy forever joined in my memory crystallized little by little in the shape of a delirious obsession with the theme of Vermeer's *Lace Maker,* a reproduction of which hung in my father's office, as I had sometimes furtively observed through the door left ajar. From that moment on, moreover,

I was to note that many emotions reached me through the elbow—which was my Achilles' heel (so that some day people will say: Dali's elbow).

Thus, in May 1955, having taken a knock on the elbow, I immediately had a sharp visualization of *The Lace Maker*. And I asked the curator of the Louvre to allow me to make a copy of that Vermeer. With a great display of precautions, the painting was brought into a small room and I set up my easel in the presence of the staff of curators and a few friends. I observed with the most careful attention the highly upsetting picture, the excitement center of which is a needle that cannot be seen and is not actually painted but only suggested. It seemed to me that my elbow was hurting again and that the needle was stuck in it, giving me the feeling of experiencing a paradisiac sensation. Behind the appearance of the painting, calm, peaceful, the image of quiet happiness, was hidden a tremendous ultra-piercing energy that to me had the value of the antiproton that had just been discovered.

I went close to the picture and with my cane took a few measurements to check out an intuition. The curators, not daring to interfere, exchanged fearful looks at my savage approach to a work that they considered a unique treasure. Suddenly, to everyone's surprise, I laid in on my canvas a set of rhinoceros horns in place of the lace maker I was supposed to copy. Their apprehension turned to stupefaction. I myself did not exactly understand the meaning of what I had done. All summer, I worked on that *Lace Maker* problem and finally realized that my intuition had gone straight to the logarithmic curves of the picture, which corresponded exactly to rhinoceros horns.

At Port Lligat, I got collections of rhinoceros horns which, in my reveries, started moving around like constellations, first forming amalgamated bread crusts but then little by little settling into a corpuscular ballet that reconstructed *The Lace Maker*. I got some fifty-odd reproductions of the Vermeer, that I hung all over my olive grove; and even on the beach, when I went bathing with Gala, I took *The Lace Maker* along.

Indulging my obsession to satiation, I continued my research on the morphology of the sunflower dear to Leonardo da Vinci and it was then that I discovered that sunflower spirals have exactly the curve of rhinoceros horns. By an even greater miracle, the virtually logarithmic curves of the sunflower soon in my eyes outlined the headdress of the lace maker, her cushion, as in a divisionist painting by Seurat. I was dazzled. The rhinoceros horn became a perfect example,

nature-made, of logarithmic spirals, and its bestiality stood in opposition to the grace of the lace maker, that expression of chastity, purity, and absolute monarchy.

The lace maker now appeared as the pure symbol of that maximum of spiritual strength that the rhinoceros carried at the end of his nose. Crushed rhinoceros horn is a powerful aphrodisiac. Beauty and Eros are one. The admirable animal not only has a cock standing on the end of his nose, but his coitus lasts for almost an hour. He carries the Dalinian rite so far as to lay out his territory by depositing his excrements as benchmarks of his property. That much refinement deserves respect and attentive observation.

With this criterion I analyzed Gala's face, and reconstructed it with eighteen rhinoceros horns; likewise a Raphael painting; but since everything is in everything and the opposite as well, by observing the rhinoceros' arse I discovered it looked exactly like a closed sunflower. So this animal had the finest of curves on his nose, and on his arse a galaxy of perfect arcs. Suddenly I came across a photograph of a cauliflower. Nothing would do but that I get a mountain of cauliflowers to check on whether the lace maker was also in their spirals. She was. My mystical strength and my paranoia-critical vision were such that all the truths subjacent to the world now appeared clearly to me.

Everyone cannot have my sensitive elbow. Everyone cannot be Dalinian, but each can take advantage of Dalinian discipline and turn clear eyes on reality. The social code of a perfect city is based on ecstasies that alone can transform desire, pleasure, anxiety, any opinion, any judgment into something sensational halfway between dream and reality. The repugnant thus becomes desirable, affection turns to cruelty, ugliness into beauty, faults into qualities, and qualities can end up being dire wretchedness. So ecstatic a world can be known only in imagination. Become ecstatic so as to experience it!

I dream of a city full of Surrealist objects inducing ecstasy in a Gaudínian architecture. The Surrealist object according to the definition I have given of it historically is impractical. It has no use but to take a person in, exhaust him, stupefy him. The Surrealist object is made solely for the honor of thought.

Flags and trophies have to be replaced by an arch of triumph of hysteria, made of limp structures, surmounted by aphrodisiac jackets, shiny with piss and emeralds.

Each person can then indulge his passion for living in the bosom of a coherent universe unified by paranoia. Each becomes the conscience and measure of the world.

I was ten or so when I got Dullita up on the Pichots' tower. I was wearing a sailor hat that squashed my ears. At the top of the tower, I took it off and the cool evening breeze so deliciously caressed my ears that I remember that I felt I was at the same time rubbing elbows with love.

In July 1957, there was an exhibit at Knokke-le-Zoute, Belgium, of thirty-four paintings and forty-eight drawings and watercolors, and at Brussels they showed my *Madone sixtine* (Sistine Madonna), the optical effects of which were a big hit. At one meter's distance you saw the Sistine Madonna, and at three meters an ear that seemed to be painted with antimatter. Who could have known that what that was, was the magnification of my childhood memory? Or that that work was dictated to me by my paranoia-critical ambition to make use of every bit of my self and my memory, to live me even unto my substantific marrow?

Dalinian irrationality was at least becoming factual. A few months later I was to go back to the myth of the ear when I made the monumental ear of Pope John XXIII in the shape of a manger for Orly—and even though I detest children—so as to make even more tangible the incarnation of that magic of love that one morning had rubbed against me facing the sky and the clouds.

The City of Paris, in 1958, was to award me its gold medal and the medal of French quality. I do not blink at one more contradiction, and it pleases me to be crowned for qualities I do not have, for then in my eyes my unseen virtues are being rewarded. When in that year I invented the *Ovocipede,* which is a plastic sphere, everyone interpreted this invention as a new method of locomotion, so I did not take the trouble to explain that it was essentially a question of materializing my paradisiac intrauterine phantasms and allowing some others to relive their most secret dreams. Societies do not like things that favor escapism or forgetfulness of codes. Escape files can be gotten into prisons only by hiding them beneath the reassuring crusts of nourishing everyday bread.

Is Dali Sensitive to the Suffering of Mankind?

"Pity is not my forte; it is the virtue of *filles de joie,*" said Nietzsche. I was once asked how I could live in Spain where so many people had an outstretched hand. I answered that I crossed Spain by Cadillac and knew that the Spanish people were a proud people who

did not hold out their hands, but died on their feet.

During the German Peasants' War led by Thomas Münzer (which the nobles ended at Frankenhausen), one of his companions, before going to face execution, cried out, "O God, I am about to die, and in all my life never once did I eat my fill!" I cannot be moved by the inequality of the human condition, which is an obvious consequence of psychological inequalities and natural hierarchy, but I cannot imagine a society without highly developed gastronomy. I remember one night arriving at Saulieu just as the chef had finished making his truffle pasty.

"Ah!" M. Dumaine said to me, "you are just in time; the haze is rising beneath the oaks, but the sky is clear, you can count the stars and the truffles. The truffles give off their scent at this time and the humidity increases their virtues, so it is the one time when the pasty can really be well made. You'll have a treat!" My imagination was at the zenith of desire. It was a royal feast.

A society without ortolans in paillotes, or without duck's livers with raisins, or gastronomical talk, has not finished its evolution. A nation is not "ready" until it has at least fifty kinds of cheeses and great vintages.

In my system of values, gastronomy gets a mark of ten out of ten, dandyism and heroism likewise, but goodness gets a goose egg. Perversity, on the other hand, ranks right up there.

In an ideal city, woman will assume a new importance. Irrational gymnastics and the streamlined ensembles of haute couture will allow her to satisfy the wildest of her dreams. I foresee bodies with detachable parts so that feminine exhibition can achieve all of its splendor as each part of the anatomy comes separately and can be eaten in its own right. Displayed on pins, like the parts of a praying mantis: the tits, the thighs, the belly, the cunt, the shoulders—each would be a separate dish.

Toward this end, I have designed a whole outfit: the corset to be of great erotic power; fake tits held high and slightly descending, starting in the back—no reason why one should not consider additional series of tits; spring heels, edible panties, thighs and bellies delectable to satiation.

In 1928, at the very apogee of functionalist anatomy, I had already announced that the new sexual entertainment of woman would come through the utilization of her spectral capabilities, that is, from possible carnal dissociations and decompositions. The hologram will give us an almost perfect realization of this proposition.

What Does Dali Think of Freedom, Future, and Justice?

As has been understood, my whole "social"—how that word repels me!—vision is one of repression of freedom. In 1971, I wrote out my code, in the form of a poem, and I suggest that the faithful learn by heart at least these five lines of it:

> Shameless, shapeless human freedom,
> Romantic, imperceptive of the five perfect, unique polyhedrons.
> Imperceptive of the cages of divine geometry,
> The happy prison of the retina,
> Imperceptive of the continual pleasure of the pitiless, rigorous networks.

Freedom is anarchy, the infantile exploitation of the being's superior capability of will, the abuse of the divine. Real freedom is the sublime duty to die for one's country, the supreme voluptuousness of being a slave—but what can be said of those who have eyes yet will not see, ears yet will not hear?

Freedom is the contrary of monarchy. Freedom is bourgeois hypocrisy.

It is significant that France has given new currency to the architecture of Nicolas Ledoux by installing a vista center in the very locale of the futurist mausoleum that had been given to the beasts of the woods. The symbolism is obvious and the process, in spreading, should soon lead to the transformation of UNESCO into an undertaking of stupefying the public so as solemnly to consecrate its primary policy. I suggest that this hotbed of bourgeois boredom be transformed into a bordello of local color under the aegis of St. Louis, pioneer of love for sale.

I am betting on the debourgeoisification of culture to the extent that society deproletarianizes itself. The new cultural style will emerge from the return to currency of the great schools of thought victimized by materialism: the combinative wheels of Raymond Lully, the natural theology of Raymond de Sebonde, Paracelsus' treatise, Gaudí's inspired architecture, Francisco Pujols' hyperaxiology, Raymond Roussel's poetics . . . a pedagogy awaiting its masters! The future belongs to the fantastic.

Democratic justice is of as doubtful a sex as a bearded woman. Real justice is monarchial. Dalinian justice is objective chance. I broke the windows of justice at five o'clock one afternoon on Fifth Avenue the day I knocked the pane out of the Bonwit Teller showcase in which my display had been sabotaged. I met justice in the person of

the little Puerto Rican in the detention room at the police precinct who, on learning what I had done, defended me against the drunks and kicked away the whole passel of bums to protect me from their vomit.

Justice is that I, Dali, the divine pig, sublime rhinoceros, may be able to consume ortolans to the end of the centuries as the consecration of an uninterrupted life of dandyism.

"I AM A MONARCHIST, IN A MORPHOLOGICAL MANNER."

XVII

How to Read Dali's Paintings

The clown is not I, but rather our monstrously cynical and so naïvely unconscious society that plays at the game of being serious, the better to hide its own madness. For I—I can never repeat it enough—am not mad. My sanity has even attained such a level of quality and concentration that there is no more heroic or prodigious personality in our century, and except for Nietzsche (who, however, died mad) there is no equivalent in previous ones. My painting bears witness to that.

Yes, I can never repeat it enough, while my painting is but a fragment of my cosmogony, it is the most significant expression of my truth. Decipher! Decipher! Then you will experience the vertigo of the human absolute.

As an axiom of my oeuvre, I state that there is no such thing as a lazy masterpiece. Any creation requires the tension of the entire being: talent is not enough. My painting—in the formula I have engraved once and for all—is the hand and color photography of the latent, superfine, extravagant, hyperaesthetic images of concrete irrationality. I advise all Dalinians to learn that by heart, for each word of it has its own weight as initiation and revelation.

This is not an "intellectual" definition. I think with my entrails, my viscera, my body. I fell in love through my ear at the top of a tower; I discovered concrete reality through my elbow; I appreciate metaphysical, aesthetic, and moral values through my jaws. I proclaim that man's first philosophical instrument is his jaw, which allows for awareness of the real. I am ahead of the men of my time, because my entire body is directly plugged in to the real. Because of that I have always had a premonitory gift which came out, for instance, six months before the Spanish war in a premonition of the "Spanish civil war." But of course I am more interested in the specific case of Dali than in any current events. Indeed I am interested only in the case of Dali. For it is I, always and everywhere, who am asserting myself in my work.

There is a great struggle going on between nature and me. I have to correct her. The painting of a still life (or, as we say in French, *nature morte:* dead nature) is a way of rectifying the real by the creation of an entropy clear to all. I am fascinated by death. It is my subject. And one vein of my work is to make death colloidal, to stretch it, milk it, like the teat of a cow, to get the milk of the resurrection of the flesh from it.

But eroticism comes before anything else; the eroticism that flows within us and springs from the helicoidal structure that I painted in the deoxyribonucleic cell. Everything born of my brush is erotic. Ultraconcrete and ultra-abstract, the point is always to dominate the heterosexual angst of the polymorphously perverse character I am to the point of self-sodomization.

Since the Limp Watches, I am historically the one who was able to give the equivalence of the space-time equation, but my entire art transmits the quality of the most modern angst because it is the expression of a delirium beyond any dimension of the real. My painting is truly that of the four dimensions enhanced by the affirmation of a paranoia-critical soul.

Time is unthinkable without space, is what my paintings say, as well as all Dalinian "subjects," the infant-nurses with supersoft windowed backs, the *Pharmacien de Figueras ne cherchant absolument rien* (Figueras Pharmacist Looking for Absolutely Nothing), *Le Téléphone dans le plat* (Telephone on a Platter), *Les Tables de nuit molles* (Limp Nighttables), all of which celebrate both my outsize lust for life and my will to transcend it.

And when I paint invisible figures as in *Le Marché d'esclaves avec le buste invisible de Voltaire* (Slave Market with Disappearing Bust of Voltaire), I force the imagining of a new reality—new and

coherent time and space. With my moiréed canvases, the microscopic texture of which contains three-dimensional images, I free the real from its terrifying vertigo by creating the gooseflesh of space-time which "at will" can be or not be. In the same way, my *Sistine Madonna* is an ear made of antimatter or of the Virgin's face, depending on the stereoscopic effect.

I am the only painter whose art solves the problem of the density of matter. I succeeded in mineralizing forms so as to give a nutritive and tastable equivalence of time-space. I made a dish of my dizziness, my metaphysical angsts. Each work is like a Eucharist that helps digest the real, i.e., by supplying the gastric juices with materialized images of irrationality.

At a time when the Cubists were moving away from four-dimensional reality by trying in vain to convince themselves of the existence of an intellectually and plastically real world that could reassure them, I spent four months painting a basket of bread which, by the power of its density, the fascination of its immobility, creates the mystical, paroxysmic feeling of a situation beyond our ordinary notion of the real. We are at the borderline of dematerialization of matter by the sole power of the mind. Beyond, there are only energy and life tamed and maintained in artificial shapes. The spiritualization of painting starts with the mineralization of shapes to end at the uranium of life.

If one is to penetrate the magic of the universe, the spiritual energy that we paralyze through our fears must first be freed. Am I afraid of a lack of testicles? I paint the testicles of Phidias' torso and my fear disappears, at the same time that the rhinocerotic disintegration of Phidias illisos appears, a formidable mystical response to the pressure of the real.

My minute attention to detail is in contrast to the great laziness of modern art, in which everything is slipshod and goes from minimal to minimal, to end up in the nothingness which is just what must be conquered. In the whole history of art there is no heresy, no inversion greater than the phenomenon of contemporary artistic creation denying its own existence.

The vertigo of vacuum ends in the cancer of the mind. The illumination of my life was that I understood I was the savior of modern art and the basic reasons of my imperialistic power; for my entire being is an inexhaustible treasure from which spring the lines of force of a truth that soon will become universal. I can say that I am today the man nearest to the existence of God; the least mad

of men and the term *divine* sometimes applied to me expresses an existential reality.

How Dali Interprets His Divine Case

In the beginning there was madness—which I fled. And the whole history of my art and life, until I met Gala, is the most terrifying struggle against the death of the mind. Professor Pierre Roumeguère (in *Gala, Dali les jumeaux divins:* Gala, Dali, Divine Twins) analyzed the dramatic turns of this adventure, which is like the Passion of Christ. As is known, three years after the death of my seven-year-old elder brother, my father and mother at my birth gave me the same name, Salvador, which was also my father's. This subconscious crime was aggravated by the fact that in my parents' bedroom—an attractive, mysterious, redoubtable place, full of ambivalences and taboos—there was a majestic picture of Salvador, my dead brother, next to a reproduction of Christ crucified as painted by Velázquez; and this image of the cadaver of the Saviour whom Salvador had without question gone to in his angelic ascension conditioned in me an archetype born of four Salvadors who cadaverized me. The more so as I turned into a mirror image of my dead brother.

I thought I was dead before I knew I was alive. The three Salvadors reflecting each other's images, one of them a crucified God twinned with the other who was dead and the third a dominating father, forbade me from projecting my life into a reassuring mold and I might say even from constructing myself. At an age when sensibilities and imagination need an essential truth and a solid tutor, I was living in the labyrinths of death which became "my second nature." I had lost the image of my being that had been stolen from me; I lived only by proxy and reprieve.

As far back as my memory—which is prodigious—can go, I feel only a postnatal homesickness, a profound attachment to my intrauterine life, preferable to the reality that was violating and dispossessing me. I am aware of my being and person as of a double. I was indeed, as soon as I apprehended the existence of things, absent from myself and forced at every moment to check on my belonging in the world—whence my polymorphous perversity, in order to set up an authentication of my whims. But I had no outlines. I was nothing, and yet all. Since I was being denied, I floated in indecision, in shapelessness. My body and my mind lived in the soft and ambiguous and

I existed in things as well as in landscapes. My psychological space had not crystallized into a body, but was on the contrary spread through indefinite space, suspended between heaven and earth as in the ascension of the angel, my dead brother to the right of the Saviour. My thought moved naturally within this dimension of unreality in which my strength and my dynamism of life flourished, whereas my own body was a kind of mirage that I was aware of only by mimesis. I slipped through it as through a hole in unreality.

My favorite psychiatrist, Dr. Roumeguère, asserts that, perforce identified with a dead person, I had no truly felt image of my own body beyond that of a putrefied, rotten, soft, worm-ridden corpse. And it is true that my earliest recollections of existence are connected with death (the bat my cousin killed, the porcupine). My sexual obsessions are linked to limp turgescences. I dream of cadaverous shapes, distended breasts, oozing flesh, and the crutches I am soon to adopt as objects of sacralization, in my dreams as a short time later in my pictures, are indispensable instruments to maintain the equilibrium of my feeble notion of reality that endlessly escapes through the holes I cut even through the back of my infant-nurse. The crutch is not merely a support element, but its fork is a proof of ambivalence. The riddle of bifurcation whips my imagination to its paroxysm. Contemplating my spread hand and the quadruple fork of my fingers, I can extend the bifurcation indefinitely and remain dreamily pensive for hours. I have a true hallucinogenic power without hallucinogenics.

Superiorly gifted, I organize my struggle against death, erect in my full transcendental strength. I invent all possible lives for myself through Butxaques, my little chum who might have been my dead brother, then with Dullita, who occupied my dreams for so long. But the phantasms only exacerbate my lust for life and I fall into those attacks of laughter or masturbation that lead me to the paroxysm of my anxieties, until, at last, Gala arrived.

A 1940 canvas, *Araignée du soir, espoir,* perfectly expresses the reality of my deeper drama. A child with angelic wings is seated in the left corner of the picture, hiding his eyes so as not to see a sexual cannon supported by a crutch from which emerges a hollow-socketed horse with a muscular body already in the process of putrefaction, its forward legs forming the arms of a winged victory that in turn ends in a gigantic runny foot that connects with a long limp breast also oozing out of the cannon like a sperm.

Before this penis-cannon, a limp woman broken in two, supported by the branch of a tree, planted in a geometrical frame, plays a limp violoncello with a viscous bow.

I leave it to others to interpret this and say whether the angel-child is my brother and the fiery horse surging from the cannon myself; whether the cannon is the penis of my aging father, and the woman my mother, with the cello as symbol of the groans detected coming from their conjugal bed, in turn symbolized by the tree planted in the rectangle. All I can say is that the limpness, the viscousness, the gelatinousness do portray in my mind the vital feeling I long had of my body and of the life of my being.

Gala brought me in the true sense of the term the structure that was lacking in my life. I existed only in a bag full of holes, limp and shapeless, always on the lookout for a crutch. By attaching myself to Gala I found a spinal column and in making love to her I filled my skin. My sperm, until then, got spilled in masturbation, as if thrown into the void; with Gala, I got it back and was revivified by it. I thought at first that she was going to devour me, but on the contrary she taught me to eat of reality. In signing my paintings Gala-Dali, all I did was to give a name to an existential truth, since without my twin Gala I would no longer exist.

Through Gala, I acquired not only the right to my own life, but the male and female part of my genius and the ability to put a distance between me and all my phantasms. The paranoia-critical method is Gala first and foremost. Now there are four of us (woman-man-Dali; man-woman-Gala) exploring the world; and my work, ever since, has celebrated this new strength. With Gala I returned to the very earliest joys, the heterogeneous paradise of the suckling babe, my total oral pleasure, and the blinding spiritual dominance. My appetite became ferocious and my intelligence prodigious. Since then I have filled the world with my most wonderful paradoxes that bring together opposites and antinomic values: anarchism–monarchy; chaste–eroticism; God's–atheistic–passion; and classical–baroque aesthetics. All possible variants of the Gala-Dali myths. And it is since then that I have been able to appreciate on a par with Raphaelian perfection the admirable anatomy of a naked woodcock on a platter, well hung and flamed in very strong alcohol. All Dalinian truths start in the mouth and assert themselves through visceral response.

My painting is gastronomical, spermatic, existential. It is neither intellectual nor sentimental. Dali feels nothing, knows no emotion, cannot be moved, not even by my love life. My intelligence does not rest on emotion; on the contrary, it is protected and thereby can develop omnisciently. My painting is that essential part of my existence that is located in the "hole" of my being, between what has been sensorially and physically lived and inquisitorial intelligence. I paint in

order to be and to unite all the forces of my self. And through my work which is my life I explore the most exalted of human secrets. That is why each of my blossomings is a harvest for all mankind.

What Stages Does Dali Distinguish in His Work?

If all of the Dali canvases could be brought together, they would make the existential file of Dali's mystical body. Divine Dali. Every being has within himself as it were a structural intuition of an image of his corporeality. Pierre Roumeguère describes three levels of reality: the body in the world, the self in the body, and the self in the world. But this image of our body which we have, which orients our perceptions, our feelings, our effect upon ourselves and the world around us, this model of ourselves is constantly being questioned and reconstructed. And that, only if we do have a feeling of our corporeality, a three-dimensional schema that rises to the threshold of consciousness and determines a projective dynamism. . . .

Modern psychology is in the process of discovering these essential truths that I have been living for three-quarters of a century. My experience some day will be regarded as fundamental and become one of the great scientific revelations. For my schema, my corporeal image, my double started by being a dead boy. I had no corporeal image, fate having willed for me to be born without a body or in an angelic one, with putrefaction images to boot.

So I projected myself into bodies to seek out my structure. A useless quest, but one that afforded me a fantastic exploration of the world; a unique experience which is at the origin of my genius. Heautoscopy is the name given to the phenomenon of hallucinatory projection by split personality such as can be experienced in a dream or before a work of art. Splitting into a second personality endowed with great tactile lucidity and sensuality which can, for instance, move into a picture, to the space suggested by the artist, while one's body remains standing before the frame. Goethe, De Musset, Dickens, Dostoyevsky even described similar states when in moments of intense literary creation.

Well, for my part, I lived through this phenomenon, not fortuitously or under the spell of a tremendous spiritual pull, but permanently, until I met Gala. So I set up in myself unusual psychic mechanisms and acquired data about the being and the real which are diamonds of cosmic value. My work yields only the visible part of the iceberg!

My canvases must be read as the archetypal projections of a new Plato's cave. A new consciousness of humanity may start with me, Dali. It is a journey to the country of horrors, to be sure, and of fear such as an explorer may feel in uncharted territory—and many is the time I provoked and felt death close by since the days when I jumped from the tops of walls or stairways to test my body, as in a slow-motion film with the sensations of my muscles and flesh bruised but alive—yet also a prodigious existential voyage in the sense in which Heidegger says, "To be is to burst upon the world." I literally burst upon the world because I had no body.

Having no bodily analogy, I could not *judge* forms and objects about me. I could only experience them from *within*. Little by little I transformed this escape of the being, this transmutation into pure consciousness. Therein lies the quality of my genius. Unable to give a meaning to things, since I had no stable self as a frame of reference, I experienced them by possessing them, getting the feel of their configuration with unbelievable sharpness, however strange it might be. And my painting therefore has a character of prodigious revelation. Most human beings have never gotten outside their own bodies—only the most gifted of them, and then very briefly, for a mere fortuitous discovery most often literally and aesthetically transformed by reason. But I come on dripping with the "other" truths, my hands full of the treasures of the real, my eyes hallucinated with visions delirious but as true as our lives. That is my "message." And from picture to picture you can readily imagine how my bodily image was little by little restructured beginning with Gala.

I had to reinvent everything. Each of the givens that are termed fundamental to the awareness of being was to me a battle and a conquest. When I say I correct nature as I paint, you must understand what my nature is. When in my 1956 *Nature morte vivante* (Unstill Still Life; or, literally: Living Dead Nature) * I show the fruit bowl floating in space with the fan and fruits and a cauliflower and a bird and a glass and a bottle emptying itself and a knife, in front of a window through which there is an endless moiré sea, while a hand holds a rhinoceros horn, I am defining and communicating a notion of time-space expressed through the vision of a levitation that shatters entropy. With the rhinoceros horn as maximum energy in minimum space, facing the infinite spaces of the sea, the picture becomes the privileged locus of a geometry that translates not only the loftiest sci-

* Also known, less felicitously, as *Still-life, Fast-moving,* according to A. Reynolds Morse, "as the painter translates it." (TR. NOTE)

entific and philosophical speculations, but allows me, Dali, existentially to know the truth of time-space and by that very fact a Dalinian truth of my person and my situation in the world. Each picture is a paranoia-critical consciousness.

When Dali Paints, Is He Trying to Teach Us Delirium?

There are creators enclosed within themselves, to whom serenity is their reason for being. But I, Dali, ever notoriously guilty of nonassistance to bodies in distress, can live only under stress. My paranoia-critical method being the lookout of my drifting, I go from explosive mutation to explosive mutation and can communicate only the seismography of my living truth. My logic moves me to project about me all the images of the mystical body which has become Dali. Actually, I have no bodily dimensions. My self is Dali, i.e., a time-space endlessly modified according to my whims—my desire, my pride, my strength.

Each picture is a code of dominant psychological genetics. Hard and soft, cold and hot, movement and repose, muscular bulges or purulence of the flesh, trompe-l'oeil or straight line, all translate and communicate the ecstasy or nausea, intoxication or lucidity that are necessary states for participation in the vision of the world I supply and the knowledge I reveal. In that sense, each picture is a Mass in which I distribute the Eucharist of a knowledge. This is no meaningless show but an initiation into the Dalinian mystique.

On my own account I am reliving the entire history of art. Through this discipline I have experienced every moment of humanity's awakening to awareness at the same time that I was reconstructing my Dalinian envelope.

From the dreams of the Renaissance, which were to do color paintings of the archetypes of Greek sculpture, by way of the magic treasures of Velázquez, master of reflections and mirrors, to the fantastic world of nuclear physics, quantum mathematics, and the biology of deoxyribonucleic acids, I have gotten to the truth of the classical dome, the creation of the glorious Dalinian body, and the illumination of the station at Perpignan. In art and in my life, I have gotten back to the tradition ruled by the principles of legitimacy and hierarchy and do not fear perfection, for I know that none can attain it and my game (both *jeu* and *je*—my I as well) is to bring about the impossible. I am the Don Quixote of unreality.

How Dali Illustrated Don Quixote *and Revolutionized the Art of Lithography*

During the summer of 1956, the publisher Joseph Foret arrived at Port Lligat with huge lithographic stones in his car. He wanted me to illustrate *Don Quixote*. I had trouble accepting the lithographic process, which struck me as limp and liberal. But Joseph Foret obstinately kept coming back with more stones. His determination made me so aggressive that I could gladly have shot the calm inflexible little man. And an angelic idea dazzled me. I would fire at the stones the harquebus bullet I had intended for the publisher. I wired him to get the weapon ready.

The painter Georges Mathieu had made me a sumptuous present of a sixteenth-century harquebus with an ivory stock.

The event took place on November 26, 1956, on a pontoon on the Seine: surrounded by a hundred sheep, I fired a lead bullet filled with lithographic ink on to the stone, making a sublime splash. I immediately made out the wing of an angel of perfect dynamism that reached the height of perfection. I had just invented "bulletism."

All I had to do now was dream to find the mathematical dispositions of my bullets. It became a considerable attraction. In New York, both TV and collectors wanted to get my harquebus shots. Each morning at the New York Military Academy I fired at a lithographic stone that instantly changed into dollars.

This invention of my genius antedated by a few months the most advanced nuclear physics experiments in which the harquebus of the cyclotron was used to penetrate the secrets of matter.

Born of a harquebus shot, *Don Quixote* also mobilized octopuses, sea urchins, and a cloud of small toads brought in by the storm to fashion my hero's costume. Fancy, whim, and objective chance worked together to bring Cervantes' most noble hero out of the stone.

I was careful to note for history that it was on July 25, 1957, St. James' feast day, that the most sublime splash in the history of morphological science took place. I had taken an empty snail shell, filled with ink. My harquebus shot fired at very close range created exactly the curve of the snail's spiral with such precision and luxury of finesse that I understood this was a case of the appearance of a "pre-snail galaxy" state, a sort of archetype of the divine snail before its creation. I was at one of the summits of Dalinian vision.

Joseph Foret was to request that in the same Dionysiac state
I do the cover for his *Apocalypse of St. John,* for which I conceived
a bronze bas-relief weighing eighty kilograms, which was my first
sculpture. In an apocalyptic surge, I took a hatchet to a wax plaque.
I was working outside on a table set up on the beach at Port Lligat.
In the wax, I embedded a piece of honey cake, for honey is the very
image of the spiritual in the Old Testament, and I stuck in gold
needles to show the radiation around the Christ above whom there
was an agate symbolic of purity. Twelve real pearls represented the
twelve gates of Jerusalem, and fourteen kinds of precious stones the
foundations of heavenly Jerusalem.

I also laid out five hundred and eighty-five nails, correspond-
ing to the categories of soul given by Raymond Lully, the philosopher
of genius, and finished the whole thing with a collection of knives
and forks, elements of daily living—because the Apocalypse is meant

to be eaten like a cheese. Publisher Foret was to make it the most expensive book in the world up to that time—but I was thinking mainly of St. John's words themselves: "And I went to the angel, saying unto him that he should give me the book. And he said to me: Take the book and eat it up. And it shall make thy belly bitter: but in thy mouth it shall be sweet as honey." (X:9)

I was to complete the three inside illustrations of the book by way of a bomb that exploded in the old Paris winter bicycle race-track. I had plastered the bomb to a watch, some medals, and some nails, that were thrown on to a copperplate and engraved into it. Over that explosive design, I drew and watercolored a Pietà.

The *Apocalypse* appeared at the same time that my illustrations for *Don Quixote* were exhibited, and the first volumes of *The Divine Comedy* reproducing my watercolors in lithography. I experienced the Apollonian intoxication of triumph and on this occasion published a text anent divine cheese that I would like to recall to Dalinians whose mental jaws should be in perpetual motion:

> Romanticism perpetrated the foul crime of giving us to believe that hell was as black as Gustave Doré's coal mines where you cannot see a thing. No, Dante's inferno is lighted by the sun and honey of the Mediterranean. That is why the terrors of my illustrations are analytical and supergelatinous with their coefficient of angelical viscosity.
>
> The digestive hyperesthesia of two beings devouring each other for the first time can be observed in the full light of day frenetic with mystical and ammoniacal joy.
>
> The mystique is the cheese; Christ is cheese, or even better mountains of cheese.

But if Dante interested me for so long—over ten years—it was because of his vision of the angelic world:

> . . . like a troop of bees,
> Amid the vernal sweets alighting now,
> Now, clustering, where their fragrant labor glows,
> Flew downward to the mighty flower, or rose
> From the redundant petals, streaming back
> Unto the steadfast dwelling of their joy,
> Faces had they of flame, and wings of gold:
> The rest was whiter than the driven snow . . .

The idea of the angel stimulates me. For if God is outside our ken, He is cosmic because without limits; but angels have shapes. Proton and neutron to me are angelic elements. Raphael and St.

John of the Cross are close to the angels. I try to approach the angelic world through the hyperesthetic paranoia-critical chastity and spirituality of these illustrations. That is my discipline for getting to heaven.

For thirty years, in exile and condemned to death, Dante dreamt of Beatrice whom he had merely glimpsed. He took refuge in his vision: "It was given to me to contemplate a wonderful vision, in which I saw things that led me no longer to speak of this blessed being until the time when I might express myself with more talent about her. And it is toward that end that I work as hard as I can, as she indeed knows."

He closes the fourteen thousand lines of his song by the two key words of *The Divine Comedy:* "Love that moves the sun and the other stars." Love which had allowed him to survive, and the stars in which he hoped to find Beatrice. Through him, I imagine myself without Gala and am shattered by retrospective terror. I did not do a single one of those illustrations but that haunting idea had me beside myself.

But the fact is I never read Dante. I dreamt about him, and then Gala, looking at the drawings I had made, placed them in the text. The best story of that kind that I know is the one about the great Dante specialist, who had spent his whole life studying the great poet, to the neglect of his family, his pleasures, and his children. Finally, he lay dying. The family gathered around his bed, to hear his immortal last words. He murmured, "Dante bores the shit out of me." And died, a free man. I will never have that problem.

In 1963 as a Dantesque antidote I did the *Galacidallahcidé-soxyribonucléique,** which is one of my most angelic and transcendental pictures in which science and heaven form Gala's arch of triumph. I published *Le Journal d'un génie* (Diary of a Genius) and *Le Mythe tragique de l'Angelus de Millet* (The Tragic Myth of Millet's *Angelus*). Tokyo, and then New York, with the four floors of the Gallery of Modern Art, were preparing huge retrospectives of my work.

When I did *Salvador Dali en train de peindre Gala, participant à l'apothéose du dollar dans lequel on peut aussi apercevoir sur la gauche Marcel Duchamp déguisé en Louis XIV, derrière un rideau à la manière de Vermeer qui se trouve actuellement être le visage invisible mais monumental de l'Hermès de Praxitèle* (Salvador Dali Painting Gala, Taking Part in the Apotheosis of the Dollar in Which One Can Also See on the Left Marcel Duchamp Disguised as Louis

* Variously known in English as *Galacidalacidesoxiribonucleicacid* or *Homage to Crick and Watson.* (TR. NOTE)

XIV, Behind a Curtain in the Manner of Vermeer Which Happens Presently to Be the Disappearing but Monumental Face of Praxiteles' Hermes)* business picked up. I was one of the kings of the world in terms of celebrity, rate of income, and the importance of my art and ideas. The rain of dollars was unabated. My chamberlain, Captain Moore, spent most of his time writing up contracts and laying out five-year plans of work for me.

This was also the time when the sun of the Perpignan station illuminated me. My fate became imperial. The youth of painting was catching up with me. In 1936, I had done my *Smoking aphrodisiaque* (Aphrodisiac Jacket) and the first thinking-machine that was the glorious earliest work of Pop Art; my *Esclave de Michel-Ange* (Michelangelo's Slave) and *Lilith* showed that in this field no one could top me. But I was already turning my attention to holograms, the three-dimensional images made with lasers, carrying on the research and painting of *La Pêche au thon* (Tuna Fishing), that transcend and sublimate all current revolutionary experiments, but within beauty and tradition so as to integrate all types of violence and the most extreme eroticism.

The Bible, the poems of Mao Tse-tung and Apollinaire, Casanova's *Memoirs,* making jewels, designing fashions, doing photographic jigsaws, all held my attention, inspiring my verve and my hand. My determined eye made Dalinian signs of all values, which thus became gold.

I thought the time had come to make a break by organizing in the halls of the Hôtel Meurice in 1967 a tribute to Meissonier to announce the return to the hierarchy of values against negation, automatism, nihilism, skepticism. Enough of experimentation: Now for discipline, technique, and style!

And it happened that everyone was becoming aware that the pontiff of pompier art—whom I had always pitted against Cézanne—had invented a kind of painting that perfectly expressed the latest discoveries in physics and was more Einsteinian than any current work. Once more I proved to be right.

I had lived in the flesh and in my work an exemplary story for the men of my time. In that perspective of exchange, my fate took on the aspect of a universal myth. I, Dali, disowned and driven out by my father, at the foot of my olive grove, among my fishermen, lived my passion to the full, like Christ. Imagining in my transports my assumption with my double—my mother—my Gala—all of them

* Usually referred to as *The Apotheosis of the Dollar.* (TR. NOTE)

reinvented by my love and my will power—having transcended my existence of rotting flesh into the essence of life, entirely reconstructed by my own creation, I had now but heroically to assume my immortality, looking without blinking, eyes wide open, at Velázquez' Christ, the symbol of my dead brother whom my genius kept in a state of antigravitation, like one of the planets in the constellation over which I held sway.

"DON QUIXOTE IS A KIND OF MADMAN, THE MOST FETISHIST ON EARTH, WHO INTENDS TO POSSESS THE RAREST THINGS IN THE WORLD. SO I FELT THAT EACH OF MY ILLUSTRATIONS FOR DON QUIXOTE *SHOULD BE THE RAREST OF THINGS THROUGH THE MEANS USED TO MAKE IT. EACH ELEMENT OF THESE LITHOGRAPHS MUST INVOLVE AN ELEMENT OF EXACERBATED QUIXOTICISM."*

XVIII

How to Judge Picasso, Miró, Max Ernst, and a Few Others

It was his uncle Salvador who, by blowing the smoke of his cigar up the nose of the stillborn "blue" baby, brought him back to life: in this way, Picasso was born twice. I think that all his life something in him remembered that death and resuscitation. And that in his case—as in mine—a certain image of the body, his own body, never quite shaped up. One does not die with impunity before beginning to live!

He always seemed to be afraid of suffocating and liked to go about naked to the waist, with the wind on his chest. The impression of quiet strength that he gave was merely an appearance. He was rather on the lookout, like those bulls that come into the arena thinking they have a lot of space, only to find themselves surrounded. His art had the aggressiveness of a lunge of the horns. In attacking the human figure and everything he could identify with it, minotaur, owl, rooster, bull, he "vented his anger" and acted the decoy of freedom. The slightest obstacle infuriated him.

There are as many periods to his art as there are women he loved. He was a lover. But he felt cramped. He became enraged. He

broke off, in order to start again: propulsions and repulsions like the waves of the sea make up an incessant motion that is the rhythm of his genius.

He was sadistic the better to enjoy existence by breathing in the pain of others. He once said his happiest memory was of when two women—one he no longer loved and the other he did not yet love—fought over him. He had brought on the scene by painting one in the other's clothes, and did nothing to try to separate them.

It has been claimed (as by Professor N. N. Dracoulides in his *Le Cas Picasso:* The Picasso Case) that the blue of his most famous period reflects the profoundly depressed mood of the time he was living in Paris with Max Jacob * in a small room in which they had to share a bed. Picasso painted at night while Max Jacob slept, and slept during the day when his roommate was at work. Max at the time was a deliveryman for his uncle's bookshop. But one day he just dumped the books in the gutter so as to get done earlier, and was himself given the heave-ho. The two of them even thought of committing suicide by jumping off their balcony. Picasso got hold of himself first. In order to go back to Spain, he tried to sell some of his paintings. No one wanted them. Vollard sneered. Finally, the wife of his color dealer, Mme. Besnard, paid him sixty francs for a *Maternité au bord de la mer* (Seaside Maternity), the same one that was sold in 1971 for half a million dollars. Enough to make you see red!

But if the blue of that period reflected anything, it was certainly not the price of a tube of ultramarine! Picasso may have burned some of his drawings to keep warm, but he was too much the painter to put to canvas any color that betrayed his vision. It was the phoenix-blue-baby reflecting that blueness in the depths of his despair: I prefer this explanation which brings things back to the arcana of creation, the roots of metamorphoses. Picasso said, "Art is the child of rejection and suffering, and I paint as others write their autobiographies."

Picasso is doubtless the man I have most often thought about after my father. He was my beacon when I was in Barcelona and he was in Paris. His eye was my criterion. I have come across him at all the high points of my reign. And when I left for America, once again he was there: without him, I would have had no ticket. I thought of him as the apple-crowned boy thought of William Tell

* A highly gifted French Cubist poet and sometimes painter who, although a well-known convert to Catholicism, died while imprisoned by the Nazis as a Jew during World War II. (TR. NOTE)

taking aim. But he was always aiming at the apple, not at me. He radiated prodigious Catalan life. When the two of us were together, the spot at which we were must have become heavier and the noösphere assumed special density. We were the highest contrasts imaginable and conceivable. My superiority over him lay in my name being Gala-Salvador-Dali and knowing that I was the savior of modern art that he was bent on destroying while his name was simply Pablo. I was two and predestined. He was so alone and desperate that he had to become a Communist. He never ceased cuckolding himself.

I am often asked what will remain of Picasso's work. What a question! All that will help to bring out the children of my own genius—when the harassed, tortured eye turns away from Picasso's paintings, it comes to ineffable delight by simple exposure to my own. Catalonia conceived us at the same time, as heirs to the noblest of traditions, and Picasso preceded me into the world the better to set me off from the most classical delirium of the creative virtuosity of imperial masterpieces to drawings quantified by energy, which in a mechanical and mediocre universe were to have the noble task of transmuting into gold and beauty the emptiness of modern painting—leading to Gala-Salvador-Dali.

Some say, "Why, Picasso never copied a photograph!"

All my life I have of course used photography. Years ago I already stated that painting was merely color photography done by hand, made up of hyperfine images the only importance of which was that they were conceived by a human eye and created by a hand. All the great works of art I admire were done from photographs.

The inventor of the magnifying-glass was born the same year as Vermeer. This has never been fully appreciated. And I am convinced that Vermeer of Delft used an optical mirror in which the subjects of his paintings were reflected so he could trace them.

Praxiteles, most divine of all sculptors, copied bodies precisely without the slightest subjective deformation.

Velázquez, likewise, reflected reality with total chastity.

The day I planned to do a painting to the glory of St. James, I happened to bump into the Vicomtesse de Noailles, who had just bought a book on Santiago de Compostela and showed it to me. Opening it, I was immediately struck by the shell-shaped architectural vault that is the palm tree of the famous shrine which I decided to reproduce. I also looked until I found a photograph of a horse bucking and traced it in the same way.

Exact copying of nature is no scandal, provided the painter

doing this is capable if he wishes to do as well as or even better than the camera. The only scandal would lie in dissembling and pretending to have created a work one has not done.

Praxiteles said that all the beauty of a work of art lay in the bit of clay the sculptor who faithfully copied his model had nevertheless left between the nail and flesh of a finger.

If you be an artist, copy, keep copying! Something will be left of it. Something more always grows out of it.

One of Louis XIV's sculptors was one day ordered by the king to make a medal. To flatter him, and in view of his admiration for Roman bas-reliefs, the artist decided faithfully to trace an extant Roman medal, yet his hand, in spite of himself, because he was the Sun-King's man and not a contemporary of Caesar, added lines, small differences of touch, imponderables which slightly modified the subject. And art historians know that it was these slight modifications that gave birth to Louis XIV style.

Today, such a phenomenon is hard for us to understand, for we live in a violent period; our contemporaries like only brutal things and are unable to appreciate shadings. The only important and decisive thing in art is the touch of the painter's brush or the sculptor's finger. The brushstroke is the only imponderable, the angelic manner of self-expression.

Today's abstract painters, a Mathieu for example, do their painting with terribly amplified brushstrokes, on an enormous scale. We must remember that one stroke of the artist's brush is the equivalent of a tragedy by Sophocles.

No need to deform, contort, or cheat on reality to express one's art. Neither Praxiteles nor Vermeer cheated in this. Yet they communicated the most sublime and complete of feelings and ideas.

Every time a painter manipulates reality, that is, does something other than to photograph the outside world, it is because he has a very feeble viewpoint on nature. He has a caricatural eye, and wants to give it predominance over beauty. The work is therefore aesthetically less important.

The painter's hand must be so faithful that it can automatically correct a photograph's deformations of natural elements. Every painter must have ultra-academic training. Only on the basis of that can something else, in a word: art, become possible.

I divine what the new painting will be, which I call quantified realism, that is, taking into account what physicists call the quantum of energy, mathematicians chance, and we artists imponderable and beauty. Tomorrow's picture will be the expression of the most faithful

reality, but one will be able to feel that it is pulsating with extraordinary life corresponding to what is called the discontinuity of matter.

Velásquez and Vermeer were divisionists in their time. They intuited modern angst. Today, the most talented, most sensitive painters merely communicate the angst of indeterminism. Modern science tells us nothing actually exists. We see scientists arguing over apparently virgin photographic film about the existence of matter. So there is nothing abnormal about some painters making their pictures out of nothing. But that is only a transitional phase. The great painter must know how to assimilate the nothingness into his picture. And that nothingness is what will give life to tomorrow's great art.

I believe the artist is the true cosmologist of the world and the painter the most compelling of artists because he is dominated by the eye—the highest organ in the hierarchy, the one that dominates situations in all ways.

It is very important for an artist to have a developed sense of the cosmos. I am much more important as a cosmic genius than as a painter. My painting is but one of the means for me to express my cosmic sense. My delirium and lucidity are more important than my painting.

How Dali Remembers His Relations with Picasso

He had a feel for adjectives, but few ideas. He listened to me and gratified me with answers full of modifiers. His whole brilliance lay in his skill as plagiarist and stager—as jewel-setter. When all was said and done, Picasso was a duettist. He always needed a partner: Ingres, Delacroix, Velázquez, and others I forget. But he was a eunuch, a caricaturing imitator who tore down and made fun of what he could not outdo.

When the magazine *Minotaure* was coming out, he and I played a game of working together on a picture that each of us redid five times. The point was to react to each other's work. I thus saw his work processes close up. And Picasso then kept the original: he did not like incriminating evidence left around. All he knew how to do was to distort as he copied.

Picasso's great discovery was Cubism, and at that he took it straight out of Catalan sculpture; it is the pictorial transposition of a position of a sculptured volume found in Catalan churches. A flattening of a three-dimensional object. Cubism was the holography of 1912.

No one at the time understood the plastic significance of this appeal, but Picasso kept at it despite the loneliness and his friends' jibes; mainly, because he wanted to go through with what he had started. He was very stubborn. For instance, he admired Juan Gris, who was a real painter. He often visited him in his studio and Juan Gris then walked him back home, but then Picasso walked him back again so he could go back into the studio and see him paint and understand how he did his grounds. But he was not patient, nor painter, enough to do as well.

In his whole painting life, Picasso never did anything but projects. He had to do the same subject a hundred times, for he never knew which was the right one. Others had to make the choice for him.

The only thing he never pulled off was a real painting. Not one masterpiece! But a prodigious quantity of satires.

He was a barbarian. Whence his success in a period interested only in immediate effect. His work was a great cymbal clap.

Each year, I sent him a postcard to remind him of an old story he had told me. In Cadaqués there was a contralto who had posed for a photographic postcard, holding Samson's head. Her underarms had tufts of hard black hairs that titillated us greatly—they were blacker and harder than Samson's. One day when her lover wanted to fuck her, she refused and went out on the balcony shouting, "In July, do not have women or snails."

Picasso never replied, but I knew he always enjoyed my annual card and this reminder. But those around him stood between us. If he had answered me, they probably would have called him a traitor to the cause. He was the prisoner of his political system, which after all was on the base level of the mob. He got his inspiration from the blood and sweat of the people. Nothing sublime in him—just always the need to make Judy O'Grady laugh or cry!

He was gifted, but not skillful. The only positive thing to be said for him was that he was cleverer than Cézanne—who is really lower than low!

What Dali Sees as the Key to Painting

The day I discovered the key to art I fell to my knees and thanked God. With both knees on the ground! And hands together! Leonardo da Vinci agreed with Euclid that the egg was the most per-

fect of shapes; to Ingres, the sphere was ideal; Cézanne put his faith only in the cube and cylinder. The truth lies not in any shape but in a geometric locus that is the same for all curved shapes of the human body: I discovered this golden rule at the rounded point of the heaven-swept cone of the rhinoceros horn. You can find it for yourself. The point is to apply this inquisitorial mathematics with an implacable rigor that alone can give rebirth to great painting.

I think the time is past for painting algae in the manner of Matisse, that lugubrious kitchen chef for the bourgeois heirs to 1789. A painter of hairs on the soup! I invite the world to a gastronomical and aesthetic revolution: softness, viscousness, gooeyness, against the straight line, the acute angle, the sign disincarnate. A painting of desire and erection. A painting of error and holiness. A painting of the sublime!

Geometry is always Utopian and bodyless. I have often proclaimed: "Geometers rarely get a hard-on!"

Many good craftsmen strayed into painting: Kandinsky, for instance, who would have fared admirably as a manufacturer of enamel-headed canes.

Cézanne is the finest expression of this decadence. He was truly unable to imitate the masterpieces and all of his admired technique is merely proof of his inability. His apples are made of cement. The paradox is that what is least admirable is most admired: nullity! What a symbol for a period! On the pretext of the academic being detestable, the worst in the class was made a hero! He opens the door to the ethics of shit! Newness at whatever cost—and art becomes just a latrine! The logic of this search for newness leads to the glorification of total shit of which Cézanne is the high priest.

Meissonier was the last painter who knew how to paint. After him came the period of disaster. (Thank God nothing but documents will remain of those two scourges, modern art and Russian Communism.) Accepted to the Salon at nineteen, Meissonier began an extraordinary career, the high points of which were the sale of his *1814* for three billion old francs and Kaiser Wilhelm II's telegram of condolences to the President of France when the painter died. What a success his existence was! What an exploit his painting which turned minute faithfulness to detail into a golden rule allowing him to assimilate the complexness, the density, and the tragedy of his time.

I see only his pupil Detaille to rival him. Received by all the sovereigns of Europe, mobilizing entire armies as extras so as to get the feel of reality when he did his sketches, calling in President Jules

Grévy, Detaille was great enough so that it can be said that without him salon painting would have gone out of existence. And his sense of microstructures was carried forward by the Cubists.

The eight hundred paintings of Gustave Moreau are in the studio-museum he willed to the State, where dreamy adolescents fall under their spell. At the end of the nineteenth century, beauty and love were conveyed by him, and will be for a long time to come. Surrealism owes him a great deal.

In Boldini I like the sensuality that lets him undress a woman with a biting stroke and makes his graphicness one of the revelations of modern painting.

I like Millet's erotic cannibalism, which recurs in my work.

But what I don't like is just as clear.

The art of painting could have done without all German painting, and especially the work of Max Ernst; quite incapable of grasping what the phenomenon of beauty is, he is merely a good illustrator. Dürer—one of the rare Germans to know how to draw—is but a pale reflection of the Italian Renaissance.

Braque used to say, "I like the rule that keeps emotion in check." Which Juan Gris felicitously corrected into, "Let us like the emotion that keeps rule in check."

Braque is the French petit bourgeois of good taste, perfectly suited as a house painter, imitator of fake marble. He was lucky in that nature took a hand in finishing his work, and his collages, for example, would be less successful without the flyshit that quantifies them.

Miró is a Catalan peasant, very gifted as are all Catalan peasants, but quite incapable of "murdering painting" as he set out to do. He might have been successful as a society painter because he looked good in evening dress, but he stuck to folklore and that hurts his standing.

Léger is the worst of all; even Braque is better than this flatfoot, for he at least is sometimes pleasing.

Soutine belongs to a filthy family of drunks.

Moore, compared to Praxiteles' *Hermes,* is the village idiot, his work a sculpture of holes.

On the other hand, I admire Marcel Duchamp who was first to paint mustaches on the *Mona Lisa,* to underline her ambivalence. Is she the Oedipal portrait of Leonardo's mother, or the shell-game image of his prattboy? Duchamp posed the question properly with his phonetic caption for the mustachioed Gioconda: *LHOOQ* (pronounced: *Elle a chaud au cul,* or: Her arse is in heat).

I like De Kooning, the colossus straddling the Atlantic with one foot in New York and the other in Amsterdam, whose paintings suggest the geological dreams of earliest ages and the cosmic happenings that record the adventures of the planet.

But today, fake culture sneaks in everywhere. One day at the St. Regis in New York, I met André Malraux. We discussed the history of art. I told him Oriental art was nothing and ought to be passed over in silence, which would be a great savings.

He retorted that Oriental art was just as important as Occidental.

"Let's take a closer look," I said. "I'll name you three Western masterpieces and you name me three masterpieces of your art of the East." And I enumerated Velázquez' *Las Meninas,* Raphael's *Madonna,* and Vermeer's *View of Delft.* "Your turn."

He told me there was a fragment of a Chinese horse's head, of he could not remember which dynasty, that he said was sublime. But what horse? What work? What dynasty? What fragment? How? Why? By whom?

Nothing. A total poverty of culture.

For the same reasons, I vomit on Monsieur Le Corbusier's infamous architecture. What leaden heaviness in that Protestant masochist who depersonalized the house! With delight, I compare to his work that of Buckminster Fuller, with the antigravity structures that breathe with the breath of life.

The sublime structures of our time are those of the American Fuller who conceived the first monarchic structures of modern architecture, since he resurrected the Louis XV ideal of Ledoux, who had made the first completely spherical houses and domes. This work was interrupted by the nefarious French Revolution, which destroyed the legitimate aspirations of the aristocracy and in its place installed the bourgeoisie, until the day when Fuller came along with the lightness of his structures, almost as wispy as the dandelion seeds on the cover of the *Petit Larousse.* One puff and they fly away . . .

Emilio Piñero, in Spain, also invented structures which Fuller has said he would not know how to solve, because their lightness is so molecular and alive. They are based on tensions that develop on their own, sheaves connected by cables; undo the cables, and they all spread out and become rigid. This is quasi-living cellular architecture.

I hope that the Europe of separate countries will be covered by drawings and architecture conceived by Piñero and Fuller. Countries are spherical structures that will stretch, as De Gaulle used to

say, from Brittany to the Urals! Karl Marx was completely wrong about everything. Historically he is the greatest cuckold of mankind. He predicted that we would live through a class struggle, which has been proven wrong, as we know, since soon there will be no more classes, though there may be a race struggle—Blacks, Whites, Chinese, and Japanese. Marx' mistake will be seen by the acceptance of Fuller's and Piñero's architecture in the USSR, when that country changes its regime.

Architecture is the demonstration that a period has reached a certain level of knowledge of structures, that is, architecture must sum up all structures, from quantum physics to biology. There is much talk today of structuralism, but architecture is what creates moral structure and ethics.

Mankind's greatest drama on this earthly globe was the time when the Bay of Biscay opened and the continents separated. The Perpignan area stood its ground, and thanks to that there was Velázquez, Vermeer, and Europe. But for that sacred region, we would be in Australia with the kangaroos.

If everything held, it was because of the Perpignan region. When the Bay of Biscay opened, there were antigravitational anomalies that caused the eels' breeding patterns to be changed and distended. These colossally migrating fish through all the phenomena followed the same paths for millions of years. The same goes for men, and the best pilgrimage is to Santiago de Compostela. Men, grasshoppers, eels go along certain paths and fight certain battles without knowing why. It would seem that human blood merely follows ancestral ruptures despite the ruptures between continents. Great architecture tries to reconcile us with the universe.

To me, the criterion of great art is that it produce an equivalence of the hazel color of Gala's eyes, to the extent that her eyes are antireality. I believe in the discrediting of reality, and the artist's role is to systematize confusion by imposing his obsession on others. The point is to use the elements of the outside world to illustrate the determinations of the mind. To create the "reality" of the double image is proof of the proper application of the paranoia-critical method. Ruse and skill, taking advantage of the slightest coincidences of shapes and colors, can transform the image of a goat into a horse, a cloud, a woman, and the acceleration of desire gives this creative power infinite capability.

What is reality? What is simulacrum? There is neither osmosis nor comparison between the two. The presence of simulacrum is

gratuitous but compelling and everything is interchangeable. Shit, blood, and death conceal treasures.

Einsteinian relativity does not exist only in the domain of physical geometry but also in the world of ideas and poetry. Paranoia-critical delirium alone is able to give us the feel of the disharmony of the real. An artist is judged on this vision of the world.

"IN ALL THE STANCES OF MODERN ART, THERE IS A SINGLE CONCERN WHICH IS PARADOXICALLY TO CREATE DISCONTINUITY OF MATTER. THE IMPRESSIONISTS START WITH THE DISCONTINUITY OF LIGHT WHICH IS THE PAROXYSM OF DISCONTINUITY, THEN COME SEURAT'S DIVISIONISM, CUBISM, ABSTRACT PAINTING, FUTURISM; ALL ARE TRYING TO CUT UP A KIND OF DYNAMISM, TO BRING ABOUT A DISCONTINUITY OF MATTER. BEFORE THEM, IT WAS BELIEVED THAT MATTER WAS CONTINUOUS, BUT FOR A MODERN, MATTER IS DISCONTINUOUS."

XIX

Dali's Days with Dali

Breakfast is brought to me and I put the tray on the bed, making a table of my knees. The cold of the metal through the sheets makes me shiver with pleasure. During this time, I sugar my coffee so violently that the liquid splashes on me. With a small spoon I stir the viscous mixture that I pretend to drink but let slowly run down my chin and neck. The hot sticky stream reaches my chest and spreads among the hairs. A delicious lukewarm sensation invades me. Still apparently indifferent and awkward, I continue with the breakfast, my eye set on the window in which flies are lazily flying about among the sunny curtains. I fix my attention on one of them. The coffee is now down to my belly button. My skin is voluptuously humid. I feel covered with some diluted spermatic fluid.

With a casual finger I tap at my shirt that as a result sticks to my skin. Traces of the coffee appear through the material where the hairs adhere to it. I put the cup down and using the tip of my forefinger create a spotted shirt, each tap making a black spot of coffee. One fly, then two, buzz near me, attracted by the smell and the sugar. Their little membraned wings, quick and delicate, glint

264

in the light and splatter rainbow colors. One is lively, one gliding.
A light buzz of pleasure makes the air tingle in my ears. Both of
them are messengers of summer and of childhood memories.

My soft viscous hairs harden gradually as they stick to the
shirt and begin to draw as they weave into the fabric. A fly lights on
a circle of coffee. I bend my head and look at his prominent eyes, with
their facets in which I must seem huge with my blue-bearded chin.
His chest is like a grain of wheat and the plastron of his belly shines
like smooth shell. He is holding on by the rear legs and using the
two front ones to test the coffee spot, then sets down his trunk. He
seems to be drinking a sugared droplet. I have moved a little and,
quick as a flash, he is gone, cautious but not frightened. I know of
no more valiant animals.

Playfully now, I push away the swarm of them assembled
about me. There must be twenty making the signs of a buzzing con-
stellation. I run my hand slowly over my chest so the whole shirt
sticks and makes just one unit with the skin through the under-
shirt I am wearing beneath. I feel viscous, covered with sweet film,
and the song of the flies makes me feel even better. A male drops
lightninglike on the back of a female, but without evidence of rough-
ness. He gets to work, as his partner tautens on her legs. Just what are
the gentleman and lady feeling? They do not part quickly and as I
make a move the female flies off carrying her conqueror on her back.
Perhaps they will continue their nuptial congress in flight as the queen
bee does. The coffee has dried on my belly and now there is a small
crust that stretches my skin as it dries. I move the sheet and scratch
with the end of my nail. My tool is still dormant in its hairy tuft. I
hesitate for a moment to titillate it.

A fly lands on the glans and scratches it with a gossamer leg,
lazily. I take pleasure in thinking of the legend that tells of the beauti-
ful woman in love with Endymion who woke him too often with her
buzzing, so he turned her into a fly. Is she going to dig her toothy
trunk into me? Or, like her Athenian courtesan ancestor, fleck me
with the fleeting caress that will make my morning virility turgescent?
I feel that if I dropped a drop of sweet coffee on my prick I would get
the lick I want, but my moving disturbs the fly. . . .

There is activity in the next room. My chamberlain is wait-
ing for me to get up. But this morning I will work in bed, still wear-
ing the sticky undershirt and nightshirt that make a soft and complex
cybernetic circuit with my skin, connecting me with all the life forces
about me.

Flies are now all over the sugarbowl. One of them lands on

MOUCHE DU

BULU

my nose, making my eyes cross. Each fly is a queen, setting out her worldly goods as she sees fit, and tithing all about. I realize I am going to have to observe flies more closely, for, introduced into my paranoia-critical system, they might bring me many of the keys to the most secret laws of the universe. For flies never die, perpetuating their genus infinitely, multiplying like light, weaving an immense network of collusions and intercommunications among all forms of the real with a wonderful economy of means, pure geniuses. Wise or delirious, mad or indifferent, they forge ahead with Brownian intelligence. Supposing they were as big as we, we would probably be nothing! Except for me, Dali, for I am probably the only human being capable of seeing, and therefore thinking, like a fly.

The captain brings in two copperplates I am supposed to engrave for a Parisian publisher. Each morning after breakfast I like to start the day by earning twenty thousand dollars. I stick the plates down on my belly, raise my knees, and on that stand I set to work with the engraving point. I take real pleasure in cutting the metal as the steel tip moves along.

There is activity about me. I am like a boat afloat surrounded by light barks. The mail is brought in and the captain opens it. He throws the checks on the bed, calling off figures that I carefully make mental note of without appearing to. As ever, my Jesuitical hypocrisy. Invitations to dinner, cocktail parties, theater tickets. I say yes, or no, as if at random, yet knowing exactly who is who, but also that I may change my mind, cancel what I promised, or reverse a refusal.

A friend has sent me an eighteenth-century picture of the statue at Gerona of St. Narcissus, patron of flies. It is well known that when Napoleon's soldiers invaded the city, the ones who tried to pillage the church were suddenly attacked by a huge swarm of enraged flies, which came out of St. Narcissus' thigh and drove them away. Frightened by the miracle, the nationalist soldiers of the Revolution abandoned the city. Since then, Narcissus has been venerated as the patron of flies.

Having this very morning paid my respects to these insects, it was only proper in paranoia-critical logic that the same day I should receive a sign from St. Narcissus; it does not surprise me. I should rather have been surprised by the opposite. But my ultralocalism is delighted by the fact that even in Paris signs can reach me from my native Catalonia, and that in the heart of feverish Parisian life my mind does not move away from true Dalinian values. Homage to St. Narcissus' flies, to the facets of the parabolic eyes that

allow the lasers of miracle to filter through, driving out the reasonableness that was galloping in on warlike horses and now beats in retreat before the magical effects of faith. I love the fly, most paranoia-critical insect of them all!

During the two periods I spend in Paris, en route between Spain and the U.S.—in October and May—I try to be in touch with all the currents running through this nervous, female city, and what pleases me most is being informed of the delirious temperature. How far too far can one go?

The light is turning blonde over the Tuileries, whose foliage I can see from my bed through the window. I put down my coppers. Little flecks of metal have fallen on my penis, and stick in the pubic hairs to irritate my skin. I lift the shirt to stretch the hairs of my chest that are stuck to it. I deliciously experience the eroticism of this dermic situation.

I remember having dreamt of white excrements, which in Danaë's Freudian vocabulary cannot be mistaken. The day will be a golden one. I tell the captain, who says he is ready, and go to the privy after stopping by a vase full of flowers to take out a jasmine and place it behind my ear.

My stool is very fluid, virtually odorless. I attach great importance to my excreta—which are the most dependable signs we have not only of our inner condition but of the quality of our immortality. A capital subject. In order to live happily, let us study shit. We wear away first in the arsehole. I would like to make my stools sweet as honey, which would be the sign of my existential success. Like the anchorites who chew roots and grasshoppers, I would like to reach the point where I do not swallow food, but merely masticate and spit it out. My progress is constant. I hardly fart at all any more, and only on awakening, very melodiously. This morning, I dedicated my fart to St. Augustine, prince of pétomanes, for I am in a mystical phase.

As I am going to appear before TV cameras, I decide to wear very narrow shoes that will painfully pinch my feet. With my undershirt stiff with black coffee making a kind of solid carapace, I can be sure my oratorical gifts will come out in all their perfection. There is hammering and shouting in the living room where a group of people are making up the décor of gilt-metal caves I have planned for Gala's arrival. Something runs between the metal tubes suspended from the ceiling. Three callers are announced, and I have all three sent up together: a redheaded tigress named Ariadne, publisher Joseph Foret, as determined as ever, and a young man who wants to

swap me a racing stable for the illustration of an edition of *Pantagruel*. They are about to have it out, when the telecast props are brought in. The phone rings. Two newspapermen make their appearance. My chamberlain announces that the richest fabric merchant in Europe is coming to offer me a deal to design the patterns for his next collection: he is a very important gentleman, checkbook in hand. He comes in at the same time as the TV crew. The photographs of the urinal in the Perpignan station that I requested are brought in. Three hippies and a guitar take their places on the sofa. The morning has begun.

I get up to welcome Mr. and Mrs. A. Reynolds Morse, the founders of the Salvador Dali Museum at Cleveland (Beachwood), my fans. I always look at them greedily. Since I first met them, on my arrival in the U.S., they have devoted their entire fortune to the purchase of my pictures. They know all my work better than I, and collect everything that I publish. I am only sorry their example has not caught on better. The more so since they have grown considerably richer through their Dalinian passion. Their capital has quintupled, and thousands of visitors come to their foundation. Dalinian delirium always engenders gold and success. The pleasure they get from it is even greater than their fortune.

This morning. I have been asked to be the main attraction at the Bal des Petits Lits Blancs (Ball of the Little White Beds), Paris' biggest annual charity affair. I answer that I am willing on condition that they put on the spectacle I have just at this instant conceived: a rhinoceros to be lowered from the ceiling to crush a one-and-a-half-meter bust of Voltaire filled with milk. The organizers swear they will do just what I want, but ask me to give them an explanation of the performance. I tell them the world needs some esotericism, that rationalism has desiccated everything, and that secret truths have to be put into circulation through the voice of divagation. During this demonstration, I will read a message, which I improvise on the spot:

> The illustrious Monsieur de Voltaire possessed a peculiar kind of thought that was the most refined, clearest, most rational, most sterile, and misguided not only in France but in the entire world. Voltaire did not believe in angels or archangels, nor in alchemy, and he would not have believed in the value of the 1900-style entrances to the Paris Métro, nor in charity.

But mostly, of course, what Voltaire would never have be-

lieved was that ex-Surrealist Salvador Dali would be coming to the Ball of the Little White Beds to extol the moral and artistic unity of the world in a setting of a subway entrance with a live rhinoceros hanging from above. It is just because Voltaire would never have believed it that I will be there.

I will be there to prove that the opposite of Voltaire is the rhinoceros. In fact, Voltaire has "everything inside," while the rhino has "everything outside," so that Voltaire is all depressions and the rhino, the most irrational and cosmic of all animals, is all relief. I too am all relief and there has often been speculation about the outsizedness of my mustaches, but fanatically I would have liked to have not two mustaches, one on either side of the nose, but two thousand two hundred and fifty-eight mustaches as hard and sharp as the spines of Mediterranean sea urchins, so that, prickly with mustaches all over, I might show the world that, as against Monsieur de Voltaire, Dali believes in everything.

Morphologically, Voltaire is a body in retraction made up of dimples and hollows, whereas the rhinoceros is a compelling system of protuberances. In morphology as in metaphysics, the hollow is antivirtue and protuberance virtue. And the rhinoceros also affords us a sort of Nietzschean "charity of power."

St. Augustine the sublime wrote, "One enters truth through the gate of charity," and I believe that for us artists of today those gates of charity are the Paris Métro entryways that feed all who have been starved on the abstract, starved on formlessness and plastic indeterminism, all those slaves to the nonobjective. The gateways to the Paris Métro are the expression of infinite spiritual charity, the symbol and aesthetic expression of a great moment of the future. For the day is not far off when cybernetics will free us of want and deliver us into perpetual pleasure. Men, then, will have more than ever to become charitable to one another. They will then look at the subway entrances as at a source of new strength.

The "white beds" turned out to be, as the French say, a "shitabed," a fouling of one's nest: the bust of Voltaire was only thirty centimeters high and the security service would not let the rhinoceros be brought down from the ceiling. But that did not change my message.

On the evening of the prestigious Bestéguy Ball in Venice, I was in a fever of excitement. With the genius of my paranoia-critical method I had transformed all of reality into a Dalinian apotheosis. I had been made guest of honor of the City of the Doges and the

Most Serene Republic was feting me: the princes of the earth had been invited to this party at the Labia Palace. A crowd of one thousand three hundred and twenty-seven privileged guests applauded my entrance. I recognized a few friendly faces.

There was Catherine the Great looking like Princess Chachavadze—before the lovers and the borzois; the Emperor and Empress of China disguised as Mr. and Mrs. Arturo Lopez; Cleopatra, pretending to have been painted by Tiepolo, with Lady Cooper's features; Mozart, the spitting image of Barbara Hutton; Prince Ruspoli as ever like himself, and Princess Hyderabad, recognizable despite her blue domino costume.

I had asked Christian Dior to make me a disguise as a seven-meter-tall giant so I could look down on everyone else. The city was in transports, and my success so great that, twenty years later, I still dream of it some nights. . . .

Now is the time to admit it, I am a snob. That means that I like to be and be seen in places where few are admitted, always and everywhere looking down from above. That is a talent I have always had. As a child, I fell in love with a woman because she was wearing a hat—which nobody did where I lived; as a young man, all I needed to see was depilated armpits to be subjugated; but, little by little, things fell into place, I mean that I worked out a veritable strategy of success through snobbery and transcended my desires— the sublimation of instincts is the characteristic of man.

A great deal of my prestige among the Surrealists came from the dinner invitations I received. As soon as the arguments at Place Blanche got hairy, and I was no longer the center of attraction, I would get up and say, "You'll have to excuse me, I'm expected at a dinner." And I always made sure the next day that my little friends, getting along on sardines and bread crusts, knew that I had eaten ortolans the night before at the Beaumonts'.

Among the snobs, on the other hand, the point was to let them know I could not stay all evening since I had to get together with my Surrealist friends to draw up a letter of insult to their cherished Catholic poet Paul Claudel. This balancing game allowed me to make my way on the tightrope. I got into the most exclusive sets in this way, preceded by my reputation for genius, for each wanted me in its clan and feared offending me. It even happened that I was sometimes the only remaining link between old friends who had fallen out over me.

When Sir Edmund Hillary was asked why he climbed Mount

Everest, he answered, "Because it was there." I wanted to get into the most inaccessible circles in order to be there. The Everest was Dali. Everyone has to get that through his head.

The height of snobbery is not being believed and savoring the pride of success by oneself. King Umberto of Italy comes to visit us at Port Lligat. A friend of my father's happens in, wanting me to authenticate an old painting that he put down near the stuffed bear in the vestibule.

"Wait," I tell him, "His Majesty the King is changing his swimsuit hidden behind the bear."

"You're a better painter than practical joker," he replies. "What do you take me for?"

And as he goes out, the sardana band, that I ordered in honor of the King, sees the door open and breaks into music, leaving him speechless.

"Don't you get tired," one visitor asked me, "going up and down steep stairs all the time and through narrow corridors with such sharp turns? Your house is a regular Dalinian maze!"

The idiot had just supplied the answer that made his question pointless. How could Dali grow tired of Dali, who is always doing something new, always astounding himself, with no limits to his imagination? His Port Lligat home was born like a polyp, a slow stratification, the conjunction of Gala's love and Lidia's passion. It is not a house made of rooms, but the arcana of a delirium. Everything in it is conceived to harbor our dream lives. Each step of the stairs, each corridor, each piece of furniture, each object recalls the dramatic steps in the saga of Dali-Gala. I am in my own atmosphere there, breathing my own air. All the walls have our two names entwined on them in watermark. Everything there celebrates the cult of Gala, even to the round bedroom, with its perfect echo, that crowns the complex of buildings and is like the dome of this Gala-ctic cathedral; and when I go through this house, I am looking at myself, living my own concentricity. I love its Mauresque severity. I had to give Gala a setting more solemnly worthy of our love. That is why I gave her the twelfth-century castle in which she reigns, and which I shall not speak of, for I have meant her to be its absolute sovereign —to the point that I go there only when invited in her own hand. It was enough that I decorated the ceilings so that whenever she looks up she finds me in her heaven.

Thus, our couple, at all seasons of its life, comes together in the wonder of the most passionate and delicate of loves.

The inauguration of the Dali Museum at Figueras (August 11,

1973) filled me with Dalinian delight. It was in this very place, then the local theater, that when I was fifteen two of my first Impressionist works were hung in the standing-room gallery among the paintings of established artists. Nothing could suit me better than a theater as setting for the facets of my caprices. This was to be no ordinary museum! Its Piñero cupola, a geodesic dome of genius, will shelter Dalinian hell and heaven. Like a living body, the Dali Museum will constantly grow richer with all my creations, and each new element will be the occasion for an event. It will be in a state of permanent unveiling.

Thus, when the Dali jewels arrived, from the Owen Cheatham Collection, I was made the gift of a wonderful depository that I had conceived twenty years earlier, from Bramante plans, for the sheltering of the treasures in the Arturo Lopez Collection. Everything comes back to its source and the satellites one by one return to the Dalinian orbit. I am waiting for a duplicate of a Guimard Métro station, which I was instrumental in having declared a landmark in Paris, and which includes one of the high points of art nouveau. All the sorts of current topics that inspire me will be grist for the delirium of the Dali Museum. For instance, the imperial mummy exhibited among the treasures of Chinese art at the Grand Palais in Paris gave me the opportunity to create a funeral armor entirely made of printed circuits and thus to send a solemn message to Mao Tse-tung in the form of a hologram, done by Madrid's Technological Institute, of this Dalinian burial statue that will be solemnly transmitted to him.

Printed circuits seem to me to be the purest expression of decorative art—a decorative art that strikes me as the most misprized of our time, efforts being made to hide it from us as if it were shameful, or there were something fearful about honoring the fact that cybernetic science, the most advanced of sciences, had in its applications engendered a decorative expression. Youth everywhere has been clamoring, Power to the imagination! And I proclaim: Printed circuits to the fore! Cybernetic décor for the people! That is why I have sent Mao—the leader of the most numerous people in the world—a veritable fountain of symbolic information.

This princess, dressed in her decorative armor of printed circuits, lies facing a ceiling on which I painted the Ballet of the Wind. In its center, the sky, but then, suddenly, the sky is the bottom of a sea from which through a breach a sort of Havana cigar protrudes which is none other than Narcissus Monturiol's submarine entering the chest of immortal Greece and appearing transformed into an angel. Images out of the hyperaxiological philosophy of Francisco Pujols.

On the left, the portrait of a Figueras inhabitant painting my own portrait and of the Figueras pharmacist who was not looking for anything in the desolate Ampurdan landscape.

The museum will also have some rare Dali canvases, one Cubist and three abstract, my "experiments" that I went beyond.

I intend also to have a Picasso Room so as to go against the current of everything that will be written and said about him during his "purgatory" period, and an Emilio Piñero Room, since his domes will one day cover the world. All the windows of the theater will be topped by gigantic Atlantes. And meanwhile I will reconstruct the whole history of sculpture since the times of the Greeks, but revised by a paranoia-critical view.

The museum will become a gigantic and sublime Dalinian "ready made," haunted by the mystery of my genius. The copy of Michelangelo's *Moses* in it will look intact, but I will have replaced the nail of the left toe by a rock-crystal nail in which the *morros de cony,* my insect of genius, will be forever arrested, so that there will be no plan, but a kind of Dalinian absolute, stuffed with the Dali mystery, a perfect bubble of the Dalinian I-game.

My deepest joy comes from the fact that Gala is at the origin of the museum. It was her perseverance that allowed my project to come to fruition. The banderillas she planted in the backs of all the officials accounted for its success: a legitimate place for Dali's genius across from the church whose bells on May 13, 1904, announced my birth, and where I was baptized Salvador. My ultralocalism encouraged Spanish imperialism to make the spiritual blood of Catalonia run through the world. Nothing is better than Catalan blood—blood sausage is one of our gastronomical wonders—we have a cult of blood, the blood of which we have four red bars on our golden crest —and was not Michael Servetus, a Catalan of genius, burned on Geneva's Place de Grève by the Calvinists for having discovered the existence of the circulation of blood? An amusing detail, it took five hours to burn him because the wood was too green, and his friends, in order to shorten his painful ordeal, kept throwing dry faggots on the stake on which he was perishing.

My museum will allow me to serve the memory of all these heroes. I fall asleep dreaming on it.

Gala, this afternoon, wants to go on an outing to Cape Creus. I have just finished my siesta. I played at making phosphenes by pressing on my eyelids and creating a succession of fascinating, hallucinogenic, paradisiac images, feeding on my own fantasy and precipitating myself into the heart of an exceptionally lucid dream

world. I get up with my mind washed clean. Fantastic Dali, determined to be Dali! My easel awaits.

I sit down on my stool. But Gala comes in. Slim, fragile, delicate, airy, so strong, so radiant, so totally herself and *us*. At every second of her presence, I can get a reading on our love. My entire determination to paint turns into renunciation, acquiescence. We leave. The fishermen greet us as we make our way between the boats to get to the car. Along the way, I am elated to see the rocks standing out beneath the sun and against the sea foaming about them. Phidias appears to have sculpted the dead gods who line this sea like eternal witnesses. We go as far as the eagle of Tudela. On foot, we wander a while among the titanic screes. Gala is laughing, talking, happy.

That evening, a shooting star crosses the sky as a sign of our indefectible happiness.

When we get back to the patio, some ten people or so are waiting and get up. I have pink champagne served. I go off by myself with two pretty women to the phallic pool. They ask me to explain what they call my temple that I built behind the house. Having gotten a cylindrical radio as a present, I had noted the startling geometry of its plastic packing, and decided then and there to make use of exactly that enlarged form to erect the tabernacle of my dreams. In the chancel, from a lead wire I hung the symbol of my babytooth like a Eucharist. My whim suddenly as I spoke took on its full meaning. I noticed that the shape of the building was very exactly the crystallization of the extraordinary design my sacred insect, the *morros de cony,* had on its back like a faceted diamond. So, the paranoia-critical method guided every one of my actions and was a proof by casting out nines of all my caprices.

Knowing that I would sleep soundly, I decided to take a soporific so as to sleep longer and drool at my ease. And, awakening the next morning very late, I discovered a big circle of saliva on my pillow. My lip was slightly chapped by this intense wetting, and a slight irritation at the corner made me scratch it. All day long, I would irritate that painful little wound with the tip of my tongue, savoring that leftover bit of sleep with masochistic pleasure. I have always liked refining small meaningless pains, which, like objective hazards, allow me to dream of my body. Soon, this chapping would be covered with a small bit of skin like a shell, I would detach it carefully with my tongue so as to catch it; that tiny grain of dead skin can be enough to trigger the most amazing journey: dreaming that I become a fish.

I see Gala's yellow boat coming near the jetty. I ask one of

the young women who just came in to give me two hairs from her head, and stick them together for a third of their length. With a rapid scissors-stroke, I make two paper butterflies and attach them to the ends of the hairs. I stick the hairs on my forehead and, borrowing a fan, make the butterflies flutter by around my head.

When Gala comes in, I am a flower and my mustache stamens on which the white wings of the lepidoptera land. This will be my gift of the evening to her, who is dearer to me than my life.

"BEFORE I WAS SIX, I HAD BEEN IN THE PRESENCE OF PUTREFYING ANIMALS, WHICH WAS WHAT UPSET ME MOST: THEN, AROUND TWELVE, I FELT A MORE AND MORE COMPELLING ATTRACTION TO ANYTHING THAT WAS PUTREFACTION. THERE WERE ALWAYS FEELINGS OF REPUGNANCE COMMINGLED WITH THE GRANDIOSE."

XX

How Dali Thinks of Immortality

I decided to have myself hibernated. This is connected with my ultralocalism.

In Figueras, there is a small café that fancies itself headquarters for the sporting crowd, known as Sport Figuerense. A good share of my doings are aimed solely at that spot: I act in terms of what people there will say about me. International opinion means less to me than their reactions!

Let's say I die. I don't want them simply to say, "Dali is dead," but I want them to add: "Once more, Dali is not like the rest. He's had himself hibernated!"

Señor Carbona held court every evening in this café. The invariable subject of conversation at his table was his mausoleum. He wanted to have a magnificent tomb built. He described it to us in detail and everybody chimed in.

One evening the man who was scouting for the ideal place for him came on the scene. "Señor Carbona," he said, "I've found it —a perpetual view of the Gulf of Rosas, a guarantee that no other building will ever be put up between the grave and the sea, no sea

breeze, no mountain wind, and very cheap to boot." Carbona listened impassively, then said, "I'm not interested in it any more." Everyone was floored. For six years, there had been talk of nothing else. Why, they asked, this change of heart?

"I thought it over," Carbona said. "What if I don't die?"

That was the real question. Dr. Hubert Larcher, one of the world's greatest teratologists, published a thesis a few years ago, titled *Will Blood Conquer Death?* In it he asked:

> What if the body should not die? If our corpses became sort of life factories? There are people who, alive, are rotters, and have a foul smell (especially in our consumers' society among bureaucrats who stink much worse than the others), but when saints die they become perfume factories. Not only saints, but also great courtesans.

According to Dr. Larcher, blood is in natural contact with the cosmos. It is perhaps the matter that alchemists were after when they peered into their retorts looking for what was inside themselves all the time.

More than fifty saints are known to have died in the "odor of sanctity"—which is not just an expression but an objective reality. Some saints' bodies, after death, can distill scented balms and oils with infinite virtues, known as myroblytes. The most famous case is that of St. Teresa of Avila, who died at the age of sixty-seven and six months on the eve of October 15, 1582. The nuns had to leave the door and windows open all night despite the weather. Lilies, jasmine, and violets seemed to have pooled their most alluring essences in the aroma that was beyond compare. Any thing brought near the body took on the same scent. Her limbs remained supple, flexible, and the arms could be bent and stretched, as if she were still alive. The alabaster white forehead had lost all its wrinkles and the lips formed a half-smile.

The corpse, without slitting or embalming, was placed in a wooden coffin and lowered into a very deep hole dug beneath the grille of the nuns' chancel. Workmen threw a great quantity of limestone and moist earth over it before sealing the sepulchral stone. The nuns at Alba, the day of the funeral, distributed her clothes: her veil, her sleeves, her coifs, cut up as relics; even the bits of rope from her alpargatas. All of these things had the aroma that exuded from the coffin, and for nine months the scent kept coming through the layers of stone and earth of her tomb.

A year later, the rotted, earth- and water-filled coffin was opened: humidity had rotted the clothes, but the body itself, though

covered with greenish mud, remained absolutely intact. Its flesh was soft, white, and scented. Most amazingly of all, perhaps, an oil was running drop by drop out of her limbs. The nuns gathered it on a great many pieces of fabric, which retained the scent. Her leather belt was removed, and the bishop of Tarazona asserted that eighty years later the belt still had its delicious aroma.

In 1594, Mother Anne of Jesus, sent by the superiors of the order from Madrid to the Salamanca convent, visited the tomb. She noted that on Teresa's shoulders there was a bright spot that looked like fresh blood.

> I applied a cloth which immediately became bloody; then another, which was moistened in the same way. In the meanwhile, the skin remained intact without any sign of a wound or tear. I leaned my face against our sainted mother's shoulder, reflecting on the greatness of this wonder, for she had been twelve years dead and her blood flowed like that of a living person.

I would also cite the case of a Maronite monk, Charbel Makhlouf, who died at seventy on December 24, 1898, at the hermitage of St. Maron's monastery at Annya (Lebanon). One time when the local police chief and several men were out hunting some fugitives from justice who they thought were hiding in the woods, they approached the monastery under cover of darkness. First they saw a dim light, which grew brighter and shone near the monastery door to the east of the chapel. They thought the culprits must be hiding there and rushed the place. But they saw nothing. They then knocked at the door of the monastery. When it was opened, they questioned and searched, but found nothing nor anyone other than the proper inhabitants. When they told the Father Superior and the monks what they had seen, the Superior answered, "For some time already, we have been told that some people see a light where you did; it is the monastery crypt, where Father Charbel is buried."

The tomb was opened the following year in the presence of the Father Superior, some monks, and ten persons who had witnessed the funeral. The body was tender, fresh, and supple, though covered with white mold. Good red blood, mixed with water, flowed from its side, without any trace of corruption.

Thirty years later, the body was placed in a wood coffin covered with zinc, still as perfectly preserved as ever. And, in 1950, pilgrims noted an oozing at the foot of the wall enclosing the tomb: a pinkish viscous liquid. The monks opened it up again: from the

sloping end of the coffin a blood-stained liquid was oozing out. The body was still as supple as ever, and its arms and legs could bend easily.

Dr. Choukrallah, who examined the body thirty-four times in seventeen years, states that the phenomenon is so unusual that perhaps no physician has ever seen its like and the history of medicine records no other. If the liquid oozing from the body each day weighs but one gram, in fifty-four years, this would make 19 kilograms and 710 grams (or just under 44 lbs.). But the average quantity of all the blood and other liquids in a human body is 5 liters (equal to 5 kilograms, or about 11 lbs.). Less cannot account for more: this is a self-evident scientific principle. And the red liquid coming from Father Charbel's corpse is far greater than one gram each twenty-four hours. Any source should dry up if not replenished over a period of half a century. This is a source of wonder that causes me wonderment.

What Dali Thinks of Survival Operations

Horace pointed the way to us when he wrote, "Can man ever write verses worthy of being preserved with cedar oil?" And Dr. Hubert Larcher has stressed the amazing preservation of cedar beams twenty-five hundred years old discovered at Nemrud in the ruins of the palace of Assurbanipal. With a new polish, they can be seen glinting to this day at the British Museum.

The amazing preservation of these beams is doubtless due to the resinous substance called cedarwood oil, derived from cedars, which preserves all sorts of objects: books treated with it are immune from worms and mildew.

In the same way certain meats, as that of the peacock, are said to be incorruptible. It can be deduced that living man resists continual changes by fending them off with what might be called the "balsamic spirit" of the blood. Putrefaction then would be the result of the loss of this vital balm. And the liquid that sometimes flows from the bodies of saints would be a balsamic, scented secretion, with an oily appearance, that can also take other forms: milk, blood, water, or dew.

Larcher, who has specially studied these oils, notes that myroblytic products seem to have a remarkable power of penetration, not only to spread through the body but also to leave it and even go through obstacles. Collin de Plancy said that the oil of St. Nicholas before the translation of his remains worked amazing cures by sweat-

ing through the marble. Moreover, myroblyte oil is said to be combustible. From every viewpoint, these balms correspond to the idea that the alchemists had of the elixir of long life. More paradoxical yet: though burned at the stake, the bodies of St. Theodore and St. Fulcran remained entire. So that the combustible oil may also give noncombustibility to a body. The example of Bernadette Soubirous who could leave her hand exposed to the flame of a candle without feeling it at all is significant. And we have all heard of the famous fakirs who each year dance barefooted on beds of live coals without being burned. Perhaps that is their secret!

For, the most amazing thing is that such properties are not reserved to saints: In 1932, Dr. Graves reported the case of an English alcoholic subject to D.T.'s. Toward the second day of one such fit, his pulse was rapid, perspiration copious, and his whole body gave off an odor exactly the same as that of musk.

> This odor was so strong for forty-eight hours that it could be smelled despite energetic ventilation of all the rooms the patient had been in. It disappeared with the other symptoms of the fit.

There is the case of François de Paule, who smelled of musk while alive. And Dr. Hammond records the case of a woman patient who smelled of pineapple during attacks of chorea (or St. Vitus's dance) and a man who smelled of violets in fits of hypochondria. A young man of thirty observed by Dr. Speranza had a forearm that exuded a perfume analogous to benzoin, yellow amber, or Peruvian balsam. He also cites two even more exciting examples: A contemporary psychoanalyst had occasion to treat a person who exuded a cadaverous stench, and under analysis it was found the patient was living with the ever-present obsession of a departed one. As treatment freed the patient from this fixation, the odor became weaker, and disappeared when the cure was complete.

A patient one day came to a Parisian dermatologist to see what could be done about his foul body odor. After careful checking, the doctor localized the source as the left ring finger. He had the patient take off his wedding band and washed the finger with alcohol: the odor disappeared. Later recurrences showed that the disagreeable smell was linked to the wearing of the band. Psychoanalysis revealed the patient was suffering from certain repressions connected with his marriage, which translated themselves into these typical reactions at contact with the band, the symbol of his matrimonial burden. Analytical treatment cured the patient of his complex and the odor result-

ing from it, and thereafter he could wear the wedding ring without untoward effect.

This example [Larcher says] allows us better to understand how in the cases of certain mystics localization of good smells may have to do with the state of the soul, the contents of the unconscious or of the conscious, or certain objects of contemplation, visions, or spiritual influence.

Man is thus his own laboratory, within the secret of his blood, which contains the formula of time-space and life-giving matter.[1]

The Immortality Formula Chosen by Dali

To create an effect at the Figueras café, so people would say, "Dali did not pass away like other people," I chose hibernation; but I am sure there will be sensational discoveries in other areas. Not enough money has been given to such research. All those who die are victims of Jules Verne, for he is responsible for all the adventures in outer space that take our attention away from real problems. There is nothing to be found out there. It is more and more certain that there is only one magical planet, Earth, on which the phenomenon of life is the miraculous phenomenon. We live at the antipodes of the upsetting thought of Pascal, who believed we were but tiny crumbs lost in the cosmos. Since Teilhard de Chardin, we are convinced of the opposite. All cosmic materials converge toward the phenomenon of life on Earth.

There are some reassuring signs that the end of all these deviltries may be near: the astronauts are already forced to drink their own piss—which delights me—and probably soon will have to eat their own shit! They will have to shit on trays so as to make mushrooms grow very fast; they will eat the mushrooms, shit again, and so on. It is very amusing to see that, thanks to these interplanetary voyages, man is reduced to consuming his own excrement. That suits me just fine.[1] If interplanetary exploration were left aside, and more attention given to deoxyribonucleic acid, which fits like a key into the cell by the same process as nasal spectroscopy of odors, we would be much closer to immortality. After all, the conquest of empty space, without eternal life, is of no interest whatever!

One daring hypothesis poses the problem of knowing whether

[1] See Note at end of this chapter.

the phenomena of life are not partially exempt from the second principle of thermodynamics, which says that energy constantly dissipates and the universe tends toward immobility and entropy. In this area, statistical laws are not absolute principles: reversibility of phenomena shows the ineptness of our means of observation. Herodotus had already said, "Given time enough, everything possible happens."

We are interested only in miracles!

I believe with Blanc de Saint-Bonnet that saintliness is a gift of the human personality. Obviously, Dalinian saintliness is immune to definition, and until my ascesis vouchsafes to me an angelic, luminous, and transcendental transformation, I see no reasons for not arranging to be hibernated.

The price is right. One of the best specialists in the field, Professor Robert C. W. Ettinger, believes that one can be deep-frozen for ten thousand dollars. It would cost fifteen hundred dollars to be frozen in liquid helium, and five hundred dollars per year for replacing of evaporated helium and upkeep, but if a communal mausoleum were created the cost per individual would be less. With ten thousand dollars invested at 4 percent thirty years before death, deepfreeze until resurrection should be fully taken care of. The Life Extension Society started by F.I.V. Cooper presently has seven hundred members planning to be deep-frozen. A certain number of periodical awakenings are planned, for the purposes of recycling, for with the acceleration of progress, which doubles every decade, in a century a frozen person brought back would have the mentality of a child of three.

In this domain, no need for miracles but just precise discoveries that are the simply logical development of known operative techniques and processes. The data are simple: it is known that hibernating animals naturally go into a deep sleep and bring their internal temperature down to 10 degrees Centigrade (or 50 degrees Fahrenheit).[1] After the heart stops, the human brain can survive for two minutes. When the body temperature is brought down 7° C (12.6° F), a person will survive fifteen minutes; below 10° C (50° F), survival continues normally. The problem then is to interrupt the vital processes—living microorganisms have been found in samples of rocksalt crystals up six million years old, so this can be done. At a temperature of −270° C (−436° F), energy stops dissipating. But, while possible for animals, for the sperm of a bull, a rooster, or even a man, such "chemical silence"—dehydration, desiccation as absolute zero

[1] See Note at end of this chapter.

temperature is approached, then unfreezing and rehydration—cannot be carried out with living human beings because of the brain. Ice crystals would burst the cells, or the mineral salts remaining after dehydration might reach a dangerous point of concentration.

The question then would be one of gradualness of refrigeration with concurrent injections of glycerine or glycerol to limit the osmotic shock. But this is getting down to detail—which in itself is reassuring because of its practicality.[1]

How Dali Sees the End of the World

I decided to have myself preserved immediately after my demise so as to await the discovery that one day will allow mankind to bring Dali the genius back to life. I am sure that a cure will be found for cancer, that amazing grafts will be perfected, and rejuvenation of the cells is just over the horizon. To restore life will be an ordinary operation. I will wait in my liquid helium without impatience.

There are however three things to be feared—apart from cell deterioration in my wonderful brain. They are that mankind, possessed of a kind of murderous madness due to the bad effects of overpopulation—like some species of Nordic rats that commit collective suicide—may start murdering the corpses. That the new life I some day wake up to may not be exactly mine, i.e., the divine Dali body as it went to sleep: Would my unfreezing be a reanimation or rather the flowering of someone new, the birth of a Dali I would not recognize? And that humanity by that time may have forgotten me, a risk which in fact seems rather slight, for my immortal oeuvre will only continue to become more meaningful, and my legend will add even more to the prestige of my genius. I am just about guaranteed that in the centuries to come men of all eras will want to see, hear, and know of the new creations of the divine Dali, and what a sublime adventure that will be for me!

I should not be unhappy if some day humanity declared my person to be sacred and that from generation to generation the torch of my body were transmitted as the eternal witness to evolution. Dali wandering through time till the extinction of all suns—what superb delirium that!

That way, I should have cuckolded the whole world of all times and all climes!

[1] See Note at end of this chapter.

*"I SAY THAT THE MAIN AREA OF HIBERNATION
OR DEEP-FREEZE OF OUR BODIES IS THE ARSEHOLE,
SINCE IT IS WELL KNOWN THAT THE FIRST THING
ANIMALS BEGINNING HIBERNATION DO IS TO
STOPPER THEIR ARSES WITH A PASTE MADE OF MUD
AND SHIT SO AS TO KEEP THEIR METABOLISM
INTACT, AND AT THE SAME TIME GUARANTEEING
THEIR INTIMACY WITH THEMSELVES!"*

NOTE

Caga i menga: In his remarkable object-book, *Dix recettes
d'immortalité* (Ten Recipes for Immortality; Paris: Editions Audouin-
Descharnes, 1973), Dali presented his ideas about the "caga i menga"
system, as follows:

In my very earliest childhood, probably around the age of
six, well before the onset of masturbation, I was very much interested
in the welfare of mankind and had sociological dreams about every-
one on earth being happy. I always saw myself as being hailed from
the tops of public monuments by grateful crowds and tears came to
my eyes at the scope of the benefits I was getting for them. Then,
later, I jerked off—for the first time—and said aloud, "Fuck man-
kind." I began to be interested in my own prick and my own sexual
problems; mankind went from a state of high esteem to one of almost
total contempt. But then, in the period when I loved mankind, I had
invented what I called *el sistema caga i menga,* or "the shit-and-eat-
system."

Here, then, as Stendhal would have had it, are the specific de-
tails: the Towers of Immortality—each city was to have one—were
fashioned after Brueghel's Tower of Babel. Each inhabitant need-
ing to defecate did it directly and in pecking order down on the in-
habitant of the next lower floor who needed to eat. Human beings,
through methods of spiritual and alimentary perfecting, produced a
semi-liquid defecation in all respects comparable to bees' honey.
Those below got the defecation from above in their mouths, and
they in turn shit on those below them—which from a social view-
point guaranteed perfect stability; besides, everyone had enough to
eat without even having to work. I saw nothing comical in this theory
and believed in it firmly. But when I mentioned it to a medical stu-
dent, he told me that human excrement was utterly devoid of any
vitamins, proteins, and so on, thus having no nutritive value whatso-
ever. So, I gave up my dreams of the Tower of Babel of Immortality,

which, unlike the Biblical one that tried to reach to heaven, was to provide Immortality here on Earth.

In the same book, he also contemplated the prospect of immortality through holography:

When I found out that one atom of holographic emulsion contained the entire image in the third dimension, I shouted without restraint: Let me eat it! That surprised everybody even more than usual, especially my friend Professor Dennis Gabor, Nobel Prize for Physics 1971. In so doing, I would have been able to accomplish, at least in effigy, one of my heart's dearest desires: to eat the adored being Gala, to ingest into me, into my organism, atoms containing smiling holographic Galas, swimming at Cape Creus. Gala, Belka (Belka is Russian for squirrel), the super-sparkling squirrel, the hibernation specialist. So, here is the recipe for holographic Immortality:

"With a glass of Solares water, swallow holographic information capable of bringing out images with a maximum of happy instantaneousness of resurrection. After the *Persistance de la Mémoire* (Persistence of Memory—the title that in 1930 already I had given to my famous limp watches), there will be the voluntary programing of desire: the image of a sybaritic squirrel coming back to life, to make man immortal."

It was in 1948 that the English physicist Dennis Gabor, of the Imperial College of Science and Technology of London, described the principle of holography (from the Greek: "to inscribe all"), based on the properties of light interference and lasers. Holography allows for photography without a lens and restitution of the image in all of its three dimensions!

In conformity with Leibnitz' monadology, the eye needs only one fragment of a hologram in order to reconstruct the image contained in the hologram as a whole! For every point in the hologram gathers the data come by diffraction from all points of the object.

Apart from its applications in interferometry, spectroscopy, microscopy, acoustics, holography as already used by Dali in painting is the key to the persistence of memory and its immortality, since 1.2 centimeters of emulsion can as of now store a hundred million elementary facts or bits of information!

DATES—FACTS—WORKS

1904: Birth, May 11, at 8:45 A.M., at 20 Calle Monturiol, Figueras, Gerona (Catalonia, Spain), of Salvador Domenech Felipe Jacinto Dali, son of Salvador Dali i Cusi, *notario,* and Felipa Domenech.

1911: Attended local public elementary school.

1913: Attended School of Brothers of the Christian Doctrine.

1914: First painting, self-portrait, *L'Enfant malade* (Sick Child). Convalescence at the Pichots', friends of the Dali family; Salvador is struck by Ramón Pichot's Impressionist painting. At ten, enrolled at Marist Brothers' School, Figueras.

1916: Enters drawing classes of Professor Don Juan Nuñez, whom he reveres.

1918–1919: His painting seems influenced by Modesto Urgel, Ramón Pichot, Mariano Fortuny, and a few of the realistic painters of the nineteenth century. Dabbles in Impressionism and Pointillism. Makes "collages" of stones in his pictures, to render depth of light.

Reads the magazine *L'Esprit nouveau* (The New Spirit), discovering Cubism and Juan Gris.

Has two pictures in a show, with thirty local artists, at Figueras theater; well noted by critics. Does poster for the Figueras festival, *Fires i Festes de la Santa Creu.*

1919: January–June, with schoolmates, publishes the magazine *Studium,* in which he writes and edits the old masters department. Begins to paint in distemper.

Participates in student political agitation; is arrested for twenty-four hours.

1920: His painting seems to reflect the influence of the Italian Futurists.

1921–1922: Attends Madrid's San Fernando Institute of painting, sculpture, and drawing; meets Federico García Lorca and Luis Buñuel. Goes from studious, monastic life with Bohemian habits of attire to worldly existence of Beau Brummel dandyism. Does classical paintings: *Portrait de sa tante* (Portrait of His Aunt), *L'Allée du verger à Cadaqués* (Orchard Lane at Cadaqués), *Autoportrait de l'artiste à son chevalet* (Self-Portrait at the Easel), *Autoportrait avec le cou de Raphaël* (Self-Portrait with Raphael's Neck), *Une cruche* (A Jug).

1922: In October, shows eight canvases at Dalmau Gallery, Barcelona, in exhibition of young Fine Arts School students.

1923: Influenced by school of metaphysical Italian painters, Giorgio de Chirico and Carlo Carra.

Suspended for one year from San Fernando Institute for inciting students to protest, following demonstration against appointment of a professor. One month's political preventive arrest in prison of Figueras.

1924: Illustrations for *Les Bruixes de llers* by Fages de Climent. Vacations at Cadaqués with García Lorca.

1925: Return to San Fernando Institute. November 14–27, first one-man show at Dalmau Gallery (17 canvases, 5 drawings). Portraits of his father and sister, Cadaqués landscapes. (Prefaces catalogue with quotation from Ingres: "Drawing is the touchstone of art.")

December 1925–February 1929: Sustained and widely appreciated contributions to the Barcelona *Gaceta de los artes.* Cubist experiments; paints a *Harlequin, La Petite Bouteille de rhum* (Little Rum Bottle), *Femme couchée* (Reclining Figure), and *Vénus et le marin* (Venus and the Sailor).

1926–1927: Permanently expelled from San Fernando Institute by decree of the King, October 20, 1926, for outrageous mis-

conduct, despite his excellent grades. Deliberately leaves his luggage behind in Madrid, to cut himself off from his youthful past.

December 21, 1926–January 14, 1927: Second one-man show at Dalmau Gallery, Barcelona (20 canvases, 7 drawings).

1926–1929: Contributor to *L'Amic de les arts (Gaceta de Sitges)*. Paints *Fille de l'Ampurdan* (Girl of the Ampurdan) with wiggling buttocks, later taken to Paris to be shown to Picasso; *Corbeille de pain* (Basket of Bread), shown at Dalmau's, later sent to Pittsburgh's Carnegie Institute show.

1927: Nine months of "goldbrick" military service.

First trip to Paris, with his sister and aunt; visits Versailles, and Grévin Wax Museum; meets Picasso.

Paints *Nature morte au clair de lune* (Still Life by the Light of the Moon; or *Peix y balcon:* Fish and Balcony) and does settings for Lorca's play, *Mariana Piñeda*. First Surrealist painting, *Le Miel plus doux que le sang* (Honey Sweeter than Blood), originally dubbed by Lorca *La Forêt des appareils* (Forest of Machines).

1928: Second stay in Paris; introduced to Surrealists by Miró, sees Picasso and André Breton. In March, publishes *Groc Manifesto* at Sitges, with Sebastian Gasch and Lluis Montanya. October 18–December 18, *Basket of Bread, Ana-Maria* (his sister), and *Muchacha de espaldes* (Girl Sitting, or Girl's Shoulders), his first pictures to be seen in the U.S., are shown at Pittsburgh's Carnegie Institute 27th International Exhibition of Painting. (*Basket of Bread,* first of his paintings to be bought in the U.S., is now in the Dali Museum at Cleveland.)

Does series of gravel collages, influenced by Max Ernst and Miró. Gala, wife of poet Paul Eluard, visits Cadaqués and meets Dali for the first time.

With Luis Buñuel, writes scenario for *Un chien andalou*. Miró introduces him to his dealer, Pierre Loeb; paints a few abstract paintings, experimentally.

1929: November 20–December 5, first Paris show, at Goëmans Gallery (11 paintings); signs first dealer contract for three thousand francs.

René Char, Gala and Paul Eluard, and Nush visit Cadaqués; Dali fascinated by Gala, Eluard leaves her behind and returns to Paris.

October 1–December 23: *Un chien andalou* runs at Studio 28, Paris, creating scandal and sensation.

Begins *Grand Pouce-Oiseau pourri et lune* (Big Thumb, Plate, Moon, and Decaying Bird), rejected by the 1929 Paris Salon d'Automne because of "erotic allusions" (later acquired by Mr. and Mrs. A. Reynolds Morse for their Cleveland Collection, largest Dalinian collection in the world).

Paints *Les Premiers Jours de printemps* (First Days of Spring), erotic vision of Dalinian delirium, also now at Cleveland. *La Revista de Occidente* publishes Federico García Lorca's *Ode to Salvador Dali.*

1929–1930: Influenced by art nouveau and work of Antonio Gaudí, Barcelona architect; paints *Commencement automatique d'un portrait de Gala* (Automatic Start for a Portrait of Gala), *L'Accommodement du désir* (Accommodations of Desire), *Les Plaisirs illuminés* (Illumined Pleasures), *Portrait of Paul Eluard,* and *Le Grand Masturbateur* (The Great Masturbator), all directly inspired by his love for Gala. Goes with Gala to Carry-le-Rouet, on French Riviera; sells a painting to the Vicomte de Noailles for twenty-nine thousand francs. Dali buys his first house, a four-by-four-meter hut, at Port Lligat. Paints *Port Lligat Landscape.* Develops passionate interest in physical, biological, and cybernetic sciences.

Stay at Torremolinos. Collaborates with Buñuel on a second scenario, *L'Age d'or,* financed by the Vicomte de Noailles. *La Gaceta literaria* publishes article by Eugenio d'Ors on Dali's life in Paris, which upsets his father. Break between father and son.

1929–1931: Critics in this period note an influence in Dali's work of early works by De Chirico, Ernst, Miró, and Tanguy, as well as Archimboldo and Bracelli.

1930: Writes and illustrates *La Femme visible* (The Visible Woman; Paris: Editions surréalistes), essays and poems dedicated to Gala. The book announces his psychoanalytical and dialectical paranoia-critical method.

Does two illustrations for *L'Immaculée Conception* (The Immaculate Conception; Paris: Editions surréalistes) by André Breton and Paul Eluard.

L'Age d'or runs in Paris at Studio 28, November 28–December 3. The League of Patriots (royalist youth) demonstrates violently against it: paintings by Dali, Ernst, Man Ray, Miró, Tanguy, on exhibit in foyer of Studio 28, are destroyed

by the demonstrators. Prefect of Police bans further showings.

1930–1933: Makes important contributions to the magazine, *Le Surréalisme au service de la Révolution* (Surrealism in the Service of the Revolution). Much concerned with double images and the legend of William Tell, he is deeply influenced by Böcklin's *Isle of the Dead* and Vermeer's *Artist in His Studio.* Dali extols Meissonier and fights the "Abjection and Wretchedness of Abstraction."

1930–1938: Illustrates several important Surrealist works, including André Breton's *Second Manifeste du surréalisme* (Second Surrealist Manifesto; Paris: Kra, 1930) and *Le Revolver à cheveux blancs* (The White-Haired Revolver; Paris: Cahiers libres, 1932); Tristan Tzara's *Grains et Issues* (Seed and Issue; Paris: Denoël & Steele, 1935); and Paul Eluard's *Cours naturel* (Natural Course; Paris: Sagittaire, 1938).

1931: Spanish Republicans come to power; riots follow proclamation of Catalan Republic.

Dali paints *L'ombre de la nuit s'avance* (Shades of Night Descending) and *Solitude,* inspired by his premonitions of civil war.

November 16–December 10: Has eight paintings and two drawings shown in The Newer Super-Realism Exhibition, at the Wadsworth Atheneum, Hartford, Connecticut.

Writes *L'Amour et la Mémoire* (Love and Memory; Paris: Editions surréalistes), and paints a portrait of Gala.

1932: Writes *Babaou* (Paris: Cahiers libres), including an introductory *Abrégé d'une Histoire critique du cinéma* (Short Critical History of Film) and a concluding *William Tell,* "a Portuguese ballet."

Three paintings shown in January at Julien Levy Gallery, Madison Avenue, New York, resulting in Museum of Modern Art's acquisition of *The Persistence of Memory.*

Paints *Méditation sur la harpe* (Meditation on the Harp), *Moi, à dix ans, quand j'étais enfant-sauterelle* (Myself, at Age Ten, When I Was a Grasshopper-Child), and *Bureaucrate moyen atmosphéricocéphale en train de traire une harpe crânienne* (Average Atmosphericocephalous Bureaucrat Milking a Cranial Harp).

1933: November 11–December 10: First one-man show at Julien Levy Gallery, New York (26 pictures).

Writes in the magazine *Le Minotaure* about Millet's *Angelus* and various skeletal and cephalic distortions.

December 8–12: For the first time, his Surrealist works are shown in Spain, at Barcelona's Galerias Catalonia. He gives a lecture that starts a riot.

At Port Lligat, paints *Cardinal, Cardinal!*, *Sevrage du meuble-aliment* (Weaning of the Furniture-Nutrient), *Le Spectre du sex-appeal* (The Specter of Sex Appeal), and *Le Couple aux têtes pleines de nuages* (Couple with Heads Full of Clouds).

1934: October 24–November 10: First London one-man show, at Zwemmer Gallery (16 paintings, 20 drawings, 17 prints). Conflict with André Breton results in his condemnation by the Surrealist movement.

At Picasso's suggestion, does forty-two plates to illustrate Lautréamont's *Les Chants de Maldoror* (Geneva: Skira). First trip to New York: contributes series of visual impressions of New York to *The American Weekly* (February 25–July 5).

Paints *Imperial Violets, The Sublime Moment,* and *Blind Horse Chewing a Telephone.*

Back at Port Lligat, paints *Image médiumnique paranoïaque* (Paranoiac Mediumistic Image).

Through 1936, makes significant contributions to the *Cahiers d'art,* particularly with *Honneur à l'objet* (Honor to the Object; Nos. 1–2, Vol. XI, 1936).

Through 1937, paints *Les Figures instantanées apparues sur la plage de Rosas* (Instantaneous Figures That Appeared on the Beach at Rosas, Spain). Evinces great curiosity about Lenin and renewed interest in Millet's *Angelus.*

Becomes interested in Hitler and in the telephone.

1935: In *La Conquête de l'irrationnel* (Paris: Éditions surréalistes), also published in English as *Conquest of the Irrational* (New York: Julien Levy), defines paranoia-critical activity as a "spontaneous method of irrational knowledge based upon the interpretive-critical association of delirious phenomena."

1936: Learns of the death of García Lorca. Paints *Le Cabinet anthropomorphique* (The Anthropomorphic Cabinet), *Banlieue de la ville paranoïa-critique* (Suburb of the Paranoia-Critical City), and *Après-midi sur la lisière de l'histoire européenne* (An Afternoon at the Edge of European History). Invents *La Vénus de Milo aux tiroirs* (Venus de Milo with Opening Drawers).

Second American trip: *Time* runs his photo-portrait by Man

Ray on its cover. He does window display for Bonwit Teller. A serious psychological crisis seems to upset his life at this period; leaves for Port Lligat and sojourn in Austria.

1937: The Germans bomb Almería: Picasso paints *Guernica;* Dali paints *Le Sommeil* (Sleep), *Paranonia* (Paranoia), and *Le Grand Paranoïaque* (The Great Paranoiac).

Publishes *La Métamorphose de Narcisse* (Metamorphosis of Narcissus; Paris: Editions surréalistes), with a paranoiac poem illustrating his double-imaged picture of the same title.

1937–1939: Three trips to Italy, staying first in Rome with the poet Edward F. W. James, then in the same city with Lord Berners, and finally in Florence. Studies Palladio, and is deeply influenced by Renaissance painters and baroque period. Paints *Le Corridor de Palladio* (Palladio's Corridor), then *Souvenirs d'Afrique* (African Memories), *L'Enigme sans fin* (The Endless Enigma), *La Plage enchantée avec trois grâces fluides* (Enchanted Beach with Three Fluid Graces), and *Gala Gradiva.*

In London, meets Sigmund Freud (introduced by Stefan Zweig), and draws portrait of the great psychoanalyst on a piece of blotting paper.

1939: Third trip to U.S. Dali has become internationally famous for having jumped through the pane of Bonwit Teller's show window to protest changes made in his composition. Publishes a broadside, *Declaration of Independence of Imagination and Man's Right to His Own Madness,* to defend his substitution of a fishhead on a Botticelli torso in *The Dream of Venus,* Surrealist setting for the show commissioned from Dali for New York World's Fair.

Metropolitan Opera puts on his ballet *Bacchanale,* with sets and costumes originally intended for Ballets Russes de Monte-Carlo.

Hitler invades Poland. Dali goes to Arcachon, where he meets Marcel Duchamp and Coco Chanel.

1940: As Hitler overruns Western Europe, Dali goes to Spain, sees his father, and then sails from Lisbon aboard the S.S. *Excemption* for U.S. exile until 1948, first as guest of Caresse Crosby at Hampton Manor, Virginia, later in his own studio at Pebble Beach, California.

Begins to paint *La Résurrection de la chair* (Resurrection of the Flesh), which will take him five years to complete, and does his *Autoportrait mou avec du bacon grillé* (Soft Self-

Portrait with Fried Bacon), expressing his new view of life in America.

1941–1942: November–January, his first great Retrospective at New York Museum of Modern Art (43 paintings, 17 drawings).

February 1942–May 17, 1943: The show tours eight principal American cities.

Dali conceives sets for several ballets: *Labyrinthe* (Labyrinth, 1941), *El Café de Chinitas* (Chinitas Cafe, 1944), *Colloque sentimental* (Sentimental Colloquy, 1944), and *Tristan fou* (Mad Tristan, 1944).

1942: Writes his autobiography, *The Secret Life of Salvador Dali* (New York: Dial Press; Haakon M. Chevalier, translator).

1943: April 14–May 5, exhibition of twenty-nine works at the Knoedler Gallery, New York. Completes plans for three paintings for New York apartment of Helena Rubinstein (Princess Gourielli).

1944: Publishes his novel, *Hidden Faces* (New York: Dial Press; Haakon M. Chevalier, translator).

1944–1948: Illustrates numerous books: Maurice Sandoz' *Fantastic Memories* (1944) and *The Maze* (1945); *Macbeth* (1946); Montaigne's *Essays* (1947); *As You Like It* (1948); *The Autobiography of Benvenuto Cellini* (1948).

1946–1965: Publishes four series of illustrations for *Don Quixote* over this two-decade period.

1948: Illustrates *Fifty Secrets of Magic Craftsmanship* (New York: Dial Press; Haakon M. Chevalier, translator).

Paints *Géopoliticus observant la naissance de l'Homme nouveau* (Geopoliticus Child Watching the Birth of the New Man). Then, after explosion of the A-Bomb: *Melancholia atomica; Nu de dos* (Rear Nude); and *Galarina*.

Returns to Europe, primarily to Port Lligat. Begins drafts of what he is to call his "classical and religious art."

1948–1949: First religious paintings. Two versions of *Virgin of Port Lligat,* first of which is blessed by the Pope.

1951: Paints *Christ of St. John of the Cross,* now in Glasgow Art Museum.

Writes *Le Manifeste mystique* (Mystic Manifesto; Paris: Editions Robert Godet).

1952: Completes one hundred and two illustrations for Dante's *Divine Comedy.*

Makes lecture tour of seven states of U.S., speaking on his "mystical nuclear" art.

Paints *Léda Atomica; Dali at the Age of Six When He Thought He Was a Young Girl Lifting up the Skin of the Water to See a Dog Sleeping in the Shadow of the Sea; Cupola Composed of Contorted Wheelbarrows; Raphaelesque Head Exploding; Galatea with Spheres; Assumpta corpuscularia lapislazulina; Poésie d'Amérique* (Poetry of America).

Begins to write a play, *Le Délire érotique mystique* (Mystical Erotic Delirium).

Writes *The Divine Marquis' 120 Days of Sodom Upside Down,* as a tribute to the Marquis de Sade.

French edition of his autobiography published: *La Vie secrète de Salvador Dali* (Paris: La Table ronde).

1954: With Philippe Halsmann, publishes *Dali's Moustache* (New York: Simon & Schuster).

Paints *Corpus Hypercubicus* (Crucifixion), now in the Metropolitan Museum of Art, New York.

Great Dali Retrospective in Rome (24 oils, 17 drawings, and the 102 watercolors illustrating *The Divine Comedy*).

Begins a film with Robert Descharnes: *Histoire prodigieuse de la dentellière et du rhinocéros* (The Prodigious Story of the Lace Maker and the Rhinoceros).

Paints *Two Adolescents* and *Young Virgin Self-Sodomized on the Horns of Her Own Chastity.*

1955: *The Sacrament of the Last Supper* exhibited at National Gallery, Washington, donated by Chester Dale.

In this period of Vermeer's lace maker, the rhinoceros, and the cauliflower, he paints *La Copie paranoïaque de la Dentellière de Vermeer de Delft* (Paranoiac Copy of Vermeer of Delft's *Lace Maker*).

Dali lectures at the Sorbonne.

1956: July 1–September 10: Great Dali Retrospective at Knokke-le-Zoute (Belgium) (34 oils, 48 drawings, watercolors).

Publishes a "treatise on modern art": *Les Cocus du vieil art moderne* (Cuckolds of Old Modern Art; Paris: Fasquelle).

Paints *Le Crâne de Zurbaran* (Zurbaran's Skull) and *Nature morte vivante* (Unstill Still Life).

1957: Presentation of *Santiago el Grande,* now in Beaverbrook Art Gallery, Fredericton, New Brunswick (Canada).

English translation of *Les Cocus du vieil art moderne* appears as *Dali on Modern Art* (New York: Dial; London: Vision Press; Haakon M. Chevalier, translator).

1958: *St. James of Compostela* and *Sistine Madonna* are exhibited at Brussels World's Fair.

At Orly Airport (Paris), Dali creates a manger on the theme of Pope John XXIII's ear. Receives the Gold Medal of the City of Paris.

Creates *The Ovocipede.*

Draws Paris' Place des Vosges and Place de la Concorde.

1959: Finishes *The Discovery of America by Christopher Columbus* (also known as *The Dream of Christopher Columbus*), his first historical painting, exhibited in Huntington Hartford Collection at New York Gallery of Modern Art, then acquired by the A. Reynolds Morse Collection for the Salvador Dali Museum, Cleveland (Beachwood), Ohio.

1960: Draws *Le Couronnement de Jean XXIII* (Coronation of Pope John XXIII), *La Crucifixion angélique* (The Angelic Crucifixion), *Le Concile oecuménique* (The Ecumenical Council), and *Les Disciples d'Emmaüs* (Disciples at Emmaus).

Creates cover for *L'Apocalypse selon Saint Jean* (The Apocalypse According to St. John), the world's most expensive book.

1961: Sets and costumes for *Ballet de Gala* and one act of the Scarlatti opera, *The Spanish Lady and the Roman Cavalier,* both produced in Venice.

New expanded edition of *The Secret Life of Salvador Dali* (New York: Dial Press; London: Vision Press).

1962: Completes large painting, *Le Bataille de Tétouan* (The Battle of Tetuan; Huntington Hartford Collection, New York).

1963: Paints *Galacidallahcidésoxyribo-nucléique* (Homage to Crick and Watson, or Galacidalacidesoxiribonucleicacid; New England Merchants National Bank, Boston).

Completes *Le Portrait de mon frère mort* (Portrait of My Dead Brother), and paints *Cinquante peintures abstraites par lesquelles à trois mètres on voit trois Lénines déguisés en Chinois, le tout formant la gueule d'un tigre royal* (Fifty Abstract Paintings Through Which at Three Meters' Distance One Can See Three Lenins Disguised as Chinese, All Forming the Maw of a Royal Tiger), and completes *La Mort de Raymond Lully* (Death of Raymond Lully).

Publishes *Le Mythe tragique de l'Angélus de Millet* (The Tragic Myth of Millet's *The Angelus*), with paranoia-critical interpretation (Paris: Jean-Jacques Pauvert).

1964: September–October, Japanese *Mainichi* newspapers organize a great Dali Restrospective in Tokyo.

Publishes *Journal d'un génie* (Diary of a Genius; Paris: La Table ronde).

Paraphrasing Avidadollars (Idsavadollar), the sarcastic anagram of his name devised by André Breton, he paints *The Apotheosis of the Dollar.*

1965: Series of illustrations for a new edition of the Bible. This is the period of the Perpignan station; works at three-dimensional art and does his first sculpture: *Bust of Dante.* Devotes his thinking to holograms and laser beams.

Abridged English version of *Diary of a Genius* (Garden City, N.Y.: Doubleday; Richard Howard, translator).

1966: Greatest retrospective show ever devoted to a living artist presents Dali's life works at New York Gallery of Modern Art. Creates a series of Pop-Objects: *Michelangelo's Slave, Lilith, The Aphrodisiac Jacket, The First Thinking Machine.* Alain Bosquet publishes *Entretiens avec Salvador Dali* (Conversations with Salvador Dali; Paris: Pierre Belfond). Dali publishes *Lettre ouverte à Salvador Dali* (Open Letter to Salvador Dali; Paris: Albin Michel).

1967: Completes his huge painting, *Tuna Fishing.*

Illustrates Guillaume Apollinaire's *Poèmes secrets* (Secret Poems); *Aliyah; Poèmes de Mao Tsé-toung* (Poems of Mao Tse-tung); *Huit péchés capitaux* (Eight Capital Sins).

Rizzoli publishes The Dali Bible.

1968: Max Gérard edits *Dali de Draeger* (Dali by Draeger; Paris: Draeger).

Illustrates poetry of Pierre de Ronsard and three unpublished plays by the Marquis de Sade.

Louis Pauwels publishes *Les Passions selon Dali* (The Passions According to Dali; Paris: Denoël).

English edition of *Open Letter to Salvador Dali* (New York: James H. Heineman; Harold J. Salemson, translator).

1969: Illustrates *Les Métamorphoses érotiques* (Erotic Metamorphoses); *Faust; Tristan and Isolde; Carmen.*

Paints *Le Toréador hallucinogène* (The Hallucinogenic Toreador).

1970: Begins doing works for the Dali Museum planned at Figu-
 eras. Publishes *Dali par Dali de Draeger* (Dali by Dali; Paris:
 Draeger-Soleil noir).
 Large retrospective show, including the Collection of Edward
 F. W. James, at Boymans-van Beuningen Museum, Rotter-
 dam (Holland).
 English translation of *Dali by Draeger* (New York: Harry N.
 Abrams; Eleanor R. Morse, translator).
1971: March 7, Inauguration of the Salvador Dali Museum at
 Cleveland (Beachwood), incorporating the Collection of Mr.
 and Mrs. A. Reynolds Morse.
 Retrospective exhibition at Staatliche Kunsthalle, Baden-
 Baden (Germany).
 Collected writings published as *Oui, Dali* (Yes, Dali; Paris:
 Denoël).
 Illustrates latest André Malraux book, *Roi, je t'attends à
 Babylone* (King, I Await You in Babylon; Geneva: Skira).
 Completes second large ceiling panel for Figueras Museum.
 Engravings, *Hommage à Dürer* (Tribute to Dürer), shown
 at Galerie Vision nouvelle, Paris.
 Completes ceilings of Gala's château.
 English edition of *Dali by Dali* (New York: Harry N.
 Abrams; Eleanor R. Morse, translator).
1972: First showing of three-dimensional oils and holograms at
 Knoedler Gallery, New York.
 Sculpts the *Easter Plate* for Lincoln Mint.
 Selects works from among those in reserve at Madrid's Prado
 Museum, for temporary showing at unfinished Dali Museum
 in Figueras.
 Devotes himself to engraving.
1973: Writes and illustrates his first object-book: *Dix recettes
 d'immortalité* (Ten Recipes for Immortality; Paris: Audouin-
 Descharnes).
 August 11: Salvador Dali Museum at his native city of
 Figueras is inaugurated.
1974: Reissue of his novel, *Hidden Faces* (New York: William
 Morrow).

SONNET A LA COMMODE DE MALLARME

ODE

Le regard de Gala, odeur d'hectolitre or
Sonore de tasses appuyées demi portugaises
Blanche péninsule où garder mon pâle trésor
Une patrie ! Que rien à moitié me déplaise.

Espagne et Portugal, saut pour ibérique : Rome
Torrent triomphal du destin impérial : Rome
Cent Maos Graals, Cadaqués, Vélasquez l'unique
Dans l'or blanc liquide, hostolitre tassé, l'homme.

Depuis des millions d'ans, la gare de Perpignan
Appuie, protège, le tassé génie de Séville
En le garant de la dérive du continent.

Trajan Ta ! Ta ! Ta ! Qu'à Rome empereur brille !
Codifiant, les guerres de Vénus à la commode,
Mous tiroirs au crépuscule, absolu, aube, ode.

SALVADOR DALI DOMENECH FHELIPHE
I HYACINTHO DE FIGUERAS

Membre de l'Académie royale de San Fernando.

Handwritten annotations:

AFRIQUE

ODE

MIROIR
MIROIR creatt
être sauvage en l'homme REMPLISSEM
le font

CRAAS MAOS

DANS
ARRET

CRAALS CERVET CADAQUES VELASQUE
CIRCUIT TASSE

POR que BIEN — PARFUM — me PLAISE

LETTRE TAXE DANS CIRCUITS

que

ASSIMETRIQUE CIRCUIT

reflet JOUG odeur hu Regard pale tresor
peninsule ... aux purinees

MIROIRS TASSES, l'homme
CERBET CIRCUIT TASSE

que
ASSIMETRIQUE
MAOS CRAAS CADAQUES velazques

l'être cett velazques

CRAALS DE MAOS VELAZQUES velazque

CERBET

CERBET CIRCUIT BINOCULAIRE L'ome

CERBET CIRCUIT TASSE

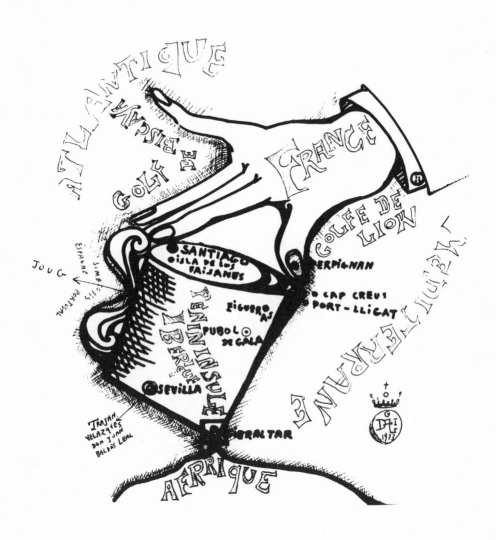